'THE WORK OF ANGELS'

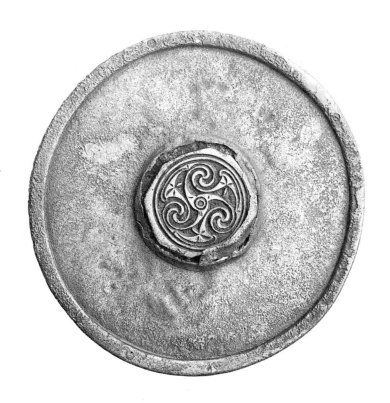

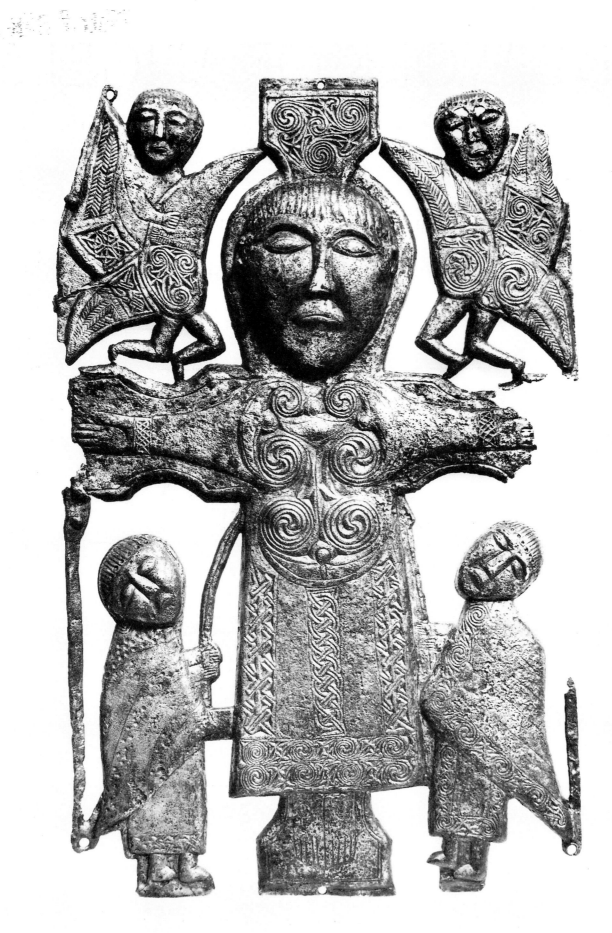

'THE WORK OF ANGELS'

Masterpieces of Celtic Metalwork, 6th-9th centuries AD

Edited by Susan Youngs

with contributions by Paul T. Craddock, Dáibhí Ó Cróinín,

Raghnall Ó Floinn, Michael Ryan and Leslie Webster

Published by British Museum Publications
for the Trustees of the British Museum
in association with the
National Museum of Ireland
and the National Museums of Scotland

The British Museum, the National Museum of Ireland and the National Museums of Scotland acknowledge with gratitude the support for the catalogue and exhibition by the Irish Government and the generous assistance of **Aer Lingus** ☘ towards the exhibition.

'THE WORK OF ANGELS'

'If you take the trouble to look very closely, and penetrate with your eyes to the secrets of the artistry, you will notice such intricacies, so delicate and subtle, so close together and well-knitted, so involved and bound together, and so fresh still in their colourings that you will not hesitate to declare that all these things must have been the result of the work, not of men, but of angels' (trans. O'Meara 1982).

Gerald of Wales, in the late twelfth century, was astounded by the artistry of an early medieval illuminated gospel book he had seen at Kildare. Gerald was a credulous and antipathetic observer of contemporary Ireland, but even he could not withhold his admiration for the ancient workmanship he had seen. His comment is equally applicable to the closely related field of ornamental metalwork, which reached its zenith in the jewellery and ecclesiastical treasures of eighth-century Ireland. These fine pieces did not stand alone and are here set in the context of earlier Celtic metalwork from Britain and Ireland, as well as of contemporary secular jewellery and other pieces. Sources of the common artistic influences at work in these areas are illustrated, as well as the technical processes which made possible the brilliant achievements of the period.

© 1989 The Trustees of the British Museum

Published by British Museum Publications Ltd
46 Bloomsbury Street, London WC1B 3QQ

British Library Cataloguing in Publication Data
The work of angels: masterpieces of Celtic metalwork,
6th–9th centuries A.D.
1. Great Britain. Celtic art metalwork, history
I. Youngs, Susan
739'.0941
ISBN 0-7141-0554-6

Designed by Harry Green

Set in Photina
and printed in Great Britain by
Butler and Tanner Ltd, Frome, Somerset

Front cover 124 Derrynaflan chalice (see also pp. 130–1, 160–1).

Back cover 69 Hunterston brooch (see also pp. 75, 91–2).

Page 1 60 Lagore disc-brooch (see also p. 64).

Page 2 133 St John's, Rinnagan, Crucifixion plaque (see also pp. 140–1).

'THE WORK OF ANGELS'

Masterpieces of Celtic Metalwork, 6th-9th centuries AD

Edited by Susan Youngs

with contributions by Paul T. Craddock, Dáibhí Ó Cróinín,

Raghnall Ó Floinn, Michael Ryan and Leslie Webster

Published by British Museum Publications
for the Trustees of the British Museum
in association with the
National Museum of Ireland
and the National Museums of Scotland

The British Museum, the National Museum of Ireland and the National Museums of Scotland acknowledge with gratitude the support for the catalogue and exhibition by the Irish Government and the generous assistance of **AerLingus** ☘ towards the exhibition.

© 1989 The Trustees of the British Museum

Published by British Museum Publications Ltd
46 Bloomsbury Street, London WC1B 3QQ

British Library Cataloguing in Publication Data
The work of angels: masterpieces of Celtic metalwork,
 6th–9th centuries A.D.
 1. Great Britain. Celtic art metalwork, history
I. Youngs, Susan
739'.0941

ISBN 0–7141–0554–6

Designed by Harry Green

Set in Photina
and printed in Great Britain by
Butler and Tanner Ltd, Frome, Somerset

Front cover 124 Derrynaflan chalice (see also pp. 130–1, 160–1).

Back cover 69 Hunterston brooch (see also pp. 75, 91–2).

Page 1 60 Lagore disc-brooch (see also p. 64).

Page 2 133 St John's, Rinnagan, Crucifixion plaque
 (see also pp. 140–1).

'THE WORK OF ANGELS'

'If you take the trouble to look very closely, and penetrate with your eyes to the secrets of the artistry, you will notice such intricacies, so delicate and subtle, so close together and well-knitted, so involved and bound together, and so fresh still in their colourings that you will not hesitate to declare that all these things must have been the result of the work, not of men, but of angels' (trans. O'Meara 1982).

Gerald of Wales, in the late twelfth century, was astounded by the artistry of an early medieval illuminated gospel book he had seen at Kildare. Gerald was a credulous and antipathetic observer of contemporary Ireland, but even he could not withhold his admiration for the ancient workmanship he had seen. His comment is equally applicable to the closely related field of ornamental metalwork, which reached its zenith in the jewellery and ecclesiastical treasures of eighth-century Ireland. These fine pieces did not stand alone and are here set in the context of earlier Celtic metalwork from Britain and Ireland, as well as of contemporary secular jewellery and other pieces. Sources of the common artistic influences at work in these areas are illustrated, as well as the technical processes which made possible the brilliant achievements of the period.

Contents

Message
from the Rt Hon. Margaret Thatcher, P.C., M.P.
Prime Minister

I am very happy to join with the Taoiseach in welcoming the exhibition *'The Work of Angels':* *Masterpieces of Celtic Metalwork, 6th–9th centuries AD,* which celebrates the strong cultural ties and creative interchange between the peoples of Britain and Ireland in the early medieval period.

These were times of momentous change, in which the Celtic peoples of Ireland and Britain, together with their Anglo-Saxon neighbours, played a significant role in shaping the religious, intellectual and artistic framework of medieval Europe. The vigour and inventiveness of Celtic culture drew fresh inspiration from the traditions of Anglo-Saxon and other Germanic art to new and brilliant effect, as we may see in this exhibition. It is particularly striking how the many fine examples of early medieval metalwork and manuscripts from these islands which went abroad to church treasuries and monastic libraries bear telling witness to a remarkable and enduring contribution to European culture.

This rich and influential tradition, and the many ancient ties between us, are just as alive today, and are clearly reflected in the spirit of close co-operation and friendship which gave rise to the exhibition itself. National museums in Dublin, London and Edinburgh have joined together in devising and hosting an exhibition which celebrates a common inheritance and a continuing purpose. I congratulate them and wish it well.

It is a particular pleasure to record our thanks to the Irish Government for their most generous financial contribution to this exhibition.

Message
from Charles J. Haughey, T.D.
Taoiseach

The title of this exhibition *'The Work of Angels': Masterpieces of Celtic Metalwork, 6th–9th centuries AD* is taken from the writings of Gerald the Welshman who used it in the twelfth century to describe the artistry of the lost gospel book of Kildare but it could apply equally well to the jewellery of the Irish, Britons and Picts of earlier times. Their craftsmen adorned the costume and weapons of the warrior with elegant ornaments of enamel and bronze. When Christianity came they devoted their skills to the service of God and in doing so they founded one of the most brilliant traditions of ornament that Europe has seen.

The craftsmen of that Golden Age did not work in isolation – they used techniques and designs that they had learned from the Anglo-Saxons and Franks, they drew heavily on the arts of the Mediterranean for their Christian symbolism, and their monastic patrons brought cherished reliquaries with them on their missions to Europe. Far from being a dark age, it was a time of achievement and advance in which the foundations of our Europe were laid down. The Celtic peoples of Ireland and Britain played a fundamental part in this movement and we celebrate it in this exhibition which brings together Celtic *objets d'art* from many countries.

I congratulate the British Museum, the National Museums of Scotland and the National Museum of Ireland for this most important cultural initiative which has grown naturally from the close ties of friendship and co-operation which exist between our national museums.

The Irish Government would like, in particular on this occasion, to acknowledge the generous contribution of the British Museum in restoring the Derrynaflan chalice and paten which are included in this exhibition.

Lenders to the exhibition

The British Museum, National Museum of Ireland and National Museums of Scotland thank the following institutions and individuals who have lent material to the exhibition and generously helped with the preparation of the catalogue:

Abbazia del Santissimo Salvatore, Abbadia San Salvatore, Siena 128

Ashmolean Museum, Oxford (Dr C. J. White, Director; Dr P. R. S. Moorey, Keeper; A. G. Mac Gregor, Assistant Keeper) 55

John Bradley Esq., Director, Urban Archaeology Survey, Dublin 54, 157–68, 197, 208, 218–19, 225, 231

Cork Public Museum (A. Ó. Tuama, Curator) 169, 198–200, 217, 223–4, 227–9

Devizes Museum (Wiltshire Archaeological and Natural History Society), (Dr P. H. Robinson, Curator) 40

Historic Monuments and Buildings Branch, Department of the Environment (Northern Ireland), Belfast (Dr C. Lynn, Senior Inspector; M. Fry, Conservator) 203–6, 210, 216

Historic Buildings and Monuments Directorate, Scottish Development Department, Edinburgh (I. MacIvor, Chief Officer; Dr D. Breeze, Chief Inspector; Dr A. Lane, Excavator) 181

Historisk Museum, University of Bergen (Dr A. Fasteland, Director; Professor A. Hagen; Dr S. H. H. Kaland, Curator) 51, 62, 67, 121

C. Marshall Esq., Louth 184

Musée des Antiquités Nationales, St-Germain-en-Laye (Dr J-P. Mohen, Director; F. Vallet, Curator) 138

Museo Civico Medievale, Bologna (Dr R. Grandi, Director) 132

Nationalmuseet, Copenhagen (Professor Dr O. Olsen, Director; Dr E. Munksgaard, Assistant Keeper 1st Department; Dr N-L. Liebgott, Keeper of 2nd Department) 131, 143

Parish Council of St Mary and St Hardulf, Breedon-on-the-Hill (A. Hawkins, Churchwarden; Dr A. Dornier, Excavator) 50

St Edmundsbury Museum Service, Bury St Edmunds (Mrs A. Partington-Omar, Borough Curator; G. Jenkins, Assistant Curator) 136

Salisbury and South Wiltshire Museum (P. R. Saunders, Curator; Miss C. Conybeare, Assistant Curator (Archaeology)) 41, 42

Scunthorpe Museum Service (Miss P. J. Spencer, Borough Museum Curator; K. A. Leahy, Keeper of Archaeology) 34

Statens Historiska Museum, Stockholm (Dr U-E. Hagberg, Director; Dr J. P. Lamm, Keeper, Iron Age Department) 120, 147

Ulster Museum, Belfast (J. C. Nolan, Director; Dr R. Warner, Acting Keeper of Antiquities; C. Bourke, Assistant Keeper) 6, 37, 61, 96, 154, 172–5, 188, 190, 193, 220–1, 226

Universitetets Oldsaksamling, Oslo (Dr E. Mikkelsen, Director; Dr I. Martens, Head of Museum Department) 52, 114–15, 134, 139, 144

Victoria and Albert Museum, London (Mrs E. Esteve-Coll, Director; Mrs P. Glanville, Deputy Keeper of Metalwork) replicas of the 'Tara' brooch and Ardagh chalice, London only

Foreword

This celebration of the achievements of Celtic metalworkers in the early Middle Ages has brought together some of the finest material from three national collections. It has provided a unique opportunity to explore the artistic and cultural bonds between Ireland and Britain in the sixth to ninth centuries AD, a milieu which produced some of the most brilliant artistic and technical masterpieces of the early medieval period.

The exhibition had its origin in the National Museum of Ireland's offer to lend the recently discovered hoard of church plate from Derrynaflan in County Tipperary to the British Museum, in appreciation of work carried out on the hoard by the British Museum's Conservation Department and Research Laboratory. This magnificent treasure provided the nucleus of the exhibition; it offered an opportunity to bring together metalwork made not only in Ireland but also in Britain, in particular, in the Irish and Pictish kingdoms of Scotland. The National Museums of Scotland have provided much of this regional material. Other museums, institutions and individuals, from several countries, have most generously made available some of their finest early medieval pieces, including some returning to these shores for the first time since the Middle Ages. An important aspect of this collaboration has been the assembly of workshop material, and here too we have been very fortunate in being able to include important unpublished material from recent excavations.

We would like to express our gratitude to those institutions and individuals who have contributed to the exhibition and the catalogue. Particular thanks, however, are due to the following colleagues, whose undaunted energy and expertise lie behind the genesis of this exhibition: Susan Youngs and Leslie Webster of the British Museum; Raghnall Ó Floinn and Michael Ryan of the National Museum of Ireland; and Michael Spearman and David Clarke of the National Museums of Scotland.

Finally, we owe a special debt of gratitude to the Irish Government for making a substantial grant towards the costs of this exhibition, and to Aer Lingus, whose sponsorship has greatly eased the costs of transportation. Their generous help has made possible this joint venture betweeen Dublin, Edinburgh and London, a collaboration which is itself a happy reflection of cultural links established between our nations in the early Christian period.

R. G. W. ANDERSON, *Director, National Museums of Scotland*
PATRICK WALLACE, *Director, National Museum of Ireland*
DAVID M. WILSON, *Director, British Museum*

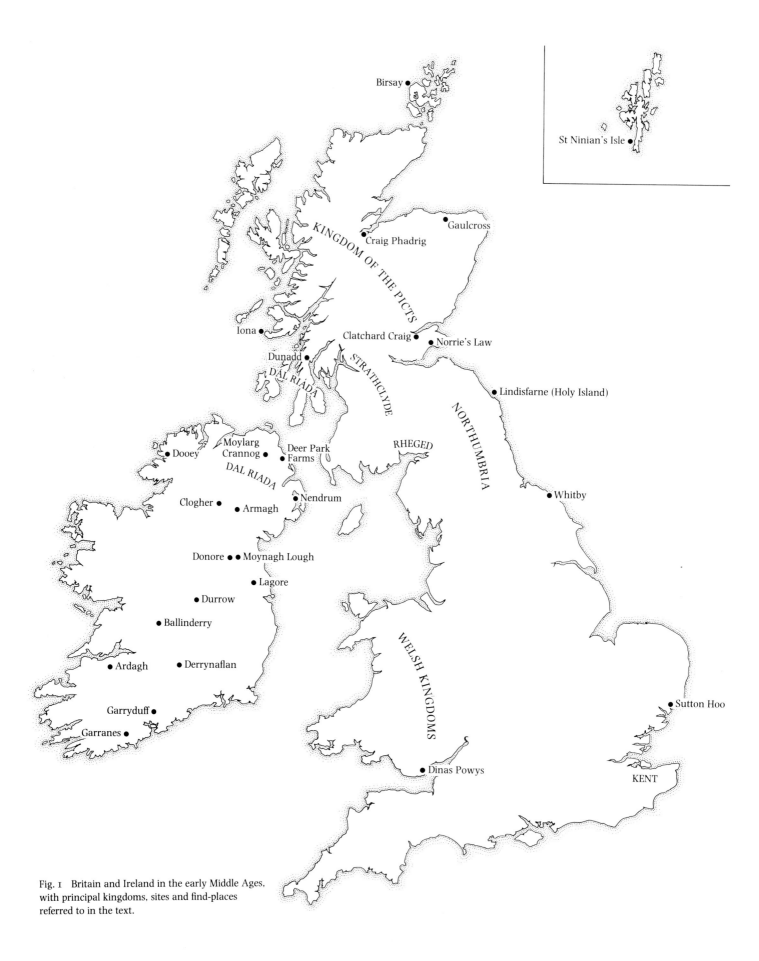

Birsay

St Ninian's Isle ●

Gaulcross ●

● Craig Phadrig

KINGDOM OF THE PICTS

Iona ●

Clatchard Craig ●

● Norrie's Law

Dunadd ●

DAL RIADA

STRATHCLYDE

● Lindisfarne (Holy Island)

NORTHUMBRIA

RHEGED

Moylarg
Crannog ●

Deer Park
Farms ●

Dooey ●

DAL RIADA

Clogher ●

● Armagh

● Nendrum

Whitby ●

Donore ● ● Moynagh Lough

● Lagore

● Durrow

● Ballinderry

● Ardagh

● Derrynaflan

WELSH KINGDOMS

Garryduff ●

Garranes ●

● Sutton Hoo

● Dinas Powys

KENT

Fig. I Britain and Ireland in the early Middle Ages,
with principal kingdoms, sites and find-places
referred to in the text.

Introduction:
Ireland and the Celtic kingdoms of Britain
by Dáibhí Ó Cróinín

Ireland was never a province of the Roman Empire and the Celtic peoples of Britain were never completely absorbed into the imperial system; beyond the Firth of Forth lay Pictish tribes outside the unifying Roman structure of one official language, law and a city-based administrative and fiscal system with a network of public roads to speed the movement of troops and goods. Mountainous Wales and lowland Scotland lay at the furthest fringes of the network where the military predominated. The Irish Sea was a physical barrier and also a highway; for the first three centuries of the millennium all these areas had been influenced by the products and culture of the classical world. In the third and fourth centuries the Irish and Picts were foremost amongst the several barbarian groups raiding, destroying and attacking the rich but enfeebled provinces of Roman Britain.

The people of Ireland were known as the 'Scoti' to the classical world. In the centuries following the first raids the Scots from Dál Riada in the north-east of Ireland and the Laigin in the south-east invaded and conquered two coastal areas of Wales and the area of modern Argyll in north-west Britain. In the north this movement was so substantial and sustained that it led first to the establishment of the kingdom of Scottish Dál Riada, where one royal family ruled on both sides of the North Channel for over a century, and eventually to the conquest of the whole of Pictish Caledonia, the birth of historic 'Scotland'. In the early medieval period British rulers continued to hold the area of Strathclyde and Cumbria, but Adomnán's life of St Columba at Iona shows how frequently travellers moved across the Irish Sea in the sixth century and the strength of the Irish hold in Scotland.

Ireland had known no invaders in the period before the coming of the Vikings at the end of the eighth century – perhaps the most important fact in early Irish history. Its consequence is evident in the development of Irish society between the fifth and twelfth centuries: it is true that traces of Roman influence can be seen in the archaeological remains, but the invasion which the Roman historian Tacitus says was once proposed by Agricola, conqueror of northern Britain, never in fact took place. When, therefore, Ireland eventually came under the influence of Rome it was, as the Irish missionary saint Columbanus put it, the Rome of Sts Peter and Paul, not that of the Caesars.

Located on the western periphery of the Empire, Ireland developed social and political institutions which were in many ways different from those that emerged in Britain and on the Continent. These differences have sometimes been exaggerated, but there is no denying that the absence of Roman influences, and the relatively undisturbed course of the country's history during the period of the so-called barbarian invasions elsewhere in Europe, saw the emergence of a society which was in some ways unique.

The most remarkable feature of that early Irish society was its homogeneity. From a

very early date Ireland could boast of a standard vernacular language, despite the fact that the country had never had to suffer the imposition of Roman rule. Irish in fact preserves the oldest vernacular literature in western Europe, and this literature reflects a uniformity of language and religious practices throughout the country which still defies adequate explanation.

But though Irish people everywhere shared the same language (and in the surviving literature there are no traces whatever of dialect variations), and probably also the essentials of common religious cults, the political organisation of society by contrast presents a very fragmented picture. Although there are traces in the older literature of a prehistoric era in which the country was a unitary whole, marked off only by the boundaries of the ancient 'Fifths', or provinces, the picture of Irish society that emerges from the documentary records of the fifth century and afterwards is one in which the country was dotted by myriad small, tribal kingdoms, each ruled by its own king. This kind of society has been characterised as 'tribal, rural, hierarchical and familiar', with the emphasis on the local and particular aspects of social organisation. By the time of these early documents (law texts, genealogies and other manuscripts) the vision of Ireland as a unitary state, ruled by a 'high-king', had apparently disappeared, to be replaced by a patchwork of local tribal kingdoms, each confident in its own distinctiveness.

The darkness that shrouds the fifth century in Irish history makes it impossible to say whether the position *c.* AD 600 represents a continuation of the political and social trends that were at work in the decades and centuries before that date. Some historians believe that cataclysmic events took place on the eve of the documented period, and point to the emergence of new political groupings and dynasties in support of this view. They argue that the older, tribal ('archaic') structures of society either collapsed or were deliberately dismantled by a new breed of men, more ruthless and dynamic than their predecessors, who rode roughshod over the ancient taboos and tribal customs of the prehistoric period in their drive for power and position.

It is possible, therefore, that the picture of Irish society which emerges from the early Irish law texts, far from being a true reflection of the state of affairs up to the Viking invasions, may in fact be a deliberately archaic vision of that society as the native (*brehon*) lawyers wished it to be. Their picture of a rural economy, based essentially on the four-generation family household kin-group, probably preserves a true enough pattern for the early period, and the detailed provisions relating to such everyday matters as the sick-maintenance due to injured parties, the sureties required for legal contracts, and so on, very likely preserve some genuinely archaic aspects of the law that can, in some instances, be traced back to Indo-European society. However, the supposedly archaic and ritualistic features of Irish society generally in the early Middle Ages are most likely exaggerated, as indeed is the thorough 'archaism' of the Irish laws on which that view is premised.

The localised nature of Irish society is well illustrated by the reference in one of St Patrick's writings to the necessity of purchasing the goodwill and protection of several kings and their *brehons* (*illi qui iudicabant*), and the real risk of physical injury or even death to anyone who wandered too far away from kin and territory is also vividly reflected in Patrick's experiences. The *brehons* were powerful and enjoyed a prestige which Irish society accorded also to poets and other members of the learned classes. These men could travel without hindrance all over the country, always under the protection of the law, and it was doubtless by their agency that the standard literary language was established at an early date. Along with the kings, the members of the

learned or *nemed* ('sacred') classes represented the summit of the social hierarchy; the less exalted members of society led a much more confined existence, seldom, if ever, moving outside their own tribal areas.

Compared with other contemporary barbarian kingdoms, where kings were few and enjoyed an extravagant wealth, based mainly on their ownership of vast royal estates, Ireland is notable for the proliferation of its kings. Where a Lombard king in Italy could boast of owning perhaps a tenth of the total land mass of the country, and the Merovingian kings in Francia disposed of comparable landed wealth, the more numerous Irish kings had much more modest resources to draw on. The absence of coinage and an urban economy meant that wealth resided in land and its produce. It has been said that the Irish were 'probably always an impecunious race', and by comparison with their contemporaries in Britain and on the Continent this was probably true; but the remarkable artistic achievements of the seventh century and after would not have been possible without the lavish support of kings and aristocracy.

By the first decades of the fifth century at the latest the Irish had come into contact with Christianity. Apart from the writings of St Patrick, almost nothing survives from that earliest period, and we have only the most meagre details about the routes by which the new religion travelled to Ireland. The evidence of archaeology, supported by occasional literary references, suggests that Irish trade with Europe must have been of some importance from an early date. The presence also of Irish colonies in western Scotland and in south-west Wales also contributed to the flow of information about 'the Roman Island'. In AD 431, according to the Chronicle of Prosper of Aquitaine, a man named Palladius, deacon of the church at Auxerre, was ordained and dispatched as first official bishop to the nascent Christian community in Ireland. The mission of St Patrick, sent by the Church in Britain, may have begun somewhat later. These two streams of influence, from Britain and from Gaul, were to leave lasting marks on Irish churches in later centuries.

Christianity undoubtedly introduced many new concepts and practices into Ireland. We still have a list of the oldest Irish names for the days of the week, dating from the very earliest period of the new Church. The Christian-Roman calendar, and related concepts of time, were to fascinate Irish scholars for centuries to come. Above all, though, the most profound change brought about in Irish society was the introduction of writing. Christianity is a religion of the book, and gospel codices and other manuscripts must have formed part of the earliest missionaries' baggage. The characteristic Irish script which developed as a result (and which, indeed, was to become the national script of England as well until the Conquest) is one of the most striking examples of how the Irish adopted and adapted such things.

Given the rigidly stratified nature of native society, the Irish would have had little difficulty in adapting to the Roman concepts of ecclesiastical hierarchy. Although the Irish were to be accused on several occasions of heterodoxy, all the evidence proves conclusively that Irish ecclesiastics such as Columbanus (writing *c.* AD 600) and Cummianus (*c.* AD 633) never deviated from their allegiance to Rome. However, although the new regulations of canon law, the new order in society represented by the clergy, and the new institutions of the Church were all successfully absorbed into Irish society (but not, perhaps, as quickly as later church writers would have us believe), the characteristic structure of the Church elsewhere proved unsuited to Irish social and political conditions. The earliest missionaries (continental and British) must have tried to impose the organisational structures that they themselves were familiar with, and the paraphernalia of territorial dioceses, ruled by bishops, with their administrative officers, was probably

envisaged for the Irish Church from the start. But territorial dioceses, based on the old Roman military regions, with headquarters in the larger cities, had no equivalent in non-Romanised, rural Irish society. This inherent weakness of the episcopal church was dealt a body-blow by the great plagues of the mid-sixth century, which seem to have devastated large areas of the country. The result was the appearance of monastic churches, now no longer confined by strict territorial boundaries, with subsidiary linked holdings scattered all over the country.

The rise of the newer-style monastic churches probably went hand in hand with the emergence of the small but dynamic dynastic families who were to dominate Irish politics for the next two centuries. The very large surviving corpus of Irish genealogies preserves scores of instances in which political and ecclesiastical offices were held in common by members of such dynasties. In Leinster, for example, the fortunes of the rising Uí Dúnlainge were closely tied up with those of the monastery in Kildare, the most important church in the province. The dynasty provided kings and bishops simultaneously, and maintained a monopoly of high office in the church there for several generations.

The most famous example of such 'restrictive practices' was the island monastery of Iona established off the western coast of Scotland by St Columba (Colum Cille) in AD 563. All but one of the first nine abbots in Iona belonged to the same kin-group, and the twelve 'disciples' who accompanied the founder were all related to him. From Iona Irish Christianity spread to the north of England, with the foundation in AD 635 of the monastery of Lindisfarne (now Holy Island) off the east coast of Northumbria. From the seventh century the north of England became what one eminent scholar described as a 'cultural province' of Ireland, and the story of the Irish mission forms one of the important themes in that greatest of medieval histories, the Venerable Bede's *Ecclesiastical History of the English Nation*. Bede's *History*, and other sources, recount numerous instances of secular and ecclesiastical contacts between the two islands; far from being a barrier between peoples, the sea in fact offered a relatively easy means of travel – hence the fact that many Englishmen ('countless numbers of the Northumbrian aristocracy', says Bede) made their way to Ireland, some to study and then return, others to stay.

Through such channels the Irish spread the knowledge of their particular style of handwriting, and their English pupils imitated them so successfully that modern scholars are frequently at a loss to distinguish the nationality of a scribe from the evidence of the handwriting alone. This common script is therefore called 'insular' because it formed the common property of all the peoples of the British Isles – Irish, English, British (Welsh) and (probably) Pictish.

A second stream of Irish missionary travel abroad was initiated *c.* AD 590 with the departure from Bangor (Co. Down) of Columbanus, with eleven companions, for Burgundy in France. The impact of the man and his personality was immediate, though not necessarily welcomed by the Frankish bishops. The three Irish foundations in Burgundy at Luxeuil, Fontaine and Annagray were to prove important centres of the burgeoning Frankish monastic movement in the seventh century and were instrumental in introducing several Irish innovations into the liturgical practices of the Gallican Church. Columbanus, however, proved too hot to handle, and he was eventually expelled from Burgundy. He crossed the Alps into Switzerland, where a disciple, Gallus, founded the monastery of St Gall, and passed on into Italy, where he established his final foundation at Bobbio, north of Milan. The library in St Gall in the ninth century boasted a collection of 'books written in the Irish script' (*libri Scottice scripti*), and the numerous Irish manuscripts still to be found there and in other continental libraries bear eloquent witness to the presence at one time of Irish pilgrim monks all over Europe.

The earliest missionaries must have brought with them the books and ecclesiastical vessels which are the basic equipment of every church (see p. 125). The new Christian Church could draw on millennia of experience in the production of fine metalwork stretching back into the Bronze and Iron Ages, and Tírechán, in the seventh century, mentions one of Patrick's followers, Bishop Assicus, who was a coppersmith (*faber aereus*). Although private celebration of the Mass is not known from the early Irish Church, it is possible that altar vessels might have travelled in the baggage of Irish missionaries and pilgrims, as gospel books and other manuscripts certainly did. Columbanus, for instance, records that the altar-board at Luxeuil had been blessed by Bishop Aéd of Bangor before his departure from Ireland, and such portable altar-boards are known from other churches in Ireland and England. Continentals remarked that *peregrinatio*, the urge to undertake spiritual exile, seemed to be second nature to the Irish, and certainly the Irish appear to have travelled in large numbers, often to Rome, sometimes even further afield, like the Iona monk Fidelis, who visited the Holy Land. One ninth-century pilgrim, returning from Rome through Liège in Belgium, journeyed up the Meuse in the company of some of the local bishop's servants, who stole everything he had. He complained angrily to the bishop, supplying an itemised list, with valuations, of all his possessions and a demand that they be restored to him.

Such Irish contacts with Britain and the Continent can be traced from the sixth century. The names of Aidan in Northumbria, Fursa in France, Gallus in Switzerland and Columbanus in Italy are all still vividly remembered, while the place-names of many towns across Europe record the presence there at one time of some anonymous *Scottus* or Irishmen. At the same time Anglo-Saxons and Franks also came to Ireland, and these twin cultural contacts must have added considerable impetus to the development of Irish artistic tastes. Ireland had already developed a distinctive script by *c.* AD 600 at the latest, and from that date there are the first traces of a feature which was to blossom into Ireland's greatest artistic achievement of the Middle Ages, the decorated book. But the fact that the Irish script had become the common property of all the insular peoples, and the fact too that all the peoples of the Irish Sea area doubtless contributed to the exchange of cultural ideas and tastes, has meant that modern scholars find it very difficult to separate and distinguish the different strands in the general fabric, much less evaluate them. Great illuminated gospel books like the Book of Durrow, the Lindisfarne Gospels and the Book of Kells are still the subject of intense scholarly debate, and the discussion is likely to last for some time to come.

Behind the elaborate decorations of the earliest illuminated gospel books there probably lies the influence of fine metalwork. This is particularly obvious in the Book of Durrow, the first of the surviving gospel books with a fully developed set of ornamental pages. The symbol of the man in the portrait of St Matthew has a rigidity which suggests a model in metal, while the chequered pattern of his cloak has all the appearance of a surface set with *millefiori* glass. It is very likely that the Irish were familiar from an early date with fine Anglo-Saxon metalwork of the type discovered at Sutton Hoo, and there may even be traces of Frankish influence (from the Merovingian period) in the animal interlace of one Durrow 'carpet' page. The Anglo-Saxons, for their part, may have nurtured slightly different tastes, combining indigenous styles with more Italianate ones introduced by such Northumbrian churchmen as Benedict Biscop of Wearmouth-Jarrow and Bishop Wilfred of York. This combination of influences is clearly to be seen in the decoration of the Lindisfarne Gospels.

Royal patronage was indispensable to the survival and prosperity of churches, and behind much of the fine metalwork and manuscript production stood the wealth of kings

and their followers. Irish archaeologists have suggested that royal residences may in fact have been the principal production-centres for fine metalwork, and the presence of mixed industrial waste at such sites as Garranes, Lagore and Clogher, indicating manufacture on an almost industrial scale, particularly in bronzeworking, seems to bear out the view that kings invested substantially in metalworking facilities. The parallel evidence for Wales and Scotland supports the case. There is no doubt that royal power increased appreciably between the seventh and ninth centuries, and the consolidation of power in a relatively small circle of aristocratic and royal families probably led to the accumulation of wealth on a grander scale than before.

The Derrynaflan and Ardagh chalices, with their respective patens and related pieces, are presumed to have been manufactured in a monastic workshop, though this need not necessarily have been the case. The recent discovery of a metalworking site at Moynagh Lough (Co. Meath), with very extensive traces of activity but with no obvious monastic or royal connections, points to the existence of purely secular, professional workshops where fine metalwork was presumably manufactured on commission. Besides, the evidence from Clogher, where royal and ecclesiastical sites existed almost side by side, and other similar settlements, suggests that the distinction between secular and ecclesiastical craftsmanship in metal at least may be of little practical use.

The Book of Durrow (Dublin, Trinity College, MS. 57) was provided with a metal casket (*cumdach*) by the Uí Néill 'high-king' Flann mac Máel Sechnaill (died AD 916), and there were doubtless similar acts of royal patronage in earlier centuries. The manuscripts themselves, however, must be the products of monastic scriptoria, though the sheer size of the undertaking must have meant that a full-scale gospel codex, requiring several hundred calf-skins, could only have been produced by monasteries with access to considerable independent or royal wealth. The seventh-century church at Kildare was lavishly decorated, and a (royal?) crown hung above the altar. The description sounds very like the contemporary Visigothic votive crowns now preserved in the Musée de Cluny, Paris, and it may well be that Irish kings invested their wealth in similar decorations for their own royal churches.

We do not know the historical context behind the manufacture of the Ardagh chalice (col. illus. p. 160), though it is generally assumed to have been produced for an important and wealthy church. The Derrynaflan chalice and paten, on the other hand, have a more clearly discernible origin. The bleakness of the site, rising up as it does from a vast flatland of bog, belies what must have been its considerable importance in the early ninth century. Originally called *Doire Eithnech* ('the ivied oak-wood'), the site was renamed from its association with two eminent Munster churchmen, Flann mac Duibthuinne (died AD 821), and Flann mac Fairchellaig (died AD 825), who gave it the new name 'the oak-wood of the Flanns'. The latter Flann was perhaps the most eminent Munster ecclesiastic of his day, combining several high offices, and he must have been very well connected politically. He was a leading light in the Céli Dé ('clients of God'), an ascetic movement of the late eighth and early ninth centuries which counted among its members the King of Munster. Royal patronage, both in political and financial terms, would have been readily forthcoming to such churchmen, and the suggestion that the Derrynaflan hoard represents in fact a royal altar set, though not susceptible of proof, cannot be lightly dismissed.

The Viking impact at the end of the eighth century, though it caused a temporary dislocation of artistic activities in Ireland, seems to have done little permanent damage to the social and political fabric of the country. It is possible that the Vikings were the direct cause of so many Irishmen leaving for Europe around this time, but this second

wave of exiles, which saw the appearance on the Continent of such outstanding intellects as Sedulius Scottus and Iohannes Scottus 'Eriugena' ('Irish-born') may have had other causes as well. There are occasional references in English and continental sources to these wandering scholars, and most of them probably passed through Wales and England on the way. This probably explains the presence in England of some Irish manuscripts, like the Mac Durnan Gospels (Lambeth Palace, London, *s.n.*), written in the distinctive Irish script and richly decorated in the style of the great insular gospel books. A note in the manuscript says that the book was given as a gift to the church of Canterbury by King Aethelstan (died AD 939).

Irish connections with Britain thus stretch from before the sixth to the ninth centuries, and beyond, and the archaeological and manuscript treasures of the period bear eloquent witness to this period of exchange and innovation.

Catalogue

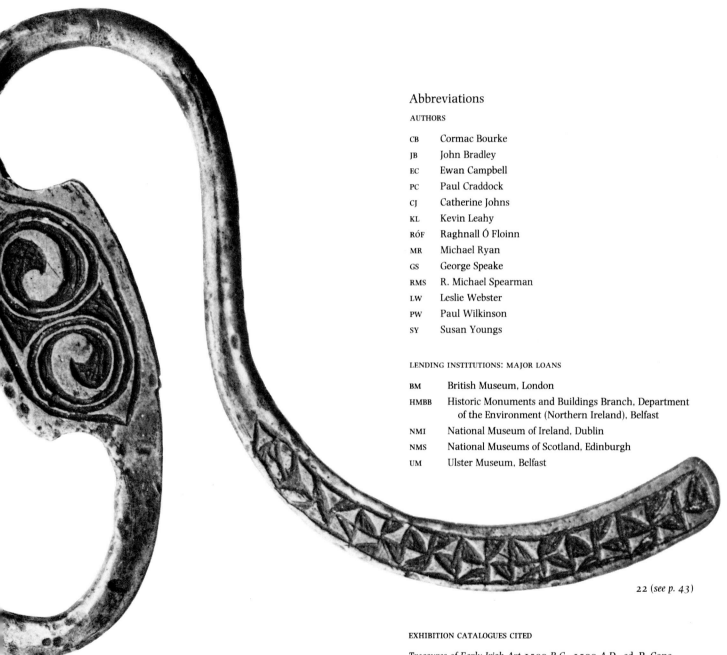

Abbreviations

AUTHORS

CB	Cormac Bourke
JB	John Bradley
EC	Ewan Campbell
PC	Paul Craddock
CJ	Catherine Johns
KL	Kevin Leahy
RÓF	Raghnall Ó Floinn
MR	Michael Ryan
GS	George Speake
RMS	R. Michael Spearman
LW	Leslie Webster
PW	Paul Wilkinson
SY	Susan Youngs

LENDING INSTITUTIONS: MAJOR LOANS

BM	British Museum, London
HMBB	Historic Monuments and Buildings Branch, Department of the Environment (Northern Ireland), Belfast
NMI	National Museum of Ireland, Dublin
NMS	National Museums of Scotland, Edinburgh
UM	Ulster Museum, Belfast

22 (*see p. 43*)

EXHIBITION CATALOGUES CITED

Treasures of Early Irish Art 1500 B.C.–1500 A.D., ed. P. Cone, Metropolitan Museum of Art, New York, 1977

Gold aus Irland, eds M. Ryan and M. Cahill, Munich, 1981

Trésors d'Irlande, Galeries Nationales du Grand Palais, Paris, 1982

Treasures of Ireland. Irish Art 3000 B.C.–1500 A.D., ed. M. Ryan, Dublin, 1983

Irish Gold: 4000 Years of Personal Ornaments, eds M. Ryan and M. Cahill, Melbourne, 1988

Fine metalwork to c. AD 650
by Susan Youngs

Before the eye-catching technical innovations of the late seventh century Irish metalworkers and contemporary smiths in Britain already commanded a range of skills: the casting, raising, engraving and tinning of copper-alloys, the application of most of these techniques to silver, and the production of red enamel-like inlay using cuprite glass paste. Ornament was derived primarily from the curvilinear, low-relief patterns of the Celtic world known from before the period of the Roman Empire, but it was newly translated in the fifth and sixth centuries on to a range of unfamiliar objects which came to dominate and characterise workshop output for up to 200 years. These include 'latchet' dress-fasteners, the open ring or 'penannular' brooch, bracelets, decorative bowls designed for suspension and a variety of dress pins. Some of these object types are localised, like latchets in Ireland and the silver chains of Pictland. With the exception of swords and other blacksmiths' work which are not considered here, these are essentially ranges of small-scale items in comparison with the massive bronze castings of the late Iron Age. Other technical changes took place: the two-piece mould was used at every workshop site, replacing the lost-wax process, and even the composition of the opaque red enamel changed (Hughes 1984, Bimson and Hughes forthcoming). Conspicuous by their absence were the buckles, disc- and long brooches of contemporary early medieval continental Europe, indicating different styles of dress and conventions for expressing status in these Celtic Christian communities which lay largely on or beyond the frontiers of the old Roman world, some behind the barrier of the pagan Anglo-Saxon settlements.

The technical, material and aesthetic standards exchanged and shared on both sides of the Irish Sea in a period of political and social upheaval, when fragmentation might be expected, are perhaps best understood as a by-product of the Irish colonial expansion beginning in the fifth century, principally a movement into western Scotland but also into Wales and even southwest Britain, where control of the tin trade in Cornwall would have been a real prize.

Metalwork of the period up to AD 650 is identified and dated by two primary aspects, the type of object and the style of its ornamentation. Very little has been recovered in contexts that can be firmly dated by archaeological means in a society that did not use or had abandoned the use of coins, and where pottery is present only occasionally as an import. Even the scientific aid of carbon-14 dating is very broad in the dates it can provide in the sixth and seventh centuries because of restrictions imposed by calibrating the results. One exception is the largely British material acquired by fair means or foul by the Germanic invaders of Britain, the pagan Anglo-Saxons, and which was buried in their graves in association with other more closely dated objects (a pattern repeated by the Vikings in the ninth and tenth centuries).

Style and decoration still provide the main dating framework within which the pieces are fitted by expert consensus: changing views on the reintroduction or survival of Roman-style animal ornament, for example, account for the dates of openwork mounts ranging from the fifth to the seventh century. The tiny scale of the Oldcroft pin (no. 1) belies its unique importance as a decorated Celtic piece dated by a coin hoard to before AD 359. Beyond this period lie richly illuminated gospel books (Alexander 1978) whose ornament is derived from fine metalwork, imitating the studs and settings as well as the animal ornament, interlace and scroll panels of the finest polychrome pieces such as the 'Tara' brooch. The completion of the Lindisfarne Gospels, dated by a later scribe to AD 698–721, suggests a date by which this technical revolution in metalwork must have taken place. For the preceding decades the Book of Durrow with its more limited and apparently 'archaic' repertoire should provide a key to dating, but here controversy continues because this manuscript is not firmly dated by features independent of the decoration. Like the running scrolls on a circular mount, the interrelationship with fine metalwork is clear, but we lack a fixed point to break the circle.

The ornament used on both bronze and silver falls into distinct categories. Straight-line, incised decoration gives a ribbed effect or is crossed to give long xs or tight grids, or angled in adjoining panels to make chevrons. Sometimes the lines are punctuated with punched circles or simple triangles and rectangles produced. Examples can be seen on pins, brooch hoops and bowl-mount frames, a straight geometry contrasting with the compass-based curving patterns which are used on the same pieces, notably the large silver disc-headed pin (no. 10) and the latchet (no. 24). Straight lines have always been a subsidiary but important element in the Iron Age Celtic repertoire (Leeds 1933, Mac Gregor 1976, Raftery 1983).

The curvilinear patterns of peltae, whorls and triskeles so closely identified with Celtic work were used in the late Iron Age in two ways: on the flat, as on the Lisnacroghera scabbards and the mirror backs of the period; and also beautifully worked in deep relief, cast or embossed on objects like the Battersea shield and a bronze disc from Ireland (Henry 1965a, pl. 10, Raftery 1983, no. 792). In the early Middle Ages curved pat-

terns are primarily two-dimensional, whether simply engraved or set in a bed of enamel, or in the case of raised patterns of the Lagore buckle type (no. 59) presented as a flat surface of ornament from which the background has been cut away to leave decorative facets in imitation chip-carved style, a technique copied from Germanic work. Three-dimensional mouldings were restricted to junctions on brooch terminals and hooked bowl mounts. Rare exceptions are the fine mouldings of the unique Ardakillen brooch (no. 58), the knobs outside the mounts on a bowl from Manton Common (no. 34) and two free-standing figures, namely the fish in the largest Sutton Hoo bowl and the stag mounted on the sceptre in the same burial (Bruce-Mitford 1978, 333–9 and 1983, I, 224–8). Less rare is the use of die-impressed or repoussé low-relief ornament on small metal foils decorating composite objects such as the mounts on Sutton Hoo hanging-bowl 2 (Bruce-Mitford 1983, 244–56) and the Swallowcliffe Down purse mount (no. 41), both probably dating towards the end of the period under consideration. Embossed curvilinear decoration familiar from the great armlets of the Iron Age seems to disappear in the intervening centuries.

Curvilinear ornament in the flat develops in complexity and elaboration during this period with the infilling of the whole of a carefully defined area with overall pattern or colour, curves and counter-curves. Spirals develop trumpet forms and animal heads, a process fully worked out by the time of the Lindisfarne Gospels. It must be the case that the fine work achieved by the illuminator with a pen in turn challenged or inspired the smith working for the same monastic patrons, and that a two-way exchange took place in the seventh century and possibly earlier. The wide missionary and inter-monastic links between houses in Ireland and north and west Britain, combined with the political domination of Irish, Pictish and Northumbrian kings, explain the universality of these design changes, how an immediate ancestor of a Lindisfarne animal scroll could occur on a bowl buried at Sutton Hoo in Suffolk (Bruce-Mitford in Kendrick *et al.* 1960, 206–10, Warner 1987).

Animal ornament was an important but subsidiary component in design. Highly stylised heads were depicted on Iron Age metalwork and are seen here on early penannular brooch terminals and in the art of seventh-century zoomorphic spirals. More naturalistic animals in the round were used to make the hooks on hanging-bowls. These animals were probably influenced by Roman metalwork. Similarly the marginal beasts in profile on buckles and other late Roman military metalwork may lie behind the openwork marginal beasts and profile bird and beast heads that appear on brooch-pins and some eighth-century brooches. Openwork mounts with confronted dolphins found at Faversham in Kent would appear to be perfect examples of Roman-derived design, but the Rome-based Christian Church provided a mechanism for the reintroduction of these images in the sixth and seventh centuries; it is significant that the Faversham dolphins meet over a cross (no. 36).

One of the largest and most studied classes of early fine metalwork is that of the penannular brooch (Fowler 1960 and 1963, Savory 1956, Kilbride-Jones 1980b, Dickinson 1982). They are a Romano-British type in Britain and one popular early form (Fowler 1963, type D) had an animal-based or zoomorphic

decoration ancestral to a large group of early medieval brooches. So few post-Roman penannular brooches have been recovered from independently dated contexts that dating relies largely on typology and remains the subject of considerable debate. The earliest examples from post-Roman Britain show some concentration in Wales and west Britain, and there are a few apparently contemporary examples from Ireland (Savory 1956, Lewis 1982). Some of these, with narrow-ribbed hoops and proportionally short pins, have small terminals with stylised animal-head decoration. These zoomorphic terminals become dominant features of a large class of penannular brooches found and manufactured in Ireland in the sixth and seventh centuries. Rudimentary ears and a snout define fields which come to be richly ornamented with opaque red enamel, sometimes with insets of *millefiori* and plain glass. The effect is luxurious and multicoloured, despite almost total reliance on copper-alloy. The surfaces of the metal could be textured, as on the brooch from Ballinderry Crannog 2 (no. 19), and a silver appearance given by tinning or the use of high-tin alloy. Decoration spread to behind brooch terminals, where it is usually incised and compass-drawn. Pinheads increased in size and solidity, with three pronounced ridges, and some have additional linear decoration of enamel and insets of *millefiori* glass (nos 16,17). They were initially cast and sprung on to the hoop and the pin shank worked up by hammering and annealing to its full length. These brooches were probably worn with the pins pointing upwards and later Irish representations confirm that they were worn by men as well as women, in contrast to the elaborate brooches worn exclusively by women in the contemporary Germanic kingdoms. An eighth-century Irish tract on status specifies the fine metals and inlays appropriate for kings and overkings in an idealised world, and large brooches must always have been significant badges of status.

Discussion has centred on when and how rapidly the inlaid terminal was introduced with its background recessed for champlevé enamel. There is agreement that the use of low-temperature red cuprite glass enamel, contrasting with fine curvilinear patterns, was rapidly followed by the addition of contrasting inlays, floating slices cut from rods of *millefiori* glass and also by mounting such inlays in copper-alloy cell walls to give a cloisonné effect. What is not yet unequivocally established is the exact time and pace of these changes, whether, for example, evidence from the recently excavated workshop debris at Clogher, Co. Tyrone, interpreted as demonstrating rapid technological change in the last decades of the sixth century (Warner 1979 and 1985/6), holds good for the introduction and spread of change throughout the other kingdoms and provinces of Ireland. *Millefiori* inlay may have been introduced around AD 600 (Ó Ríordáin 1941–2, 118–20, 140–1, Bourke 1985, 136). Yellow enamel was introduced not long afterwards.

Workshop debris as well as actual examples show that a variety of penannular brooches other than the Irish inlaid zoomorphic type was produced in the seventh century and later throughout most of Ireland, in lowland and in Pictish Scotland and in Wales (Bradley 1984, Curle 1982, Warner 1979, Laing 1973, Close-Brooks 1986, Alcock 1987). Terminal forms were

varied: simple balls and faceted ends were manufactured at the Moynagh Lough workshop; while lozenge-shaped and bird-headed brooches were made at Dunadd and Birsay, examples of this last type having been found in northern Ireland (see nos 181,182). Broad terminal types ancestral to later decorated forms were produced at Dunadd and the Mote of Mark (Laing 1973 and see no. 181). The basic types were categorised and their possible ancestry and relationship discussed in Fowler 1963.

The use of fine-line curvilinear ornament against an enamel background, of *millefiori* inlays and the ribbing and cross-hatching of bars and hoops, link the design and manufacture of the zoomorphic penannular brooches very closely to two more enigmatic classes of fine metalwork. The first is a distinctive asymmetrical dress-fastener, essentially a flat disc and hook, known misleadingly as a 'latchet'. These seem to have been originally equipped with wire coils, often missing, to attach them to fabric. Despite a very few early British examples, most latchets have been found in Ireland where they sometimes occur in sets (see no. 21): a developmental series can be recognised (Smith 1917–18, Laing 1975, 332, Kilbride-Jones 1980a, 211–13). Some latchets early in the series, such as the example found at Newry (no. 21), and perhaps of fifth- to sixth-century date, have motifs derived from the Roman world and found on other early Irish metalwork (no. 19), but they appear to grow in size in the sixth and early seventh centuries and also in ornamental elaboration, leading to the fine example from Dowris (no. 24). Here scrolls as well as chevron and lattice patterns are found in the enamelling. The enamelled chevrons on this latchet match those on the implement found at Stoney-ford (no. 20), another specialised object of uncertain use. The final decorative development of the latchet appears to be the zoomorphic spirals of no. 23.

The other category of metalwork closely allied in smithing techniques to the penannular brooches is that of the hanging-bowls – thin copper-alloy vessels designed exclusively for suspension from three or four hooks, with decorative mounts attached to the outside below the rim. Changes took place in the production of enamel appliqué mounts for these bowls which must have been broadly contemporary with the evolution of zoomorphic penannular brooches; but in this case an indication of date is given by the recovery of most hanging-bowls from furnished pagan Anglo-Saxon burials in eastern and southern Britain, in contexts broadly datable within the period AD 550 to 650. Despite the use of identical decorative motifs on Irish metalwork, there is no direct evidence for the use or manufacture of hanging-bowls in seventh-century Ireland beyond two mounts, one from the river Bann (no. 37) and the not inconsiderable finds of somewhat later date from Viking graves in Norway, almost certainly looted from Ireland (see no. 51 and Petersen 1940). In the seventh century Tírechán reported seeing in Irish churches bronze vessels made much earlier by St Patrick's companion Assicus (Bieler 1979, 140–1), but the early Christian period bronze vessels found in Ireland are not the distinctive hanging-bowl type (no. 123). Nevertheless, artistically and technically there are very close links between the enamelled mounts from a hanging-bowl found at

Sutton Hoo in Suffolk (Bruce-Mitford 1983, I, 206–44) and a brooch from Ballinderry (no. 19). The bowl was repaired before burial c. AD 630 and both it and the brooch perhaps date to c. 600 or slightly later. The trumpet scrolls and spirals of the hanging-bowl found at Winchester (no. 33) are mirrored in the decoration of the Book of Durrow (col. illus p. 36). Applied discs, both foils and enamels like hanging-bowl mounts, are found on Irish church metalwork (nos 47,125a) and in miniature form behind eighth-century Irish annular brooches (nos 71,72), but detached discs also occur in earlier contexts such as at Clatchard Craig (Close-Brooks 1986, 168) and as a stray find on the Fosse Way (no. 31).

A great deal of research has gone into the classification and dating of these vessels (Kendrick 1932, Henry 1936, Fowler 1968, Longley 1976, Bruce-Mitford 1983, I, 202–90, Brenan 1988). While rim forms and bowl profiles have indicated a relative chronology, the different types of ornament have proved less amenable to objective analysis. Recent components analysis confirms that the simplest, most utilitarian forms are the earliest in the series (Brenan 1988). Even identical bowls can have totally dissimilar decorative mounts (see no. 34). The decorative mounts soldered or riveted to the bowls fall into three basic categories: circular, bird-shaped and openwork. The only evidence for the manufacture of escutcheons comes from one Pictish site in Scotland, a mould for an openwork mount from Craig Phadrig (no. 38). Examples of this last class have been found as far apart as the river Bann and an Anglo-Saxon cemetery at Bekesbourne, Kent. British hanging-bowls remain enigmatic: their functions are obscure as they often have decoration inside, outside and underneath. Wear on hooks and rings shows that they were not only suspended from a tripod but were frequently hung by one ring from a hook when out of use. In the seventh century King Edwin of Northumbria arranged for bronze drinking vessels, *cauci*, to be hung from stakes by springs to refresh travellers (Colgrave and Mynors 1969, 192–3), and there is an eighth-century reference to bowls hanging as church lamps in Northumbria (Campbell 1967, 50–1). Handwashing before or during a feast and the ritual welcome of a guest are obvious possibilities: Adomnán writing at the end of the seventh century described how water for handwashing was brought to Columba in a bronze bowl while on a visit to Irish Dál Riada (Anderson and Anderson 1961, 316). Was there some distinction of social practice between the native British and the Irish such as an exclusively British custom of presenting a hanging-bowl as a bridal gift? There is much opportunity for speculation, but the craftsmanship and lavish decoration of many hanging-bowls show they were not purely utilitarian. They continued to be made in the late seventh century and beyond (no. 51).

The universal metal dress-fastener was the pin, which throughout the early period was manufactured in a number of forms. The simple stick-pin has a variety of terminal decoration and dates to the fifth century and earlier, as examples from Covesea and Traprain Law show (Burley 1955–6). Iron Age pin forms appear to lie behind distinctive, highly decorative pins with disc-heads (nos 10 to 12) and the handpin, its head resembling a fist with the fingers bent forwards. The discovery

of examples ancestral to the decorated handpins in dated late Roman contexts in Britain has established a starting-point for the development of this group. Finds from Gloucester (Heighway 1987, 15, 17(8)), St Albans (Selkirk 1986, 182–3) and in particular the silver and enamel pin from Oldcroft (no. 1) – coin-dated to before AD 359, give a long chronology for the type that appears in a massive, highly decorated form in the late sixth and early seventh centuries (nos 3–6). There is evidence that these forms developed in lowland Scotland (Warner 1983, 183), and the handpin was then adopted throughout Ireland using the common stock of late Celtic ornament found on latchets and other metalwork.

Pins with loose rings through the head are found in many forms but the most common types date from the Viking period. A group with pendent heads, however, raises important questions about outside influence on design and ornament in metalwork, whether their form is simply an adaptation from the late seventh-century false penannular brooch or one already inde-pendently established, as the use of a recess at the hoop apex to fix the pin suggests. Similarly, how far was the use of openwork pendants, the omega shape, the classical marigold and other compass-inspired geometric ornament, profile beasts and stylised animal heads drawn directly from the world of late antiquity and not freshly introduced in the seventh century from the Germanic kingdoms of Europe and from Italy? The openwork brooch-pin with confronted dolphins from Armoy, Ireland (Henry 1965a, fig. 20a) raises the same question as the dolphin escutcheons from Faversham, Kent.

Belt-buckles were certainly a foreign kind of fastener intro-duced to Ireland from overseas perhaps *c.* AD 600, and decorated examples are relatively rare finds (de Paor 1961). The Lough Gara buckle (no. 46) with its triangular plate and three large rivet heads shows Germanic influence in its form and decor-ation. The finger ring (nos 28–30) also appears as a new form copied from the late antique and a rare survival compared with the various forms of dress-fastener. The Anglo-Saxon and Merovingian travellers in seventh-century Ireland recorded by Bede must represent a very small proportion of foreigners bring-ing in new metalwork, either on their persons or to give or trade, although no foreign imports have been found. The Irish kingdom of Dál Riada in Scotland was an important channel for the introduction of Germanic designs and forms in the seventh century, on the evidence of a workshop at the royal stronghold of Dunadd (no. 181). This complements the his-torical evidence for strong ecclesiastical links with the Anglo-Saxon kingdom of Northumbria. Borrowings such as these heralded a technical and artistic revolution in the later seventh century.

Celts and Picts: dress and status (*nos 1–30*)

1 Proto-handpin

Oldcroft, Lydney, Gloucestershire
Silver and enamel; L. 6 cm, WT 3 g
Romano-British, 3rd–4th century
BM, Prehistoric and Romano-British Antiquities, P.1973,8–1,1

The upper arc of the pin's projecting ring head has four beaded mouldings and two tiny circular settings for red enamel at each end, while the flattened lower segment of the circle is filled with red enamel against which a central pelta and two flanking volutes are reserved in silver.

The proto-handpin is a form ancestral to the handpins of the early medieval period (see no. 3). The curvilinear motif, as well as the shape of the pin, has affinities with later developments of the type, but the enamelled decoration has even closer connections with pre-Roman and early Roman enamelled metalwork. The pelta with a central spot running out to two volutes can be found in continental Iron Age art as early as the fourth century BC, and is still to be seen in work of the early Roman period in Britain. The Oldcroft pin was found in association with some fragments of scrap silver and over 3,000 bronze coins which provide a *terminus ante quem* of AD 359. It therefore demonstrates the continuity of the motif and, with its impeccable late-Roman context, constitutes an important link between Celtic metalwork of the pre- and post-Roman periods in Britain. CJ

BIBLIOGRAPHY Rhodes 1974; Johns 1974

1

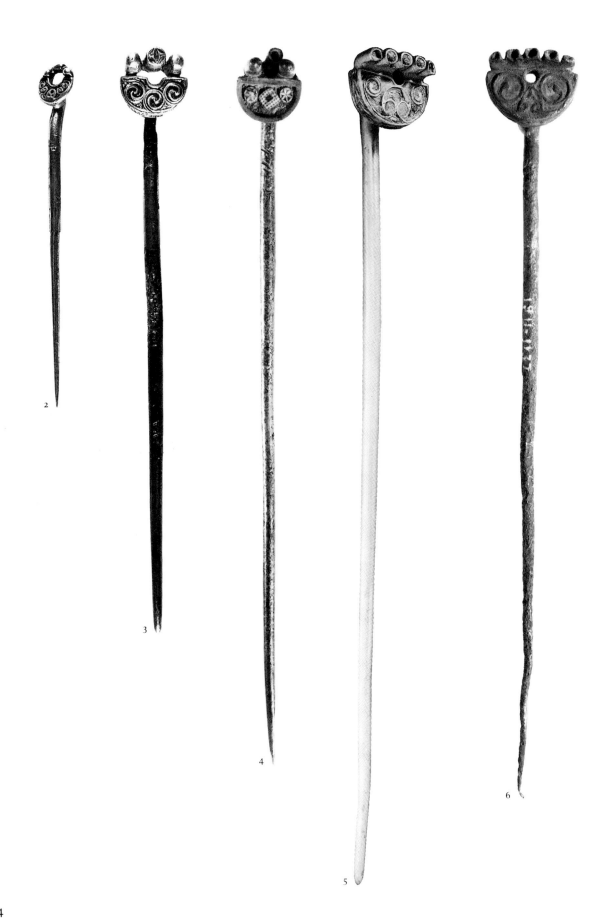

2 Proto-handpin

Castletown, Kilpatrick, Co. Meath. Found in 1848 with no. 3
Silver; L. 8.48 cm, head DIAM. 1.09 cm, WT 5.89 g
Irish, probably 6th century
NMI 7.W.24

Silver ring set parallel to a round-sectioned shank at the end of a short, right-angled arm. The ring consists of a lower crescentic plate from the ends of which a beaded arc springs. The plate bears two reserved pelta scrolls flanking a subcircular area with three circular depressions. This appears also to have been a worn (or botched?) reserved scroll. It is unclear whether the background was enamelled or not. The reverse of the ring is plain. The form stands close to the ancestral form of the handpin. MR

BIBLIOGRAPHY Armstrong 1915, 295; Mahr 1932, pl. 1, 3; Raftery (ed.) 1941, 92–3

3 Handpin

Castletown, Kilpatrick, Co. Meath. Found in 1848 with no. 2
Copper-alloy, heavy silver plating; L. 14.1 cm, head DIAM. 1.7 cm
Irish, late 6th–early 7th century
NMI P.634, Petrie Collection

Handpin with right-angled shank and plate mounted parallel to the longer section. The head consists of a crescentic plate, the ends of which are linked by three tubular beads – the 'fingers' – placed side by side. The crescentic plate and the central bead bear reserved ornament, on the plate there are tightly wound double spirals and on the bead a hollow-sided square with a central oval. There is herringbone ornament along the side of the plate and billeted lines and punched dots in groups of three occur on the reverse.

Called 'handpins' because of their resemblance to a human hand held up with the fingers bent at right angles to the face of the palm (some have five projecting tubes), they were presumably used as decorative cloak fasteners. The type evolved from pins with heads in the form of a partially beaded ring which were current especially in northern Britain in the early centuries AD. The handpin appears to have been fashionable in Ireland in the poorly understood period from the fourth to the early seventh centuries.

Precise stylistic dating of individual handpins is to a large extent speculative, but this example shares some of the features of decoration of certain penannular brooches and might therefore be later sixth to earlier seventh century in date. MR

BIBLIOGRAPHY Armstrong 1915, 295; Mahr 1932, pl. 1, 7; Raftery (ed.) 1941, 93

4 Handpin

Ireland
Copper-alloy, enamel, *millefiori* glass; L. 18 cm, decorated face DIAM. 1.65 cm
Irish, late 6th–early 7th century
NMI P.636, Petrie Collection

Pin made up of four elements: a long shank with a right-angled projection at the top, terminating in a circular plate fitted at the back with a free-riding loop and a long tube projecting at the front with an incised herringbone design. Attached to this is a thick, semi-circular plate to which are fixed two further similar tubes. The

sunken front of the semicircular plate was originally filled with enamel but most of this is now missing. Two fine, small roundels of blue and white *millefiori* glass – one in a hexafoil, the other a marigold pattern – flanking a quadrangular platelet of yellow and red survive on the front. The side of the plate is also sunken and in it are quadrangular copper-alloy panels most of which still carry small *millefiori* medallions in blue, white and red glass. They, too, were intended to have been seen against a background of red enamel, now missing.

The pin was misattributed (Ball and Stokes 1893, 291, Stokes 1932, 64 and Ryan and Cahill 1981, 45) to Clonmacnoise. Raftery ((ed.) 1941, 93) equally without foundation attributes it to Lagore Crannog. Its decoration is related to that of the Ballinderry brooch (no. 19) and it thus may date to *c.* AD 600 on the basis of comparisons with the largest Sutton Hoo hanging-bowl. MR

EXHIBITIONS *Gold aus Irland* 1981, no. 47; *Treasures of Ireland* 1983, no. 41

BIBLIOGRAPHY Ball and Stokes 1893, 291; Coffey 1909, 33–4; Mahr 1932, pl. 19, no. 2; Stokes 1932, 64; Henry 1936, 223; Raftery (ed.) 1941, 93

5 Handpin

Craigywarren Bog, Skerry, Co. Antrim
Copper-alloy and enamel; L. 23.35 cm
Irish, 7th century
BM, MLA 1880,8–2,132

Copper-alloy handpin, the semicircular head capped by five projecting 'fingers' fixed to a right-angled projection at the top of the shank. A drilled hole below the central finger indents the decoration on the front of the pinhead, which consists of a peltate design reserved against a red enamel background. The edge of the pinhead has a herringbone pattern inlaid with red enamel, and enamel also occurs on the ends of the fingers. The back of the head has a pattern of four incised lines radiating from the hole.

Closely related to no. 6, this pin represents an elegant native Irish version of the handpins. The elongated pin and 'five-fingered' head with central hole are considered to be typologically later developments from earlier forms (see nos 1–4). LW

BIBLIOGRAPHY Smith 1903–5, 352; Smith 1923, 130, fig. 167

6 Handpin

Portglenone, Co. Antrim
Copper-alloy, formerly enamelled; L. 21.8 cm, head W. 2.75 cm
Irish, 7th century
UM A1911.1137

Copper-alloy pin with separately cast semicircular head attached by two rivets to the angled extremity of the shank. The head is a semicircular plate with a row of five projecting cells or fingers on its upper margin. Cast, fine-line design on the front forms two spirals springing from a central pelta. The side of the head bears straight and oblique lines in two parallel zones. The sunken areas on the front were designed to contain enamel, and enamel or glass may have filled the projecting cells, now empty. A hole below the central cell derives from the open ring of the prototype (see nos 1, 2 and 5). CB

BIBLIOGRAPHY Henry 1936, 227, pl. xxviii.2; Kilbride-Jones 1980a, fig. 71.4

Early Pictish metalwork, 6th–7th centuries
(nos 7–11)

The Picts were culturally related to but distinct from other Celtic peoples. In the early medieval period they inhabited the northern part of modern Scotland. While their metalwork shares many forms and techniques with other contemporary Celtic metalwork, like their sculpture it has certain features unparalleled elsewhere. Most striking among them are the massive silver chains of unknown function (see no. 9) and the use of enigmatic symbols (nos 8, 9). The latter occur widely in early Pictish art, and have been linked to tribal or dynastic groupings. The amount of silver available is also exceptional and may reflect access to sources of late Roman silver. LW

BIBLIOGRAPHY Wainwright (ed.) 1955; Henderson 1967; Stevenson 1976; Friell and Watson (eds) 1984

The Gaulcross hoard, Ley, Banffshire (no. 7)

The Gaulcross hoard was a group of silver objects comprising a handpin, chain, bracelet and a number of other pins and brooches found shortly before 1840 in the ring-cairn of a stone circle called Gaulcross at Ley, Fordyce, in Banffshire. Only the three pieces exhibited here survive. They are on loan to the National Museums of Scotland from Banff District Council.

7a Handpin (col. illus. p. 33)

Silver, enamel; L. 14.3 cm, WT 28.1 g
Pictish, 6th–7th century
NMS L.1962.128

Cast silver; the semicircular palm of the pinhead is decorated with three exceptionally fine hair-spring spirals which are picked out against a background of red enamel. Three fingers project forward above the palm of the pinhead. The tip of the middle finger is decorated with an eight-pointed star, the centre of which is pierced, the whole being reserved against red enamel. The ridge between two grooves, which run around the curved edge of the palm, is beaded. There is also lightly punched dot decoration on the back of the pinhead and between the palm and fingers of the pin. The tip of the pin shank is bent and broken.

7b Chain (col. illus. p. 33)

Silver; section 1.2 cm × 1.2 cm, L. 27.9 cm, WT 132.9 g
Pictish, 6th–early 7th century
NMS L.1962.130

Silver chain, each of the sixty-two wire links formed and curved with considerable precision so as to allow them to fit into their neighbouring links while giving a tight, almost rope-like, appearance.

7c Bracelet (col. illus. p. 33)

Silver; L. 5.4 cm, DIAM. 6.4 cm, WT 45.7 g
Pictish, 6th–early 7th century
NMS L.1962.129

Silver bracelet made from a spiral band of undecorated beaten silver.

The band is convex in section, its outer surface polished and its inner edges bevelled. The ends are simply rounded off.

The hoard is not independently dated. Yet the three components in their separate ways appear to stand somewhat apart from other Pictish (and Irish) metalwork: they all lack the characteristic Pictish symbols; the bracelet has no parallel; the chain is more delicate and more complex than the massive silver chains so characteristic of Pictish metalwork (see no. 9). The controlled complexity of the handpin's decoration, with its hair-spring and 'tadpole-head' features, and its punched ornament, make it both the finest of the Pictish handpins and the closest to the best of their proto-handpin precursors, like that from Castletown (no. 2). The lavish use of silver, seen in other early Pictish metalwork, reflects the reuse of Roman silver, which in Scotland was certainly accessible in considerable quantity, as the huge Traprain Law hoard indicates (Curle 1923). It seems most probable that the Gaulcross hoard may date to the sixth or early seventh century, a precursor of the Norrie's Law hoard. RMS/LW

EXHIBITION Foul Hordes: The Picts in the North East and their Background, exh. cat. I. Ralston and J. Inglis, Anthropological Museum, University of Aberdeen, 1984

BIBLIOGRAPHY Stuart 1867, 75, pl. 9; Stevenson and Emery 1963–4; Stevenson 1976, 249.

The Norrie's Law hoard, Fife (no. 8)

A very large hoard of objects estimated at 400 oz of silver was found c. 1819 at the foot of a prehistoric mound. It was dispersed and much is known to have been melted down, but further investigation recovered the rump of this great treasure: three pins, two penannular brooches, a pair of unique plaques, a bossed disc, decorated and plain strips and some objects folded and cut about for reuse (hack-silver), which included Roman spoons and a late Iron Age embossed disc. Two coins dating to AD 360–80 (now missing) were said to be associated and also, from the original find, a now discredited seventh-century Byzantine coin (Laing and Laing 1984; Graham-Campbell 1985, fn. 29). The broad-terminalled brooches independently suggest a date in the seventh century, giving a very wide range of dates for the material assembled in this hoard.

One handpin and the plaques are decorated with symbols of a type known primarily from Pictish stone monuments. This gives these pieces particular importance in the identification of specifically Pictish metalwork. Pictish symbols are distinctive formalised motifs, some almost naturalistic representations of birds and beasts, others apparently showing household objects, such as combs and mirrors; further symbols, including the Norrie's Law 'z-rod', appear more abstract to modern commentators. The same designs were used in various combinations on stone monuments widespread in eastern and northern Scotland, the heart of the historic Pictish kingdoms. Repetition demonstrates the symbolic nature of the motifs. The stone monuments were memorials perhaps, or marked territorial claims, and the symbols were not considered out of place on the overtly Christian churchyard monuments which succeeded. There has been much debate about the origins, date and meaning of these figures which occur very occasionally on

Ireland
Ancient Land

HISTORY is everywhere in Ireland – from the earliest stone age to the wonders of mediaeval times and beyond. To visit man's treasures is to walk in history itself and better understand the beauty of the land.

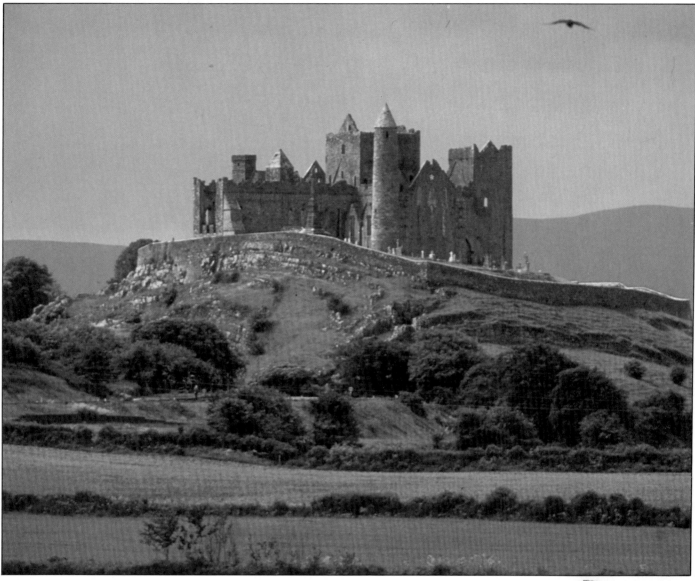

▲ Erupting from the Golden Vale of County Tipperary, the <u>Rock of Cashel</u> presents one of the most striking cluster of monuments from mediaeval Ireland. Having been the seat of the kings of south Munster, it was handed over to the Church in 1101, and all the existing monuments date from after this event – a Round Tower, Cormac's Chapel (1127-1134), probably Ireland's first Romanesque church, and a thirteenth-century Cathedral. The Hall of the Vicar's Choral now houses the twelfth-century High Cross.

<u>High Cross of Moone, County Kildare.</u> Among Ireland's High Crosses, sculpted in stone around the ninth century, Moone has a special place. It is unusually tall and slender in its elegant proportions, but its main appeal lies in the naive simplicity of its graphically-conceived flat figure carving on the base – as exemplified by the Twelve Apostles with their heads looking like corks in a bottle! ▶

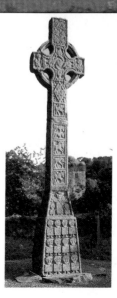

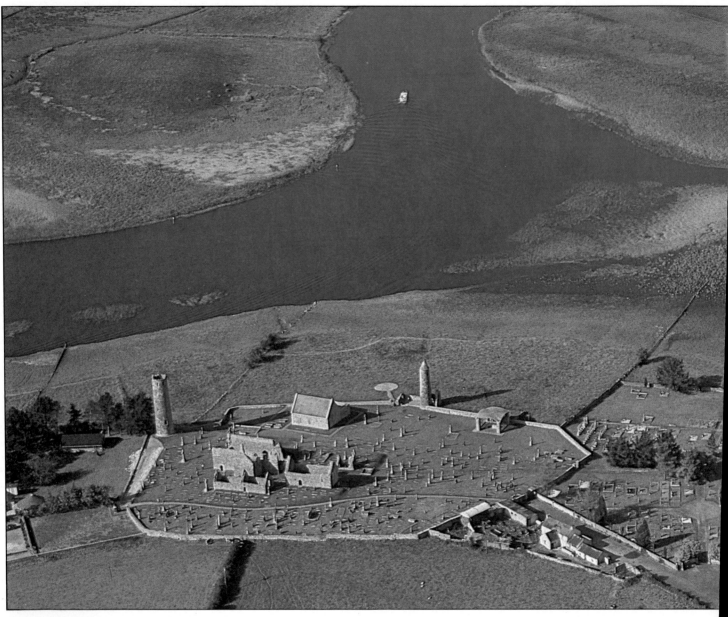

▲ Aerial view of <u>Clonmacnois</u>, where St
saint's tomb has attracted pilgrims from shortly a
its location near a ford where the main east-we
Surviving metal treasures probably emanated fr
two complete High Crosses, including the Cro
Round Towers (one forming part of a Romanes
shrine, built at various periods between the te

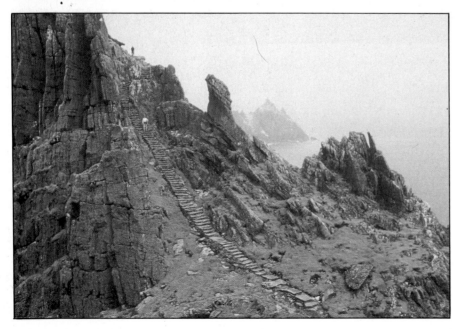

◀ <u>Skellig Michael</u> is one of the most a
Christian activity in mediaeval Ireland. Situat
miles off Ireland's south-west coast, it houses a
beehive huts and two oratories placed on a w
feet above the sea. Often difficult of access, eve
marvellously conjures up for us the ascetic sim
early Christian Ireland.

...ran founded one of the most famous monasteries of early mediaeval Ireland. The ...is death in 548 down to the present day. Its magnetic attraction was supported by ...adway crossed the River Shannon, the country's main north-south traffic artery. ...workshops, and the site is well-known for its stone monuments. These comprise ...the Scriptures, numerous fragmentary crosses and cross-decorated slabs, two ...uurch), and numerous churches, including the Cathedral and St. Ciaran's oratory ...nd the thirteenth centuries.

...ding witnesses to an island twelve ...on of half a dozen ...own plateau 560 ...mmer, the island ...of monastic life in

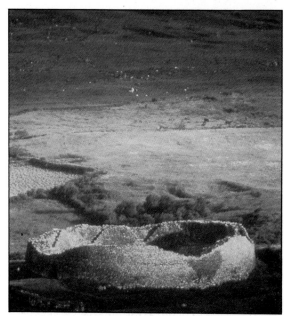

Staigue Fort, beautifully situated in the upper reaches of a valley on the Ring of Kerry in the south-west of Ireland, is one of a number of imposing, yet enigmatic round stone forts located not far from the western and north-western coasts of Ireland. Their purpose is generally taken to be defensive, but their date – pagan or Christian? – has yet to be established satisfactorily. ▶

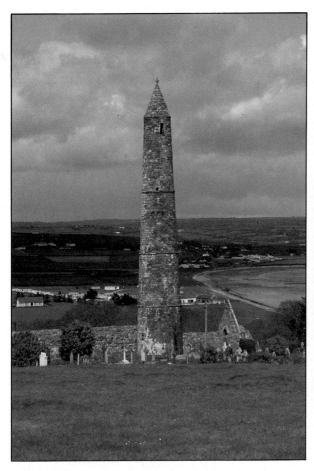

Ardmore, Co. Waterford, is the resting place of St. Declan, who was one of the first to bring Christianity to Ireland from Britain – even before St. Patrick!

This attractive site, dominating the Celtic Sea, preserves a mediaeval church with curious Romanesque sculptures, and also a twelfth-century Round Tower – one of the last ever to have been built.

Glendalough, County Wicklow. This hauntingly beautiful valley in the Wicklow hills was chosen as a hermitage by St. Kevin in the sixth century, and the monastery which grew up around his tomb contains many churches probably of the eleventh-twelfth century date, as well as one of the best-preserved Round Towers in the country. Though often considered to have been erected as a defence against the Vikings, these towers are more likely to have had a religious purpose – as bell-towers, storehouses of monastic treasures and probably also as beacons to approaching pilgrims.

other early metalwork (see no. 9; Henderson 1971; Stevenson 1976, 248–50; Thomas 1984; Ralston and Inglis 1984, 28–33). None of the later Pictish silver, dated on art-historical grounds to the eighth century and later, carries these symbols (nos 103–12). SY

8a Handpin

Norrie's Law, near Largo, Fife
Silver, enamel; L. 17 cm
Pictish, 6th–7th century
NMS FC30

Silver handpin, the front of the pinhead decorated with red enamel which provides a background to fine spiral decoration on the palm and a cross on the centre finger. An engraved herringbone decoration and line of beading runs around the edge of the pinhead, and there is an incised Pictish symbol, a 'z-rod', on the reverse, engraved before the head was attached to the neck and shank of the pin.

This is one of a pair of very similar handpins found at Norrie's Law. Its partner is, however, of a better standard of workmanship, although it lacks the z-rod symbol on its reverse. It has been suggested that the pin exhibited here was in fact a deliberate, and perhaps later, copy of its partner. Similar z-rod decoration occurs in more complicated forms on the two silver plaques from Norrie's Law as well as on the terminal of the Whitecleugh massive silver chain (nos 8b, c, 9). RMS

BIBLIOGRAPHY Anderson 1881, 39; Anderson 1883–4, 243–6; Stevenson and Emery 1963–4, 207–9; Stevenson 1976, 248

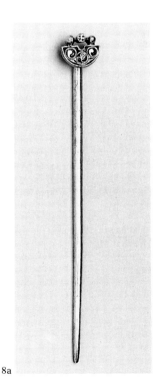

8a

8b, c

8b, c Plaques

Norrie's Law, near Largo, Fife
Silver, enamel; L. 9.1 cm, W. 3.2 cm
Pictish, 7th century
NMS FC33 and 34

Pair of silver leaf-shaped plaques with incised Pictish decoration picked out with red enamel. The two plaques are virtually identical in shape, size and decoration, with the exception that one (FC33) has an incised line around its border. At the narrower end they have a silver boss ornamented with spirally divergent lines.

The central decoration on each plaque is an arrangement of two circles separated by a decorated z-rod symbol. The infilling of the two circles with triple spiral decoration is unusual on the Pictish symbol stones, although spiral infilling does appear on the terminal of the silver chain from Whitecleugh, Lanarkshire (no. 9), and the lost bronze plaque from Laws, Angus (Anderson 1883–4, 45, 51). Below this symbol are the torso and head of an animal, perhaps that of a dog. Similar dog heads appear in the Lindisfarne Gospels, although the figure is also characteristic of animals on the Pictish monuments of Scotland, and is reminiscent of the dog head on the reverse of the bronze plaque from Laws, Monifieth.

There is no sign of any method of attachment on the reverse of these pendants, and their detailed function is unknown. RMS

BIBLIOGRAPHY Anderson 1883–4, 240–7; Stevenson 1976, 248–9

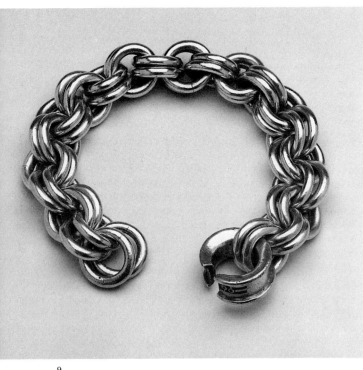

9

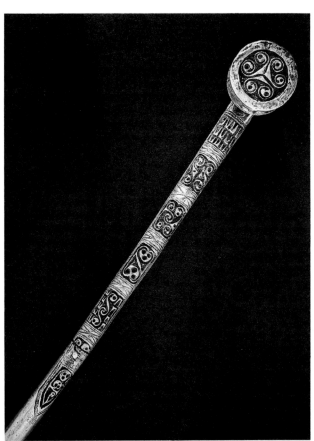

10

9 Chain

Whitecleugh, Shieldholm, Crawfordjohn, Lanarkshire
Silver; chain L. 48 cm, WT 1731.3 g; terminal 5.3 cm × 4.7 cm, WT 136.35 g
Pictish, 6th–7th century
NMS FC150

Massive double-linked silver chain with penannular terminal ring. There are forty-four plain circular rings in the chain, linked together in pairs (two more links were broken off and 'lost' in the nineteenth century). The terminal ring is of subrectangular section and the outer face is engraved with Pictish designs, inlaid with red enamel. On one side of the penannular terminal is an arrangement of two circles with spiral decoration separated by a decorated z-rod.

The motif is similar to that on Pictish sculpted stones and the Norrie's Law silver plaques (no. 8b). The edge of the same side of the terminal is decorated with a band of chevron decoration set against a background of red enamel. On the other side of the terminal is a Pictish design, well known from a number of sculptured stones, although it does not appear on other metalwork.

Ten such chains are known from Scotland, but only one other, that from Parkhill, Aberdeenshire, has a decorated terminal. The Whitecleugh chain was found projecting from the bank of a drainage ditch in 1869 by a shepherd. RMS

BIBLIOGRAPHY Smith 1872–4, 333–5; Clark 1879–80, 223–4; Henderson 1979

10 Disc-headed pin

UNPROVENANCED
Silver, enamel; L. 32.4 cm, WT 116.79 g
Irish or Pictish, probably 6th century
BM, MLA 1888,7–19,100, Londesborough Collection

Silver disc-headed pin, the disc fixed to a right-angled projection at the top of the shank. The outward-facing parts of the head and the upper half of the shank are entirely covered with small panels of incised decoration, in which various toothed and curvilinear designs reserved against a background of red enamel alternate with plainer patterns composed of incised saltires and triangles and circular stamps. Borders of circular stamps frame everything except the triple-pelta motif on the disc face. The pin has been crudely repaired in three places, following ancient damage.

This pin and no. 11 are evidently products of the same workshop, as their closely similar ornamental repertoire shows. Their distinctive construction also clearly links them to the handpins, with which they are at least partly contemporary. Certain decorative elements, especially the saltires, circular stamps and the distinctive 'tadpole heads' which appear in the curvilinear ornament, link these pins to the Gaulcross hoard pin (no. 7a), which seems to stand at the beginning of the Pictish sequence. Another link with the Pictish handpins lies in the rare use of silver for these disc-headed pins, instead of the more usual bronze. It was not until the eighth century that silver became more readily available in Ireland. This raises the possibility of an origin in Scotland.

Close dating is fraught with difficulty but a date in the sixth century is likely. LW

BIBLIOGRAPHY Smith 1903–5, 354, fig. 11; Smith 1923, 130, fig. 169

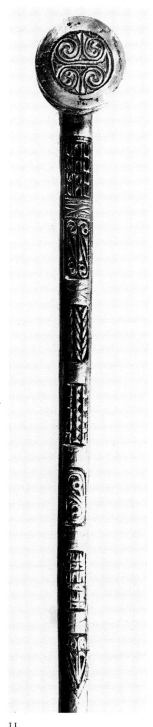

11 Disc-headed pin

UNPROVENANCED
Silver; L. 24.7 cm, disc DIAM. 1.7 cm, WT 75.9 g
Irish or Pictish, probably 6th century
NMI 6.w.26

Closely related to the handpins in form, the object consists of a long tapering pin (its point now missing) with a right-angled projection at the top which ends in a thick disc. The disc is decorated with a series of interlocking pelta scrolls as a silver reserve on a sunken field keyed for the reception of champlevé enamel which is now missing. The side of the disc, the angle of the shank and an area of the front of the pin carry small panels of reserved ornament, also formerly enamelled. Motifs employed include scrollwork, eyed-rolled spirals, herringbone, saltire and z step-like patterns.

Three other similar decorated pins exist, one silver (no. 10), possibly from the same workshop, and two of copper-alloy, one from Treanmanagh, Co. Limerick, and the other unlocalised (no. 12). A small number of undecorated examples are also known. The saltire ornament and other features link this object to the Castletown silver handpin (no. 3) and that in the Gaulcross hoard (no. 7a). MR

EXHIBITIONS *Gold aus Irland* 1981, no. 48; *Irish Gold* 1988, no. 51

BIBLIOGRAPHY Coffey 1909, 33, 36; Armstrong 1915, 295

12 Disc-headed pin

Ireland
Copper-alloy, enamel; L. 13.9 cm, disc DIAM. 1.1 cm
Irish, 6th–7th century
NMI W.201

Pin with shaft of circular cross-section, repointed in antiquity, forming a right angle at the top and terminating in a thick disc. The side of the disc is decorated with reserved ornament consisting of a row of v shapes. The disc bears a reserved pattern of three back-to-back pelta scrolls, the ends of the scrolls being decorated with a single drilled dot, set in a field of red enamel.

The hair-spring spirals formed by fine lines reserved against an enamelled background are a feature of certain later hanging-bowl mounts, best exemplified on the largest Sutton Hoo hanging-bowl. This style is also found on smaller objects like the handpin from the Gaulcross hoard (no. 7a) which also has fine drill holes at the spiral terminals. A date in the later sixth or seventh century is therefore likely.

An unfinished disc-headed pin, still with its casting seam visible, was found associated with metalworking debris at Garranes, Co. Cork (Ó Ríordáin 1941–2, fig. 3, 352). RÓF

BIBLIOGRAPHY Wilde 1861, 582–3

11 12

13 Curved mount

River Shannon, near Athlone, Co. Westmeath
Copper-alloy, niello(?); L. of each portion 11.6 cm, 10.2 cm
Irish, 6th–7th century
NMI W.24, presented by the Board of Works

Two fragments of a decorative mount made of strips of copper-alloy
of u-shaped cross-section. The larger piece is curved along its long
axis and tapers in width from one end to the other. Its outer surface
is covered with a variety of transverse, linear patterns which are
chased, not cast, including cross-hatched panels and rows of inter-
locking concave-sided triangles with a central dot. The narrow end
has a hollow, cast human head riveted to it. The figure is bearded,
the forehead decorated with cruciform arrangements of lentoids,
the cheeks with concave-sided triangles against a reserved ground.
The eyes were set with a metal paste (niello?), traces of which
remain. The hair is indicated by parallel incised lines, filled with the
same metal paste. There is a second rivet hole at the wider end. The
smaller fragment is broader but decorated in the same manner and
is also curved along its long axis. It has a single rivet hole at one
end. The decoration on the curved strips does not extend to the
edges but is confined to rectangular fields, sometimes outlined.

The function of this curved mount is made clear by a recent find,
from the same locality, of similar mounts which seem to belong to
a saddle such as that from the early seventh-century Frankish
cemetery of Wesel-Bislich (Janssen 1981). The cruciform arrange-
ment of lentoid petals is a common decorative feature of developed
zoomorphic penannular brooches (see no. 19) and handpins
(Kilbride-Jones 1980a, fig. 74), while the concave-sided triangle
with central dot occurs on objects like the Newry latchets (no. 21)
and the Killeeshal bracelet terminal (no. 26). A more compelling
parallel is found in the silver bands from the Norrie's Law hoard
(Stevenson and Emery 1963–4, pl. XI, 4). In size and ornamentation
they are very close to the Athlone fragments and may have had a
similar purpose. This would suggest a date somewhere in the later
sixth or seventh century for this piece. A fragment of a similar
binding strip with more restrained decoration was found in the
excavations at Garranes, Co. Cork (Ó Ríordáin 1941–2, fig. 4, 341).

<div align="right">RÓF</div>

BIBLIOGRAPHY Wilde 1861, 639–40

14 Zoomorphic pin

UNPROVENANCED
Copper-alloy; L. 10.2 cm
Irish, 4th–5th century
NMI X.2945

Bronze pin, cast and engraved. The stem is circular in cross-section,
tapering to a fine point. The head takes the form of a stylised animal
head seen in plan, the curved snout facing towards the point. Below
the snout is a series of closely set horizontal lines on the front of the
pin only, and the flat back of the pinhead bears incised horizontal
and diagonal lines. There are parallel striations on the pin near the
base of the stem. Kilbride-Jones (1980a, 11) reckoned these to be a
feature of the decoration, but the absence of patina in this area and
the relative shortness of the pin compared with others indicates
that the point was recut and that these striations are file marks.

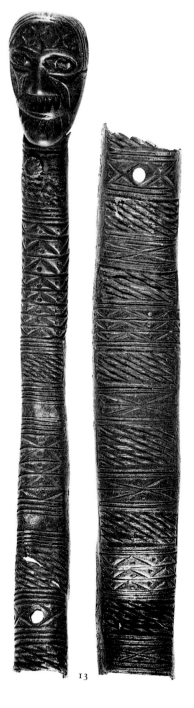

13 14

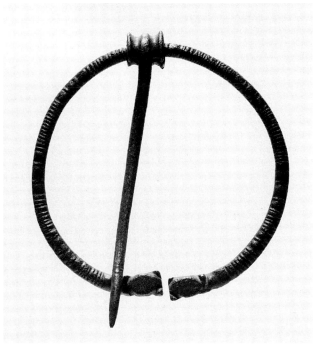

15

The form of the pinhead recalls the terminals of some early zoomorphic penannular brooches (see no. 15), The engraved zigzag ornament on the reverse of the pinhead is also a feature of these early brooches (Kilbride-Jones 1980b, fig. 23, nos 23 and 24). These zoomorphic pins are said to be derived from the proto-zoomorphic pin series, developed in northern Britain in the second and third centuries, some of which have pins up to 45 cm in length (Boon 1975). The zoomorphic pins, of which this is the only provenanced Irish example, seem also to have been a north British development, being otherwise known only from Traprain Law and the Roman forts of Chesters and Halton Chesters along Hadrian's Wall (Kilbride-Jones 1980a, figs 1 and 4).

Neither pin type comes from closely dated contexts and it is possible that both were contemporary. Fowler (1963, 122) would date these pins to the fourth and fifth centuries. Their use, if not manufacture, continued into the sixth century to judge from the discovery of a pin of the 'proto-zoomorphic' type in an early Saxon cemetery at Purwell Farm, Cassington, Oxfordshire (Leeds and Riley 1942, 70, fig. 16b–d). RÓF

BIBLIOGRAPHY Fowler 1963, 151; Boon 1975, 403, and pl. LXXXV, f; Kilbride-Jones 1980b, 11, and fig. 4.4

15 Penannular brooch

Porth Dafarch, Anglesey, Wales
Copper-alloy; loop max. DIAM. 6.9 cm, pin L. 7.7 cm
British, 5th–6th century
BM, MLA 1881,7–6,19

Cast hoop, round in cross-section with decorative ribbing alternating between closely packed lines and more widely spaced sections. Small flat terminals each have a plain rounded lozenge with knobs at the

corners, the whole derived from a simplified and stylised animal snout with ears, the mouth swallowing the hoop. The pinhead is a barrel-moulded rectangle wrapped around the hoop, with a decorative x by the join. The shank is dished, either by design or through wear.

This is a simple zoomorphic brooch of a type ancestral to the large ornate form, such as that from Ballinderry 2 (no. 19). The proportionally large diameter of the thin hoop and the short length of the pin are early features. The marked curvature of the pin is seen on a number of contemporary brooches and may be deliberate. Brooches of this type have been found in Wales and the west of England in Saxon graves and in the north of Britain as well as in Ireland (Savory 1956, Fowler 1963, 101–5, Longley 1975, 8–9). Some of the British brooches have simple enamel inlay on small terminals, but the zoomorphic form was developed and widely produced in sixth- and seventh-century Ireland (for example, no. 18). It is possible that this brooch along with similar examples was made in the west midlands. SY

BIBLIOGRAPHY Stanley 1876; *Archaeologia Cambrensis*, 4th ser., IX (1878), 24–7, 33–4; Smith 1914, 226; Smith 1923, 133; Savory 1956, 50; Fowler 1963, 103–4; Kilbride-Jones 1980b, 34, 88

16 Penannular brooch

Ireland
Copper-alloy, enamel; hoop DIAM. 4.8 cm, pin L. 8.0 cm
Irish, 6th–7th century
NMI W.358, Dawson Collection (no. 1609)

Cast hoop, round in section. The pin is corroded and the tip is missing, the shank bent where it crosses the hoop. The pinhead is flat and is bent into a loop, the front decorated with parallel vertical incised lines between side flanges. The hoop is decorated with bands of ribbing on the front only, now badly worn. The broad terminals contain sunken fields keyed for red enamel, traces of which can still be seen. Each terminal contains a Maltese cross as a reserve of metal. One of the crosses has a triangular stem extending from one of the arms towards the narrow end of the terminal plate. The sides of the animal snouts are decorated with a herringbone pattern, also keyed for an enamel inlay. The backs of the terminals are flat and

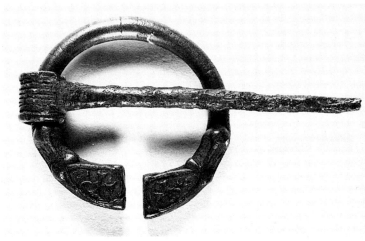

16

are ornamented with punched circles. The sides also carry punched circles and diagonally incised lines.

The ribbed hoop and broad terminals would suggest that this brooch is late in the penannular brooch series. It is one of a small group of about six brooches decorated with Maltese crosses. None are from stratified contexts and only a few are provenanced (Kilbride-Jones 1980b, nos 110 and 121, and Anon. 1873, 184).

The cross form is of interest as it is found on cross-inscribed pillars in Ireland, Scotland and Wales which are considered to be early (Henry 1965a, 119–23). Many of the brooches of this group have triangular 'stems' extending from one of the cross arms (Anon. 1873, 184) which are remarkably close to crosses found on the Cathach manuscript, usually dated to around AD 600 (Henry 1965a, pl. 12). A date in the later sixth or early seventh century is therefore likely for these brooches.

This is the only group of zoomorphic penannular brooches decorated with any overt Christian symbolism. However, the triangular 'stem' is also found on terminals of Kilbride-Jones's Group c4 brooches (1980b, fig. 45). These are decorated with stemmed palmettes which may also have had a Christian symbolic meaning – perhaps representing the handled *flabellum* (liturgical fan).

Nothing is known of the history of this brooch except that it formed part of the extensive collection of the Rev. Henry Dawson, Dean of St Patrick's, Dublin, which was acquired by the Royal Irish Academy in 1841. RÓF

BIBLIOGRAPHY Coffey 1909, 23, fig. 28

17 Penannular brooch *(col. illus. p. 34)*

Arthurstown, Co. Kildare. Found in a disturbed context in a sand-pit
Copper-alloy, enamel, *millefiori*; hoop DIAM. 6.52 cm, pin L. 14.15 cm
Irish, 6th–7th century
NMI 1934:10863

Penannular brooch of cast copper-alloy. The barrel-shaped pinhead bears enamelled lentoid ornament and *millefiori* platelets; the terminals, which are hollow, carry reserved bronze scrollwork in a field of red enamel. In the centre is *millefiori*. The outer aspect of the ring is ribbed.

Both this and brooch no. 18 show the developed Irish form of a distinctive class of zoomorphic brooch (see also no. 15). They are characteristic of the finest Irish brooches made before the technical changes of the later seventh century. The use of glass inlay in bright colours shows the importation of new materials and the beginning of polychrome metalwork. *Millefiori* glass was widely used in the Roman world and came back into use in both Anglo-Saxon and Celtic metalwork *c.* AD 600, with some differences in the patterns employed. MR

BIBLIOGRAPHY Kilbride-Jones 1980b, 119

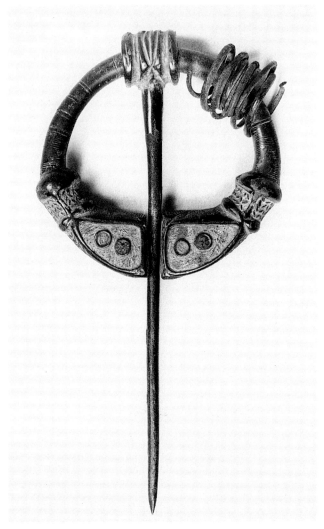

18

18 Penannular brooch

Near Castledermot, Co. Kildare. Found in 1860
Copper-alloy, enamel; ring DIAM. 7.56 cm, pin L. 15.16 cm
Irish, probably late 6th–earlier 7th century
NMI 1945:311, Kilkea Castle Collection

Penannular brooch of cast copper-alloy, the hollow terminals taking the form of stylised animal heads with their snouts towards the ring. The ring is decorated with fine ribbing, worn on its outer aspect. The terminals are recessed and keyed for champlevé enamel, and in the centre of each are two circular settings. Of these one of each still contains blue and white *millefiori*. The outer sides of the terminals and the beasts' snouts bear herringbone ornament. The ears of the beast on the inner and outer edges are hatched. On the ring are four coils of copper-alloy wires, perhaps a supplementary fastening. The pinhead is barrel-shaped and decorated with lentoid petals. The pin is round and tapering and bent where it crosses the ring. It is closely comparable with the Ballinderry brooch (no. 19). MR

BIBLIOGRAPHY Kilbride-Jones 1980b, 119

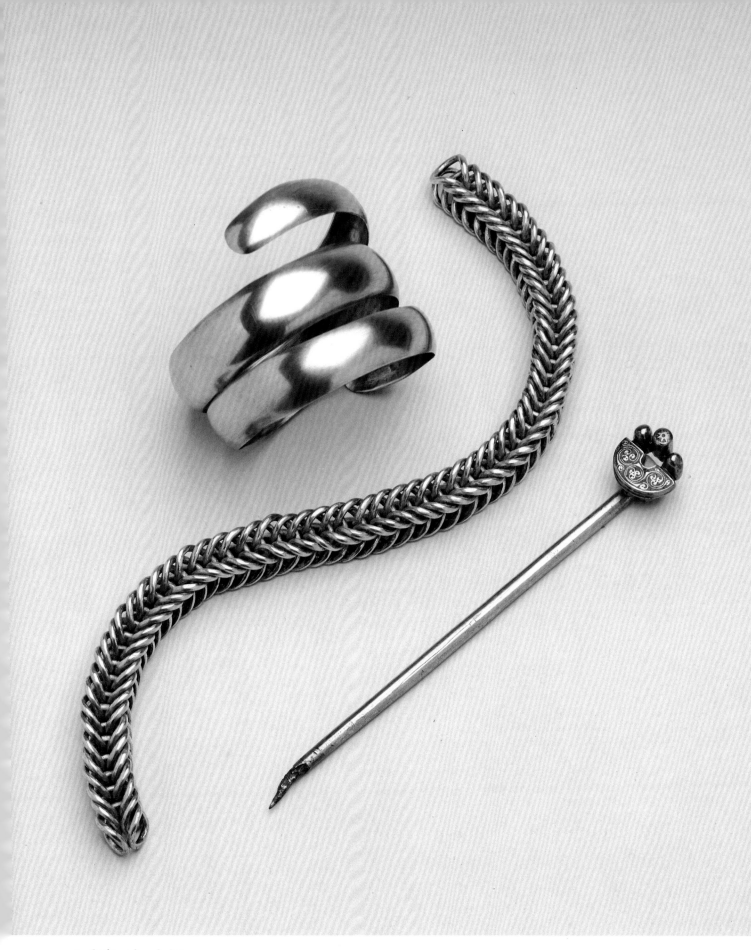

7 Gaulcross hoard of silver.

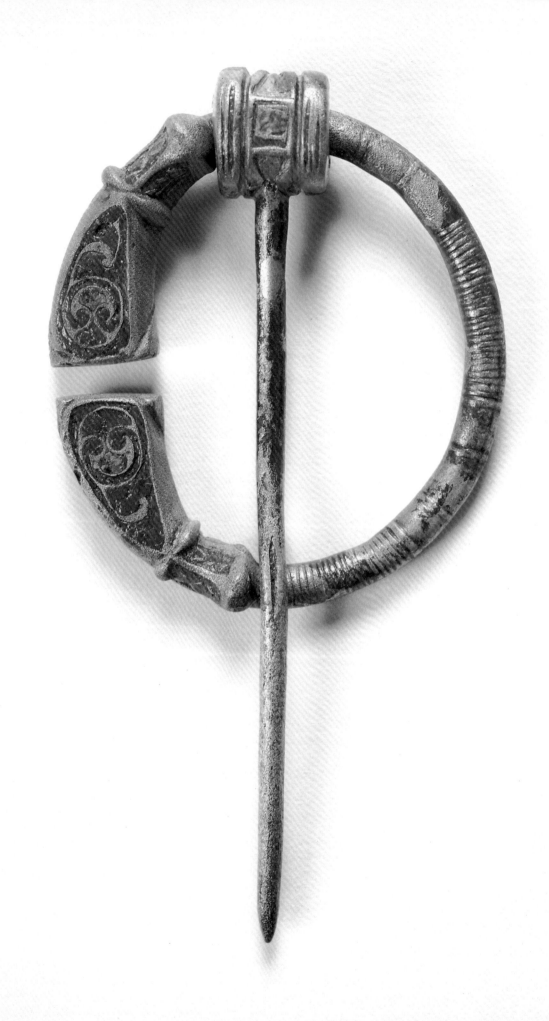

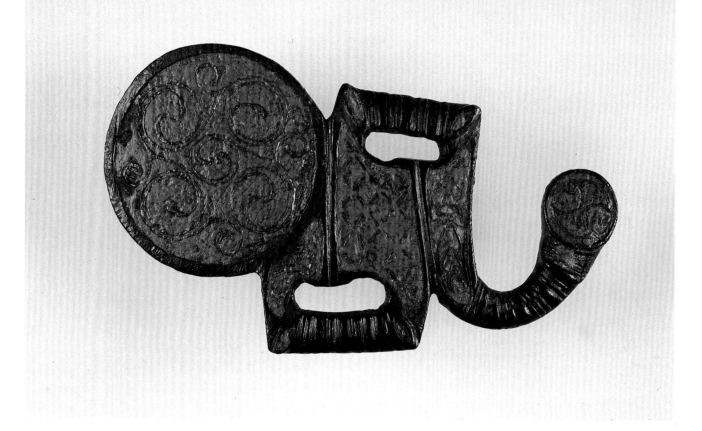

24 Dowris 'latchet' dress-fastener.

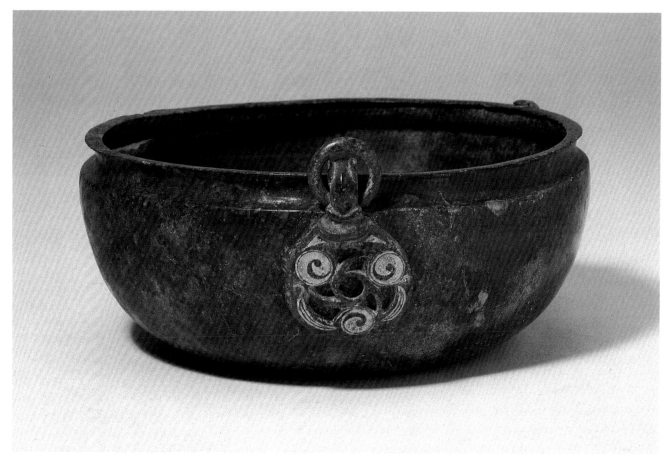

32 Garton Station hanging-bowl.

Left 17 Arthurstown penannular brooch.

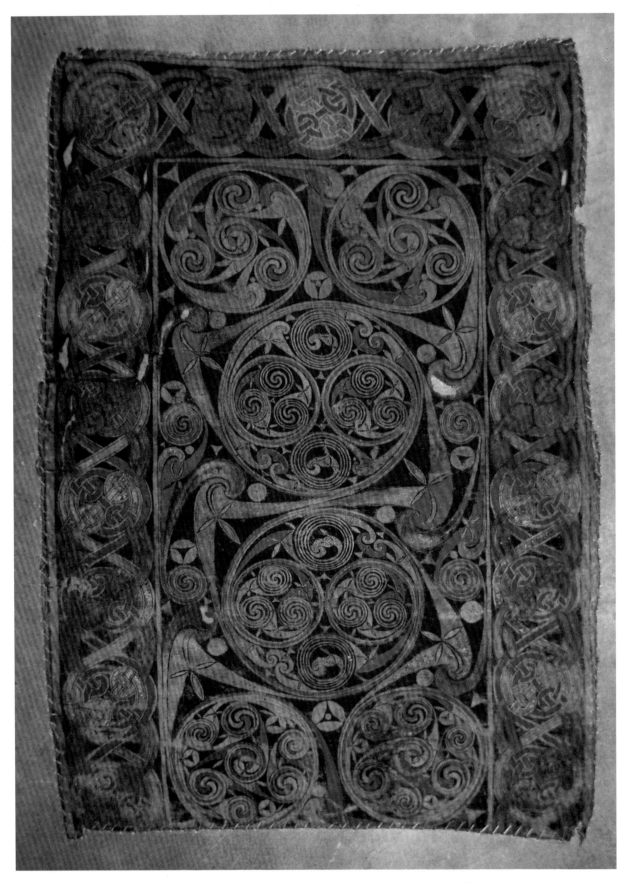

Ornamental page from the Book of Durrow, second half of 7th century, decorated with motifs also found in metalworking.
Trinity College Library MS. A 4.5 (57), folio 3v.

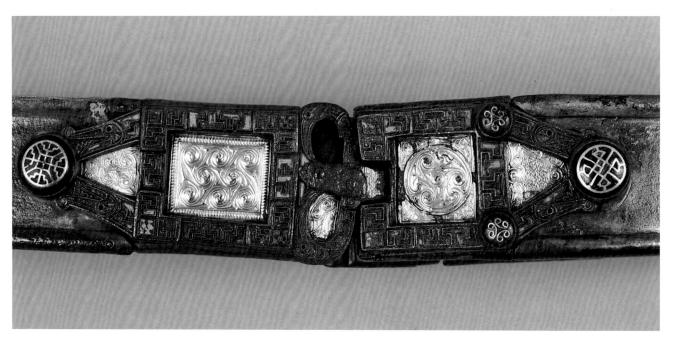

47 Moylough enshrined belt, detail.

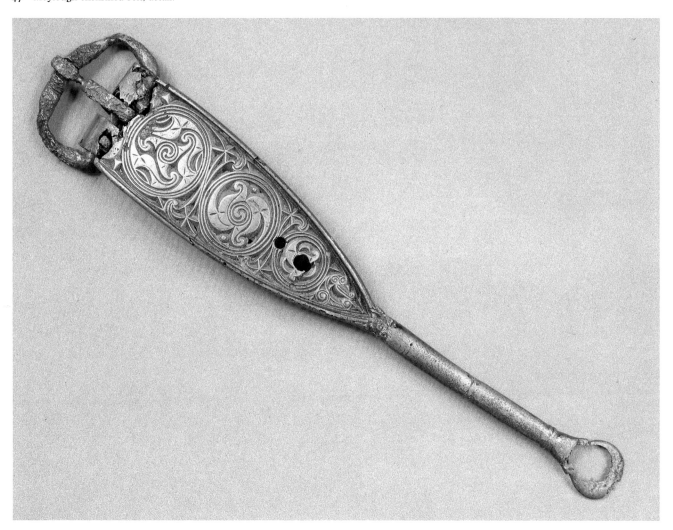

59 Lagore buckle.

52 Oseberg enamelled mount.

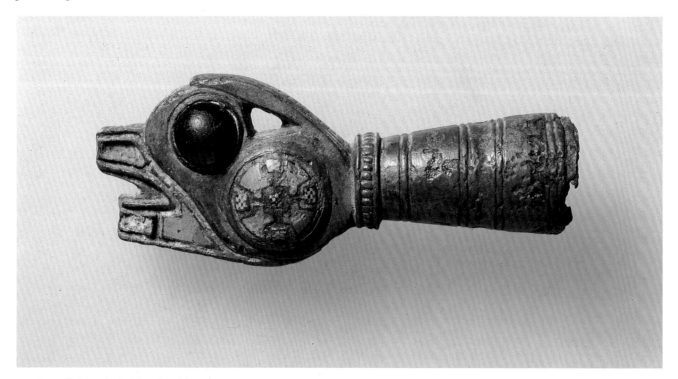

55 Enamelled terminal, Ashmolean Museum.

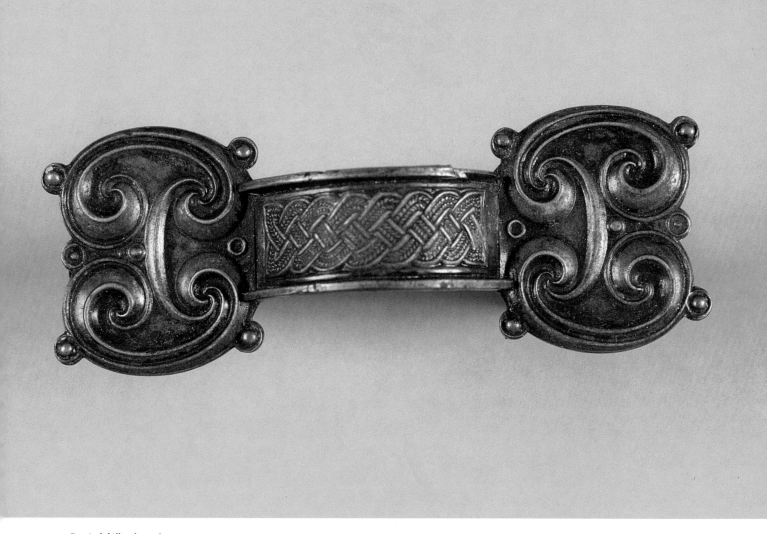

58 Ardakillen brooch.

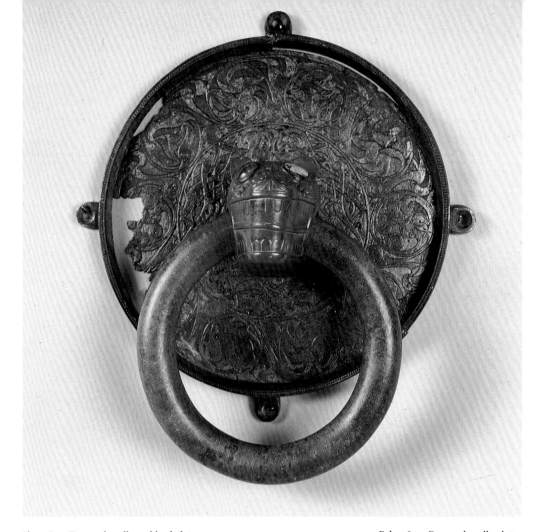

Above 64 Donore handle and backplate.

Below 65 Donore handle plate.

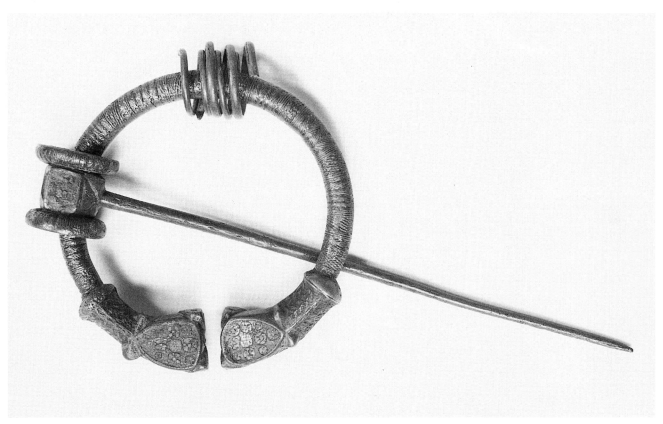

19

19 Penannular brooch

Ballinderry Crannog 2, Co. Offaly. Excavated from underneath a timber floor
Copper-alloy, tin, enamels, *millefiori*; pin L. 18.3 cm, ring max. w. 8.6 cm
Irish, early 7th century
NMI E6:422

Made of cast copper-alloy, the terminals take the form of stylised
animal heads with their snouts turned towards the ring: slight
projections at the gap in the ring indicate the ears. One of the
most elaborate of zoomorphic penannular brooches, it has on each
terminal and on the pinhead sunken fields of red champlevé enamel
with inlaid platelets of *millefiori* glass. The reverse of each hollow
terminal is covered with soldered plates decorated with engraved,
compass-drawn marigold and partial-marigold designs. The sides of
the terminals bear incised herringbone motifs and traces of tinning,
now missing elsewhere on the brooch. The ring is decorated with
alternating bands of lines, hatchings and herringbones which look
remarkably like a translation into cast copper-alloy of wire bindings.
The pin is rounded and tapered; the pinhead consists of a barrel-
shaped element to which are soldered two decorated side rings. The
reverse of the pinhead has a sunken oval panel. On the ring there
is a pair of copper-alloy wire coils; each has one sharp and one blunt
end, and they may have been used in combination as an additional
fastening device to pass through the cloth of the garment and to
hold the pin in place.

This is a very important object, because the ornament of its ring
and its enamels raises interesting questions about the relationships
between the Irish, the native British and the Anglo-Saxons. In many
ways the best comparisons for its ornament are to be found on the
largest copper-alloy bowl found in the great Anglo-Saxon ship burial
at Sutton Hoo. Discarded pieces of mouldings in the style of the ring
of the brooch have been found at Ballinderry and at a number of
other Irish sites demonstrating local manufacture. MR

EXHIBITIONS *Gold aus Irland* 1981, no. 50; *Treasures of Ireland* 1983, no. 45
Irish Gold 1988, no. 53

BIBLIOGRAPHY Kilbride-Jones 1935, 443, 444; Hencken 1941–2, 34–8;
Haseloff 1979, 234, no. 168c, d; Kilbride-Jones 1980b, 120; Bruce-Mitford
1983, 272–4

20 Toilet implement

Stoneyford, Co. Kilkenny. Said to have been found with no. 30
Copper-alloy, enamel; max, L. 8.45 cm, max. w. 1.83 cm
Irish, 6th–7th century
NMI 1881:526

Made of cast copper-alloy, decorated with a complex triskele with suggestions of bird-head motifs at the ends of the scrolls and simple herringbone devices reserved in a field of red champlevé enamel. The object takes the form of a short handle with mouldings expanding into a broad flattened comma-shaped hook. The handle is equipped with a ring and loop for suspension. It has been compared with late Roman and other continental toothpicks but, while similar in shape, it was probably too thick to have functioned as such.

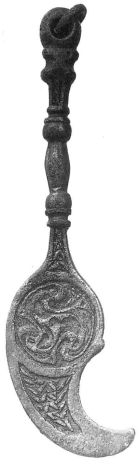

Although its purpose is unclear, there is little doubt that the form of the handle follows a pattern familiar in small personal kits of the late Roman world, while the general form is similar to toilet implements of the period. Technically and stylistically it is closely allied to the 'latchet' (no. 24) and certain penannular brooches. Examples of the form have been found in contexts as late as the later eighth or early ninth century but by no means as heavily decorated.
MR

EXHIBITION *Treasures of Ireland* 1983, no. 40

BIBLIOGRAPHY Ó Ríordáin 1945–8, 63–4; Rynne 1964, 72; Bateson 1973, 73; Martin 1976, 459–60

21 'Latchet' dress-fastener

Near Newry, Co. Down
Copper-alloy; L. 8.15 cm, disc DIAM. 3 cm
Irish, 6th century
BM, MLA 1913,7–15, 6, Robert Day Collection, ex Glenny Collection

Single-sided casting in a serpentine shape with a flat disc at one end and a small scalloped terminal at the other. The disc has a central hexagon of six recessed triangles and an outer sunburst border which were originally inlaid with enamel. The first curve broadens into a rectangular field with recessed ovals between concave-sided triangles with punched dots. The last curve has fine ribbing below the terminal. The metal is very grey and may have a high tin content.

This is one of four matching dress-fasteners found together. The curious asymmetry of these and related objects has given rise to the misnomer 'latchet', but they are items of dress, possibly developed in an imperfectly understood sequence from an Iron Age pin type

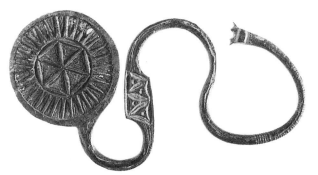

(but see discussion under no. 22). Some have loose coils of wire on the shank which could be twisted through coarsely woven fabric, and it may be that they were all worn in this way. The creation of an expanded panel on the shank may have been to keep the coils in position, a development which reaches its logical conclusion on the Dowris latchet (no. 24). Although a few small and apparently early examples have been found in Britain, larger and more elaborately decorated latchets are unique to Ireland where they developed in size and flamboyance until about the seventh century when they apparently went out of fashion. The single-sided castings are shallow compared with contemporary brooches, made in two-part moulds, and could have been cast in open moulds. Enamel is therefore also shallow and often missing, and no latchet has so far been found with *millefiori* inlay. The hexagon prominent on three of the Newry latchets is found on the sixth-century Dooey motif piece (no. 152), and although it has been described as a debased form of the Roman compass-drawn hexafoil or 'marigold' pattern, it seems to be an independent motif; in contrast the concave-sided triangles on the curving bar of this latchet *are* elements of the arc-based marigold pattern, here placed in a rectilinear design. The fourth latchet in the Newry set does have the full 'marigold' pattern. The sunburst pattern is given unusual prominence on these four pieces; it occurs elsewhere in miniature form as on the head of a pin from Gaulcross (no. 7a) and on *millefiori* platelets applied to handpins and hanging-bowl mounts. It reappears in an enamelled form on the strap hinge of the Monymusk shrine (no. 129).

The decoration on this latchet is a reminder that not all early

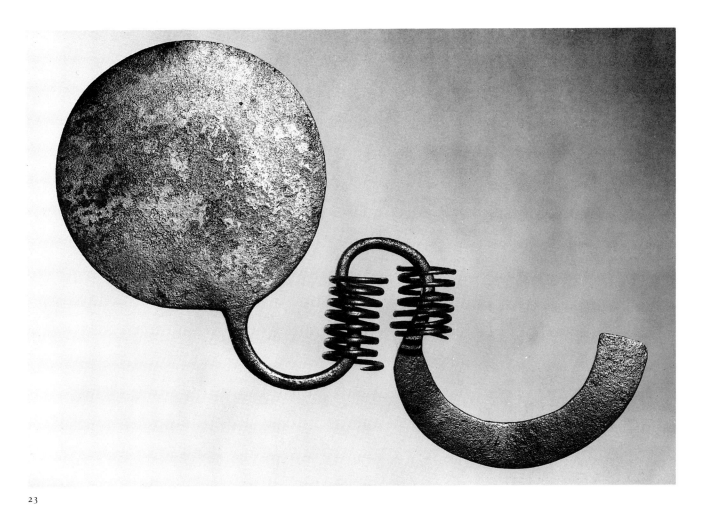

23

medieval Celtic metalwork relied on spiral and zoomorphic motifs but employed a wider range of patterns, some absorbed from the Roman world but here applied to a purely native type of object.

One of the group of four is in the same collection, the other two are in the Ulster Museum; another latchet of different design is also said to have been found near Newry (Smith 1917–18, fig. 6). SY

BIBLIOGRAPHY Wood-Martin 1903–4, 165; *Proc. Soc. Ant.*, XXII (1908), 78; Smith 1917–18, 127–8; Smith 1923, 132; Kilbride-Jones 1980a, 64, 66, 209

22 'Latchet' dress-fastener (illus. pp. 18–19)

UNPROVENANCED
Copper-alloy, enamel; L. 13.1 cm, max. disc DIAM. 5.9 cm
Irish, 6th–7th century
NMI W.492

Made of cast and hammered copper-alloy, this object consists of a circular flat plate from the edge of which springs a sinuous s-shaped tail. The disc, a flattened expansion of the tail and its end bear champlevé enamel decoration. Originally red, the enamel has now almost completely disappeared. The design was fairly crudely executed. The principal motif is a roundel containing a reserved triskele with bird-headed arms with tightly wound spirals and counter-rotating lobed scrolls extending from them. The circle containing this has four equally spaced but uneven peltae projecting from it. The expansion of the arm bears a pair of reserved opposed tightly wound spirals terminating in comma-shaped lobes in a lentoid frame. The end of the arm is slightly expanded and has

a series of asymmetrical cross forms made up on an enamelled background. Close inspection shows that the cutaway surface has been roughened or 'keyed' for the reception of enamel. Irregularities in workmanship can also be clearly detected.

The style of decoration links the latchet with a number of other objects decorated with curvilinear motifs in reserve in a field of champlevé red enamel. However, it is difficult to date but is generally regarded as being contemporary with similarly decorated hanging-bowls in sixth- and early seventh-century Anglo-Saxon graves in England. There is evidence to suggest that latchets were worn in pairs. Although this is a distinctively Irish form, the latchet may have originated in 'dragonesque' brooches of Roman Britain. One early example has been found at Icklingham, Suffolk. MR

EXHIBITIONS *Treasures of Early Irish Art* 1977, no. 25; *Treasures of Ireland* 1983, no. 30

BIBLIOGRAPHY Wilde 1861, 566–7; Smith 1917–18, 127–9; Henry 1965a, 68–9; Haseloff 1979, 234–5, no. 167a; Kilbride-Jones 1980a, 211–13

23 'Latchet' dress-fastener

River Shannon at Athlone, Co. Westmeath. Found in 1849
Copper-alloy; L. 17.5 cm, disc max. DIAM. 7.4 cm
Irish, 6th–7th century
BM, MLA 1854, 7–14,96, Cooke Collection

Plain copper-alloy disc linked by an s-shaped shank to a flat terminal hook. Two substantial coils of copper-alloy wire sit on alternate curves of the shank and were used to attach the latchet to clothing.

This substantial but undecorated piece is one of a number of similar latchets, six of which are said to have been found at Slane Castle, Co. Meath (Smith 1917–18, 126). It has retained a pair of attachment coils, but despite its apparently 'late' size does not have a thickened section on the curved shank, considered a late feature on other similar latchets. The sickle-shaped terminal is also eye-catching and related to the decorated terminal on no. 22. This may represent a regional style, one favoured by the Irish west midlands. The large undecorated spaces are unusual in the context of con-temporary Irish metalwork, but another example from Portora, Co. Fermanagh, is equally plain and the wire coils show that this latchet was a finished piece and in use. It is perhaps early evidence that Irish smiths were happy to leave quite large surfaces unadorned, a feature of eighth-century church metalwork; more prosaically, however, it was probably merely cheaper to produce. SY

BIBLIOGRAPHY *UJA*, IX, 1861–2, pl.i, fig. 1, 271; Smith 1917–18, 126

24 'Latchet' dress-fastener (*col. illus. p. 35*)

Castle Island, Dowris, Co. Offaly. Found in 1850
Copper-alloy, enamel; L. 7.5, disc DIAM. 3.3 cm
Irish, 6th–7th century
BM, MLA 1854,7–14,97, Cooke Collection

Asymmetrical shallow bronze casting ornamented on one side only. A broad disc is linked by a z-shaped section with two open slots to a curved hook terminating in a smaller disc. The whole piece is slightly convex. All the reserved surfaces are inlaid with red enamel with fine line ornament in copper-alloy. On the large disc four large and four small spirals spring from a central double loop. The large spirals are of two designs and are paired across the disc (first correctly published in Bruce-Mitford 1983, 271–3). Three central fields have lozenge patterns and diminishing chevrons. The collar to the small disc is also inlaid, and the little disc has a pattern of four alternating concave and convex curves. The top and bottom of the z have rounded, ribbed bars with enamelled oval corner settings. Some of the enamel is now missing.

The rich colour and overall ornament of this latchet and the way in which the serpentine middle section of earlier forms, such as the Newry example (no. 21), has coalesced into a solid centre, place this piece at the end of a developmental series (Smith 1917–18). The scrolls show no zoomorphic influence, and the distinctive use of enamelled straight-line ornamental patterns in combination with curvilinear ornament is also found on the unique Stoneyford implement (no. 20). The lozenge grid was worked on the sixth-century Dooey motif piece (no. 152), alongside scrolls, and the same combination appears on a terminal, now lost (Henry 1965a, 69, fig. 5c, described as a latchet).

The appearance of a lozenge grid and sunburst pattern on an unusual hanging-bowl mount from Eastry, Kent, suggests that this was a style not confined to Ireland but which never achieved the popularity of the dominant spiral, pelta and scroll (Longley 1975, fig. 10f). SY

BIBLIOGRAPHY *UJA*, IX (1861–2), 274; Smith 1917–18, 129–30, fig. 15; Smith 1923, 132–3; Kilbride-Jones 1980a, 212, fig. 211, 5; Bruce-Mitford 1983, 271–3

25 Bracelet terminal

Ireland
Copper-alloy, enamel; L. 3.8 cm, terminal DIAM. 2.5 cm
Irish, 6th–7th century
NMI 1959:626, Talbot de Malahide Collection

Cast copper-alloy mount, similar in form to no. 26. The terminal disc contains a marigold pattern, and the voids between the petals contain recessed lentoids flanked by dots filled with red enamel. The cusp is decorated with a cross-hatched pattern engraved after casting. One edge has been worn smooth at the back as if through rubbing.

Said to be possibly from Lagore in NMI 1961, there is no evidence for this, and the absence of finds of a similar date from the site, either as old finds or from the excavations, makes this unlikely. This, the succeeding example (no. 26) and a third from Newcastle, Co. Down (Swanston 1903), the latter previously identified as part of a latchet (Henry 1965a, 69, fig. 5c), are all identical in construction and represent a hitherto unidentified object type. On the basis of

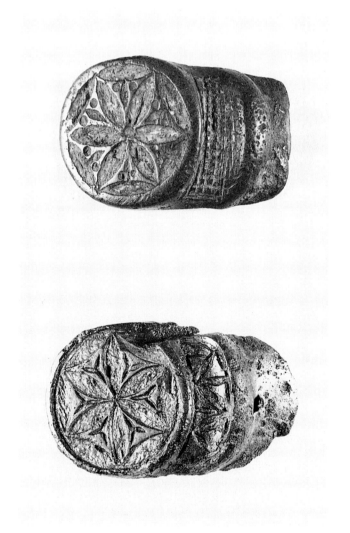

25 *top*, 26 *bottom*

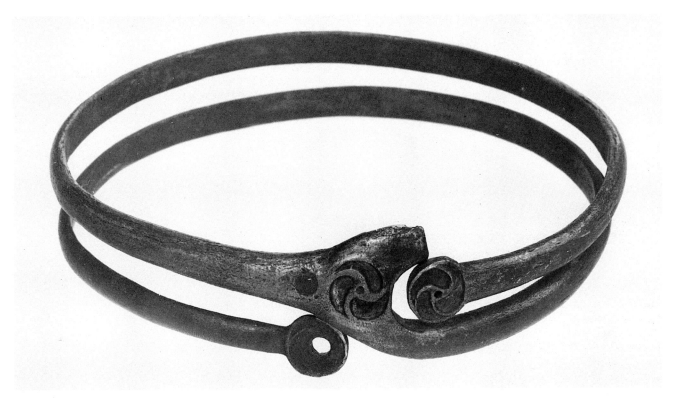

27

similarities with the terminals of the Ballymahon armlet (no. 27) it is likely that they are fragments of coiled armlets or bracelets. The wear both on the inner and outer edges of the terminal discs would be consistent with such an interpretation. The cusps behind the disc link them to the 'proto-zoomorphic' pin series (Boon 1975) from which they must be descended, and they share decorative motifs with the developed zoomorphic penannular brooches. RÓF

BIBLIOGRAPHY NMI 1961, 98, and fig. 23, d

26 Bracelet terminal

Killeeshal, Co. Carlow. Found in ploughsoil in ringfort
Copper-alloy, enamel; L. 4.1 cm, terminal DIAM. 2.5 cm
Irish, 6th–7th century
NMI 1980:96

Cast copper-alloy mount, hollow at the back. One end is broken off, the other is in the form of a disc containing a marigold pattern in red champlevé enamel. The reserved concave-sided triangles formed in the spaces between the petals contain trilobate recesses filled with red enamel. There is a raised cusp on one side of the terminal disc, which is decorated with a zigzag arrangement of lentoid recesses filled with red enamel. There is considerable wear along one side of the front of the piece across the disc and cusp. The wear is smooth and polished as if through constant rubbing. Similar wear occurs on the inner face of the terminal at a point diagonally opposite that on the front. RÓF

27 Armlet

Ballymahon, Co. Meath. Found in drainage works at the junction of the
 rivers Deel and Boyne
Copper-alloy; external DIAM. 9.9 cm; av. coil w. 6.5 mm
Irish, 6th–7th century
NMI W.504, presented by the Board of Works in 1852

Armlet of copper-alloy, incomplete, consisting of two circular coils, each ending in a circular terminal. There was originally a third coil, now missing, and there are traces of an ancient repair in the form of a pair of rivets at the broken end. On one of the terminals and at the junction of the coils are circular champlevé recesses containing triskeles, keyed for enamel. One of the terminal discs is perforated at its centre, while the other bears traces of a triskele-like device with an enlarged central perforation. Both show traces of wear along the edges caused by friction with the coils.

So far it has been possible to date this piece only by reference to the spiral ornament on the terminals. Rynne (1964) considered this armlet to be of fifth- or sixth-century date. Raftery (1984, 196) suggested that it might even be of Iron Age date and that its form may be derived from north British coil bracelets of the early centuries AD. It is clear, however, that it is not a unique piece, that the decorated terminals (nos 25 and 26) are from similarly constructed bracelets, and that Rynne's original dating to the post-Iron Age period is correct. RÓF

BIBLIOGRAPHY Mulvany 1852, liv; Wilde 1861, 570, and fig. 478; Armstrong 1923, 18, and fig. 10; de Paor and de Paor 1958, 39; Rynne 1964; Raftery 1983, 178–9, and fig. 149; Raftery 1984, 196, and fig. 99

28　Finger ring

Rathbally, near Blessington, Co. Wicklow
Copper-alloy; ring DIAM. 2.1 cm, max. W. 0.6 cm
Irish, 6th–7th century
NMI R.2048

Cast copper-alloy unclosed finger ring of rectangular cross-section narrowing towards the back of the hoop. The broader portion is decorated with recessed fields of opposed s-scrolls ending in a pelta-like shape between a pair of circular cells, all keyed for enamel. The remainder of the ring bears an incised pattern of interlocking triangles.

As Coffey (1909, 23) noted, the decoration on this ring could be compared with the terminals of some zoomorphic penannular brooches, such as that from Lough Neagh (Kilbride-Jones 1980b, fig. 35, 70) which has the same axial symmetrical arrangement of scrolls. This finger ring is unique but demonstrates how the decoration found on brooches was applied to a variety of forms.　RÓF

BIBLIOGRAPHY Coffey 1909, 23, and fig. 29; de Paor and de Paor 1958, 39; Laing 1975, 334–5, and fig. 129, 1

29　Finger ring

Derrycoagh, Lough Gara, Co. Roscommon. Surface find on crannog 88
Copper-alloy, tinned, enamel; hoop DIAM. 2.8 cm, bezel w. 1.3 cm
Irish, 5th–6th century
NMI E20:872

Finger ring of D-shaped cross-section, the tinned surface surviving in places. The bezel is oval in shape, its setting empty. On each shoulder is a heart-shaped champlevé panel consisting of a pointed pelta divided down its centre by a lentoid area of reserved metal. The background is keyed and still retains traces of red enamel. The hoop, which is cracked, is strengthened by a copper-alloy strip

which is decorated with a band of chevrons, cut off at one end. The other end is expanded and contains a rectangular rivet hole. The patina on this strip differs from that on the hoop and there is no sign of tinning.

A tinned copper-alloy finger ring of the same form, but lacking the champlevé decoration, was found in the excavations at Dooey, Co. Donegal, but its date context is unknown.

The shape of the ring is based on late Roman prototypes of the first to third centuries of Henig's Type V (1978, 37–8) which were set with engraved gems. The pointed pelta motif is more a feature of the typologically late five-fingered handpins (Kilbride-Jones 1980a, fig. 71, 3–8) than of the zoomorphic penannulars where the pelta is more rounded. The chevron pattern of the repair strip occurs on some developed zoomorphic penannulars and on the Dooey motif piece (no. 152). A fifth- to sixth-century date seems likely.　RÓF

30　Finger ring

Near Stoneyford, Co. Kilkenny
Copper-alloy, enamel and glass;
ring DIAM. 2.0 cm, bezel 1.4 × 1.2 cm
Irish, 6th–7th century
NMI 1881:291

Finger ring with plain hoop of rectangular cross-section. The raised rectangular bezel is cast in one piece with the hoop. It contains a sunken field of red champlevé enamel with subrectangular glass settings at the corners. Two of the settings consist of four pairs of opposed triangles of blue glass set in a white paste, while the other two contain a star-shaped pattern of triangular blue and green glass rods. It is not certain whether these settings represent true *millefiori*.

Finger rings with *millefiori* settings are known from Ireland (Ó Ríordáin 1945–8, fig. 4). Bezel-hooped rings are of Roman origin, the Iron Age ring form in use in Ireland being spiralled (Raftery 1984, 197–8). This ring belongs to Henig's (1978, 40) Type XV which would be dated to the fourth and fifth centuries on the basis of coin associations, a period when there is no Roman *millefiori*. It suggests Irish use of an old form with a new inlay. Plain examples are also known such as that from the Great Horwood, Buckinghamshire, hoard (Waugh 1966, 63) of similar date.

The ring is said to have been found *c.* 1852 not far from the site of a Roman burial (Bateson 1973, 73), perhaps in association with no. 20 and a small pronged toilet implement.　RÓF

BIBLIOGRAPHY Armstrong 1914, 40, no. 160; Ó Ríordáin 1945–8, 58, and pl. 2, 4; Bateson 1973, 73

Hanging-bowls and related mounts (*nos 31–8; see also nos 49, 51*)

31 Disc and frame

Fosse Way, west of Leamington Spa, Warwickshire. Found in a roadside
 trench section between Chesterton and Princethorpe
Silver, copper-alloy, enamel; DIAM. 1.7 cm
British, ?6th century
BM, MLA 1976,9–1, 1 and 2

Disc, slightly hollowed at the back, the front with a plain flange
originally covered by the frame, and a central field ornamented with
a triskele of spirals, each with a subsidiary club-ended scroll with
large and small dots. The surface of the silver has distinctive pink
patches where the silver is apparently unevenly mixed with copper.
The recessed background is filled with red enamel. The frame is
semicircular in cross-section with even ribbing and has a join,
suggesting it was formed from a cast strip; it appears to be very
debased silver or possibly copper-alloy.

 The ornament on this tiny disc is very close to that on other early
silver pieces including the disc-headed pin (no. 10) and a handpin
from Gaulcross (no. 7a). The club-ended scroll with a dot is found
as early as the fourth-century Oldcroft pin (no. 1), but on this disc
there is a subsidiary bulge with a smaller punch mark. There is
no precise evidence for the length of time this motif remained in
production, but its association with silver and red enamel on this
mount suggests a possibly sixth-century date. This mount is unique:
it was part of a larger, composite piece but the complete frame
shows that it is not a miniature hook mount from a hanging-bowl.
A copper-alloy disc (DIAM. 2.5 cm) was found on a bowl from Stoke
Golding, Leicestershire, but the smaller Fosse Way disc is unlikely
to have been a central mount for such a bowl. Small cast discs are
used in the eighth century on best-quality annular brooches such
as the Breadalbane brooch (no. 72). Another small unmounted disc,
this time in high-tin bronze, was excavated at the Pictish site of
Clatchard Craig, with a different form of curvilinear ornament,
raising the same question of function (Close-Brooks 1986, 168–9),
at present unresolved. SY

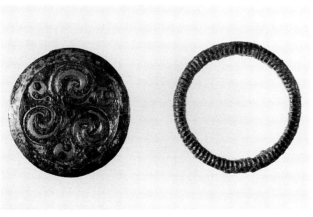

31

32 Hanging-bowl (*col. illus. p. 35*)

Garton Station, Humberside, England
Copper-alloy, enamel, glass, tin; external DIAM. at rim 16.8 cm, H. 6.3 cm
British, late 6th–early 7th century
BM, MLA Loan 108, Crown Estate Commissioners

Complete, well-formed bowl achieving maximum girth just below
the concave neck. The rim is formed by flattening horizontally; its
surface appears tinned and has three lengths of simple incised
s-scrolls which respect the three hook attachment points. The rim
is stippled at these points perhaps to increase adhesion of solder.
The base has a deeply recessed disc, blocked out after polishing on
a lathe; the centring mark for the lathe is now perforated. Solder
marks and corrosion show there were originally three circular
mounts attached below the rim: one now *in situ*, one detached and
one replaced by an undecorated shield-shaped mount. This last is
riveted and soldered in position, with a hook made from a separate
folded strip of copper-alloy, and carries a ring made from a length
of thick wire with butted ends. The circular mount, still in position
(DIAM. 3.85 cm), is a thick casting with openwork: three curving
lines spring from a central ring leaving openwork triangles. The
outer frame has three enamelled scrolls with lobed tips, linked by a
pair of simple enamelled swags with lines. Two small triangles below
the hook are also enamelled. All enamel was originally red. The
hook base is a heavy projecting collar, with a lesser one above which
runs into a curved neck and snout, flanked on each side by flat discs
forming ears. Slight mouldings indicate slanting eyes. The snout
rests on the bowl rim, slightly overlapping its engraved decoration.
This mount holds a solid, cast suspension ring and is held in position
by three rivets and solder.

 The detached hook mount exactly fits a horseshoe solder mark
on the bowl and has lost its attachment hook and upper part. There
are several rivet holes in the bowl where this missing part was once
attached. This disc is also openwork but is a thinner, less heavy
casting with more delicate decoration. It has a similar openwork
ring at the centre, three curves spring from it clockwise, and in the
outer border three fine animal-headed terminals, curved swags with
zigzag ornament, small triangles and lentoids are all enamelled in
red, now degraded. Hatched lentoids, which are engraved on the
openwork, are also the main surface decoration of an openwork
disc originally soldered to the lower surface of the recessed base.
This thin, flat casting again has a central ring from which radiate
tapering scrolls with lentoid engraving creating pairs of trumpets of
differing sizes. The inner, anticlockwise scrolls run back into outer,
clockwise scrolls, with further lentoids at the junctions. Differences
in detail between the tips of each scroll avoid mechanical regularity
in this well-balanced design.

 The evidence of the rivets and holes shows that all the hook
mounts have been reattached in antiquity and that the riveting is
additional to original solder. The base ring used only solder. Two of
the mounts are original; despite the differences between them in
weight and detail, they are exactly the same size. The third is
intriguing evidence for the use and repair of the bowl in a milieu
where there was no expertise in casting and decorating bronze in
this way. The substitute is a crude piece of work. Like the Sutton
Hoo bowl 1 repair patch, it argues against the suggestion that these
bowls were produced by local native craftsmen for Anglo-Saxon
patrons. It is harder to evaluate the difference between the two

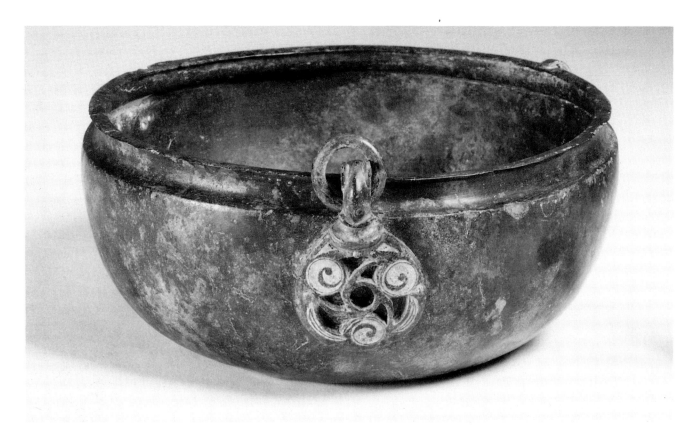

32

openwork mounts, but the evidence for the production of other multiple, non-identical but matching mounts at later workshop sites such as Moynagh Lough (no. 167) suggests these are all original and contemporary. None of the rivets are primary attachments because they do not repeat from mount to mount.

The crisp profile of the bowl neck and rim is similar to that of a bowl found at Capheaton, Northumberland, which is slightly larger (Cowan 1931; Fowler 1968, fig. 7). It is identical with the best preserved rim fragment of a bowl from West Ham, Basingstoke, Hampshire (BM, MLA 1908,2–17,1) and the base profiles also match precisely. The compass-drawn decoration on the underside of the Basingstoke bowl is of the same diameter as the Garton applied openwork disc with its compass-designed scrolls. The hook mounts on the two bowls, however, are different types. The bowls must be the product of the same workshop; the significance of the decoration on both requires further study (Capheaton also has compass-work on the base). The openwork mounts on the Garton bowl belong to a varied group which includes the Bann type (no. 37) and Faversham examples (no. 36), but here the openwork is more complex and stylistically closer to a solid disc from Camerton, Somerset (Henry 1936, pl. XXXIII, 1). There is a wide distribution of the openwork type, but the zoomorphic scroll terminals and geometric ornament, though not the style of openwork, suggest a link with the Bann escutcheon.

The bowl was found in a robbed grave (no. 5), in an Anglo-Saxon inhumation cemetery excavated in 1985, at the foot of a woman and child, associated with a fossil and three glass beads. SY

33 Hanging-bowl

Oliver's Battery, Winchester, Hampshire
Copper-alloy, tin, enamel; DIAM. 28–28.6 cm, H. 12.2 cm
British, 7th century
BM, MLA Loan 6 from Hampshire County Museum Service

Lathe-polished copper-alloy bowl with rounded shoulder and well-formed concave neck below a flat rim, the rim formed by folding the metal inwards (w. 1 cm). The base has a central recess (diam. 9.9 cm), which is decorated inside and out by a pair of applied discs with raised tinned frames and a pattern of triskeles – one central, five outer – with trumpet scrolls reserved against a red enamel background. Three hook mounts are set below the rim, the integral hooks cast in the form of maned animal heads which rest on the rim and hold cast rings for suspension, one missing. The circular mounts have similar ornament based on three running spirals counter-balanced by rather degenerate trumpet pattern with lentoids, a negative version of the basal pattern. The centres have an unusual dot and ring motif. The surfaces of all the mounts and their frames are tinned to give a silver appearance. Frames and discs were made separately. The bowl is complete and in excellent condition. All the mounts were originally soldered in position and although all were detached at the time of excavation some still sat on their original positions (Andrew and Smith 1931, 3–4).

The form of this handsome bowl is matched by one from Lowbury Hill, Berkshire (Kilbride-Jones 1936–7, fig. 4, no 9, Atkinson 1916, 21, pl. v). A bowl from Hawnby, Yorkshire, has a similar rim profile but different mounts. The ornament and form of the Winchester

hook mounts are close to an example from Oving, Buckinghamshire (VCH Bucks, vol. I), and the Lowbury Hill example has a similar but more competently executed design. Another parallel is the mount from Barrington, Cambridgeshire (Leeds 1933, 149, pl. I I I), which is unusual for its use of yellow enamel and indicates a late date in this series. The basic design of the hook mounts is a not very fluid version of a traditional circular three-spiral motif found very widely in metalwork and manuscripts – etched on the back of the 'Tara' brooch, for example, where a central stud recalls the ring and dot at the centre of the Winchester mounts. The same central ring appears on the Lagore disc-brooch (no. 60), but on both these Irish examples the three arms of the design curve out smoothly from the centre, while the Winchester and Oving design loops from spiral to spiral and is not generated from the centre. The design of the base disc is quite different, springing from a central small triskele, the

trumpets in enamel with solid lentoids, reversing the elements of the smaller disc pattern. It is curiously unfocused and runs tendril-like all over the disc. No obvious parallel comes to mind. The development of the spiral ornament places this bowl late in the series associated with pagan graves, the dating confirmed by the association of the Lowbury Hill example with a late form of Anglo-Saxon shield boss. Excavated from a seventh-century male Anglo-Saxon burial which included a seax (a long single-edged knife) and spear blade. SY

EXHIBITIONS *Early Celtic Art*, Arts Council, London and Edinburgh 1970; *Winchester: Saxon and Norman Art*, M. Biddle, Winchester Cathedral Treasury, 1972, no. 4

BIBLIOGRAPHY Andrews and Smith 1931; Kendrick 1932, 176, 177, 178, 182, pl. VI; Kilbride-Jones 1936–7, 213, 230, 232, 240; Longley 1975, 25, fig. 19, h

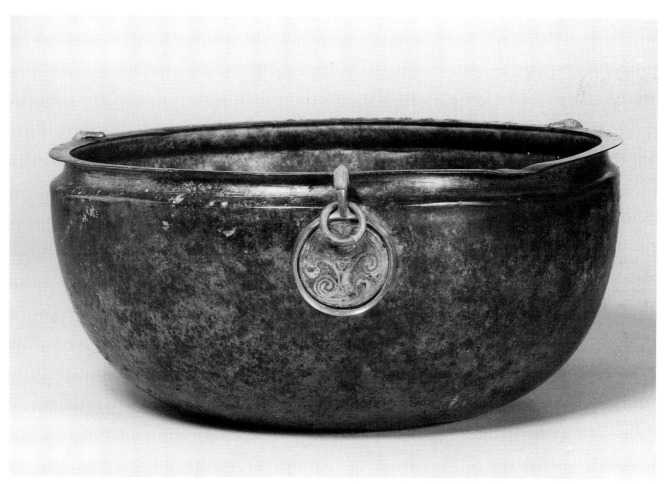

33

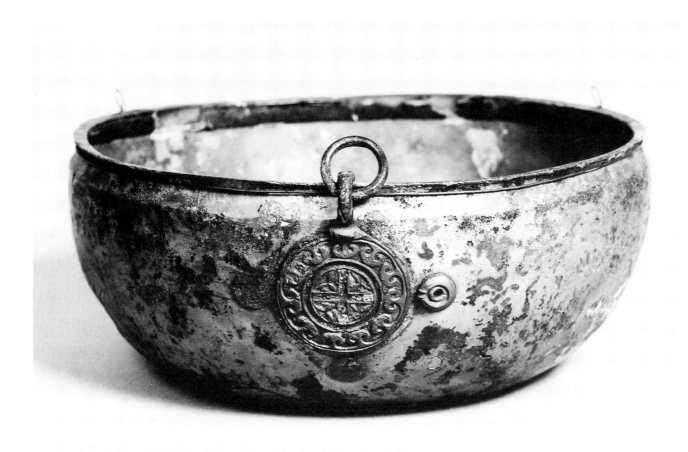

34

34 Hanging-bowl

Manton Warren, Manton, South Humberside
Copper-alloy, enamel, *millefiori*; DIAM. 25.5 cm, H. 11 cm
British, 7th century
Scunthorpe Museums Service, 57.39

Bowl with a narrow rim and concave neck and rounded shoulder; the base has a circular recess *c.* 10.5 cm in diameter. Originally fitted with three circular hook mounts, one is now missing. The hooks are simple representations of animal heads and were cast with the discs. Staining shows that the discs originally had outer frames. Each mount was flanked by three studs with decorative moulding and a central recess, but only one survives. The discs bear a strong pattern of an outer ring of heavy peltae, positive and negative, the latter keyed for enamel; an inner ring is now empty, the centre has a bold equal-armed cross originally filled with *millefiori* squares of blue and white, and the outer quadrants have a trefoil pattern. The internal base mount has a frame with a rope-like decoration broken by six sets of three circular recesses for *millefiori* inlay. Inside, a running border of scrolls carries further *millefiori*, originally set in enamel. This is divided from the centre by a second, thicker applied rim which is grooved. At the centre is a round setting, now empty, with a curvilinear pattern linking four rings set with triple sets of *millefiori* platelets. All the ground of enamel is missing. The under-disc has lost most of its double rims. Here the central ornament consists of an outer circle set with *millefiori* and enamel, an inner

ring with rectangles of *millefiori*, and a large rectangular central setting filled with a large piece of *millefiori* glass dominated by a pattern of four light crosses.

The rich decoration on this bowl places it outside the main types of hanging-bowl. The vessel itself has a rim profile similar to that on the largest Sutton Hoo bowl, although the latter is 6 cm wider (Bruce-Mitford 1983, fig. 156). The variety and large amount of *millefiori* glass employed are exceptional. Although the largest Sutton Hoo bowl also has an exceptional amount of decoration, these two bowls are in rather different decorative traditions. The only point of similarity lies in the heavy peltae on the stand of the Sutton Hoo fish and those on the Manton discs. The latter bowl with its equal-armed crosses appears to be explicitly Christian, the crosses contrasting with the long Latin form found on the Faversham and Whitby examples (nos 35, 49). The minor three-armed motifs between the cross arms on the Manton bowl are found enlarged in a bold, angular form on the base of the eighth-century Miklebostad bowl (Henry 1936, pl. XXXVII, 1). All this suggests a late date in the British series, perhaps around the mid-seventh century.

The bowl was found in 1939 in a sand-pit, with no known associated finds other than a cloth wrapping which fell apart. KL/SY

EXHIBITION *The Lost Kingdom. The Search for Anglo-Saxon Lindsey*, Scunthorpe Museum and Art Gallery, 1987–8

BIBLIOGRAPHY Dudley 1949, 229–30, fig. 82; Bruce-Mitford 1983, part 1, 265–9, fig. 209

35 Hanging-bowl mount

Faversham, Kent
Copper-alloy, enamel; H. (incomplete) 3.3 cm, W. 1.2 cm
British, first half of 7th century
BM, MLA 1870,4–2,802, Pollexfen Collection

Copper-alloy mount cast in one piece with projecting hook, now broken off, and the whole resembling a stylised bird. The main field is filled with enamel, originally red but now degraded, with fine line ornament of three small spirals, all different, running in to form a larger central spiral. The whole pattern is punctuated by three pairs of pointed ovals, the upper pair raised above the surface. The mount is slightly dished to fit the rounded surface of a bowl.

The hook will have ended in a stylised head, by analogy with other mounts, in particular the bird-shaped one from Benniworth, Lincolnshire, and a set of large, almost plain, mounts on a bowl from Hawnby, Yorkshire. None of these have separate frames, unlike most of the solid circular mounts.

The early Anglo-Saxon cemetery at Faversham was richly furnished and included remains from several hanging-bowls of different

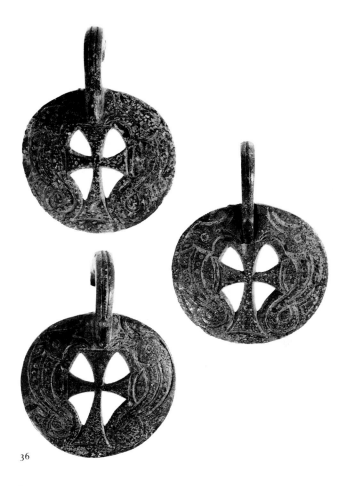

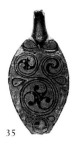

35

36

types but all richly decorated and probably of late sixth- to seventh-century date (see no. 36). The ornamental scrolls on this piece are of particular interest because they combine a club-ended and an angular zoomorphic type; the former was found prominently on early silver objects, the latter adopted and elaborated in illuminated insular gospel books, in particular the late seventh-century Lindisfarne Gospels, but already a feature of early seventh-century metalwork, notably the mounts on the large Sutton Hoo hanging-bowl. Neither scroll type features on the disc from the same bowl, which serves as a reminder of the range of ornament available to the metalwork designer SY

BIBLIOGRAPHY Smith 1907–9, 79, fig. 16; Leeds 1933, 145, 148, fig. 39; Henry 1936, 227, figs 7, 8; Longley 1975, 27, fig. 18

36 Set of hanging-bowl mounts

Faversham, Kent
Copper-alloy, enamel; L. 6.2 cm, W. 4.8 cm
British, 6th–7th century
BM, MLA 1248'70, Gibbs Collection

Three matching hook mounts; two are complete castings with the hooks shaped as open-mouthed beasts, their curved necks each with two decorative grooves. After joining the mount the beasts curl to form looped tails. The third mount has a substitute hook riveted in position, which appears to be modern work. Openwork defines a

long Latin cross with expanded arms, the edges faceted. The surface of each mount is recessed for fine lines and spots of enamel, some of which survives. This enamel work forms a pair of profile fish with open mouths, circular eyes, bars on the head and two rows of dots along each side. The body of each fish loops under itself to form a blunt tail against the cross arms.

This set of hook mounts was originally attached to a hanging-bowl and buried, with or without it, as a furnishing in the Anglo-Saxon cemetery at Faversham. A complete bowl and mounts from several others, including no. 35, were also recovered from this cemetery. This is the only Faversham example of what F. Henry called enamel engraving (1936, 226) found on other openwork mounts. Despite the Roman look of the sea beasts, the explicit Christian symbolism of the crosses and the use of openwork place these objects in the main period of mount production. Anglo-Saxon material in the cemetery dates from the fifth into the mid-seventh centuries. Finds include another bowl mount with an enamelled equal-armed cross with expanded terminals (Smith 1923, fig. 23). Other bowls with possible Christian imagery can be dated to the seventh century from the extensive use of *millefiori* (no. 34). There seems every reason to regard these Faversham pieces as contemporary, in an antique revival style. They epitomise the difficulties of dating without fixed points of reference. SY

BIBLIOGRAPHY Smith 1923, 49–50, fig. 51; Henry 1936, 226, pl. XXV, 2

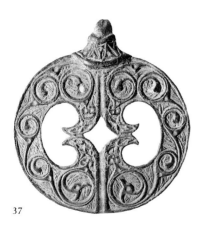

37

38

37 Hanging-bowl mount

River Bann, Mountsandel, Co. Derry
Copper-alloy; DIAM. 5.1–4.7 cm
North British or Irish, c. AD 600
UM AL 18.1939

Cast, openwork suspension mount of double pelta form from a lost hanging-bowl. The main decoration is of fine lines, consisting of running spirals terminating in crested bird heads, reserved against a background heavily keyed for red enamel, now missing. Rudimentary palmettes can be seen springing from the spirals. At the base of the missing hook are alternating dotted triangles.

There is much argument about the origin of hanging-bowls, with the trend of opinion now being towards a north British milieu as a major production area, particularly for those carrying these openwork peltiform mounts, a mould for which has been found in Pictland (no. 38). The cast and tooled-up decoration on this particular mount, however, is specifically Irish in decorative detail, and may indicate an origin close to its find-spot.

The escutcheon was found a few hundred metres downstream from the important monastery of Cambas Comghaill (now Camus, Co. Derry). This monastery is known to have had strong links with Iona during the late sixth and early seventh centuries, and the mount serves to support the thesis that Iona provided a connection between Pictland, Scottish Dál Riada and Ireland. It is of some interest that in the seventh-century Life of the sixth-century founder of Iona, Columba, the saint is described as visiting Cambas Comghaill on his journey from the synod of Druim Cett, in modern Co. Derry, to his embarkation point somewhere in north Co. Antrim.

This fine piece illustrates some of the problems and controversy surrounding the origins of hanging-bowls and their mounts. RW

BIBLIOGRAPHY Henry 1948; Bruce-Mitford 1987, 32–3; Warner 1987

38 Mould for hanging-bowl mount

Craig Phadrig, Inverness-shire. Excavated in 1971
Baked clay; DIAM. 6.6 cm; TH. 1.4 cm
Pictish, 6th–7th century
NMS HH 885

Front half of a bivalve mould for the casting of hooked hanging-bowl mounts, most probably in bronze. The resulting mount would have been 2.5 cm in diameter, pierced by two opposed pelta shapes with a diamond shape between them.

Mounts of similar openwork design have been mainly found on hanging-bowls from Anglo-Saxon graves in England. A mount of this precise design has, however, been found on a fragmentary hanging-bowl (now in the West Highland Museum, Fort William) from Castle Tioram, Argyll (Kilbride-Jones 1938). The similarity between the Craig Phadrig mould and the Castle Tioram hanging-bowl mount is such that it seems highly likely that this bowl was made at Craig Phadrig. RMS

BIBLIOGRAPHY Small and Cottam 1972, 43; Stevenson 1972, 49–51; Stevenson 1976, 250–1

The decades of change: mid-7th–early 8th century

In the course of the seventh century the techniques and styles of Celtic metalwork were dramatically extended. The transformation of techniques comprised the manufacture of castings of remarkable fineness with complex designs, the adoption of multicoloured inlays including polychrome glass studs and champlevé enamels, the use of gilding on silver and bronze, the application of panels of gold foil with complex filigree work and other fine wire work such as the manufacture of chains. Other inlays, niello and amber extended the repertoire of colours. Complex vessels and shrines were constructed from separate components using a variety of mechanical means. These new polychrome materials and finishes expressed new designs: geometric step-patterns and angular cell shapes; animal ornament with profile quadrupeds with distinctive emphasis of eyes, jaws, hips and feet, mixed with birds and reptilian beasts in the same style; interlace, both abstract and animal-based – all this in addition to the trumpet scrolls and spirals of earlier metalwork. These new motifs were drawn from top-quality Germanic jewellery of the late sixth and seventh centuries. Multicoloured pieces like the gold and silver Kentish disc-brooches were particularly influential, where panels of cut garnet and glass in cloisons alternated with trays of gold filigree, often around a central domed stud with stepped cells. Contemporary Anglo-Saxon buckles, where sinuous beasts and interlace in filigree dominate the buckle-plates, were also sources of inspiration. Equally important was the adoption by Celtic craftsmen of the

faceted surfaces of Germanic metalwork in imitation of chip-carving, to give brilliant reflective surfaces and depth. Discrete panels of ornament in contrasting styles became a characteristic feature of the work of Celtic craftsmen and can also be seen on contemporary decoration in gospel books.

The much debated evidence of the decorated late seventh-century Lindisfarne Gospels and our knowledge from historical sources of the importance of the Irish Iona-based mission in the seventh-century Northumbrian kingdom (reaching far north and west of the present county) show how the brilliant, innovative fusion of styles came about. The 'new look' was adopted simultaneously in Ireland where it achieved unsurpassed excellence and virtuosity in the workshops of the Irish midlands. The recent establishment of a firm seventh-century date for the workshop excavated at the royal Irish stronghold of Dunadd in Scottish Dál Riada contributes greatly to our knowledge of these changes: evidence of specialised crucibles for gold and silver, the presence of top-quality imported Germanic gold and garnet work, moulds for the production of brooches Celtic in form but Germanic in style, with bird heads and interlace, and also moulds for the manufacture of broad-terminalled brooches with walled compartments related to the Hunterston and 'Tara' types.

Behind such developments must lie the generation and consolidation of wealth supporting the growth of royal and ecclesiastical patronage, as well as the comings and goings of scholars, messengers, clerics and princes in exile and their retinues recorded by Bede and the early hagiographers and annal writers. These journeys linked the Irish kingdoms, both north, south and in Scotland, British Strathclyde and the Pictish territories, with the Anglo-Saxon kingdoms from Northumbria to Kent, the wide Frankish territories and beyond. SY

Contact, change and exchange in Britain and Ireland (*nos 39–58*)

39 Stud

Wickhambreux, Kent. From a rich seventh-century male grave
Gold, garnet, blue glass; DIAM. 1.7 cm
Anglo-Saxon, 7th century
BM, MLA 1905,4–18,16

Domed gold stud with rectangular loop at back and composite collar of twisted and plain beaded wires. The centre is inlaid with garnet and blue glass cloisonné in a pattern of triangles and stepped cells around a central circle. The stepped cells and central roundel are now empty, though an early drawing shows an empty cruciform cell at the centre of the roundel, framed by four garnets. The back is undecorated.

The stud was originally set in a white sword bead, an amuletic jewel suspended from a sword. The use of polychrome stepped

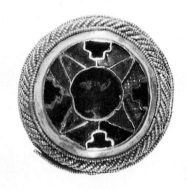

39

cloisonné studs in seventh-century Anglo-Saxon luxury metalwork took the fancy of Irish jewellers, who adapted the idea to enamelling techniques. The brilliant enamelled blue and red step-pattern studs which decorate masterpieces such as the Ardagh chalice and the Derrynaflan paten (no. 125a) reflect this source of inspiration. LW

BIBLIOGRAPHY Dowker 1887, 7, fig. 6; Hawkes 1958, 68; Meaney 1981, 196

40 Pin suite

Roundway Down, Wiltshire
Gold, garnet and glass; pins L. 4.3 cm, chain ensemble L. 12 cm
Anglo-Saxon, mid-late 7th century
Devizes Museum (Wiltshire Archaeological and Natural History Society) s6f, gift of C. E. Colston (Lord Roundway)

The two pins have disc-heads set with cabochon garnets framed in beaded wire, and incised lines at the top of each shank; each is linked by means of a loop on the head to a filigree-decorated boar's head which terminates the chain. This chain consists of two sections, each of six folded links, flanking a central roundel containing a blue glass stud in a twisted wire collar. The stud is decorated with a cast pattern of stepped cells around a small central cross. It possibly originally contained a contrasting inlay of enamel or a silver grid. The back of the stud setting has simple interlace ornament.

The pin suite is of Anglo-Saxon workmanship and is of well-known seventh-century type. It was found in a richly furnished barrow burial of a woman, excavated in 1840. Its present interest lies in the use as a centrepiece of a glass stud of a type known primarily from sumptuous pieces of Irish church plate such as the Ardagh chalice (see col. illus. p. 160; Ryan 1985), the Derrynaflan paten stand and the Moylough belt-shrine (nos 125a, 47). A recently excavated example comes from a context dated to the first half of the eighth century (no. 210), and the workshop site at Lagore, Co. Meath, produced several moulds for the production of glass studs including no. 209. The original inlay could have been a contrasting colour, as on no. 125a (Meaney and Hawkes 1970, 48), or contained a silver or gold grid (no. 210). The burial of the stud at Roundway gives a firm date in the seventh century for the production of some of these glass settings with their imitation of garnet cellwork. It is interesting to note the use of lignite (also worked on

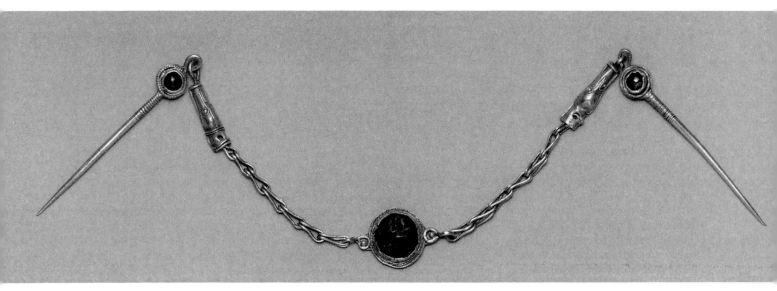

40

Irish sites) instead of garnet in some of the necklace pendants found in the same grave. How the stud came to Wiltshire cannot be established but there is at least one documented Irish monastic foundation nearby, that at Malmesbury, some twenty-four kilometres away to the north. SY

BIBLIOGRAPHY *Proc. Soc. Ant.*, I, (1843), 12–13; Merewether 1849, 82–112; Akerman 1855, 1–2, pl. I; Cunnington 1860, 164 ff.; Leeds 1913, 52; Cunnington and Goddard 1934, 241 ff.; Meaney and Hawkes 1970, 48–9; Robinson 1977–8; Campbell 1982, 35, pl. 31.49

41 Satchel-mount

Swallowcliffe Down, Wiltshire
Copper-alloy, tin, glass, gold and silver foil; DIAM. 8.1 cm
British/Saxon, second half of 7th century
Salisbury and South Wiltshire Museum, 130/1984

The decorated mount, displayed on a modern reconstruction of the satchel, consists of an openwork tinned copper-alloy disc with gold and silver repoussé foils mounted behind the openings. The openwork cover, which is slightly convex, was secured to an underlying leather and cherrywood support with six bronze nails, four of which survive. All have a concave depression in the nail head, a distinctive feature which is absent on the nails used to secure the strips and disc of the satchel lid. The openwork cover overlies a total of nineteen stamped gold and silver foils, decorated by seven different dies. Gold and silver foils alternate in the six perimeter panels and bear the same impressed design. The gold foils are much thinner than the silver foils and more fragmentary. The design of each perimeter foil, which has been carelessly clipped from a larger design, shows two rows of linked knots contained within dotted borders. The knots are double stranded but are not all of constant size: there is a variation in scale at either end as well as a taper in the width of the rows.

Two different dies have been used to create the pale gold foils contained within the 'petals' of the marigold frame. The designs are indistinct: one shows a spotted band interlace of subtriangular form, the other a fine dot interlace. No zoomorphic details are apparent. Alternating with these six fragmentary gold foils are six silver 'axe-blade'-shaped foils, three of which are decorated with Celtic scrolls and trumpet patterns. The three other axe-blade foils bear a dense, flat, irregular plaitwork made of a cabled band contained within double-strand borders. In contrast to the several clipped foils which surround it, the circular gold foil containing a central setting of a colourless glass cabochon seems specifically designed for its position on the mount. Five pseudo-filigree c-scrolls are evenly and snugly spaced in a ring around the central cabochon, and bordered by an inner beaded wire and on the perimeter by opposed twined strands, both repoussé versions of filigree technique.

The mount was found in 1966, with no. 42 and other material, in the richly furnished burial of an Anglo-Saxon woman, datable to the late seventh century. In terms of craftsmanship the mount leaves a lot to be desired. Some allowance must be made for the decay of the copper-alloy sheet underlying the gold foils and their subsequent damage, in addition to the shrinkage and decay of the cherrywood

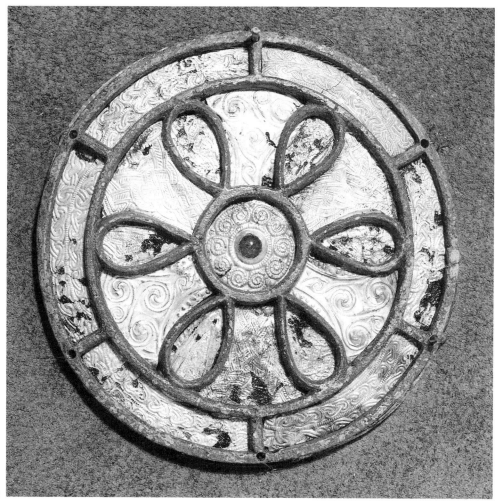

41

base. Nevertheless, the foils with their roughly clipped edges, have the appearance of being a cannibalised assemblage of repoussé work from several sources, both Celtic and Saxon. A considered appraisal of the foils can no longer support an earlier stated view that the mount is of 'probable Irish workmanship' (Speake 1980, 93). While suggestive parallels for the Celtic scrollwork and trumpet patterns on three of the silver axe-blade foils can be found in Irish metalwork – for example, on the Moylough belt-reliquary (no. 47) – some similarity also exists with the silver repoussé base mount from the St Ninian's Isle silver hanging-bowl, arguably of seventh- or early eighth-century Northumbrian workmanship, in contrast to the Pictish origin for the remainder of this hoard. Parallels for the dense

interlace designs of the three other silver axe-blade foils and the linked running knot designs of the perimeter foils, although not in repoussé, exist on a miscellaneous group of seventh-century Anglo-Saxon metalwork (Speake 1989).

Whether all the metalwork fittings of the satchel are contemporary is uncertain. In details of technique, construction and ornament the decorative mount is quite distinct from the tinned strip framework and annular disc of the satchel lid. The size and curvature of the lid section would suggest that the satchel was worn on the hip, attached to a midriff belt. GS

BIBLIOGRAPHY Speake 1980, 65, 93, pl. 16i; Speake 1989

42

42 Sprinkler

Swallowcliffe Down, Wiltshire
Copper-alloy, enamel; H. 20 cm, DIAM. 11.6 cm
British, 7th century
Salisbury and South Wiltshire Museum, 130/1984

The sprinkler consists of three parts: two thin hemispheres soldered together and a hollow cast ring-ended handle which was soldered to the pole of the upper hemisphere. Damage sustained during excavation caused a bullet-like perforation (w. 1.6 cm) on both the upper and lower sections. At the base of the lower hemisphere are nine holes. Five of these are arranged in a regular quincunx: four smaller holes, rather unevenly placed around the quincunx, are evidently secondary additions punched from outside after the two hemispheres had been soldered together. The handle is an ingenious piece of casting, a hollow cylinder with an inset hollow ring (DIAM. 3.4 cm). Radiating from the collared base of the handle and curved to fit the contours of the upper hemisphere were four diametrically placed lentoid plates of which three now survive. These and the ringed basal collar contain traces of deteriorated red enamel.

The sprinkler, which was contained, along with other items, within a maplewood casket, comes like no. 41 from a richly furnished female burial datable to the late seventh century. It is a unique find in an Anglo-Saxon context and can be paralleled by the decorated example of similar form from Vinjum, Aurland, Norway (no. 121), which Bøe (1924–5, 3) suggested was a censer, Celtic in origin and ecclesiastical in use. Bakka (1963, 33) has been more cautious in his assessment of the Vinjum find, seeing it related, in terms of form, construction and arrangement of ornament, to the amulet capsules of sixth- and seventh-century date, found in Germanic women's graves, mostly in the middle Rhine area, but with scattered examples in south Germany, Switzerland, France and Spain.

The subsequent identification of both these objects as sprinklers, rather than censers or amulet capsules, is based on a consideration of their design which makes their use with liquids more plausible. Neither object bears any Christian motif to suggest ecclesiastical use, nor in terms of their design and construction are they linked to the heavy, cast-bronze Christian censers from the Byzantine or early medieval periods, which possess pierced, detachable upper sections. Likewise the continental amulet-capsules differ in that they are hinged and could be opened; moreover, none have perforations or a tubular handle. Clearly the two soldered hemispheres of the Swallowcliffe sprinkler indicate that it was sealed and not intended to be opened.

Experiments carried out with a replica of similar scale to the Swallowcliffe find have shown that when the capsule is partially immersed in a liquid the perforations in the base of the capsule allow liquid to enter, the displaced air being evacuated through the top of the tubular handle. By placing a finger or thumb over the open end of the handle, the simple law of atmospheric physics prevents any liquid within the capsule from escaping, when the capsule is withdrawn from the container of liquid. The flow or sprinkling of liquid through the nine holes at the base of the capsule could be controlled, therefore, through the simple action of releasing the contact of finger or thumb from the aperture at the top of the handle. In the experiments which were conducted it was found that the most convenient method was to hold the capsule through the ring with two fingers, using the thumb for controlling the flow of air into the capsule.

The use of the Swallowcliffe capsule as a sprinkling device could be both domestic and prophylactic. That the Swallowcliffe sprinkler is Celtic in origin, or made by an Anglo-Saxon craftsman conversant with Celtic metalwork, is strongly suggested by the technique of its manufacture and the use of red enamel at the base of the tubular handle. Just as the decorated hanging-bowls were acquired and treasured by the Anglo-Saxons, so too presumably were other items of Celtic manufacture, of which the Swallowcliffe sprinkler would appear to be the unique survivor in an Anglo-Saxon grave. GS

BIBLIOGRAPHY Speake 1989

43 Miniature buckle (col. illus. p. 73)

Faversham, Kent
Gold; L. 3.15 cm
Anglo-Saxon, 7th century
BM, MLA 1094A'70, Gibbs Collection

Gold sheet openwork sub-oval buckle, with extensive filigree decoration in plain and beaded wire. Two opposed pairs of linked bird heads with incised hooked beaks enclose a rectangular central

panel containing interlacing snakes on a two-part base. The filigree overlies a repoussé openwork base soldered to a separate flat sheet, which is soldered to the underside of the buckle, filling a rectangular cut-out. An additional foil patch secures this on the back, where small right-angled hooks (L. 0.3 cm) attached the buckle to thick fabric or leather.

The buckle, one of a pair which probably came from garters or other clothing, shows a variety of techniques used by Anglo-Saxon and other Germanic craftsmen, including granulation and plain twisted and beaded wires in a variety of weights and arrangements. A special feature of this piece is the use of an openwork repoussé base (hollow platform) set on a separate foil sheet, a technique rare in Anglo-Saxon England but more widely used in prestige Celtic metalwork – for instance, on the Dunbeath fragment (no. 44), the Derrynaflan paten (no. 125a) and the Hunterston brooch (no. 69).

LW

BIBLIOGRAPHY Smith 1923, pl. I, no. 3; Bruce-Mitford 1974, pl. 26b; Stevenson 1974, 30, pl. XXA

44 Penannular brooch, fragment *(col. illus. p. 74)*

Achavrole, Dunbeath, Caithness
Silver, gilt, gold filigree, amber; L. 7.2 cm, terminals W. 3.5 cm, WT 24.6 g
Irish style, 8th century
NMS FC9

Broken terminal and lower arm of a cast silver-gilt penannular brooch. The fragment is decorated with amber settings and panels of gold filigree work set on trays of gold foil. There are two small circular amber bosses at either corner of the terminal, while a further subrectangular setting of amber divides the outer border fields of the terminal. The junction between the terminal and arm of the brooch is marked with a larger circular stud of amber, and further decorated with a bird head cast in profile on the outer edge of the brooch plate.

The centrepiece of the terminal is an interlaced filigree beast, executed and framed in twisted and beaded wire on a tray of gold foil. The body of the beast has been infilled with gold granulation. The panel is fitted into a hollow platform, the rim of the surrounding casting being ornamented with cable decoration. Around the edge of the terminal are four similar panels of filigree decoration. The end panel is filled with c-scrolls, the other with s-scrolls. The lower arm of the brooch is decorated with an interlaced filigree serpent or fish, the body of which is also infilled with gold granulation.

On the reverse of the terminal is an empty triangular recess suitable for another decorative inset, although there is no evidence that it had ever been filled.

The brooch was apparently complete when buried, but it was damaged when discovered during ditch digging *c.* 1860. No other parts of the brooch survive, but the fragment sits well within the small group of highly decorated 'Tara'-type brooches. There is, however, no indication that this terminal was joined to its partner by some form of bar to close the gap in the brooch hoop, as is the case with most brooches of the 'Tara' type. Presumably manufactured in Scotland where the gapped ring remained fashionable, it is one of the few silver penannulars to approach the large silver annulars in style and technique of decoration. Its hollow-platform filigree relates it to a small group of eighth-century pieces which includes the

Derrynaflan paten (no. 125a) and the Hunterston brooch (no. 69). Such adaptations of ornament to different forms is probably the result of travelling craftsmen attempting to satisfy local variations in taste in what was otherwise a fairly homogeneous material culture.

RMS/MR

BIBLIOGRAPHY Anderson 1879–80a; Anderson 1881, 16, fig. 11; Grieg 1940, 196; Stevenson 1974, 35, pl. XX, c; O'Meadhra 1986, 83, 86–7; Whitfield 1987, 78, pl. IJ

45 Buckle

Faversham, Kent
Silver, gilt, gold foil and filigree, niello; max. L. 7.7 cm
Anglo-Saxon, early 7th century
BM, MLA 1097'70, Gibbs Collection

Subtriangular buckle with cast parcel-gilt silver frame, tongue and loop. In the centre of the frame is a gold-sheet inlay with interlacing filigree animal ornament on a repoussé base. The sides of the frame are inlaid with filigree strips imitating plaitwork and terminate in stylised boars' heads at the broad end; three bosses with beaded wire collars conceal the rivets which held the buckle plate to the belt. The backplate is missing. The tongue base is inlaid with geometric filigree. The front of the loop has cast lattice decoration with niello inlay, changing to panels of stepped niello inlay at the sides.

This buckle exemplifies a range of Anglo-Saxon stylistic features and techniques which were readily adapted by craftsmen in Ireland and Scotland in the seventh and eighth centuries. Perhaps most significant among these was the adoption of filigree decoration and animal ornament – often, as here, in the form of a single animal

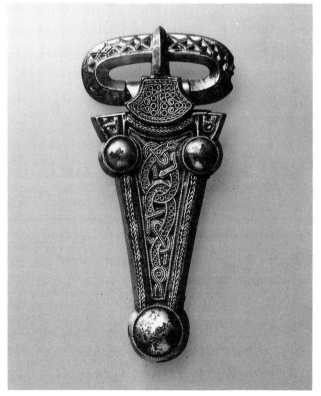

45

elegantly executed in filigree on a repoussé base. The sinuous filigree patterns of Anglo-Saxon triangular buckle-plates were readily transposed to the similarly shaped terminals of late seventh-century penannular brooches. The fashion for large, domed bosses was also absorbed by Celtic goldsmiths, along with other Germanic features, such as geometric stepped patterns (seen here on the buckle loop) and polychrome cloisonné inlays (see, for example, nos 47 and 50).

LW

BIBLIOGRAPHY Jessup 1950, 137–8, pl. XXXVIII, 2c

46 Belt-buckle

Lough Gara, Co. Sligo. Surface find on lakeshore
Copper-alloy, glass, enamels; max. L. 7.6 cm, max. W. 2.5 cm
Irish 7th–8th century
NMI 1958:20

Made in three sections, the belt-buckle consists of a loop, a tongue on a cross-shaped plate and a subtriangular body. All are joined together by a single pin which acts as a hinge. The upper surface is decorated with rectangular, cruciform and T-shaped panels of

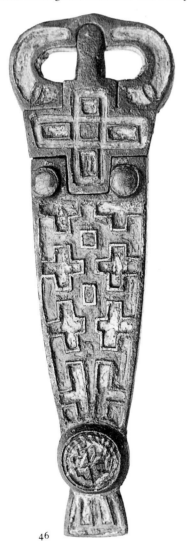

46

green and yellow enamel on a field of red. Two brown glass studs occur at the broad end of the body and a blue and white glass one at the narrower. The head bears a step-and-cruciform pattern originally inlaid with a differently coloured enamel. The loop takes the form of opposed, long-snouted animal heads, originally enamelled.

The angular panels of enamel may have been influenced by similar settings for semi-precious stone, especially garnet, known in Germanic high-quality jewellery. The buckle form is based on larger Germanic prototypes: a particular feature of many is a hinged shield panel on the tongue with a talismanic cross on it. A mould for a large undecorated buckle tongue with rectangular plate in Germanic style was excavated at Dunadd in Scottish Dál Riada in a seventh-century context. The inlaid stud is typical of Irish work from the later seventh to the ninth centuries. The long-snouted animals are a simple variant of Germanic forms current in the later sixth and seventh centuries and are matched on the buckle of the Moylough belt-shrine (no. 47).

MR

EXHIBITIONS Gold aus Irland 1981, no. 53; Irish Gold 1988, no. 53
BIBLIOGRAPHY: NMI 1960, 37: de Paor 1961, 651–2, Taf.51,2

47 Belt-shrine (col. illus. p. 37)

Moylough, Co. Sligo. Found in a turf bog
Tinned copper-alloy, silver, enamels, *millefiori*, mica, leather; L. extended 90.1 cm; average W. 5.2 cm
Irish, 8th century AD
NMI 1945:81

A reliquary in the form of a belt, made up of four hinged segments. Each segment consists of two sheets of copper-alloy (formerly tinned) held together along their long sides by round mouldings which are riveted in place. Within each segment a leather strip is enclosed. In the centre of each there is an applied, cross-shaped medallion. Two of the segments have further applied decorative rectangular panels beside the hinges. The remaining two had a rectangular panel each: on one is a large, elaborately decorated false buckle and on the other, a false counterplate, equally elaborate. Only the setting for the rectangular panel on the buckle segment survives, its surface plated with mica.

Of the five surviving rectangular panels four are decorated with die-stamped fleshy scrollwork, billeted mouldings and narrow strips of egg-and-dart ornament. The fifth bears openwork interlace executed in tinned copper-alloy. Of the cross-shaped medallions two are in the form of ringed crosses decorated with enamel and *millefiori* glass. The remaining two are circular settings with D-shaped projections which are to be read as the arms of the cross. Both are decorated with enamels and *millefiori* and contain near-identical die-stamped silver plates with curvilinear ornament; a series of tiny, hair-spring spirals are linked by means of trumpet scrolls to form an elaborate whirligig. The false buckle and its counterplate are embellished with interlocking L- and T-shaped settings for enamel, *millefiori* glass, cast-enamel studs with inset metal grilles or wire scrolls, die-stamped silver panels with curvilinear ornament, animal interlace, snakes and beast heads. The borders of the buckle and counterplate mouldings terminate in the heads of fanged beasts biting at enamel studs, while the bow of the buckle takes the form of two bird heads equipped with long curving beaks. Three of the

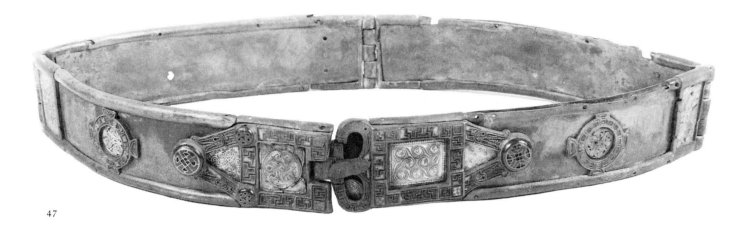

47

silver panels are somewhat ill-fitting and may be recycled components from another piece. The buckle has been crudely repaired in antiquity, and the pin holding it is very worn through use.

There is no doubt that this elaborate belt-shaped shrine was made to preserve the leather girdle still contained in it. It is likely that the shrine was handled by the devout and perhaps even placed around the bodies of people seeking the intercession of the saint. The use of mica in the large setting of the counterplate may have been intended originally as a form of window through which the relic could have been seen. Its use forms a link to the reliquary buckles of the Continent which sometimes have inspection windows (Bruce-Mitford 1986, 184). It has been suggested that the shrine mimics a fashion amongst the Franks for large decorated buckles with matching counterplates in the decades around AD 600. Large reliquary buckles are known on the Continent at this time, and large buckled belts have been identified in the Burgundian area, as part of the costume both of women and clerics (Werner 1978, 528–30). The rectangular and cross-shaped ornaments have humbler comparisons on early medieval European belts in the metal stiffeners applied to the leather to prevent its curling. These can be traced back to late Roman military equipment and they have their counterparts on early Germanic belts. Evison in contrast (1968, 234) has argued that the form of the Moylough pseudo-buckle reflects the design and layout of the buckles of provincial late Roman type as represented by the find from Mucking, Essex. There are difficulties with this proposal: for example, the bow of the buckle type represented by Mucking is relatively small and completely contained within the decorated plate, while the Moylough buckle is clearly derived from a different type. The picture is complicated by the late Roman contribution to most types of Germanic buckle, and

convergences of design details in buckles widely separated in time and space are to be expected. It would seem, therefore, that the craftsman based the shrine on a continental model or models of the later sixth or early seventh centuries. It is conceivable that this model was a complete cleric's belt with all its metal fittings intact. We cannot know whose belt it was as the shrine was found in a turf bog in 1945, and no evidence exists to explain why it was hidden there or what church it came from. The dating of the shrine is somewhat controversial, but there is little doubt that it belongs to the eighth-century climax of Irish art of which, despite the damage that bog acids have done to its enamels and surface, it is one of the finest expressions. The fact that it is based on earlier models is no barrier to this dating.

Miraculous girdles and references to their enshrining in reliquaries are mentioned in a number of Irish saints' lives and credited with remarkable cures – one features prominently in the life of the female saint Samthann. It is worth noting that a number of Frankish churchmen are recorded as living in Ireland in the seventh century, and it is tantalising to think that the original on which the Moylough belt-shrine is based was worn by one of these. St Columbanus, one of the most influential Irish missionaries, was active amongst the Franks and Burgundians in the early seventh century and his monastery, Luxeuil, was an important point of contact between Ireland and the Continent. Although the Moylough belt-shrine is distinctively Irish in certain respects, it is important to see it as the product of influences from outside Ireland. MR

EXHIBITION *Irish Gold* 1988, no. 57

BIBLIOGRAPHY Duignan 1951; O'Kelly 1965; Evison 1968, 234–5; Werner 1978, 528–30; Harbison 1981

48 Glass stud

Whitby Abbey, North Yorkshire. Excavated in 1942
Glass, gold; 2.0 × 2.0 cm
Northumbrian, 8th century
BM, MLA, Strickland Loan W 50

A translucent rectangle of dark blue glass with a chamfered upper edge. The bevel is irregular and gives a subrectangular appearance to the piece. The surface is inlaid with gold. A fine line from one corner forms a large loop and returns to the adjacent corner; the same pattern is repeated from the opposite side and the two overlap in the middle. Damage conceals the underlying order of the design.

This stud shows the absorption of Irish craftsmanship in the monastic workshops of Northumbria. It is a variation of the more common circular stud seen on the finest Irish metalwork; polychrome rectangular glass studs were produced for the Derrynaflan

paten stand (no. 125b). The bevelled edges on this piece show the influence of faceted rectangular amber settings. The looped pattern of the metal inlay is also found on a circular glass stud found in a late pagan burial at Camerton, Somerset (Leeds 1933, pl. XXXI). Excavation at Whitby produced a second mount of this shape made from seven twisted rods of blue and white glass (*reticella*) placed side by side. The monastery at Whitby was an important double community of both monks and nuns founded in AD 657. It was most celebrated for holding a historic meeting in 664 at which the advocates of a reformed Christian calendar argued successfully against supporters of a northern Irish unreformed calendar and about authority within the Western Church. Material excavated at the monastery reflects the British and Irish cultural mixture that characterised much of Northumbrian monasticism in the seventh and eighth centuries (see also no. 49). SY

BIBLIOGRAPHY Peers and Radford 1943, 73, fig. 22; Hencken 1950–1, 148, fig. 71

49 Hanging-bowl mount

Whitby Abbey, North Yorkshire
Copper-alloy, enamel; H. 5.6 cm, W. 5.2 cm
Northumbrian, 8th century
BM, MLA, Strickland Loan W16

Pointed oval mount with crescentic lugs, damaged top and bottom and part of a lug missing. The whole mount is curved. The surface is recessed for enamel inlay with heavy reserved ornament of simple open crescents on the lugs and, on the main field, a Latin cross with slightly expanded arms set upon a four-lobed knot. There is a triquetra in the fields between each arm of the cross. The original enamel colour was yellow. The mount may have had a simple tail at the base like that from Benniworth, Lincolnshire.

The famous Saxon monastery at Whitby founded in the mid-seventh century has produced a rich assembly of material evidence

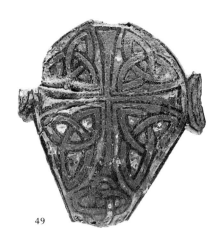

49

for the mixture of Irish, British and Anglo-Saxon influences which produced the insular art of that period (see no. 48). This hanging-bowl mount is one of a small number with clear Christian symbolism (see nos 34, 36). Its context implies local use, in contrast to the many bowls recovered from pagan cemeteries. The simple style of double-contoured ornament and the use of yellow enamel show it is late in the hanging-bowl series and probably of local manufacture. Seven different types of hanging-bowl mount were excavated at Whitby, three of them bird-shaped. SY

BIBLIOGRAPHY Peers and Radford 1943, 49, fig. 10.9, pl. XXVIc; Henry 1965a, 73–4; Longley 1975, 27, fig. 18

50 Enamelled mount

Church of St Mary and St Hardulph, Breedon-on-the-Hill, Leicestershire
Copper-alloy, enamel; L. 6.0 cm, W. 3.2 cm, H. rivet 1.9 cm
Irish, 8th century
Parochial Church Council, Breedon-on-the-Hill

Cast subrectangular plate with an open rectangle at the centre. One short side angles out from the corners and the edge between them is incomplete. At the opposite end a large semicircular projection pierced for a tall, domed rivet is flanked by a pair of flanges at right angles to the main plate. The plate is recessed with ornamental cells

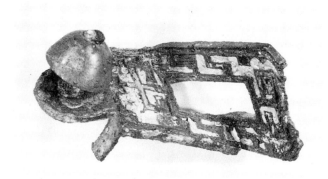

50

in relief creating an angular pattern filled with red, yellow and light blue enamel. The whole piece is bent and some enamel is missing.

The shape of this piece and its sturdy attachment give it a strong resemblance to the upper section of a shrine strap-hinge, like those on the Monymusk and Copenhagen shrines (nos 129, 131), the latter with an open centre. However, this plate is less substantial and the flanges do not appear to function as a hinge. The multicoloured enamels and angular cells, as well as the panel form, also echo the mounts on the Moylough belt-shrine (no. 47), but the large rivet head and flanges argue against a similar use. The function remains obscure, but the coloured enamel and cellwork place it among Irish metalwork of the eighth century.

The mount was found in a 1975 excavation at the church which was founded in the late seventh century. The precise records of the foundation depend on dubious charter evidence, but in 731 a priest from Breedon, the scholar Tatwine, was made Archbishop of Canterbury, establishing the importance of the house in the early eighth century. The rich architectural sculpture preserved in the present church gives independent confirmation of this importance. The find-place suggests that this fitting was part of the treasure of the early Anglo-Saxon monastery, and is evidence of the exchange of works of art and possible transmission of styles and techniques. SY

BIBLIOGRAPHY Dornier 1977, 164, fig. 41, 1

51 Hanging-bowl mount

Myklebostad, Eid, Sogn og Fjordane, Norway
Copper-alloy, enamel, *millefiori*; H. 7.7 cm
Irish, 8th–9th century
Historisk Museum, University of Bergen, B2978

Three-dimensional casting in the stylised form of a man with a disproportionately large head with deep brows, prominent oval eyes, downturned mouth and indications of a beard and moustache. The body is a rectangular plate inlaid with five panels of *millefiori* glass in a quincunx, the central and largest one of a different pattern, interspersed with pairs of L-shaped cells of yellow enamel, the whole being set against red enamel. The bottom of the mount is recessed, leaving a pair of legs and feet each side of a rivet head. F. Henry observed the piece was cast from a wax model (Henry 1965a, 94).

This is one of a set of hook mounts from a hanging-bowl, the base of which has a circular enamelled disc richly inlaid with *millefiori* platelets. The use of *millefiori* is analogous to that on the mid-seventh-century bowl from Manton Common (no. 34), but here the bowl itself has the rim reinforced with an iron rod, a feature of later vessels. Stylised squat figures were also used on the Oseberg bucket as handle terminals, equally powerful images with similar functions. The habit of using the body space as a purely decorative area is an old one reaching back to the evangelist symbols in the Book of Durrow, where chequering on the symbols of St Matthew gives the effect of *millefiori* inlay (Henry 1965a, pl. 57).

The bowl itself was a spectacular discovery in a male Viking grave of the first half of the ninth century. It was filled with iron shield bosses. SY

BIBLIOGRAPHY Rygh 1885, 727; Petersen 1940, 100–2; Henry 1954, pl. 33; Henry 1965a, 94, 104, pl. D

52 Enamelled mount *(col. illus. p. 38)*

Oseberg, Slagen, Vestfold, Norway
Copper-alloy, gilt, *millefiori*, enamels; 4.2 × 4.2 cm
Irish, 8th–9th century
Universitetets Oldsaksamling, Oslo, Oseberg no. 157

Rectangular mount inlaid with red, yellow and blue champlevé enamels. Strong diagonals join the corners of a central rectangle with L-shaped enamel cells around a central setting. Outside, four panels of *millefiori* glass emphasise the cruciform elements in the design. The panels are framed by red enamel or gilt-bronze lines.

Polychrome cellwork of this kind has its roots in Germanic glass and garnet inlays, in particular the studs of the seventh century (no. 39). Irish metalworkers translated the idea into stepped panels of enamel or glass. Some fine rectangular panels can be seen on the Derrynaflan paten (no. 125a). Here the same coloured cells are seen in bolder, coarser work. The original use of this mount is not known; it was included amongst the treasures of a Viking noblewoman's richly furnished grave of the first half of the ninth century. SY

BIBLIOGRAPHY Grieg 1928, 75; Petersen 1940, 25; Wamers 1985, no. 116, Taf. 15, 5

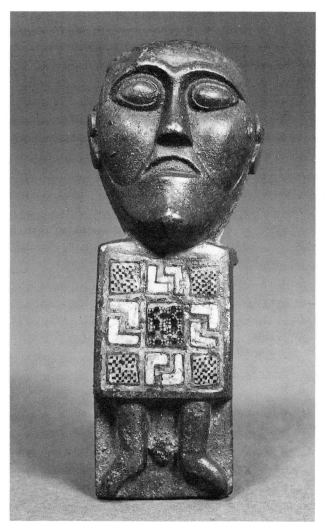

51

53

54

53 Drinking-horn terminal

Lismore, Co. Waterford
Copper-alloy; L. 9 cm; external socket DIAM. 1.4 cm
Irish, 8th century
BM, MLA 1853,10–13,3

Copper-alloy casting, the socket tapered internally and externally, decorated by a banded collar and pair of grooves. It has two rivet holes in the rim. The socket supports a round head with a huge chamfered snout, open along the middle and ending in a knob with a spiral scroll. The toucan-like jaws were originally joined by teeth along part of their length. The eyes of this 'bird' are stylised in a human shape. Two running spirals decorate each rounded cheek, and neat, conical punch marks run around the cheeks from upper to lower 'beak' and also along the top and bottom of the beak. The abraded surface shows no evidence now of gilding.

This handsome stylised fitting for the end of a drinking horn is of a type derived from Anglo-Saxon mounts dating from the early seventh century and recovered from aristocratic burials such as those at Sutton Hoo and Taplow. The bird-headed terminals of these silver Saxon mounts have here become a toothed beast in copper-alloy, and some later Irish horn terminals retain this reptilian style (Henry 1965b, 58–61, pl. 6a), while the Moynagh Lough example is an eared animal whose 'beak' is a long tongue (no. 54). Finds from ninth-century and later Viking graves in Norway show that the zoomorphic terminal remained popular alongside a knobbed form (Petersen 1940, 53, 57, 71, 73; Ó Ríordáin 1949, 64–7).

The terminal decorated an important piece of household equipment in a society where feasting and formal entertainment played a major part. The seventh-century heroic British poem *Gododdin* refers frequently to feasting the warbands and to the use of drinking horns for mead and wine (Jackson 1969). SY

BIBLIOGRAPHY Mac Dermott 1950; Henry 1965b, 59

54 Drinking-horn terminal

Moynagh Lough, Co. Meath. Found in levels contemporary with round
 house 1
Copper-alloy, glass; L. 5.8 cm, socket DIAM. 1 cm
Irish, 8th century
John Bradley, ML 1984:433

Socketed terminal mount for a drinking horn in the form of a stylised animal head with eyes of blue glass and a low ridge defining the ears. The tongue projects from the snout and terminates in a small spiral. There is a gap between the jaws.

A horn terminal excavated at Carraig Aille 2 (Ó Ríordáin 1949, 64–7) has openwork jaws which enclose a stout ring probably for a suspension strap. This suggests a similar purpose for the jaw opening here and perhaps on the Lismore terminal (no. 53). For discussion see no. 53 above. JB

BIBLIOGRAPHY Bradley 1982, 118, fig. 43 (6)

55 Terminal (col. illus. p. 38)

Co. Antrim (see below)
Copper-alloy, enamel, *millefiori*, glass; L. 6.55 cm, socket DIAM. 1.65 cm
Irish, 9th century
Ashmolean Museum, Oxford, 1927.123

A cast terminal with a circular hollow socket and animal-head finial. The socket is damaged at the rim and has two rivet holes for attachment, four bands around the circumference formed by paired grooves with a single wider groove in the centre, tapering to a collar with beaded decoration. The zoomorphic finial has a flattened, tapering section, the upper surface decorated with border lines and beading. Domed blue glass inserts form prominent eyes, and the gaping jaws, broken at the ends, are decorated on either side with champlevé panels of yellow enamel within a white enamel surround. On either cheek there is a prominent boss of yellow enamel with a champlevé enamel cross with square fields of black and white chequered *millefiori* glass at the centre and terminal of each arm. The head is pierced by a triangular hole beneath a forward-pointing ear.

The cruciform bosses on the cheeks are very similar to one on the drop of the complete ninth-century crozier from Prosperous, Co. Kildare (Bourke 1987, 168, pl. 1c, d), while the boss-eyed head and forward-pointing ear are found on the Helgö terminal (no. 147) and have been identified in the animal repertoire of the Book of Kells (Bourke 1987). The precise function of this terminal is not clear, whether from a horn or handle. The paired grooves on the socket are matched on the Lismore horn terminal (no. 53).

The provenance of Ballymoney (Henry 1956) should have read Ballymena, but this is only the address of the collector from whom the piece was acquired. SY

EXHIBITION *ROSC '77: the poetry of vision*, National Museum of Ireland, Dublin, 1977, no. 51

BIBLIOGRAPHY Shetelig 1933, 168, fig. 60; Henry 1956, 84, pl. xd; Henry 1965b, 59, 60 fn.; Bourke 1987, 168, pl. 1d

56 Openwork mount

Ireland
Copper-alloy; L. 3.9 cm, W. 3.3 cm
Irish, 8th century
NMI X.2981

D-shaped mount cut from a copper-alloy sheet. The outer frame has semicircular projections at the corners of the straight edge, while the centre of the curved side contains part of a broken loop. The openwork centre is occupied by a symmetrically arranged pair of bipeds seen in profile. Their necks are crossed, as are the forelegs which form a circle in the centre of the frame. The hind legs are bent upwards in the lower corners.

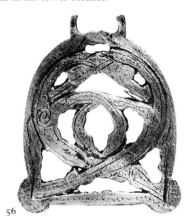

56

This piece is very sketchily executed. The bodies of the animals are double-contoured with a single row of dots between. The straight edge is also decorated with a row of dots. The shoulder and hip-joints are spiralled.

The function of this mount is unknown. Wear on some of the openwork spaces suggests it was nailed or riveted to a backing. The arrangement of the animal ornament is reminiscent of the interlocking beasts on the back of the 'Tara' brooch. Given the fact that one is cast and the other engraved, the treatment of the heads is similar on both. The dotting is a feature found as a background on more accomplished pieces such as the Monymusk and Copenhagen shrines (nos 129, 131). RÓF

BIBLIOGRAPHY Raftery (ed.) 1941, 150, and pl. 106, 5

57 Disc-brooch

Togherstown, Co. Westmeath
Copper-alloy, gilt; disc DIAM. 2.89 cm
Irish, 8th century
NMI 1929:1400

Small circular openwork cast brooch with traces of heavy gilding. Within the raised rim of the disc is a whirligig pattern composed of three kneeling men, who appear to be naked with bowed heads and elaborate ribbed hair-styles, shown in profile. Each one grasps the leg of the next. The centre of the brooch is abraded and the edge is damaged for about one-third of its circumference. On the reverse are the stumps of two projections which would have carried the fastening pin.

This circular brooch was a new type in early Christian Ireland

57

and is sometimes compared with Anglo-Saxon saucer brooches. The brooch carries ornament based on the human figure which is characteristic of the heyday of insular art in the eighth and ninth centuries, and especially of the Book of Kells and the Derrynaflan paten. The brooch was excavated in 1929 in a ringfort in the fill of a souterrain. The Togherstown site lies on the flank of the Hill of Uisneach, reputedly the centre of Ireland and a place of assembly in early medieval Ireland. MR

EXHIBITION *Irish Gold*, 1988, no. 59

BIBLIOGRAPHY Macalister and Praeger 1931, 79–80

58 Bow-brooch *(col. illus. p. 39)*

Ardakillen Lough, Co. Roscommon. Found in 1851 in a crannog cutting
Copper-alloy, ?tin; L. 7.75 cm, terminals W. 2.84 cm
Irish, ?7th century
NMI W.476

Bowed brooch with two decorative expansions and fastened by a pin and catchplate on the reverse. Decorative plates of repoussé peltae are riveted to the endplates which are cut to conform to the outline of the pattern. Four small projecting lugs carry the fastening rivets. The bow of the brooch has the edges turned up to form pronounced lips. Inside these is a die-stamped metal strip with a pattern of double-contoured strapwork with imitation rope moulding internally. The edges of this sheet are folded over the lips on each side and soldered in position along the back of the bow. The reverse of the brooch bears white metal plating. The edges are outlined by a fine line and row of faint, triangular dotting. The pelta ornament of the endplates is very smooth. The top of the curves is ridged. There are two false rivets and a ridged circle on each plate. The pin is broad and flat and fits into a neat catch made of a square-sectioned bar. The edges of the pin bear finely incised lines.

This elegant brooch bears a distant relationship to equal-arm brooches of Merovingian-period Europe. It seems to be a unique variant of the pin-and-catchplate brooches of early medieval Ireland. It is difficult to date but it may well belong to the seventh century. The ridged scrolls appear on the silver plate of unknown use from the Norrie's Law hoard. The (?) tinning and dot-outlining of the reverse are regular features of Irish metalwork from the later sixth century onwards. The plating may have been intended in part to protect garments from cuprous straining.

Ardakillen crannog was one of many near Strokestown which produced finds during drainage works. MR

BIBLIOGRAPHY Wilde 1861, 568–9; Coffey 1909, 15; Mahr 1932, pl. I:5; Raftery (ed.) 1941, 91; Hübener 1972, fig. 14, 244

New forms and new designs in Ireland (*nos 59–68*)

59 Belt-buckle (*col. illus. p. 37*)

Lagore Crannog, Co. Meath. Found in disturbed context outside palisade
Copper-alloy, formerly gilt; L. 15.8 cm, decorated plate max. W. 2.4 cm
Irish, 7th–8th century
NMI E14:213

The buckle consists of a loop and tongue on a long subtriangular decorated plate from which a long shank extends, with an eye to attach the strap. The decoration comprises three tightly wound connected spirals of decreasing size in the La Tène tradition. The centre of the largest spiral is occupied by a triskele figure. The spiral endings proper can be seen on close examination to be very stylised versions of Germanic animal heads with hooked snouts. The central and smallest spirals have fleshy lobes as central ornaments. A dog-like animal with backturned head is placed at the apex. It is a mature Irish expression of Insular animal style.

The buckle was not enamelled but seems to have been gilded. The deep sloping facets and the angular interconnections between the spirals indicate that the model from which it was cast was treated in the chip-carved manner. The style of the scrollwork is fairly close to that of the Lindisfarne Gospels and 'Tara' brooch, but there is sufficient difference to make dating difficult. MR

EXHIBITIONS *Gold aus Irland* 1981, no. 52; *Treasures of Ireland* 1983, no. 49; *Irish Gold* 1988, no. 55

BIBLIOGRAPHY Hencken 1950–1, 66–7; de Paor 1961, 650–1; Henry 1965a, 13, 103, 140; Haseloff 1979, 235–6, no. 169b

60 Disc-brooch

Lagore Crannog, Co. Meath. Found in disturbed context outside palisade
Copper-alloy, enamel; DIAM. 6.98 cm
Irish, 7th–8th century
NMI E14:210

A simple brooch made by setting a decorative octagonal plate of copper-alloy, perhaps from another object, in a rimmed disc of the same material. The plate carries a reserved triskele design in a field of red enamel of which only traces remain. Tags, presumably for the pin and catchplate, occur on the reverse.

The triskele design is similar in some respects to the decoration on the belt-buckle from Lagore (no. 59). A few brooches fastened by pins are known in the early medieval period in Ireland, but the circular form of the present example is rare. It is often thought to be an adaptation of Anglo-Saxon 'saucer' brooches like that from Togherstown (no. 57). MR

EXHIBITIONS *Gold aus Irland* 1981, no. 51; *Irish Gold* 1988, no. 54

BIBLIOGRAPHY Hencken 1950–1, 67

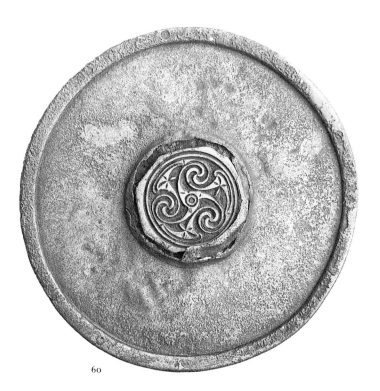

60

61 Chalice

Ireland
Copper-alloy, tin; H. 6.05 cm, bowl DIAM. 11 cm, base DIAM. 6.2 cm
Irish, 7th–9th century
UM A87.1954. Gracey Collection, Kilrea, Co. Derry

A chalice consisting of bowl, pedestal and foot. The hemispherical bowl is pierced by two holes and has a continuous groove below a simple out-turned rim. The pedestal is a solid casting with a biconical centre and evenly expanded ends. A projection from one end pierces the bowl and has been beaten flat internally; a projection at the other end engages a square hole in the centre of the foot. The foot, which is now detached, is a disc with one decorated face on which a ring of flattened D-section was applied to the edge by riveting. Approximately one third of the ring is now missing. The chalice is made entirely of copper-alloy, but the exterior of the bowl and the decoration on the foot are tinned.

The foot alone is decorated, the ornament consists of a crudely engraved 'developed trumpet pattern' of three spirals rotating in one direction. These are linked at the circumference by the conjunction of four 'trumpets' which form a cluster with two trumpet-shaped voids. The whole pattern was engraved free-hand and is enclosed by an incised line. There are indications that this surface was designed to be uppermost – among them a void in the ornament where the pedestal can be attached, and the presence at the point

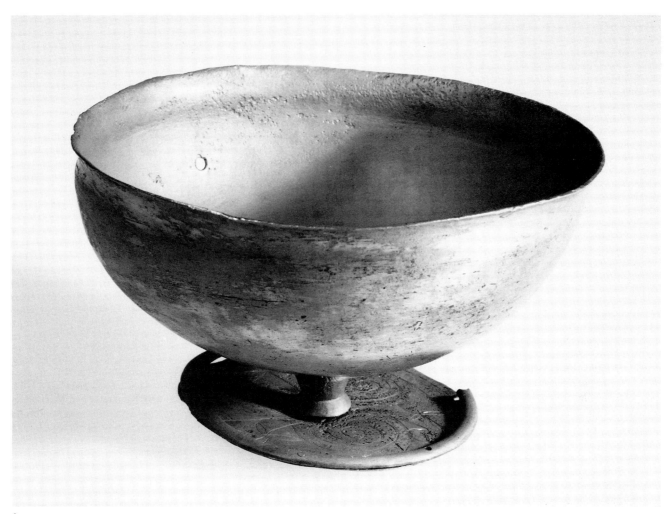

61

61 *base*

of contact of differential colouring, if this is not of recent origin. All elements of the design, excluding negative areas or voids, are tinned and decorated with stippling.

Like the lesser bronze chalice from the Ardagh, Co. Limerick, hoard, this example can be identified as a celebrant's chalice (a *calix minor* or *calix sanctus*), and can be dated only on the grounds of ornament and form. The motif on the foot – a trumpet pattern based on a triple spiral – occurs in the enamelled escutcheons of hanging-bowls found in England (for example, no. 33), where the reserved metal lines are frequently tinned. The motif is also common in Irish metalwork and tinning is widely attested. Both appear on the Moylough, Co. Sligo, belt-shrine (no. 47), and tinning occurs in combination with stippling on a square mount from Donore, Co. Meath (no. 65). Stippling appears too on the bowl of the silver chalice from Ardagh, Co. Limerick. Another feature of this chalice and of that from Derrynaflan (no. 124), a panelled ring applied to the edge of the foot on its upper surface, has a simple equivalent in the ring on the foot of this unlocalised example. The presence of the ring helps to identify the decorated surface as the uppermost in the chalice as originally constituted. The bowl, too, recalls the bowl of the Ardagh chalice by its proportions and 'silver' appearance. However, the pedestal finds its closest parallel outside Ireland in the Anglo-Saxon chalice from the Trewhiddle, Cornwall, hoard, deposited *c.* AD 868. CB

BIBLIOGRAPHY Ryan 1985, 9, 15

62 Bowl-shaped fitting

Jåtten, Hetland, Rogaland, Norway
Copper-alloy, gilt; DIAM. 10.5–11.0 cm, H.3.7 cm
Irish, 8th century
Historisk Museum, University of Bergen, B.4772b

The bowl is cast and has a broad zone of decoration beneath the rim, consisting of six semicircular fields containing intricate curvilinear ornament with fine spirals, triskeles and trumpet scrolls. The intervals between the fields have trumpet ornament with hatched details. There is a wide undecorated zone around the apex of the bowl, which is surmounted by a secondary rivet. A fragmentary bronze band inside the bowl is also probably a later addition.

The fitting comes from a small Viking hoard found in 1891, which consisted of a pair of portable scales, eight lead weights in a linen bag, a bronze ringed pin, two pieces of cloth, and this fitting, which may have served as the scales-case. Its original function is still less certain, though its relatively large size and the marked absence of decoration around the apex of the piece suggest that it was unlikely to have been a shrine mount. The blank area was clearly not designed to be easily visible. This, and the position of the central rivet hole (if original), suggests that the bowl was attached to another element which masked the blank area – the stem or knop of a drinking vessel, for instance – to which it could have served as cup or foot.

The exquisite quality and invention of the curvilinear decoration link the fitting to the Donore mounts and other outstanding non-zoomorphic pieces of the eighth century. LW

BIBLIOGRAPHY Bøe 1924–5, 1–34; Petersen 1940, 32–3, fig. 26; Raftery (ed.) 1941, 122–3, pl. 27, 2a–b; Graham-Campbell 1980, no. 306; Wamers 1985, no. 88, pl. 32.2

The Donore hoard, Co. Meath (nos 63–6)

The circumstances of the concealment of the Donore hoard are difficult to explain. The objects seem to consist of a series of handles, backplates and frames made *en suite* (although the different quality of finish and style of engraving of no. 65 raises questions about this). In addition to the two ring-handles exhibited an incomplete copper-alloy coated iron example was included in the find, together with the very decayed fragments (not exhibited) of a frame with panels of interlace, animal interlace and birds which may have been intended to fit disc no. 63. If it is accepted that these objects were associated with a church, then they may have originated either in Kells or at near-by Dulane, Co. Meath, but there are other possibilities in the general area. Although one disc is worn, the objects do not

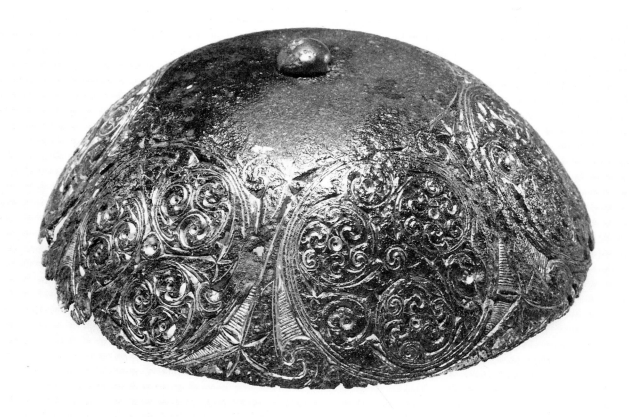

62

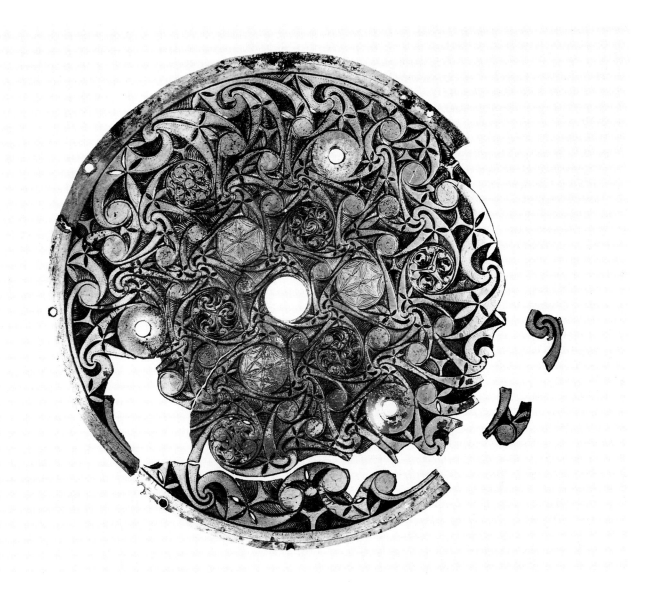

63

show signs of prolonged exposure to the elements; they may therefore have been mounted on some feature of a church interior, perhaps a partition or a tomb-shrine, from which they were removed with care and concealed in the face of threat.

Taken together with the 'Tara' brooch and the Lagore buckle, the objects provide strong evidence for the adoption of the style seen in the Lindisfarne Gospels in the east midlands of Ireland around the beginning of the eighth century.

63 Engraved disc

Donore, Co. Meath. Found in a hoard in a riverbank with nos 64–6
Copper-alloy, tinned; DIAM. 13.1 cm, TH. 0.5 mm
Irish, early 8th century
NMI 1985:21a

Cast and hammered to shape, this object is slightly dished, on its outer surface convex. The edge is pierced by nail holes. There are a large central and three smaller perforations. The lips of the central and one of the smaller perforations are buckled. The outer surface is tinned, and deeply engraved hatched areas produce a complex reserved pattern in white metal. The pattern consists of an elaborate composition of opposed trumpet scrolls, asymmetrical peltae and lentoid shapes whose edges are outlined by dotting. They are in the main compass-constructed and finished free-hand. There are three repeats of the pattern. Two concentric rings of six roundels occur. The outer ring consists of three plain perforated roundels and three with deeply engraved miniature compositions of trumpet scrolls, zoomorphic elements and in one case a three-legged figure. The inner zone has three roundels with reserved hexafoils drawn on a dotted background and three with reserved triskeles – two variants of which have zoomorphic elements. There is an animal-head graffito on the reverse. The metal is cracked in places. By analogy with no. 64 it may have been the backplate of a handle. MR

BIBLIOGRAPHY Ryan 1987a, 57–8

64 *animal-head handle*

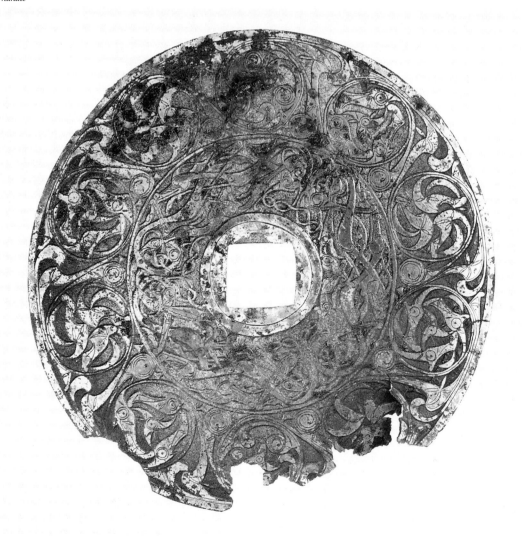

64 *disc*

64 Zoomorphic handle assembly *(col. illus. p. 40)*

Donore, Co. Meath. Found with nos 63, 65–6
Copper-alloy, tinned, glass; disc DIAM. 13.5 cm, ring DIAM. 10.1 cm
Irish, early 8th century
NMI 1985:21b,d,e

The evidence of assembly marks (an 'x' incised on each) makes it clear that these three objects should be reconstructed to form a handle complete with its decorative plate and moulding. It consists of three elements: an animal head grasping a ring in its mouth with a long square-sectioned tang projecting from behind the head; a circular plate with a square perforation to accommodate the tang; and a lugged circular frame which fits neatly around the plate.

The animal-head handle is made of cast copper-alloy. The ring is cast in place and the tang shows a casting seam along its length. The head of the beast is beautifully modelled with the teeth clearly shown. The hairs of the snout are indicated by long s-scrolls, and the upper part and back of the head are covered by tightly wound imitation chip-carved scrolls containing trumpets and semi-abstract zoomorphic elements in the style of the 'Tara' brooch. At the back of the head is a flange or stop-ridge. The ring is worn smooth. The end of the tang is perforated to receive a fastening wedge.

The disc is made in the same way as no. 63 but it lacks nail holes. About one quarter of its edge is badly worn and torn. The ornament consists of two concentric rings of reserved patterns seen against the golden colour of the copper-alloy. The inner zone is a complex interlacement of twelve animals in profile. Six large beasts are shown with crossed necks and forelegs with back and hindquarters coiled almost to a full circle. They have head lappets and tails. Three pairs of smaller beasts are interwoven with these, each pair having their snouts interlocked. All beasts have incised joint spirals, and their hind legs have faint suggestions of trumpet scrolls.

The outer ring is a series of ten tightly wound large spiral scrolls, each linked to its neighbours by smaller scrolls and trumpet devices 'penny-farthing' fashion. The centre of each larger scroll contains variants of the three-legged triskele device of which six contain semi-abstract beast heads. These are clearly in the style of the

imitation chip-carved ornaments of the reverse of the 'Tara' brooch and the Lindisfarne Gospels.

The tinned copper-alloy circular frame is now in two fragments. Its upper surface is billeted and it has four projecting lugs perforated for nails.

The handle assembly is executed in a decorative style closely comparable with that of the Lindisfarne Gospels and the 'Tara' brooch and suggests a date of *c.* AD 700. The handle is clearly an Insular rendering of the lion-head door-handles of classical antiquity. In the Greek and Roman world such handles had sacral, funerary or imperial associations, and their use throughout medieval Europe was confined to churches. The earliest-surviving north European analogues are to be found on the cast copper-alloy doors of Charlemagne's palace chapel at Aachen (shortly before AD 800). Whether the Donore example was attached to an external door or shrine is unknown. It did, however, see extensive use as the wear on the ring testifies. MR

BIBLIOGRAPHY Ryan 1987a, 58–63

65 Engraved plaque and frame *(col. illus. p. 40)*

Donore, Co. Meath. Found with nos 63–4, 66
Plaque: copper-alloy, tinned; 7.05 × 6.9 cm, TH. 0.5–1 mm; frame: copper-alloy; max. 8.8 × 8.5 cm
Irish, early 8th century
NMI 1985: 21c,h

Square, with rounded corners, the tinned copper-alloy plaque has a central perforation with an applied collar which stands proud of the obverse. It is decorated with incised trumpets, lentoids and four triskele devices seen against a stippled background. The pattern is in part compass-drawn and in part free-hand. A square copper-alloy frame, now broken, with perforations in corner settings (three survive, two square- and one lozenge-shaped) and lozenge decoration was made to fit over it. The plaque itself lacks nail holes.

 MR

BIBLIOGRAPHY Ryan 1987a, 59–60

65 plaque

65 frame

66

66 Enamelled handle

Donore, Co. Meath. Found with nos 63–5
Copper-alloy, enamel; handle L. 9.5 cm, smaller ring DIAM. 4.45 cm, link L.
 4.65 cm, larger ring DIAM. 6.76 cm
Irish, early 8th century
NMI 1985:21f

A round shank with pronounced casting seams projects from a faceted and perforated head. A copper-alloy ring connected by a figure-of-eight link to a larger ring hangs from the perforation. The facets of the heads are decorated with traces of enamel and little bosses at the angles. Two bear applied round settings for studs, perhaps of enamel, and a third is perforated to receive such a setting, now missing. The shank can fit through the central perforation of disc no. 63, but that this was originally intended cannot be proved.

MR

BIBLIOGRAPHY Ryan 1987a, 60

67 Door-ring

Vik, Stamnes, Bruvik, Hordaland, Norway
Copper-alloy, ring copper-alloy on iron core; ring DIAM. 11.2 cm, TH. 1.7 cm,
 animal head L. 5.8 cm
Irish, 8th–9th century
Historisk Museum, University of Bergen, M.A.60

The massive iron ring, thickly coated with bronze, runs through a double animal head cast in copper-alloy. The two heads are set back to back, sharing the same pair of snarling jaws. They have rounded ears and their pupils were perhaps originally inlaid with enamel.

The ring is said to have been found in a Viking grave mound; a bronze rivet is the only other recorded find. Its scale and form, particularly that of the blunt-nosed animal heads, clearly relate it to the Donore (no. 64) and Killua Castle Collection (no. 68) door fittings, placing it firmly in an Insular context. It is perhaps to be seen as a Viking souvenir from an Irish monastery door. LW

BIBLIOGRAPHY Shetelig 1927, 4–5, figs 1–2; Petersen 1940, 48, fig. 49; Raftery (ed.) 1941, 138, pl. 81, 4; Wamers 1985, 31, no. 75, pl. 6, 6

68 Animal-headed mount

Ireland
Copper-alloy, gilt and tinned, glass; ring DIAM. 6.2 cm, plate DIAM. 6.2 cm
Irish, 8th–9th century
NMI 1920:60, Chapman Collection, ex Killua Castle Collection

Cast copper-alloy mount in the form of an animal head with prominent eyes and ears, ribbed snout with spirals indicating the nostrils and gaping jaws. The sides are flat and plain. The back is fitted to a circular plate which bears one of originally four lunate projections decorated with interlaced imitation chip-carved knotwork. The animal head grasps a ribbed solid ring which in turn is linked to a solid loop cast in one piece with a flat, D-shaped plate. The loop is decorated with a central groove and a raised lip at its junction with the plate. The curved sides of the latter are bordered by a pair of incised lines. It was attached to a backing by two pairs of rivets and further secured by three rivets held in semicircular recesses at the ends of the curved sides and in the centre of the straight side. Gilding was confined to the animal's face and mouth and to the imitation chip-carved panel on the backplate.

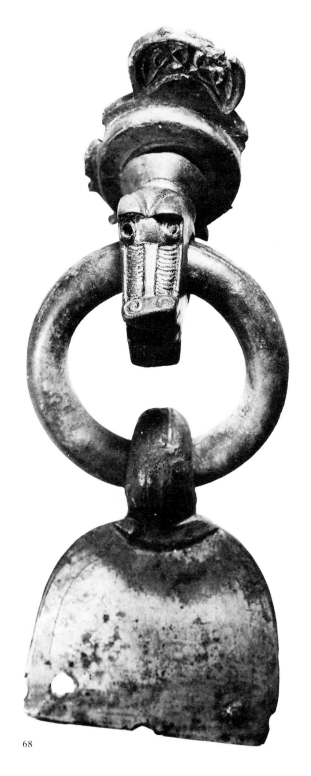

67

Owing to its incomplete state, it is not clear how this mount was fixed to a backing. The D-shaped plate resembles strap distributors found in the Navan assemblage (see no. 113), and the size and arrangement of the rivets suggest that it was attached to the end of a leather strap. The animal head seen from above with ribbed snout and scrolled nostrils is found frequently in Irish metalwork. Close examples are to be found, reused as decorations for lead weights from ninth-century Viking graves at Kiloran Bay, Scotland and Islandbridge, Ireland (Graham-Campbell 1980, nos 307, 2, and 308, 5). They are best seen on the pinhead of the 'Tara' brooch and on the terminals of the Cavan brooch (no. 73). The lunate panel of imitation chip-carved interlace is directly paralleled on a motif piece from Lagore (O'Meadhra 1979, no. 129, A3). RÓF

BIBLIOGRAPHY Armstrong 1922

68

Secular metalwork in the eighth and ninth centuries
by Raghnall Ó Floinn

It is generally assumed that in early Irish society a man's standing was measured by the number of cattle he owned. However, the literary evidence suggests that among the wealthier classes at least other possessions were regarded as important in establishing their position in society. The evidence comes from Irish sources and there is little information on how early Pictish society was organised. The archaeological evidence does show that objects of a secular nature in Ireland and Scotland in the eighth and ninth centuries were very similar.

In a coinless economy such as existed in both these areas in the early Middle Ages a notional unit of account was necessary. From the Irish law tracts written down in the seventh and eighth centuries this exchange unit was the *sét*, which was the equivalent of a heifer or half a milch cow. Silver bullion based on a unit of one ounce was also in use and seems to have gradually displaced the earlier unit in the eighth and ninth centuries (Ó Corráin 1972,73). Gold is less frequently mentioned and this is reflected in the metalwork of the period. Only one brooch made entirely of gold is known, that from Loughan, Co. Derry (no. 83), the use of gold being otherwise confined to surface gilding or as panels of filigree.

The increase in the use of silver for ornaments was accelerated by the presence of permanent Viking settlements from the ninth century onwards. No regular supply of precious metals was available in Ireland or Scotland before then, and many Irish words associated with trade and coinage are Scandinavian borrowings. Secular hoards of precious metals of the eighth century are rare. There are none from Ireland, but from Scotland there is the impressive group of objects from St Ninian's Isle (nos 97–107) and smaller hoards from Rogart (nos 111,112), Croy and the Broch of Burgar (Graham-Campbell 1985), all found in Pictland. In the ninth and tenth centuries hoards are more common, largely of a type found throughout the Viking world containing coins, ingots and ornaments usually cut up into small pieces. The number of single finds of silver ornaments also increases at this time. The Ardagh hoard with its four silver brooches (nos 76,81) was probably buried at the end of the ninth century. The amount of silver in circulation in Ireland during this period was significantly greater than in Scotland, the increase in supply probably owing to the presence of Viking towns as opposed to the more dispersed nature of Scandinavian settlement in Scotland. The majority of these Irish hoards and single objects have been found in areas not settled by the Vikings, and many from Ireland come from native settlements indicating the wealth that could be accumulated by Irish kings.

As in other early medieval societies, the possession of personal ornaments and other equipment made of precious metals was a mark of status and success. Excess wealth was converted into jewellery and could be commissioned directly or received as payment or by gift. The seventh-century *Life of St Brigid* records the miraculous recovery of a precious silver brooch owned by a high-born layman. A later life of the saint, recounting the same episode, describes the owner of the brooch as a poet who received it as payment for his work from the King of Leinster. Objects of value might also be exchanged to strengthen political alliances. The twelfth-century Book of Rights records the tributes and reciprocal gifts exchanged by Irish kings and their subordinates. The picture is somewhat idealised but it does list items considered appropriate as gifts which include swords, shields, saddles, bridles, drinking horns, armlets and gaming-boards. The Irish law tracts provide more detail, a tract on status being particularly informative on the personal possessions of the various grades of nobles: for example, the *aire desó* – the lowest grade of lord – is described as having a house with its furnishings which include drinking vessels, cauldrons, a trough and a full supply of working vessels. In addition, he has a suitably saddled horse with a silver bridle, four other bridled horses and a precious brooch worth an ounce of silver.

Brooches seem to have been universally worn and vary considerably from humble brooch-pins of copper-alloy to elaborate examples of silver set with gold filigree, glass and enamels. The latter were the treasured possessions of the rich and some are inscribed with the names of their owners. The Hunterston brooch (no. 69) is inscribed with an Irish name in runic script; the Ballyspellan brooch (no. 89) has a series of names in ogham; and the brooch from Killamery (no. 80) asks for a prayer for Cormac written in Insular script.

Stone carvings show that these brooches were worn not in pairs but singly on the breast or shoulder. A decorated stone from Hilton of Cadboll in Ross-shire shows a female figure riding side-saddle wearing a penannular brooch with circular terminals on her breast, the pin lying horizontally. The scale of the brooch is exaggerated as are associated symbols – a comb and a mirror. Another stone from Monifieth, Angus, has a female figure wearing a brooch in a similar position. There are a number of Irish representations of brooches on 'high crosses' at Monasterboice, Co. Louth, and at Kells, Co. Meath. The clearest example occurs on a carving of a warrior, perhaps David, at White Island, Co. Fermanagh (fig. 2). The brooch is worn on the shoulder, with the pin pointing downwards between the terminals indicating that the brooch is annular.

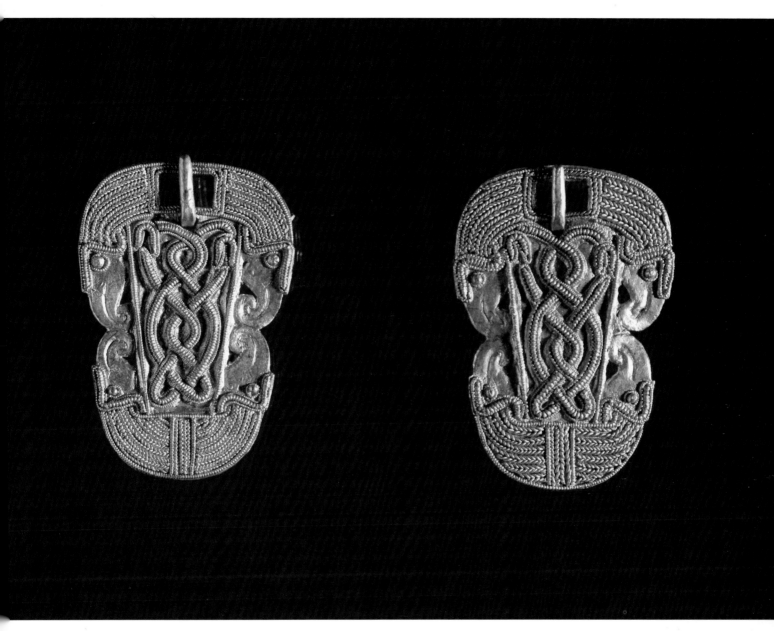

43 Faversham pair of miniature gold buckles (one exhibited).

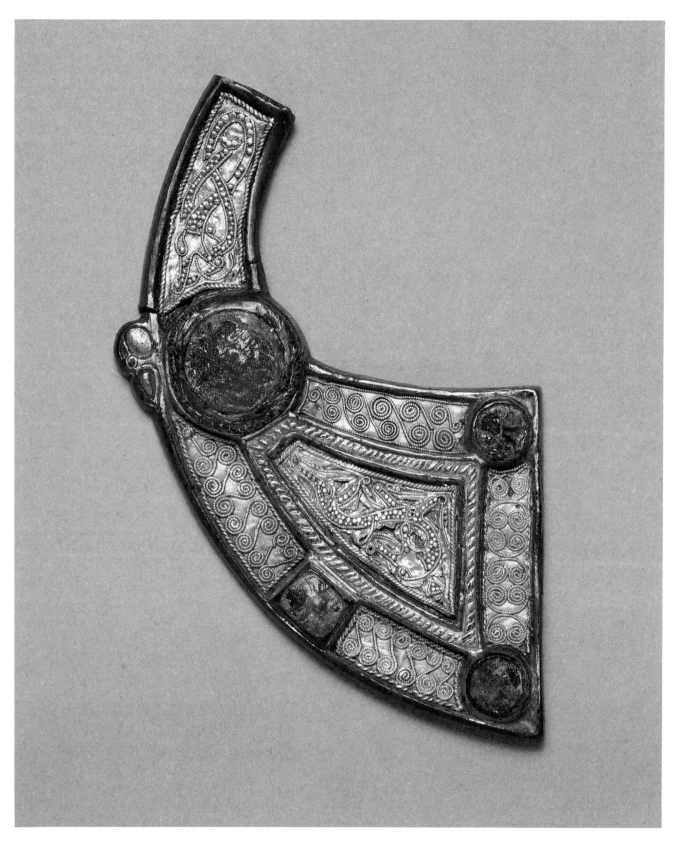

44 Dunbeath penannular brooch fragment.

Opposite 69 Hunterston brooch.

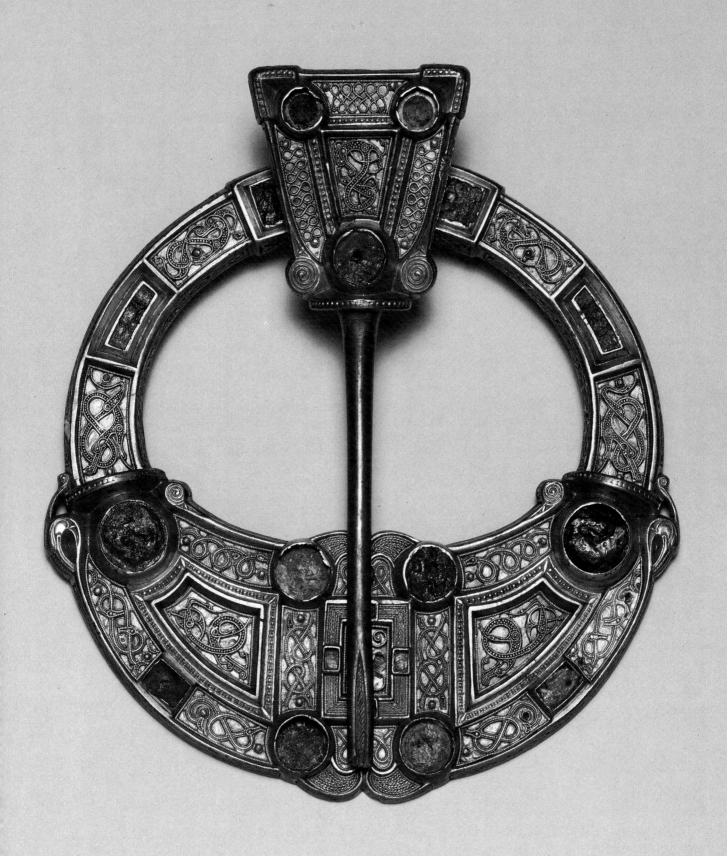

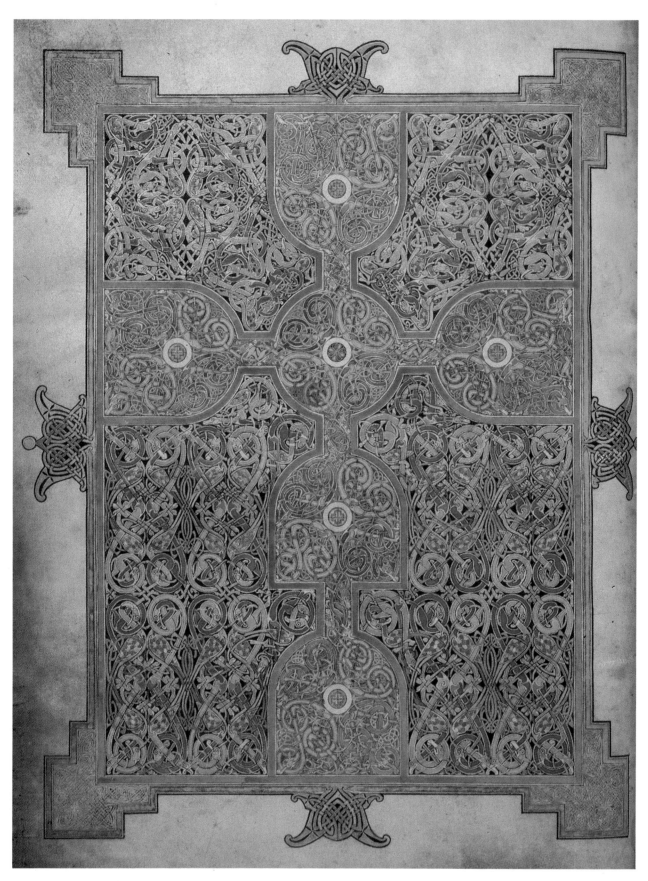

Ornamental page from the late 7th to early 8th-century Lindisfarne Gospels showing a repertoire of animal ornament also used on the finest metalwork. British Library MS. Cotton Nero D IV, folio 26v.

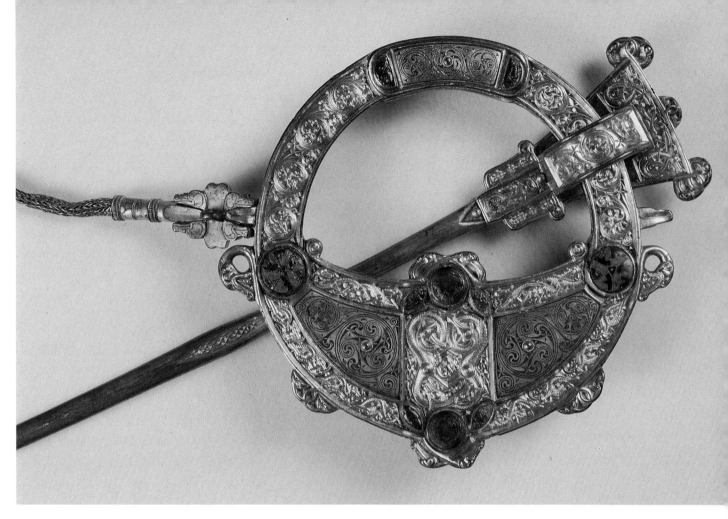

The 'Tara' brooch found at Bettystown, Co. Meath, 8th century. *Above* back view; *below* front view. NMI R 4015.

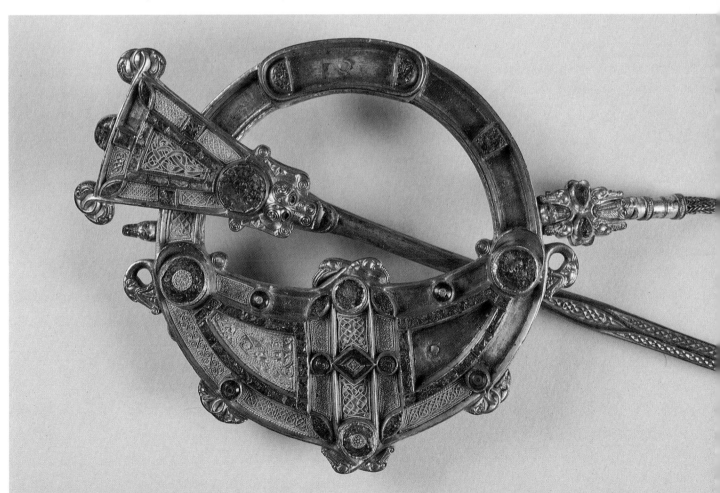

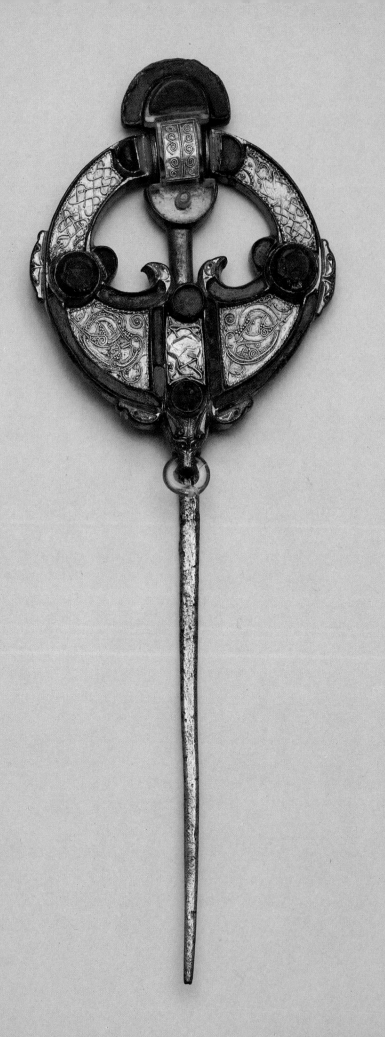

70 Westness
brooch-pin.

70 Westness
brooch-pin.

Opposite 71
'Londesborough'
brooch.

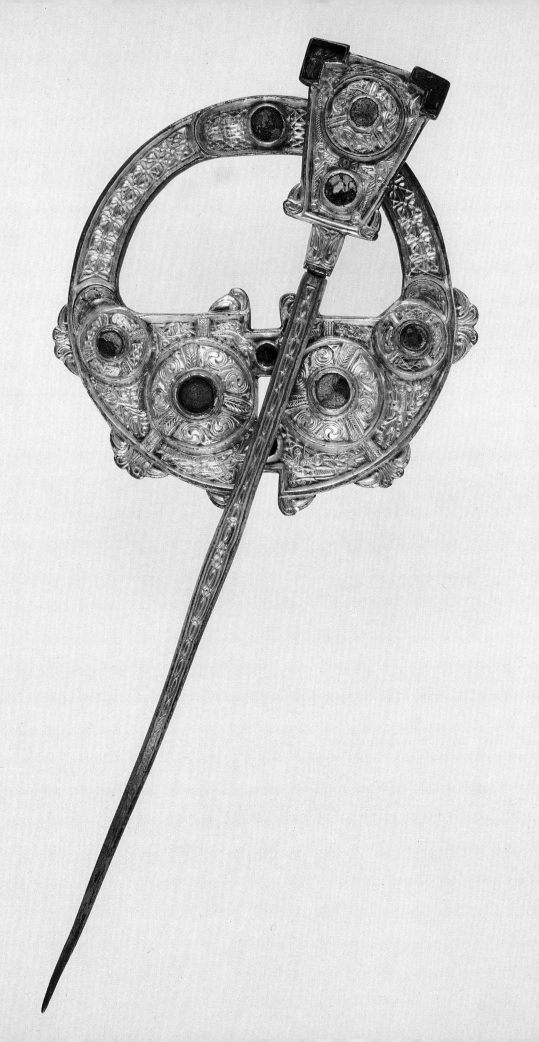

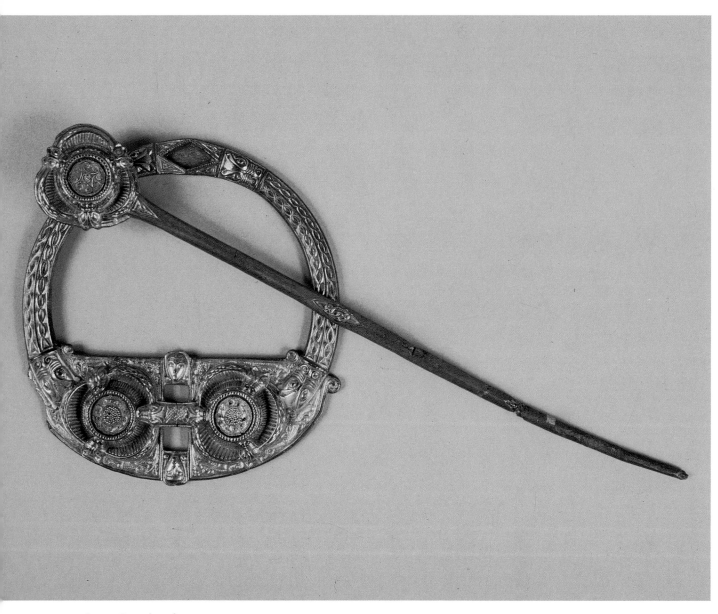

73 County Cavan brooch.

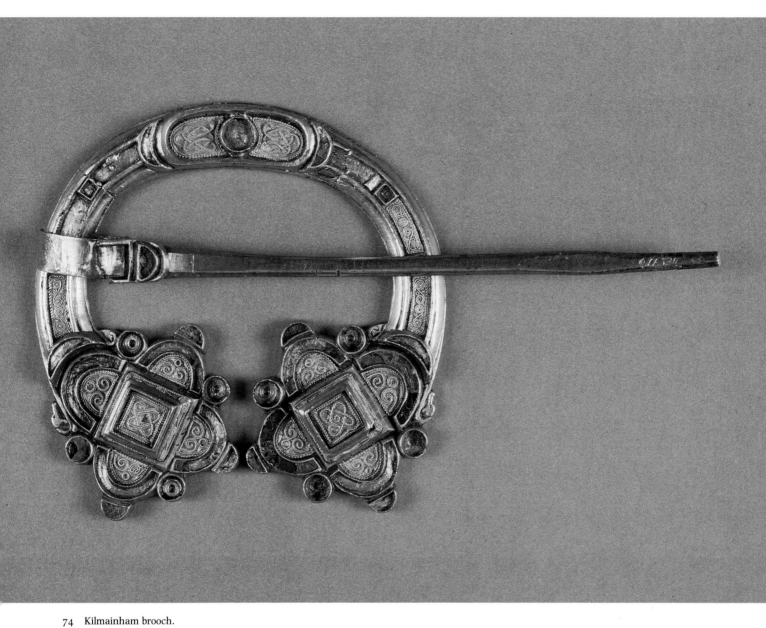

74 Kilmainham brooch.

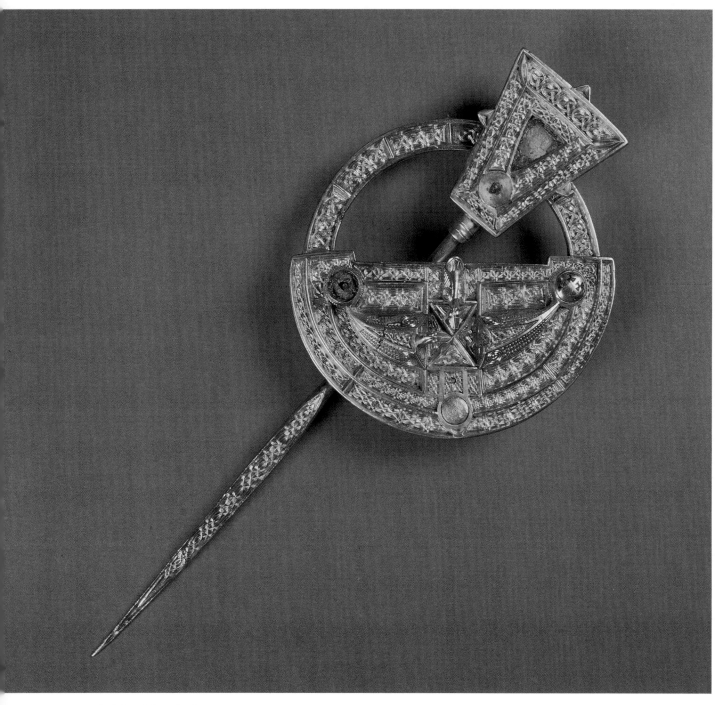

76　Ardagh hoard, brooch 1874:104.

Opposite 78　Loughmoe 'Tipperary' brooch.

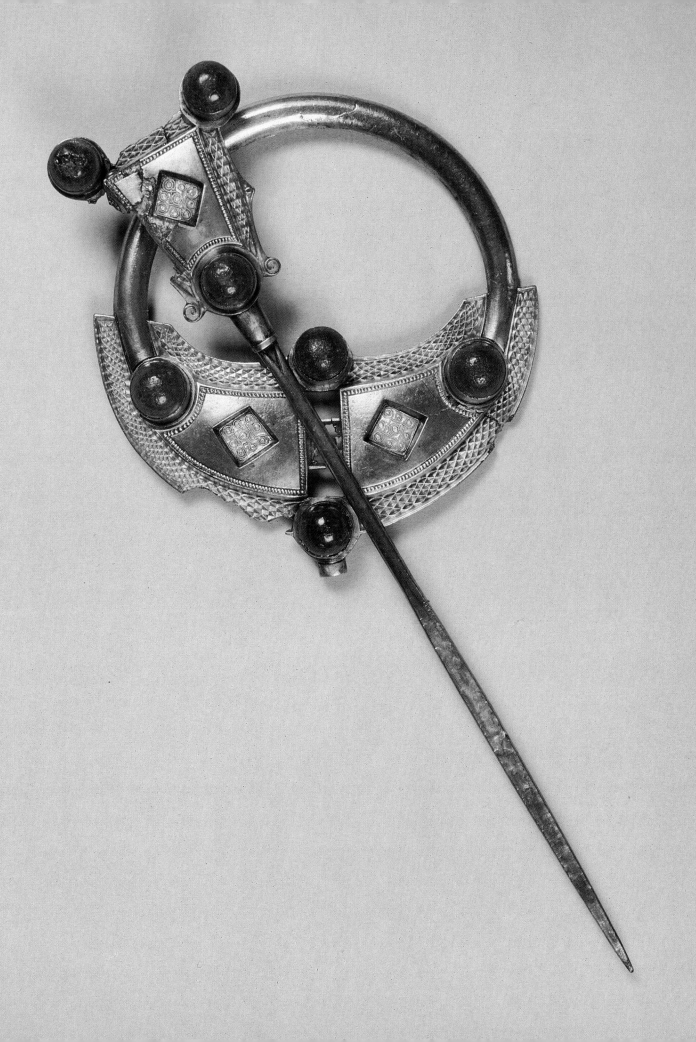

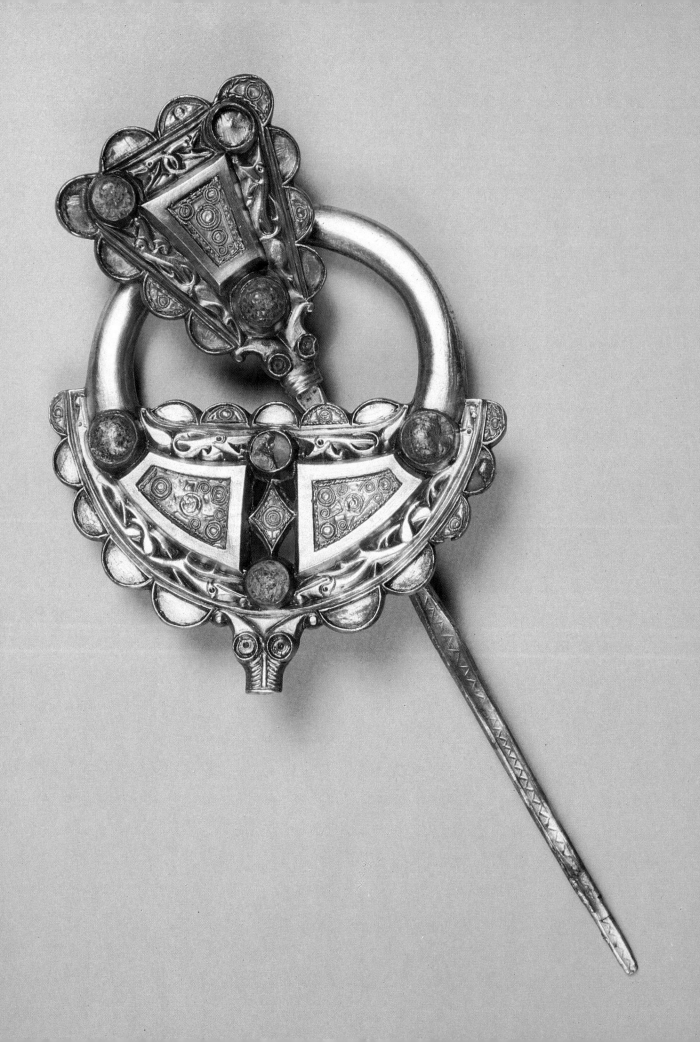

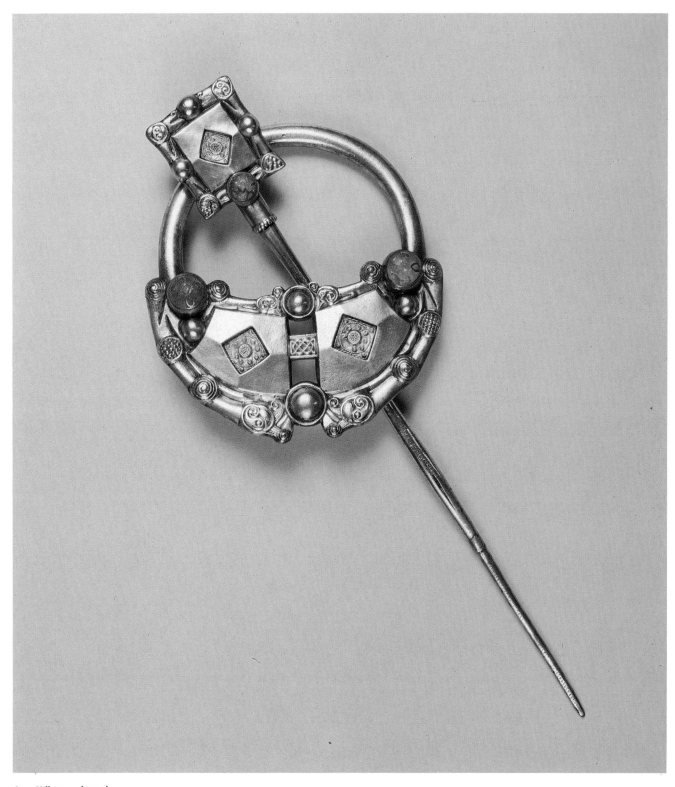

80 Killamery brooch.

Left 79 Roscrea brooch.

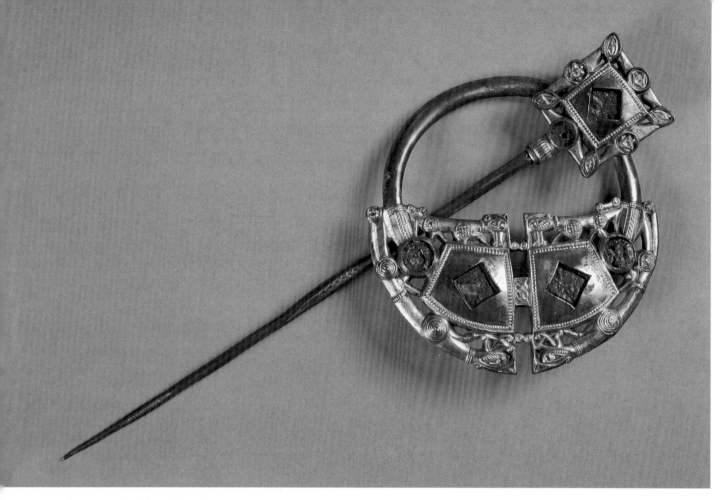

Above 81 Ardagh hoard, brooch 1874:102.

Below 85 Ballynaglogh brooch.

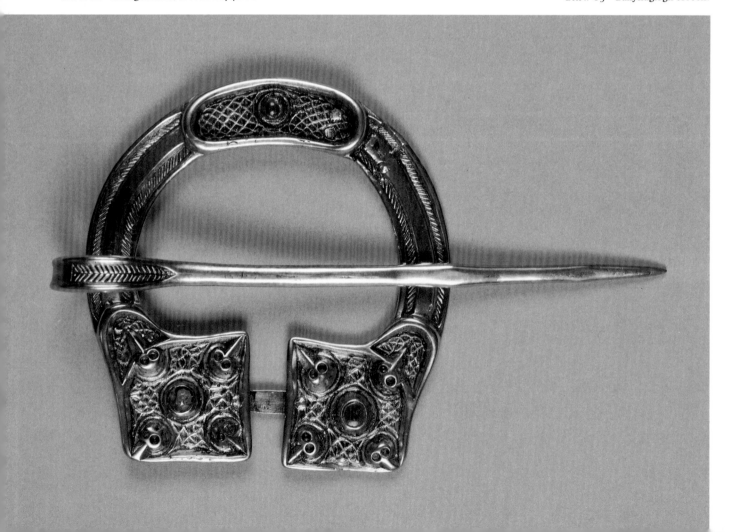

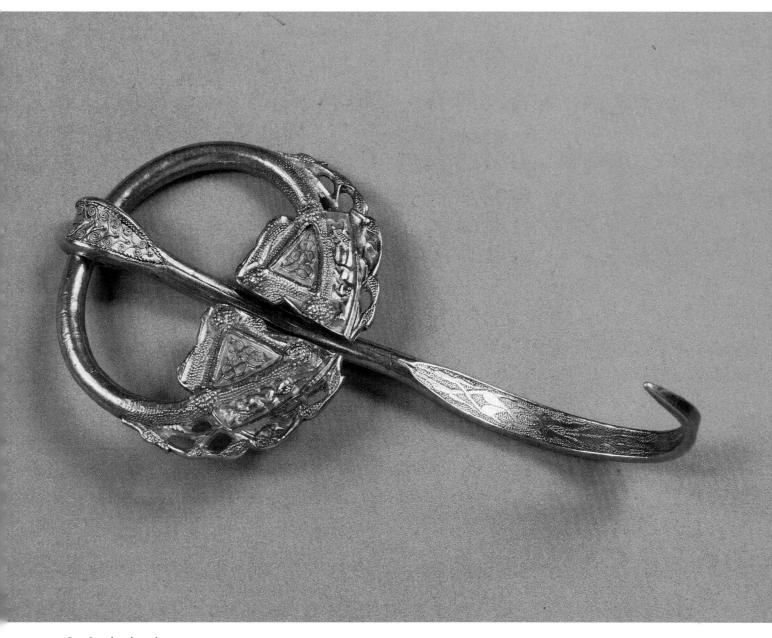

83 Loughan brooch.

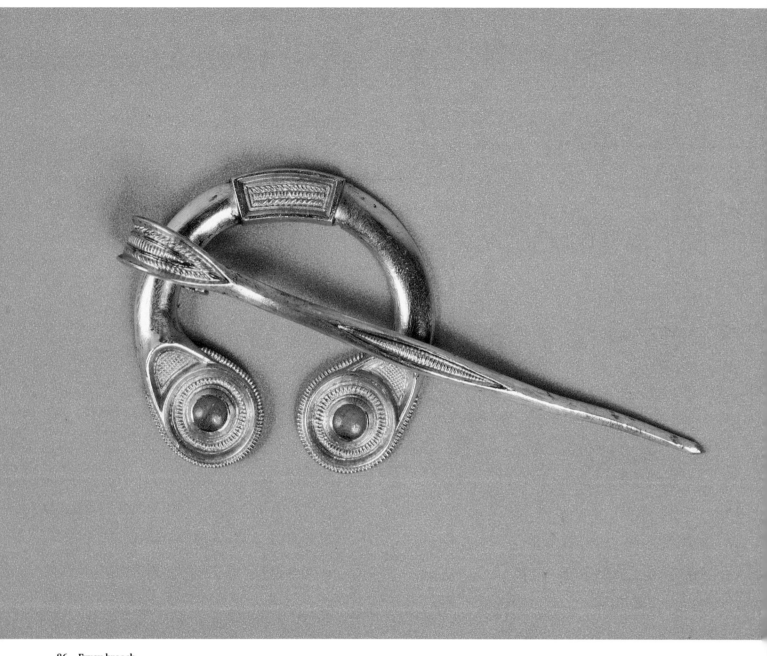

86 Ervey brooch.

Fig. 2 Stone pillar, White Island, Co. Fermanagh, 8th or 9th century AD, depicting a warrior carrying a short sword and shield and wearing a brooch fastened at the shoulder.

The other Irish examples also appear to be worn by male figures and all are shown with brooches pinned at the shoulder. This distinction between male and female methods of wear is referred to in an Irish law tract relating to accidental injury. This states that if a person is injured by the pin of a brooch the wearer is not at fault if the pin does not project too far and if it is correctly worn, by men on the shoulder and by women on the breast. It is likely that brooches were worn also by ecclesiastics, and there is a reference to a brooch – the *Delg Aidecta*, or Brooch of the Testament – being kept as a relic at Iona.

The origin and development of the highly decorated brooches of eighth- and ninth-century Ireland and Scotland are far from clear. It is not possible to date individual examples, and research

has tended to focus on the more elaborate brooches. The basic form is a development from the zoomorphic penannular brooches of the seventh century and two distinct series evolved in Ireland and Scotland. Small penannular brooches with lozenge-shaped faceted terminals such as those represented by brooch moulds from excavations at Dooey, Co. Donegal (no. 172) and Dunadd, Argyllshire (Dickinson 1982, fig. 6, 38–40), seem to lie at the beginning of the series of penannular brooches which replaced brooches with zoomorphic terminals in the seventh century. This type of brooch appears to have been a development from small Anglo-Saxon ring brooches of fifth- and sixth-century date. The important series of brooch moulds from Dunadd – seat of the kings of Scottish Dál Riada – includes many forms which were found in seventh-century contexts and which were to continue into the eighth. Two distinct series of brooches were developed in Ireland and in the Pictish areas of Scotland. The terminals were enlarged to provide a greater decorated surface. The preference is for multifaceted imitation chip-carved ornament of band and animal interlace. In construction brooches of the Irish and Pictish series are quite different.

The Irish brooch of the eighth century is annular, the terminals joined by a bar or by a solid panel. The most elaborate have sunken panels of gold filigree held in place by stitching and are set with studs of glass, enamel or amber with inset grilles of silver or gold. The ring is purely decorative and could not be used as a locking device as on the earlier penannulars. In effect, these brooches functioned as pins with elaborate heads. There is no satisfactory explanation for this development. One of the earliest of these annular brooches, the Hunterston brooch (no. 69), has a device consisting of a cross surrounded by four bird heads which fills the gap between the terminals. The bird heads are derived from Anglo-Saxon jewellery, and it has been suggested that the prototype for this element in the design was a buckle or brooch which incorporated a relic (Stevenson 1974, 38–40). Other brooches, like that from Co. Cavan (no. 73), have human heads between birds or grasped between the jaws of animals, perhaps symbolising Christ between two beasts, a common motif found in early medieval art.

The pinheads of Irish brooches are of complex construction, their shape and decoration often reflecting that of the terminals, and the ring of the brooch may be decorated along its entire length. The curvilinear style of ornament, which featured so prominently on brooches of the seventh century, was no longer in fashion and occurs on the reverse of a few examples such as the 'Tara', Hunterston and Londesborough brooches.

The annular brooch continued in use in Ireland in the ninth century and is characterised by stylised animals along the margins of the rings. Filigree, where it occurs, is less accomplished, and the enamelled studs of eighth-century brooches are replaced by plain amber settings. These trends are best seen in the brooches from Loughmoe, Roscrea and Killamery (nos 78,79,80), all from the southern half of Ireland. In the north of Ireland the penannular form was revived, probably because of the close connections with Scotland where it never went out of fashion. Of plain silver, decorated with metal bosses and animal patterns, they are known as 'bossed pen-

annular brooches', such as those from Drimnagh and Bal-lyspellan (nos 82,89). The bosses are joined by hatched bands which divide the surface of the terminals into discrete fields each occupied by a single contorted animal. It was previously thought that this layout was copied from Viking oval brooches, but it is more likely that the design is borrowed from ninth-century Anglo-Saxon silver disc-brooches (Graham-Campbell 1975). A number have been found in coin-dated hoards in Ireland and northern Britain, which suggests that the type was popular throughout the ninth and first half of the tenth centuries. A brooch of this type was probably the inspiration for the artist who drew the brooch on a piece of stone from Dunadd (no. 155). Bossed penannulars, along with the so-called 'thistle brooches', represent the final phase of Irish brooch manufacture.

Throughout the eighth and ninth centuries simpler brooch-pins were also in use. These have small heads and relatively long pins. Two forms were used, those with pins which moved freely on the ring like the Killaloe example (no. 95) and those with fixed pins (no. 70). Both forms are commonly found in Ireland, their rings decorated with imitation chip-carved inter-lace and set with simple studs of glass or amber (nos 91–4). The earliest and finest example of the latter type comes from a Viking grave at Westness, in the Orkney Islands (no. 70). However, brooch-pins seem otherwise not to have been popular in Scotland – the only other example is that from Dunipace (no. 90).

Brooches of the Scottish series have been studied in detail and their characteristics are well known (Wilson 1973). They can confidently be called Pictish as most come from the north and east of Scotland, from the main area of Pictish settlement. Finds from Ireland and from the Irish kingdom of Dál Riada in western Scotland are few. These Pictish brooches, best exem-plified by those from the St Ninian's Isle hoard (nos 104–7), are truly penannular. Decoration is confined to the terminals and to a curve-ended panel in the centre of the ring. They lack the elaborate pinheads of the Irish series, their heads being hammered into flat lentoids which are engraved and bent back over the ring to form a simple hook. The pins were therefore easily removable, and the terminals of these brooches were provided with raised cusps to prevent the pins from slipping off. Terminal shapes vary – lobed or trefoil examples were especially favoured. The Pictish brooch series is remarkable for its hom-ogeneity, as compared with those of Irish manufacture, and this might suggest that they were manufactured over a rela-tively short time-span. At a guess this probably extended from the mid-eighth to the beginning of the ninth centuries.

Brooches of the Irish and Pictish series did not develop in isolation from one another, and hybrid examples which contain elements of both traditions are known such as the small brooch from Ervey, Co. Meath (no. 86), and one of the brooches in the St Ninian's Isle hoard (Wilson 1973, no. 18). The brooch from Pierowall (no. 195), which has a ring of Irish type to which a Pictish-style pin has been added, was further adapted to Pictish taste by removing the connecting bar between the terminals to convert it into a true penannular brooch. The unique gold brooch from Loughan, Co. Derry (no. 83), was produced under

heavy Pictish influence. The pin form is of Pictish type and the beautifully executed birds on the stem, picked out by dotting, compare well with the dot-outlined animals on the silver bowls from St Ninian's Isle (nos 97,98) and on the Monymusk reli-quary (no. 129).

Ornamented drinking vessels of metal, horn and wood were also used in the homes of the wealthier classes as elsewhere in Europe at this time. By the twelfth century drinking horns had become prominent in the stipends given by Irish kings to their sub-kings (Byrne 1973, 153). Gifts of decorated vessels to mon-astic treasuries are recorded in the twelfth century in the Irish annals. In 1151 the King of Connacht bequeathed to the Abbot of Clonmacnoise a horn ornamented with gold along with a gold cup and a gilt-copper dish. There is no reason to assume that these objects were ecclesiastical and they could just as easily have been secular plate. It has been argued that the group of objects from St Ninian's Isle represents a secular hoard or at least the secular portion of a rich treasury (Wilson 1973, 145–6). The silver bowls from the treasure can be considered as tableware and are comparable with vessels from the eighth and ninth centuries in Denmark (Wilson 1973, 106–7).

Drinking horns were especially common, to judge from the large number of terminal mounts which survive (nos. 53–5). Many have been found in Viking graves, and one Norwegian find still has its aurochs horn preserved (Petersen 1940, 71). The mounts are of cast copper-alloy in the form of bird or dragon heads. The most elegant is perhaps the unlocalised Irish example now in the Ashmolean Museum (no. 55). The head has a backward-curving lappet and eyes of blue glass with cheeks set with enamelled studs containing *millefiori*. The work-manship compares with the best of eighth-century work and is particularly close to the enamelled studs on the strainer-ladle from Derrynaflan (no. 126).

The two copper-alloy vessels from the Derrynaflan hoard would not be out of context in a secular site. Both are in the insular tradition of bowl manufacture which also includes the hanging-bowls. A basin of a size comparable with that from Derrynaflan found in a Norwegian grave at Kaupang bears an incomplete runic inscription, presumably added by its Viking owner, describing it as a hand-basin. In Adomnán's Life of St Columba water for washing the hands is brought to the saint in a bronze vessel (Anderson and Anderson 1961, 317). Incised compass-work is found on many of these copper-alloy vessels, the marigold pattern made up of joining arcs being especially popular. The device occurs on some of the ninth-century bossed penannular brooches and on the reverse of the terminals of the Ervey brooch (no. 86). Incised curvilinear ornament combined with arrangements of punched dots is found on the Derrynaflan strainer-ladle (no. 126) and on the strainer from Moylarg Crannog (no. 118).

Suites of domestic vessels of insular manufacture sometimes accompany female Viking burials. These include bowls and ladles of the type found in the Derrynaflan hoard and wooden buckets bound with decorated metal sheets. The finest of these comes from the cemetery at Birka in Sweden (no. 120). The finely engraved ornament of birds and plant scrolls, which is so commonly found on Northumbrian and Pictish carvings, is

derived ultimately from the inhabited vine scroll of the Mediterranean. Irish examples are less ambitiously decorated with geometric or scroll patterns often executed in openwork (no. 119). The workmanship is often very clumsy and cast ornament, where it occurs, is of the most rudimentary kind. The quality of the work is closer to that found on engraved buckles of sheet metal found in Viking graves of the ninth and tenth centuries in Scandinavia and the west rather than in the best eighth-century Irish work, as seen on the Donore door furnishings (nos 63–6).

There are frequent references in early Irish literature to ornamental bridles. Depending on rank, these may be enamelled or of gold and silver (the latter probably refers to the gilt or tinned surfaces of the objects). The gilt copper-alloy harness mounts from Navan, Co. Meath, are the most complete set found in these islands comparable in size with those from Norwegian graves at Gausel and Soma (no. 114). Smaller finds, from Oseberg, Norway (no. 115), and from Markyate, Hertfordshire (no. 116), indicate that elaborate suites of harness mounts were not uncommon. Moulds for producing imitation chip-carved mounts similar to those from Navan have recently been uncovered from excavations at Moynagh Lough near by, suggesting that they could have been locally made. There is a general similarity in the shapes of the mounts but the decoration varies considerably between sets. Those from the Navan find are mainly covered with interlace, while the Crieff mounts are composed of scrollwork forming stylised animal heads. They are derived from earlier Anglo-Saxon and Nordic harness fittings such as the splendid series from the rich cemetery of boat burials at Valsgärde in Sweden (Arwidsson 1942, pl. 24).

The elaborate scabbard fittings from St Ninian's Isle (nos 102,103) are so far unique. Irish swords of the period were small and plain, and the Viking merchants brought with them superior swords of Frankish workmanship. The shorter sword favoured in Ireland and Pictland is neatly represented on the Athlone plaque (no. 133) and on a small mount from Rise in Norway (no. 134) where it is fitted with a curved chape like those from the St Ninian's Isle hoard.

The early conversion to Christianity of the native peoples of Ireland and Scotland has denied us the burial evidence which is so invaluable to students of early Anglo-Saxon and Germanic society. We do not know how certain types of ornaments, for example, buckles and harness fittings, were used. The number and quality of grave-goods buried with the dead would have allowed us to make assumptions about the relative wealth of regional communities. This drawback is to some extent offset by a wealth of contemporary documentary evidence which has not yet been fully exploited. Excavation of productive sites such as Dunadd, Lagore and Moynagh Lough gives a valuable insight into early medieval settlement, economy and production methods, which provides a context against which the products of early medieval Irish and Pictish craftsmen can be assessed.

Aristocratic jewellery (nos 69–96; see also nos 182, 190–2, 194–5, 211)

69 Annular brooch (col. illus. p. 75, back cover)

Hunterston, West Kilbride, Ayrshire
Silver, gold, amber; hoop DIAM. 12.2 cm, broken pin L. 13.1 cm (originally
 c. 15.0 cm), WT 319.9 g
Irish or Irish type, late 7th–early 8th century; Scandinavian 10th-century
 runes
NMS FC8

Large brooch of gilded cast silver, the front and pinhead of which are sumptuously decorated with amber mounts and panels of filigree ornament. The filigree goldwork is set out on raised trays of gold foil which are fixed within recesses in the brooch casting. The larger of these recesses are further defined by cast relief decoration. The reverse of the brooch is set with four further decorative panels, in this case of gilded cast silver. The edges of the hoop are decorated with imitation chip-carved interlace, and there are also two bird heads cast with the hoop, at the junctions between the arms and terminals of the brooch. The back of the hoop has been engraved subsequently with runes and rune-like graffiti.

The form is that of a penannular brooch with triangular terminals that are, however, completely joined together by a central decorative panel. The pin is broken but appears to have been only some 2.0 cm greater than the diameter of the hoop. The pinhead is keystone-shaped and the pin moves freely along the hoop.

The filigree insets on the front of the brooch include eight main panels, one of which is on the pinhead. Each of these panels contains an interlaced beast executed in beaded wire of various diameters and filled with gold granulation. These interlaced beast panels on the hoop alternate with amber insets as they progress round the circuit of the brooch. The central panel on each terminal is set within an ornate border of cast surface relief, and flanked by four smaller panels of interlaced filigree serpents which are again separated by amber settings. These smaller panels mirror one another across the terminals. The central blocking panel between the terminals is decorated with simple filigree s-scrolls, some of which are damaged. The border of the central panel is filled with pseudo-plaited gold wire, as are the four beak-shaped areas attached above and below it.

The four imitation chip-carved panels on the reverse of the brooch contain a variety of decorative images. On the hoop are a pair of interlaced beasts in the same style as those executed in filigree on the front. On the reverse of the terminals the decoration consists of trumpet spirals punctuated with bird beaks and heads reminiscent of similar decorative panels in the Lindisfarne Gospels. On the back of the central blocking panel is another rectangular panel filled with two-strand ribbon interlace.

The Scandinavian runes and rune-like characters scratched on the back of the brooch have been variously interpreted. They include on the right-hand side of the brooch the statement that 'Melbrigda owns [this] brooch'. The runes on the left hand of the hoop are less certainly related, although they have in the past been taken to read

that 'Olfriti' also came to own the brooch. The parallel scratches on the reverse of the terminals appear to be a deliberate infilling, more perhaps to prevent further claims of ownership than for decoration.

The Hunterston brooch is one of the finest products of the Celtic goldsmith's art. It stands at, or near, the beginning of a series of large annular brooches, usually of silver and often decorated with filigree ornaments. The type enjoyed a particular vogue in Ireland but unlike Hunterston and its very close analogue, the 'Tara' brooch, few have completely closed rings (exceptions are nos 44 and 76, the largest Ardagh brooch). The majority carry a reminiscence of the gap in the ring of the penannular brooch which contributed to the emergence of the new form (nos 71–5, 77–81). In the central area of the Hunterston brooch there is a rectangular panel with a cross pattern. Simplified bird heads, the beaks projecting and breaking the outline of the ring, flank the inner and outer edges of this feature which Stevenson has compared with Germanic brooches on the Continent (Stevenson 1974, 94, and 1983). On the latter eagle heads form the outlines of brooches which carry a central cross.

The Hunterston brooch is one of the earliest manifestations of the practice of making pinhead and terminal plates *en suite*, a style which was to be characteristic of brooches made in Ireland in the eighth and ninth centuries. The relative contributions of Celtic penannular brooches, Germanic styles and of small native hinged brooch-pins to the development of this new brooch type are obscure, but it is likely that the type developed rapidly in the later seventh century. Stevenson (1974 and 1983) has argued that a single elaborate brooch designed by a master craftsman gave rise to the entire series.

The ornament of the brooch is exceptionally fine. The filigree in particular owes a great deal to Anglo-Saxon practices. The repertoire includes false plait, granulation and hollow-platform backing plates, the latter a feature otherwise shared in Irish and Scottish work with the Dunbeath brooch (no. 44), Derrynaflan paten (no. 125a) and Ardagh chalice (Whitfield 1987, 78). The faceted scrollwork of the reverse is close in style to the zoomorphic trumpet scrolls of the 'Tara' brooch and Lindisfarne Gospels. The brooch is therefore likely to date from the later seventh or earlier eighth century. The runic inscription on the reverse added at a later date records that it was owned by an Irishman, Melbrigda.

The precise circumstances of the discovery of the Hunterston brooch are uncertain, but in either 1826 or 1830 the brooch was found on the hillside at Hunterston in Ayrshire. The brooch was acquired at the time by Mr Hunter of Hunterston and sold to the Society of Antiquaries of Scotland in 1891. RMS/MR

BIBLIOGRAPHY Wilson 1863, 267–76, and frontispiece; Anderson 1881, 1–6; Grieg 1940, 185–7, and figs 88a,b; Olsén 1954, 169–71; Stevenson 1974; Stevenson 1983; O'Meadhra 1986, 85–6, 88; Whitfield 1987

70 Brooch-pin *(col. illus. p. 78)*

Westness, Rousay, Orkney, Scotland
Silver, gilt, amber, glass; hoop DIAM. 6.25 cm, pin L. 17.5 cm
Irish, 8th century
NMS IL 728

Cast brooch-pin ornamented with panels of filigree and set with amber and red glass. The decoration of the hoop gives the appearance of a penannular brooch, but the 'terminals' are joined by a central panel of filigree work, unfortunately damaged, mounted on a tray of gold foil. Above and below this panel were circular settings of amber, of which only the lower stud survives. On the outer edge of this blocking is an animal head cast in full relief. A small metal ring (now replaced with a ring of perspex) originally passed through the mouth of this animal. This may have held a cord which could be tied to the point of the pin to secure the brooch when it was being worn.

The terminals of the brooch are filled with panels of similar zoomorphic filigree work set on trays of gold foil which are enclosed within border panels of red glass. These panels of glass are capped on the inside of the ring by bird heads and on the outside by animal heads. The junctions between the terminals and the arms of the hoop are set with large amber studs. The arms themselves are filled with further panels of zoomorphic filigree work divided at the top of the ring by a bar on which the pinhead was fixed. This recess is marked on either side by semicircular amber settings of which only the left-hand one survives. The pinhead has been restored but was originally hinged around the bar at the top of the hoop. Only the panel of filigree interlace decoration on the bridge of the pinhead survives, but originally the two semicircular fields above and below the bridge would also have held gold trays of filigree work. The upper semicircle is still bounded by a border of red glass. The shank of the pin is of circular section and undecorated.

This is by far the most elaborate brooch-pin that has survived. The details of the filigree techniques displayed on this object have been compared with the 'Tara' and Hunterston (no.69) brooches and with the brooch fragment from Dunbeath (no.44) (O'Meadhra 1986, Whitfield 1987). All these brooches also have cast animal heads in profile along the margins of their terminals, and these similarities suggest a date perhaps in the early eighth century for the Westness brooch-pin. The innovative feature on Westness is that the pinhead is confined between buffers at the centre of the hoop, preventing it from sliding along the hoop. The pin is proportionally much longer in relation to the hoop compared with that of the brooches, and the object thus functioned as a pin rather than a brooch – hence the term brooch- or hinged pin (Stevenson 1987, 92). The bowed pinhead is another innovation, found on some other brooch-pins (Bourke, Fanning and Whitfield 1988, 91) and on the pinhead of the Kilmainham brooch (no.74).

As well as the usual studs of amber, the Westness brooch-pin contains inlaid plaques of red glass, perhaps in imitation of the garnet inlays on Anglo-Saxon jewellery. Such glass inlays are rare and are found, for example, on the Kilmainham brooch and on a pinhead of a brooch very similar to that from Westness found in a grave at Skjeggenes in Norway (Bourke, Fanning and Whitfield 1988).

The Westness brooch-pin was found in 1968 by a farmer burying a cow. Subsequent archaeological investigation of the site indicated that the farmer's pit had disturbed a mound covering a rich ninth-century burial of a Viking woman (Kaland 1973). RMS/RÓF

EXHIBITION *The Vikings*, British Museum, London, 1980

BIBLIOGRAPHY Stevenson 1968, 25–31; Wilson 1973, 87–8; Stevenson 1974, 34ff.; Graham-Campbell 1980, no. 312; O'Meadhra 1986, 85–6; Stevenson 1987, 90–2; Whitfield 1987, 78, 80, 82 and pls ii and iia–c; Bourke, Fanning and Whitfield 1988, 93, 96

71　Annular brooch (col. illus. p. 79)

? Ireland
Irish, 8th–9th century
Silver, gilt, tin-bronze, amber, glass; max. DIAM. 10.15 cm, pin L. 23 cm, WT
　201.5 gm
BM, MLA 1888,7–19,101; Londesborough Collection

Annular brooch cast in silver with composite silver pin. The brooch metal is heavily debased silver, approximately 65 per cent copper, 34 per cent silver, with traces of lead and gold (British Museum Research Laboratory). The brooch front is thickly gilded and ornamented with cast interlace, birds and animals and raised settings for amber on foils, some now empty. The hoop has a raised rim and broadens to a central panel with amber setting between fine net-like interlace; to either side panels of geometric interlace run round to the terminals. At the junction are curving segments in relief with egg-and-dart derived ornament on their sloping surfaces. The inner and outer rims of the terminals are decorated by paired and single bird heads in profile, while a pair of eagle-like birds, their wing feathers carefully depicted, peck down towards the bridges linking the terminals. Two pairs of raised bosses dominate the terminals, their surfaces divided into three and four by ribs; the panels between the ribs are filled with small animals, plain interlace and, on the larger bosses, pairs of running spirals. Interlaced animals with hatched bodies and pronounced eyes and jaws fill the reserved panels between the bosses. Despite apparent symmetry, there are numerous minor differences between the left and right terminals in the details of decoration. On the back of the terminals two circular frames hold concave gilt tin-bronze discs of cast spiral ornament. Plain blue glass studs mark the end of the hoop.

The pin was cast in two parts. The rhomboidal head is decorated with a raised frame with profile bird heads, L-shaped settings for blue glass on the corners and a zoomorphic collar for the pin. A low, circular boss has three panels of animal ornament and a central stud of amber. A second amber setting lies below, and the rest of the field is filled by interlace and two beasts with exaggerated open-jawed heads with long fangs, hatched jaws and bodies. The pinhead is attached to the shank by a rivet between lugs and two pairs of clips. The shank has an omega-shaped loop around the brooch hoop and cast gilded interlace and hatching almost the full length of the pin front.

This sumptuous brooch has not been much discussed, perhaps because in techniques and design it lies outside the main interrelated groups of top-quality annular brooches. The absence of filigree is noteworthy. The unique domed bosses recall larger shrine fittings (no. 140). It could have been produced as part of a suite of metalwork for a senior cleric, a king-abbot perhaps. There is sculptural evidence for the wearing of such brooches by ecclesiastics. The pinhead type and smaller details look back to the 'Tara' brooch design – the zoomorphic collar on the pin, the peripheral bird heads and a raised segment at the hoop and terminal junction. The Breadalbane brooch (no. 72) also shares many details including L-shaped settings and decoration on the raised segments. Hatched animals and birds are also found on the 'Tara' brooch, but on the Londesborough example they exhibit the fangs and gaping jaws seen on slightly later metalwork – for example, the Paris mounts and Helgö mount (nos 138, 147) – and also found in the Book of Kells, where the complete birds too have distant relatives (Henry 1974, 79, 208, ff. 271R, 190V).

SY

BIBLIOGRAPHY Smith 1914, 228, 233; Smith 1923, 134–5, pl. XI; Mahr 1932, pl. 23,2, Henry 1965a, 113, 116

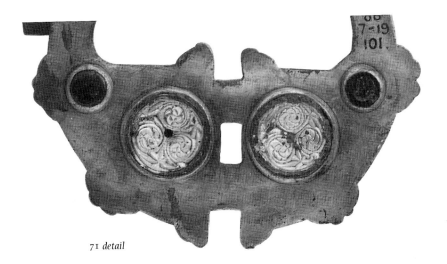

71 detail

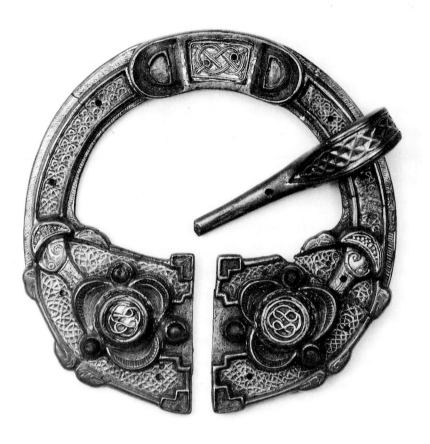

72

72 Penannular brooch

Scotland, possibly Perthshire, Tayside
Silver, gilt, gold, glass; max. DIAM. 9.8 cm, pin L. 6 cm, WT 140.86 g
Irish and Pictish, 8th–9th century
BM, MLA 1919,12–18,1, Ramsden gift, ex Breadalbane Collection

The ring of this brooch is solidly cast in silver and gilded on the front, with gilding only on the applied decoration on the back. The terminals were originally joined by a central linking element making this an annular brooch of Irish type, but this link was cut away in antiquity to create a true open ring of the style preferred by the Picts. The hoop is edged with hatched flanges which run on to the terminals and end in profile bird heads. Two curved panels inside raised borders contain cast geometric interlace, and at the apex a very deep panel with raised semicircular settings, now empty, has a central applied panel of gold foil framed with filigree, where a simple open knot is made from two snake-like strands of beaded gold wire. At the junction of hoop and expanded terminals two cast, profile animal heads with scrolls on the cheek and hatched muzzles spring from raised crescentic inset panels with beaded wire frames and collared gold granules. The centrepiece of each terminal is formed by three curving segments in high relief with vertical ribbing on both faces, surrounding a tall setting with an integral collar of cast interlace holding a circular panel of worn gold filigree. The terminal background is reserved and textured with cast geometric

interlace and is divided into smaller areas by three small circular settings with translucent green glass cabochons (one now missing). Raised edges to both terminals have two further bird heads, back to back, and end in empty T-shaped cells top and bottom, with plain, ungilded surfaces where the ring was cut open. Some applied decorative element is missing from this area, and there is at least one 'stitch' to hold a panel in place (observed by N. Whitfield). Both the T cells and semicircles on the hoop may have contained amber, a favourite inlay on contemporary jewellery (see nos 69, 79). The back of the brooch is plain, apart from two raised circular settings with applied silver-gilt discs, which bear three simple trumpet spirals.

The pin, now incomplete, is cast with an integral loop, and a gilt-silver foil with geometric interlace is riveted to the head. The loop is broken short at the back. It has a decorative semicircle in low relief where the loop tail met the pin. The brooch is now broken in three places and is peppered with drilled holes, most for early modern repairs and possibly for wiring to a backing.

This brooch is one of a small group of top-quality annular Irish brooches defined by distinctive features, principally the use of three crescentic cusps in deep relief around a central setting on each terminal, a form derived from a seventh-century class with disc (Fowler 1963, type H). Similar ornamental cusps dominate a large silver brooch found at Snåsa, Norway (Rygh 1885, no. 697, which shows the terminal links; Petersen 1940, 66, fig. 73), another from

Lagore (Hencken 1950, 61–2), and the Cavan brooch (no. 73). The Lagore example also has L-shaped cells emphasising the terminal corners, and a terminal link in the same position as the missing one on the Breadalbane brooch, although the former piece is of inferior quality, without filigree and coloured inlays. Three- and four-cusped terminals were favoured by Pictish silversmiths (nos 111, 112) and the motif was not confined to brooches – it appears on Irish harness mounts found at Gausel, Norway, where it is also closely related to the classical egg-and-dart motif (Wamers 1987). The background interlace and Germanic-style zoomorphic filigree all reflect the development of an insular ornamental style. The relegation of native Celtic ornament to the back of early eighth-century metalwork and its apparent segregation from the other decorative motifs are seen on a number of pieces of fine metalwork such as the Hunterston brooch (no. 69) and the 'Tara' brooch, where the shape of the spiral ornament panels on the back reflects the terminal shapes of earlier, sixth- and seventh-century zoormorphic penannulars.

The Cavan and Lagore brooches supply two possible forms, either triangular or rectangular, for an original cast pinhead on the Breadalbane brooch repeating the three-cusp theme. The present simple pinhead is of Pictish type and finds close parallels on the St Ninian's Isle brooches (nos 106, 107) and the smaller brooch from Rogart, Sutherland (no. 112). In Scotland in the eighth and ninth centuries the practice continued of wearing brooches in true pen-annular style, that is, by twisting the ring round to lock the pin in position instead of treating the whole brooch as a stick-pin with a decorative head, as favoured in Ireland. True penannular brooches continued to be manufactured, and it is likely that the loss of the original pin of this brooch and its replacement by a smith in Scotland led to the contemporary opening up of the ring by the same smith, whose normal production would have resembled the open ring types found at Croy, Inverness, St Ninian's Isle and Rogart.

Stevenson (1985) has pointed out that because the vendor of the Breadalbane brooch in 1917 was a descendant of the first Marquess of Breadalbane, and other items in the sale came from the collection of the second marquess (d. 1852) and had been Breadalbane property from the sixteenth and seventeenth centuries, a provenance in Perthshire (now Perth and Kinross) is likely. SY

BIBLIOGRAPHY *Proc. Soc. Ant.*, XXXII (1919), 63–6; Smith 1923, 135; Henry 1965a, 111; Small, Thomas and Wilson 1973, 83, 85, 90, 98; Laing 1975, 310, 313; Stevenson 1985, 236; Whitfield 1987, 80, pl. 2, g

73 Annular brooch (col. illus. p. 80)

Co. Cavan
Silver, gilt; ring DIAM. 11.4 cm, pin L. 18.9 cm, WT 245.55 g
Irish, later 8th–early 9th century
NMI W.43, acquired c. 1862 by the Royal Irish Academy from the Rev. Richard Butler, Dean of Clonmacnoise

This brooch, the 'Cavan' or 'Queen's', is of developed Irish annular form. The decoration of the pseudo-terminals is closely matched by that of the pinhead. The gap in the ring of the ancestral penannular type is strongly indicated by the organisation of the decorative panels but it is 'bridged' by three decorative tags, the outer two carrying cast relief human face-masks and the inner one, a fine interlacement. Except for three roundels with simple motifs in beaded wire and gold granules – one on each terminal and one on

the pinhead – filigree and other applied gold ornament are avoided. Instead, lavish imitation chip-carved decoration occurs on almost all the surfaces of the front. In the centre of each pseudo-terminal is a subtriangular form composed of three raised cusps disposed around an ornamental, flat-topped boss. The cusps are separated from each other by delicately modelled animal heads biting inwards. The sides of the lobes carry cast interlacements and on each boss a band of egg and dart. The background on each terminal is decorated with animal motifs: each beast is shown as having a hatched or billeted ribbon-shaped body, a backturned head and long snout grasping its own trunk.

The hoop of the brooch is divided into two main parts on each end of which are animal heads. There is one on the pseudo-terminal on each side facing the hoop and continuing its line to the central lobes. At the other end of each section is a similar head facing towards the terminal. The principal decorations of the hoop seg-ments are long double-contoured skein patterns. In the middle of the hoop is a rectangular panel with a lozenge-shaped sunken area, originally perhaps for filigree, now missing. There is stitching along its sides. In the triangular areas around it are simple knotwork devices.

The pinhead reproduces the lobed decoration of the terminals and there are two small panels of cast interlace on the shank of the pin, one of them on a swelling at the mid-point.

The reverse of the brooch is generally plain, but there are two simple beast heads, each with prominent fangs and a long tongue, at the points where the loop meets the pseudo-terminals, and there are also two hollows corresponding to the terminal bosses.

It is difficult to suggest a close date for the brooch. The cusps may be regarded as a somewhat late feature in the annular series. The long-snouted animals with backturned heads seem to anticipate developments of the Irish animal style of the ninth century. The relative paucity and simplicity of the filigree and the complete absence of glass might with caution be taken to suggest that the high point of craftsmanship had passed by the time the Cavan brooch was made. However, factors such as individual taste and different workshop traditions make that line of reasoning somewhat unreliable. There can be little doubt that the Cavan brooch is a fine and imposing object. It may be dated to the eighth century or early ninth century. MR

EXHIBITIONS *Treasures of Early Irish Art* 1977, no. 41; *Treasures of Ireland* 1983, no. 55; *Irish Gold* 1988, no. 58

BIBLIOGRAPHY Coffey 1909, 28; Smith 1914, 231; Armstrong 1915, 298; Raftery (ed.) 1941, 130–1; Henry 1965a, 111; Lucas 1973, 94–6

74 Penannular brooch (col. illus. p. 81)

Kilmainham, Co. Dublin
Silver, gold, glass; max. DIAM. 9.67 cm, terminals W. 4.88 cm, unrestored pin L. 14.3 cm, WT 154.80 g
Probably Irish, later 8th–earlier 9th century
NMI W.45

Penannular ring of silver with a flattened cross-section and four-lobed terminals with raised, rectangular bosses at the centre. The margins of the lobes are defined by semicircular settings with red glass surviving in two of them. Small lunette-shaped settings occur

on each lobe, a larger one at the junction of the ring and terminals. Between these are circular settings evidently for glass, but most are empty and one, together with two lunettes, contains traces of backing material. Each lobe bears a semicircular panel of filigree executed in beaded wire with a twisted strip border. The motifs are simple scrolls, but the wires are complex, one on two to produce a trefoil cross-section. The rectangular bosses are composite, the upper part being held by rivets passing through the body of the brooch, and the sides bear narrow panels of filigree s-scrolls. The tops carry four-lobed knots of twisted wire flanked by smaller wires within a frame of false plait. In the centre of the right-hand panel is a small circle of twisted plain wire. The foil on the left-hand panel at this point is torn away. The ring is divided into seven panels, three on each side, of which two bear simple filigree scrollwork. At the top is a round-ended 'keystone' panel with filigree interlace and a central setting now empty. At the ring and terminal junction on each side is a backward-looking beast head. A fine edge-moulding suggests the body of the beast.

The hoop reverse is plain with a flat moulding bordering the edge. The reverse of the terminal bosses is hollow, with the heads of the fastening rivets clearly visible within. On the back of the 'keystone' panel is a pair of dog-like beasts with crossed forelegs and coiled hindquarters. There is a modern repair on the ring. The pin, which is now badly damaged, fits into a half socket on a surviving fragment of the pinhead. The pinhead carries a D-shaped setting for glass and part of a longer setting, with worn stitching marks, probably originally for filigree.

In its penannular form with lobed terminals and panelled ring this brooch is clearly heavily influenced by contemporary fashions in Pictland. Although now badly damaged, its pin was evidently of the more complex Irish form with the shank fastened in a half socket. Although at first sight the filigree looks unusual, it falls within the range found on Irish metalwork of the period (Wilson 1973, 83–4). The terminal of a closely similar brooch was found in a grave mound at Eia, Sokndal, Rogaland, Norway (Wamers 1985, 101, no. 104).

The find circumstances are unknown. Kilmainham was the site of an early monastery and later part of the Viking-Age cemetery of Dublin. MR

EXHIBITION *Treasures of Early Irish Art* 1977, no. 42

BIBLIOGRAPHY Coffey 1909, 28; Armstrong 1915, 298–9; Mahr 1932, pl. 22, 1; Raftery (ed.) 1941, 132; Wilson 1973, 83–4

75 Penannular brooch

Isle of Mull
Copper-alloy, gilt; hoop DIAM. 11.4 cm, pin L. 17.9 cm
Irish, 8th century
NMS FC5

Cast brooch, gilded and ornamented with studs. The gilding of the brooch has suffered from corrosion and abrasion, and the brooch has lost all of its original twenty-one ornamental studs. When cast the brooch formed a complete circle, its terminals being joined by an inset cross-bar which was subsequently removed.

The entire brooch front, apart from the pin shank, is covered with sockets for studs or cast ribbon and zoomorphic interlace decoration. There are also two panels of zoomorphic interlace decoration on the

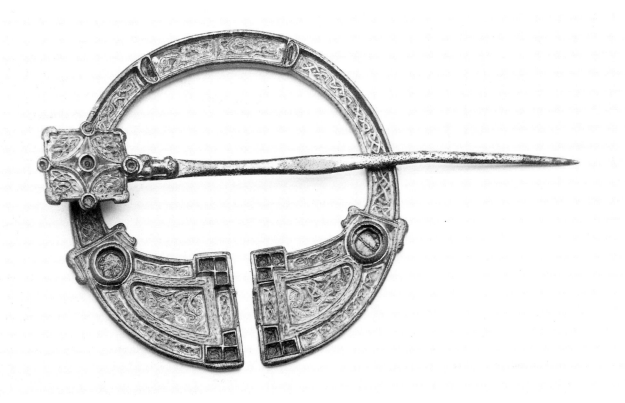

75

reverse of the terminals. The junctions between the terminals and the arms of the brooch are marked by large circular settings which are further bounded by pairs of long-snouted beasts cast in profile on the inside and outside of the hoop. The corners of the terminals are decorated with L-shaped blocks of three smaller rectangular settings. The central panels of the terminals are recessed and decorated with zoomorphic interlace depicting a back-facing biting beast. This central panel is surrounded by a raised boundary of simple ribbon interlace which is in turn enclosed by three recessed panels of more elaborate ribbon interlace. Similar ribbon interlace fills the two arms of the brooch. At the top of the hoop is a cartouche bounded by sockets for semicircular settings and filled with two interlaced animals. The reverse, of the brooch is decorated with triangular panels filled with zoomorphic interlace figures on each of the terminals.

The shank and head of the pin have been cast separately and soldered together. The round-sectioned shank is hipped but otherwise plain. The head of the pin is a rectangular plate which is divided into four fields by a cross. These fields are decorated with ribbon interlace, while the centre point and arms of the cross were originally decorated with circular studs. Another long-snouted animal head extends from the rectangular pinhead along the shank. The tongue on the back of the pinhead is hooked so that the pin moves freely round the ring of the brooch.

The brooch was originally annular in the Irish manner with *en suite* pinhead and terminals. The bar bridging the terminals has been cut away to adapt it to the penannular form fashionable in Scotland. The chip-carved animal ornament of the ring reflects the filigree ornament of the great silver brooches. An annular brooch closely similar in style and ornament was found at Bonsall, Derbyshire (Smith 1914, 230, fig. 5).

Other than that it is from Mull, the circumstances of this brooch's discovery are unknown. It was in private hands until the 1840s.

RMS/MR

BIBLIOGRAPHY Duns 1879, 67; Anderson 1881, 12–15; Grieg 1940, 197, and figs 93a,b; Wilson 1973, 85, and pl. XLVII

76 Annular brooch *(col. illus. p. 82)*

Ardagh, Co. Limerick
Silver, gilt, glass, ?lead; pin L. 33.5 cm, hoop DIAM. 13.1 cm, terminal W.
 14.4 cm, WT 499.96 g
Irish, late 8th–9th century
NMI 1874:104

The hoop is divided into panels with imitation chip-carving, and three birds in high relief decorate the plate, two with their wing feathers indicated by a pattern of scales and panels of interlace on their backs. One of the pair of birds has a portion of the metal on one side torn away revealing a crude nineteenth-century repair, not a bone core as previously described (Ryan (ed.) 1983, 128), and the head of the other is missing. The third bird is smaller and less heavily decorated; its tail is clearly modelled. The pinhead is trapezoidal with triangular projections on three sides. Its decoration echoes that of the plate and includes an empty triangular setting, perhaps for another bird. The shank bears a narrow panel of cast chip-carved decoration along an expanded portion of its length. Round settings occur on the pinhead and ring in the customary

positions but only one stud, of silver, hemispherical and embellished with angular glass inlays, survives. It is clearly a clumsy attempt to imitate the appearance of the elaborate grilled or inlaid polychrome studs on objects such as the Ardagh silver chalice.

On the reverse an incised line borders the edge of the brooch. Two panels, answering the position and general outline of the larger birds on the front, carry gilt-bronze imitation chip-carved beast motifs on thin plates, which evidently cover the lead fillings of hollows on the terminals at those points. A similar feature occurs on several other Irish brooches. These thin-bodied beasts are related in style to examples on other eighth- and ninth-century brooches.

The absence of filigree, the relative lack of accomplishment of the surviving stud and the animal panels on the reverse might all suggest a date after the finest period of metalworking. The appearance of the prominent bird ornaments recalls the use of bird heads on the terminals of a number of elaborate Scottish penannulars, a type also represented in Ireland, and on the crook of the Irish 'crozier' from Helgö, Sweden (no.147).

The brooch was found in September 1868 along with three other brooches (including no. 81) and two chalices at Reerasta Rath near Ardagh, Co. Limerick. The objects were partially protected by a rough flagstone placed in an upright position. MR

EXHIBITIONS *Treasures of Early Irish Art* 1977, no. 40; *Treasures of Ireland* 1983, no. 51c

BIBLIOGRAPHY Coffey 1909, 37, 40–1; Raftery (ed.) 1941, 142; Lucas 1973, 94

77 Annular brooch

Tara, Co. Meath
Silver, gilt, amber, ?lead; max. DIAM. 7.7 cm, pin L. 15.6 cm, WT 57.34 g
Irish, 9th century
BM, MLA 1893,6–18,29, Bateman Collection

Slender hoop, at the apex two panels of gilt interlace framing an empty rectangular setting. The junction with the expanded terminals is marked by deep circular settings for amber, one piece remaining. The centre of each terminal has a raised subtriangular field subdivided into five panels – an empty central lozenge with four irregular panels each with a profile animal. Each terminal has a flat border of repetitive interlace and is gilded overall. Two thin strips and an empty rectangular setting link the terminals. The backs of the terminals have incised, angular interlace and compass-drawn marigolds. The raised front fields were hollow cast and one still retains a filler of ?lead, capped with a silver sheet.

The pinhead, which is a separate casting riveted to the shank, has an empty central lozenge framed by cast beading and simple interlace and four empty settings. A border of c-scrolls and billets gives the head a falsely cusped appearance.

Not to be confused with the Bettystown 'Tara' brooch, this later and simpler brooch belongs to a group, mostly in copper-alloy, where the broad, subtriangular terminal plate has a wide outer border, slender bridges linking the terminal and circular settings or bosses at the junction of the plate and hoop. Repetitive, stiff interlace is another common feature. This example has animals distantly related to those on contemporary ninth-century Anglo-Saxon and Carolingian metalwork, reflecting a common continental inspiration. The central lozenges may have held filigree panels. Lead or

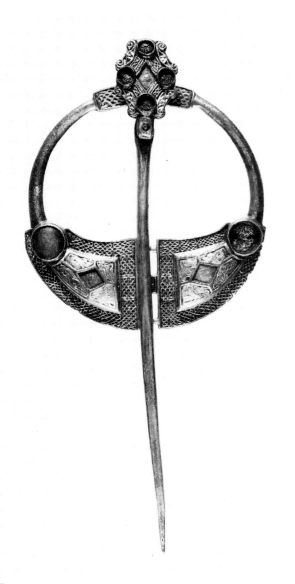

77

which are raised areas each with a billeted margin and central quadrangular setting for filigree. The edges of the terminal plates are composed of broad areas of gilt imitation chip-carved six-strand interlace. Only one side of the pinhead is intact, bearing a spiral and narrow trumpet scrolls. The short and other long side are damaged. The pseudo-terminals are linked by three bars, the two outer bearing hemispherical amber studs, the middle being a panel of interlace, now damaged. Where the ring joins the pseudo-terminals, and at the corners of the pinhead, are similar amber studs. The raised areas of the terminals and pinhead were cast hollow and filled with lead or lead-alloy. The voids on the terminals are covered by silver plates with cross-and-circle decoration of billeted lines. That on the pinhead is plain. The filigree was slipped into place before the lead-alloy filling. The three motifs are similar squares with loops on the corners and circles of beaded wire in the centre and at the sides. They are executed in beaded wire soldered to foil: the backing material has been pushed up from behind to simulate granules. The pin shank is made of a strip of silver, flattened and expanded near the point but round on its upper part. The loop is a strip of silver with the edges hammered up into high flanges. The pin, loop and pinhead are riveted together.

Known for a long time as the 'Tipperary' brooch, it is now known to have been found near Loughmoe. Its raised pseudo-terminals and marginal interlace link it to the British Museum brooch said to have been found at Tara (no.77). The D-sectioned ring relates it to the bossed silver penannulars of the later ninth century. Its limited filigree is close in style and technique to that of the Roscrea brooch (no.79) which shares the lavish use of amber and other formal characteristics. MR

BIBLIOGRAPHY Smith 1914, 239; Armstrong 1915, 294; Raftery (ed.) 1941, 147; Whitfield 1987, 76–7, 82; Ó Floinn forthcoming

79 Annular brooch (col. illus. p. 84)

Said to have been found in the neighbourhood of Roscrea, Co. Tipperary
Silver, gold, amber; pin L. 18 cm, ring max. DIAM. 8.62 cm, WT 122.84 g
Irish, 9th century
NMI P.737, Petrie Collection

Made of cast silver with gold filigree and amber ornaments and engraved motifs. The principal decorative features are the frills of projecting semicircular settings along the ring and pinhead, used alternately for amber and coarse filigree; the strange, stylised tube-like animals along the margins of the pinhead and pseudo-terminals; and the crude filigree decorations of the raised panels of the ring and head of the pin.

Typologically, it can be argued that the frills represent a development of small projecting panels on other eighth- and ninth-century annular brooches. The animal patterns are comparable in some respects with marginal beasts on other ninth-century annulars. On the reverse are two engraved animal heads, one on each side where the ring and terminals meet. They are probably related to similar engraved beast heads on some bossed silver penannulars of the later ninth and tenth centuries, as is the form of the plain, plano-convex ring. The workmanship of the filigree is of interest: it is coarse and attempts to achieve in a simpler way effects copied from more sophisticated work. For example, instead of employing granules of gold surrounded by collars of beaded wire as on earlier work, the

pewter blocks in the hollow terminal backs would have increased the weight and apparent value of this silver brooch. They are found on other contemporary brooches including the 'Tipperary' brooch (no.78) with which this example shares stylistic features, notably the raised terminals. SY

BIBLIOGRAPHY Smith 1914, 239, 248, pl. XXVI, no. 7

78 Annular brooch (col. illus. p. 83)

Loughmoe, Co. Tipperary. Found in 1842
Silver, gilt, gold, amber, ?lead; pin L. 24.3 cm, ring max. DIAM. 11.55 cm, WT 286.6 g
Irish, 9th century
NMI I7.W.42

This brooch follows the classic pattern of the developed Irish annular brooch; the pinhead matches the design of the pseudo-terminals

smith raised small bosses on the surface of the backing foil to simulate its appearance – clearly seen on the right-hand pseudo-terminal panel. On the filigree of the pinhead the craftsman produces the effect of plaiting by laying twisted strips of gold side by side. It is probable that the Roscrea brooch belongs to the mid- or later ninth century. MR

EXHIBITIONS *Treasures of Early Irish Art* 1977, no. 46; *Treasures of Ireland* 1983, no. 62

BIBLIOGRAPHY Ryan 1982

80 Annular brooch *(col. illus. p. 85)*

Killamery, Co. Kilkenny. Found by a labourer in 1858
Silver, partly gilt, glass; ring DIAM. 12.63 cm, pin L. 31.17 cm, WT 484.69 g
Irish, 9th century
NMI R.165

Made of cast silver, the brooch has most of the characteristics familiar on ninth-century versions of the type. The gap between the pseudo-terminals is bridged by two plain studs and a bar with imitation chip-carved ornament. Animals with tubular bodies decorate the inner and outer margins of the pseudo-terminals, their joints indicated by spiral and 'brambled' bosses. Details are picked out in gilding. The square pinhead has a pair of similar stylised beasts forming its edge. Their rumps and shoulder-joints are indicated by pointed ovals with ambiguous designs, which can be interpreted as either human face-masks or animal snouts. Sunken lozenge-shaped panels in the pseudo-terminals and pinhead carry filigree ornaments on sheets of gold foil. They are simple whirligig devices consisting of a central repoussé nest containing gold granules within a ring of twisted wires from which radiate lines terminating in cones of twisted wires, each capped by a granule of gold, the whole design framed in a border of twisted wire. Slight variations in the panels exist: that on the left-hand pseudo-terminal has a matt appearance which may have resulted from the partial flooding of the wires and foil with solder during manufacture. The foil is secured by 'stitching'. The hoop is oval in section, and where it joins the terminal plate on each side there is a round glass stud in a raised setting with a four-lobed inlaid silver knot. The pin shows evidence of much wear and damage, having been repaired a number of times. The shank is secured in a half socket projecting from the pinhead and narrows slightly for the upper third of its length before expanding to accommodate a thin, lozenge-shaped slit on each face, below which it again tapers gradually to a blunt point. Incised ornament, now much worn, occurs along the front.

On the reverse are two animal heads with open jaws in low relief, one on each side where the hoop and terminal plate meet. Two magnificent panels, each with a cast and engraved squatting dog-like beast, are the chief ornaments. With backturned heads, the beasts are shown biting their own tails. The foreleg of each is raised up in front of the face, and the ears are indicated by triquetra knots, while a further knot occurs between the hind leg and the belly. The body and limbs are heavily hatched and joints are indicated by

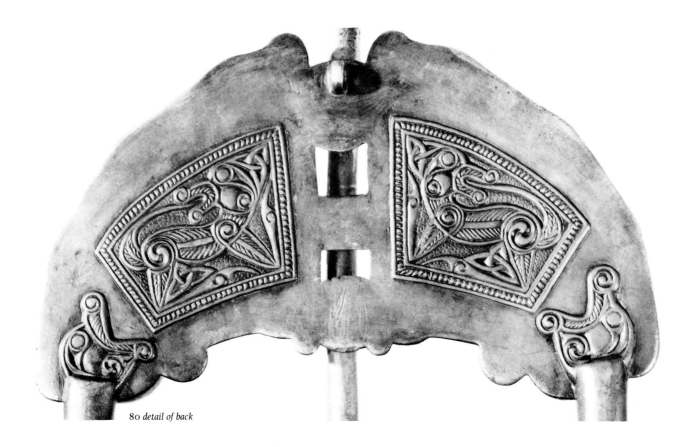

80 detail of back

spirals. The border is billeted in imitation of rope-moulding. At the centre of the outer edge of the brooch there is a loop for a thong. On the surface of the silver, near the inner margin, is a faint scratched inscription which has been read as *Or ar Chiarmac* ('Pray for Cormac'). It may have been the name of a former owner of the brooch. MR

EXHIBITIONS *Treasures of Early Irish Art* 1977, 47; *Treasures of Ireland* 1983, no. 63

BIBLIOGRAPHY Anon 1858–9, 242–50; Coffey 1909, 27; Smith 1914, 240; Raftery (ed.) 1941, 142, 147; Henry 1965a, 112; Graham-Campbell 1972, 115–17, 120; Lucas 1973, 96, 143

81 Annular brooch (*col. illus. p. 86*)

Ardagh, Co. Limerick
Silver, partly gilt, ?lead core; pin L. 26.6 cm, w. across terminals 11 cm, WT 227.8 g
Irish, 9th century
NMI 1874:102

Annular brooch with openwork marginal animals and sunken settings for decorative inserts, now missing. The marginal animals are elongated beasts with tubular bodies. Those on the outer margin are shown with open jaws, tongue and fangs, and their crests, or lappets, are extended to form decorative scrolls in the gap between the pseudo-terminals. Their joints are emphasised by spiral relief bosses. The beasts of the inner margin have closed jaws and their crests are used in the same manner. Their joints are marked by brambled bosses which are clearly intended to substitute for the enamelled studs with gold granules of eighth-century work. The pinhead is square with a raised central area in which there is a sunken panel; this is surrounded by lobed forms in openwork connected by oval and round bosses with simple faceted ornament on them. Round settings on the terminals and pinheads have been incorrectly described as containing traces of red enamel. In fact they are filled with a paste made of a whitish base with black particles in suspension, similar to the backing in the terminal. These settings may have contained thin amber sheets, glued in place in the manner of those on the studs of the handle-escutcheon of the Ardagh silver chalice. The shank of the pin has two sunken pointed-oval panels with simple imitation chip-carving on the front and a plain sunken panel on the back. On the back of the pseudo-terminals are two slightly convex silver plates divided by cruciform gilt rope-mouldings originating in circles.

It has been argued that the brambled bosses are an important component in the development of ninth-century brooch styles and may have contributed to the appearance of the 'thistle' brooch. The absence of enamels and glass is also noteworthy. Part of the Ardagh hoard (see no. 76), this group of objects, ranging in date from the eighth to the early tenth centuries, was probably concealed in the tenth century.

This brooch, along with no. 76, is important in showing the emergence of traits which became prominent on the bossed pennannulars of the ninth century. MR

EXHIBITIONS *Treasures of Early Irish Art* 1977, no. 48; *Treasures of Ireland* 1983, no. 51e

BIBLIOGRAPHY Coffey 1909, 37, 40–1; Raftery (ed.) 1941, 142

82 Bossed penannular brooch

Drimnagh, Co. Roscommon. Found in a bog at a depth of 1.2 m
Silver; ring DIAM. 9.19 cm, terminals max. w. 4.4 cm, pin L. 16.2 cm, WT 123.05 g
Irish, later 9th–earlier 10th century
NMI 1931:14

Of hammered, chased and engraved silver, the brooch's terminals bear single bosses bounded by an inner imitation beaded border and an outer billeted one. The terminal margins take the form of stylised beasts with a stippled background. The animals' cheeks are also stippled. The hoop ends on either side in an animal head which appears to bite the terminals. The pin is round for most of its length but its lower portion is quadrangular. The pinhead, which is cylindrical with an engraved medial moulding, is bent over the ring and pinned to the shank. For discussion see no. 89. MR

EXHIBITIONS *Gold aus Irland* 1981, no. 62; *Irish Gold* 1988, no. 70

BIBLIOGRAPHY Anon. 1928, 166; Johansen 1973, 121

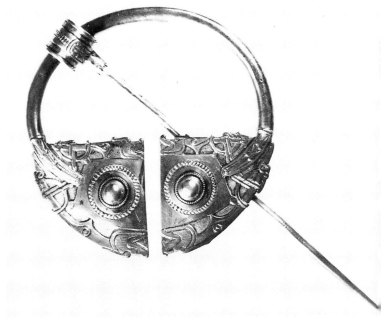

82

83 Penannular brooch (col. illus. p. 87)

Loughan, Co. Derry. Found in 1855 at ancient ford on river Bann
Gold; pin L. (now) 10 cm, max. w. of terminals 5.2 cm, WT 72.2 g
Irish, 9th century
NMI 1878: 29

The only Irish brooch of early medieval date made entirely of gold.
The terminals, front and back, are decorated with animal motifs.
Those on the front project in openwork from the outer edge. Along
the inner edge and the edges of the gap are beautifully modelled
birds. Two further animals cast in imitation chip-carving occur in
panels on the terminals. The central motif on the front is a pair of
stamped knotwork designs on foil set in a triangular raised area
with a 'brambled' boss at each angle. The decorated areas and parts
of the animal motifs are emphasised by dotting. The reverse of each
terminal bears a cast motif of pairs of simplified, almost abstract,
bird-like animals in relief against a background textured by ring-
punching. The pin is simply looped over the ring. The shank of the
pin is beaten from a bar: it is round, but the head is flattened and

carries a broad panel which is sunken and decorated with simple
filigree scrolls of beaded wire in a border of twisted wires. The lower
part of the pin is also flattened and is decorated with an elegant
design of intertwined, stylised birds standing in reserve against a
stippled background. Some of the details of the birds' eyes, bills,
wings and wing joints are faintly incised.

This is a work of great delicacy and refinement which can be
appreciated only by careful study. Fancifully associated in the past
with the ancient tribe, the Dál Riada, it is now known to have been
found in an area outside the boundaries of their territory. Like the
Ervey brooch (no. 86), it represents an Irish response to the fashion
for penannular brooches which remained vigorous in Scotland
throughout the period. The metal bosses and openwork animals
along the margins were to become important components of the
silver bossed brooches of the later ninth and tenth centuries. MR

EXHIBITION *Gold aus Irland* 1981, no. 60; *Irish Gold* 1988, no. 67

BIBLIOGRAPHY Smith 1914, 233, 248; Raftery (ed.) 1941, 147–8; Warner
1973–4, 58–60, 66; Graham-Campbell 1973–4, 52–5

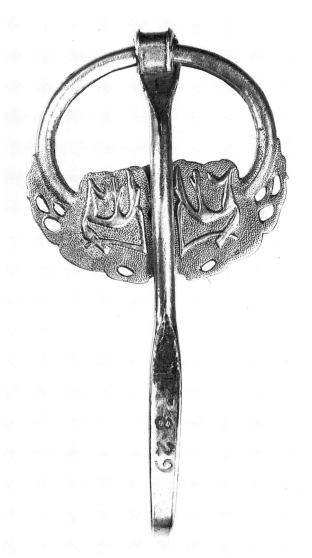

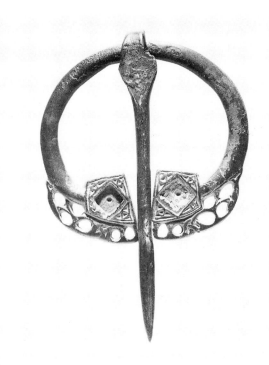

84

84 Penannular brooch

Killucan, Co. Westmeath. Found in peat bog
Copper-alloy, max. DIAM. 5.9 cm, pin L. 8.6 cm
Irish, 9th century
BM, MLA 1906,2–10,4

The brooch is cast in low relief with a plain, almost flat, hoop and
subrectangular terminals edged by an openwork border of now
indistinct interlacing animal ornament. Each terminal has a
recessed lozenge for a setting framed by four triquetra knots and
now empty. The backs are plain. The pin has a simple integral hook,
and the shank was worked up from a small bar or thick sheet and

83 *back*

has a central seam and tool marks. Solder for a decorative plate remains on the lozenge-shaped head.

The piece is a poor-quality version of a type related to the gold Loughan brooch (no. 83) and the silver examples from Ardagh and Killamery (nos 80, 81), a reflection of lower status and a common fashion. SY

BIBLIOGRAPHY Smith 1906–7, 66–8, fig. 5; Smith 1914, 238, fig. 11; Graham-Campbell 1973–4, 52–4; Lewis 1982, 154

85 Penannular brooch (col. illus. p. 86)

Ballynaglogh, Co. Antrim. Found c.1910 in a bog, reputedly at a depth of c.6 m
Silver, partly gilt, amber, glass, modern copper-alloy additions; pin L. 13.9 cm, ring DIAM. 8.3 cm, WT 96.85 g
Pictish, late 8th–early 9th century
NMI 1930: 495

Silver penannular brooch, partly gilt, the back plain. The pin is circular in cross-section, hammered flat to produce lozenge-shaped swellings towards the point. The pinhead is flattened and bent into an open loop with flanged sides, the front decorated with an engraved herringbone pattern. The hoop of the ring is rectangular in cross-section, with a plain mid-rib flanked by cable patterned borders. In the centre of the hoop is an elongated panel with rounded ends: within is a central setting containing an amber stud flanked by ribbon interlace, badly laid out. The terminals are roughly square with raised cusps where they join the hoop. Each bears a central setting with an amber stud surrounded by four outward-pointing beaked animal heads seen in plan, their eyes set with small beads of green glass, some of which are missing. The cruciform space between is filled with poorly executed ribbon interlace, as are the lunate panels between the terminals and the cusps. The brooch was repaired after discovery by the addition of a copper-alloy bar riveted between the terminals. A second bar was riveted to the back of the hoop.

Wilson (1973, 93) has argued previously that this brooch could have come from the same workshop as the (now lost) brooch from Banchory, Scotland, and another from Hålen in Norway, so close are their dimensions and ornament. Viewed from above, the stylised animal heads found on these brooches contrast with those on contemporary Irish brooches such as that from Co. Cavan (no. 73). RÓF

BIBLIOGRAPHY Mahr 1932, pl. 20, 2; Raftery (ed.) 1941, 132; Wilson 1973, 82, 93, 99 and pl. XXXIXb

86 Penannular brooch (col. illus. p. 88)

Ervey Crannog, Ervey Lough, Co. Meath. Found in 1958 on surface of crannog along with three pins of early medieval type
Silver, gilt, glass; pin L. 7.75 cm, ring W. 3.8 cm, WT 15.5 g
Irish, 9th century
NMI 1958:70

This small penannular brooch has disc-shaped terminals, each of which carries a brown glass stud in a setting with cast gilt imitation rope-moulding. Behind each is a cusped recess, the base of which is decorated with a mesh design in a similar technique. The edges of

the terminals are bordered by a rope-moulding. The ring is D-shaped in cross-section. On the front diametrically opposite the gap is a keystone-shaped panel with prominent lip. Its base also bears a cast pattern in imitation of beaded filigree wires. On the reverse there is a compass-drawn marigold on each terminal. Behind the keystone panel the projection of the ring is outlined by a border of dotting. The pin is beaten from a rod of silver. The loop is a lentoid expansion bent over the ring. The pin carries an elongated sunken area, like the pinhead, decorated with cast beading. MR

EXHIBITIONS Gold aus Irland 1981, no. 58; Irish Gold 1988, no. 65

BIBLIOGRAPHY NMI 1960, 35; Rynne 1965, 104; Wilson 1973, 84, 130

87 Annular brooch

Scattery Island (Inis Cathaig), Co. Clare
Silver, gilt; max. DIAM. 4.7 cm, WT 19.09 g
Irish, mid–late 9th century
BM, MLA 1872,5–20,14, Purnell Collection

Plain hoop of oval section cast with subrectangular terminals which are linked by a narrow bar with two lines of hatched ornament. Each terminal has, on the front, a deep circular setting, now empty,

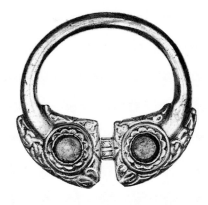

87 front

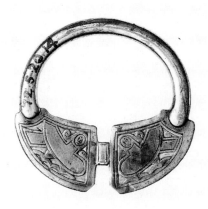

87 back

framed by a scalloped collar and edged by animal interlace. The back of each has a chunky bird with curled crest and a pair of two-clawed feet, all set in a frame. The body, head and tail are emphasised by an inner line. Worn gilding remains all over the decorated surfaces on the front and runs on to the end of the hoop, and gilding remains in the recessed background of the birds in their panels. The pin is missing and the outer corners of the terminals are cut away and the linking bar cut through at one side.

This brooch is one of two (see no. 88) found in 1836 near St Senan's Abbey. A very similar example comes from Donegal (BM, MLA 1893,6–18,25). The Scattery provenances, dating and significance of the group were established by Graham-Campbell (1972). The increased availability and hence use of silver and the development of new styles in the metal characterise the changes in Irish brooch styles in the ninth century under the influence of Anglo-Carolingian art, seen here in the marginal animals and birds. The elusive ancestry of the bird may be connected with the two-footed, crested birds in profile inhabiting a Q initial in a late eighth-century gospel book (Alexander 1978, no. 34). This brooch, along with no. 88, is an outlier of two groups which appear to be restricted to the northern part of Ireland and perhaps represent regional styles.

SY

BIBLIOGRAPHY Smith 1914, 248–9, pl. XXVI, 4; Graham-Campbell 1972, 117 ff., pl. 19

88 Annular brooch

Scattery Island (Inis Cathaig), Co. Clare. Found near St Senan's Abbey with no. 87
Silver; hoop max. DIAM. 4.0 cm, pinhead L. 2.1 cm, WT 27.56 g
Irish, mid–late 9th century
BM, MLA 1872,5–20,15, Purnell Collection

Plain hoop of almost circular cross-section, with subtriangular terminals each bearing cast decoration of four raised circular brambled bosses in plain collars with ribbed spandrels in between. A plain bridge links the terminals. Crouched animals with large oval eyes confront each other across the gap, their billeted hindquarters terminating in scrolled legs. On the back of each terminal are two

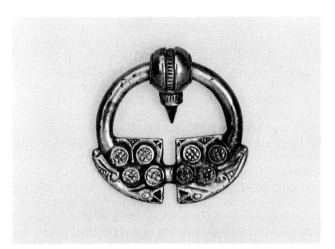

88

crudely incised concentric circles with punched dots between. The pinhead, which prefigures a type found on the great thistle brooches of the tenth century, is spherical and cast in one around the hoop; decoration consists of a median row of recessed billets and a matching collar above a short conical tenon, which would have originally been soldered on to a separate pin shank, another feature of later brooches.

This brooch marks an important stage in the development of new native Irish styles in silver that culminated in the massive bossed and thistle brooches of the late ninth and tenth centuries. SY

BIBLIOGRAPHY Smith 1914, 240, fig. 13, 248; Graham-Campbell 1972, 120 ff., pl. 19

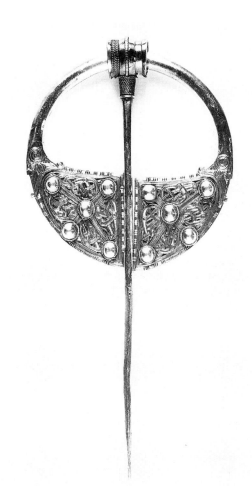

89

89 Bossed penannular brooch

Ballyspellan, Co. Kilkenny. One of three found together, two of which are no longer traceable
Silver; ring DIAM. 11.49 cm, pin L. 25.28 cm, WT 306.29 g
Irish, late 9th–early 10th century
NMI R.89, Royal Dublin Society Collection

Made of hammered silver; the sunken area of each terminal has set into it a complex openwork panel of four animal designs separated by grooved bands which connect four domed bosses. Each boss is

set in a ring of ribbed wire and is riveted to the body of the brooch, thus holding the openwork decoration in place. A deeply incised animal head, shown biting the terminal, ends the ring on each side. The upper half of the pin is round, the lower half quadrangular in section. The pin is fitted into a projecting socket in the pinhead, which is barrel-shaped and folded from a ridged sheet of silver. It is bound by a beaded wire loop, the ends of which are secured by a tight binding of twisted wire around the pin socket. One side of the pinhead has a further binding of five turns of the same wire and another such may have existed on the other side. The back of the brooch is plain, but scratched on its surface are four names in Irish ogham writing: CNAEMSECH CELLACH; MINODOR MUAD; MAELMAIRE; MAELUADAIG MAELMAIRE. It has been suggested that they were the names of former owners of the brooch.

Decorated in a mixture of Irish and Anglo-Saxon traditions, this is one of the finest examples of a late penannular brooch. The type, characterised by the bosses, was current in various versions in Ireland and northern Britain in the late ninth and early tenth centuries. In Ireland they seem to represent the final stage of the manufacture of elaborately decorated annular brooches. The Ballyspellan brooch does not, however, indicate a true return to the locking penannular form because its pin cannot pass through the gap between the terminals. The lavish use of silver in their production is due to the relative abundance of that metal as a result of Viking commerce, and fragments of these brooches have been found in early tenth-century silver hoards in both Ireland and northern England. Fragments of finished and unfinished brooches were found in the Cuerdale hoard, Lancashire, deposited *c.* AD 905. MR

EXHIBITION *Treasures of Ireland* 1983, no. 66

BIBLIOGRAPHY Johansen 1973, 74, 78, 82–3, 86–9

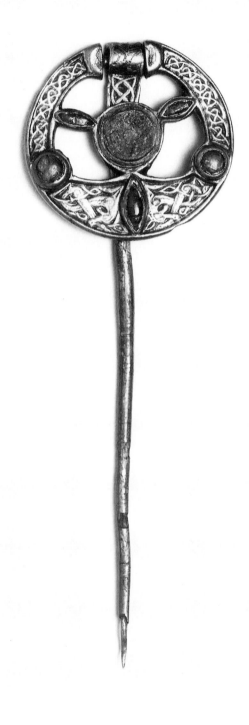

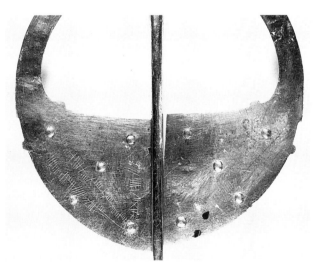

89 detail of back

90

90 Brooch-pin

Dunipace, Stirlingshire, Scotland
Silver, gilt, amber; ring DIAM. 3.4 cm, pin L. 11.3 cm, WT 19.3 g
Irish, 8th century
NMS FC10, Bell Collection

A brooch-pin of silver gilt, ornamented with interlaced and zoomorphic patterns and set with amber. Although the decoration on the hoop gives the appearance of a penannular form, the 'terminals' are blocked by a pointed oval setting of amber. The pin is fixed around a recess at the top of the decorative ring so that it is hinged but does not move freely around the ring. On the back of the brooch there is some lightly incised and incomplete interlace decoration on the arched hook of the pinhead.

This brooch-pin is important for two reasons: it is of silver, whereas most brooch-pins are of copper-alloy; it is one of only two examples with a secure Scottish provenance. Two other brooch-pins of unknown provenance were acquired in Scotland in the last century (Wilson 1863, pl. XVIII).

The occurrence of animal ornament on the terminals is unusual, ribbon interlace being the usual decorative motif. As is the case with other contemporary objects such as the Monymusk reliquary (no. 129) and the bell-shrine crest from Killua Castle (no. 137), incised ornament is confined to the back. RMS/RÓF

BIBLIOGRAPHY Wilson 1863, 277, 311–13, and figs 159, 173; *PSAS*, 8 (1868–70), 307–8; Anderson 1881, 24–5; Grieg 1940, 188–9, and fig. 90

91 Brooch-pin

Grousehall, Co. Donegal. Found in a bog at a depth of 1.2 m
Copper-alloy, amber; pin L. 12.7 cm, ring W. 3.7 cm
Irish, 8th–9th century
NMI 1931:16

The shank of the pin is of circular cross-section and is bent through use. It is flattened at the head and is bent over to form a loop. The loop is decorated with a pair of converging incised lines. The pin swivels on a hinge-bar set between raised buffers. The ring is oval and takes the shape of a pair of animal heads grasping a human head in their open jaws. Their eyes are composed of amber studs set in raised collets. The jaws and necks of the animals contain imitation chip-carved decoration set within raised borders. The jaws are hatched as are oval panels set behind each eye. The necks bear simple two-strand interlace. The open centre of the ring is occupied by a triangular device with central amber setting and there are trefoils at the ends of the three radial arms. The back is plain.

This brooch finds no close parallel among the more highly decorated brooches, although the terminals of some Pictish (Wilson 1973, pl. XXXIV, a) and Irish (Ryan and Cahill 1981, 52) brooches sometimes take the form of animal heads with open jaws and this feature is common on bossed penannulars of the ninth century (no. 89). The human head grasped in the jaws of animals occurs in a more elaborate form on the shrine crest from Killua Castle (no. 137), on another brooch-pin from Islandbridge (Armstrong 1921–2, pl. XII, fig. 3, 3). RÓF

BIBLIOGRAPHY Anon. 1929, 176, and pl.; Ó Ríordáin 1934–5, 182, and pl. XXI, 75

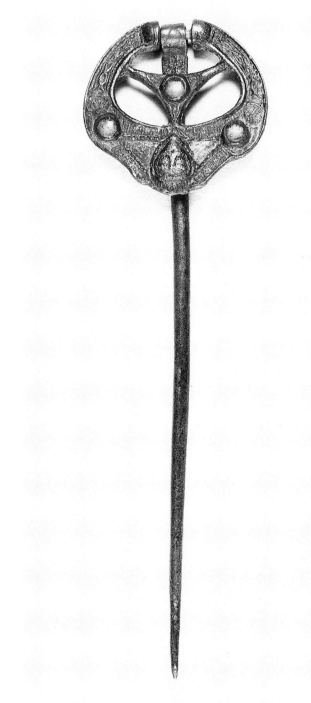

91

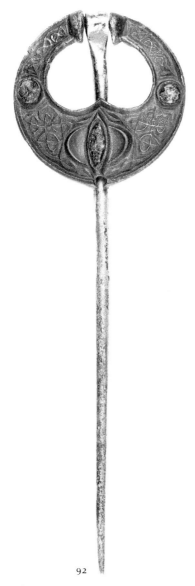

92

92 Brooch-pin

Lagore Crannog, Co. Meath. Found in 19th century
Copper-alloy, set with amber stud; pin L. 12.2 cm, head DIAM. 3.8 cm
Irish. 8th–9th century
NMI W.343

Brooch-pin consisting of a ring which is damaged and a movable
pin. The latter is circular in cross-section, the head hammered flat
and bent into an open loop. The ring has lost the linking bar at the
centre of the hoop; this was flanked by D-shaped buffers which
project on the front and back. The hoop and terminals are flat with
raised edges enclosing a kidney-shaped space. There are circular
settings at the junction of hoop and terminal containing amber
studs. A third stud in a lentoid setting occurs in the centre of the
terminal plate flanked by raised lobes. The entire surface of the front
is filled with interlaced knotwork, and a perforation in the outer
edge of the terminal plate was used to secure the ring to the pin.

This brooch-pin finds its closest parallel among the elaborate

filigreed silver brooch-pins of the eighth century with that from
Westness in Orkney (no. 70). Stevenson (1987, 92) pointed out that
these 'hinged pins' have a hinge-bar such as is found on the West-
ness brooch-pin and that only one, from Dunipace, Stirlingshire
(no. 90), has a certain Scottish provenance. The type is widespread
in Ireland (Armstrong 1921–2, pl. XIII, fig. 2). While the Lagore
example has only a simple rolled-over pinhead, the pinhead of the
brooch-pin from Cormeen, Co. Cavan (Ryan (ed.) 1983, no. 64), is
cast, bow-shaped like that on the Westness brooch. The kidney-
shaped opening in the ring, the fixed pinhead and the provision of
a loop in the base of the ring to secure it to the pin represent a
separate development from the free-moving pins of the 'Tara' and
related type of brooch, which led ultimately to the development of
the kite-brooches of the ninth and tenth centuries. The lobed devices
on either side of the central amber setting are simplifications of a
pattern found on the Cavan brooch (no. 73) and, indeed, on an
annular brooch from Lagore itself found in the nineteenth century
(Hencken 1950–1, fig. 8).

The provenance of the piece is of interest as the running knots
on the hoop and interlaced knotwork on the terminals are directly
comparable with the interlace on the motif piece from Lagore
(no. 153). The provenance is incorrectly given as Oghil Bog, Co.
Kildare, by Armstrong. RÓF

BIBLIOGRAPHY Wilde 1861, 585–6; Armstrong 1921–2, 76, and pl. XII, fig. 2,
no. 5

93 Bossed penannular brooch

Lough Ennell, Co. Westmeath. Found in 1983 on lake bed
Silver; pin L. 14.73 cm, ring DIAM. 5.13 cm, terminal W. 1.94 cm, WT 39.50 g
Irish, later 9th–earlier 10th century
NMI 1984:14

Penannular ring with asymmetrically lobed terminals, each with a
central boss in a beaded setting. The plain D-sectioned ring ends in
stylised animal heads. The terminal edges and settings for the bosses
are bordered by lightly incised double lines filled with fine triangular
nicks. Along the outer edge of each at one point are two lentoids
giving a suggestion of trumpet scrollwork. The animal heads are
reproduced on the reverse in engraving, and the border is outlined
by a fine line. Compass-drawn circles are drawn about the heads of
the rivets holding the bosses in place. The pin is tapering, lozenge-
shaped in cross-section. The pinhead is a flattened hammered exten-
sion with a central vertical moulding bent over the ring.

The simple incised ornament of this brooch is unusual, and the
lentoids are a faint, late echo of the curvilinear ornament of earlier
times. MR

94 Annular brooch

Ireland
Copper-alloy, tinned; pin L. 12.4 cm, ring W. 3.5 cm
Irish, 9th century
NMI 1943:291, Chapman Collection, ex Killua Castle Collection

Brooch consisting of a hoop with decorated terminals and a pin,
both originally tinned front and back. The head of the pin is ham-

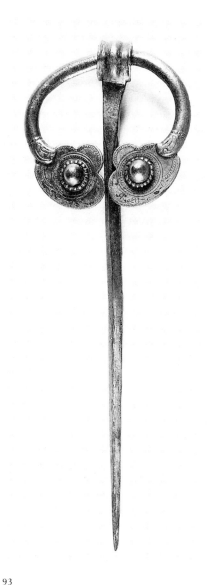

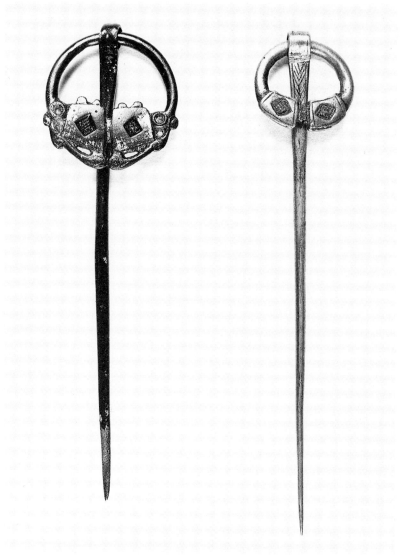

93 94 *left*, 95 *right*

mered flat and looped over the ring. The shank of the pin is round but is flattened along its lower length, which is decorated on the front with a pair of incised lines. The ring is plain and oval in cross-section. There is a circular setting at the junction of the hoop and each terminal. Both contain a wax-like filling but the settings are missing. The terminals are curved trapezoidal in shape with central lozenge-shaped recesses, keyed with cross-hatched grooves, perhaps for a foil inset. At each corner of the terminal is a drilled hole, in one case with traces of an incised circle around it. The terminals are joined by a bar of metal. The outer edges are decorated with simple openwork zoomorphic devices consisting of an almond-shaped eye extending backwards to a pair of scrolls on each terminal.

This brooch is a simpler version of more elaborate brooches with lozenge-shaped recesses in the terminals and marginal animals such as those from Ardagh (no. 81) and Cahercommaun, Co. Clare (Hencken 1938, fig. 11). The tinning would originally have given the appearance of a silver brooch. RÓF

95 Brooch-pin

River Shannon at Killaloe, Co. Clare
Copper-alloy; pin L. 13.1 cm, hoop DIAM. 2.5–2.7 cm, pinhead w. 0.6 cm
Irish, 9th century
NMI 1912:12

Brooch-pin, complete. The pin is circular in cross-section, but the upper portion is hammered flat and decorated on the front with a wedge-shaped, incised herringbone pattern. The pinhead is bent over to form a loop, the junction with the shank decorated with three transverse incised lines and the sides of the loop outlined with incised lines.

The ring is oval in outline. The hoop is plain, D-shaped in cross-section, ending in curved trapezoidal terminals, joined by a flat bar which bears the remains of a perforation along its lower edge. The terminals are slightly faceted and are outlined with incised lines. Each has a central lozenge-shaped sunken panel, the base cross-hatched presumably for a foil inlay. The back is flat and plain.

This is another copy, in miniature, of more elaborate brooches (nos 81, 93). The perforation in the linking bar of the terminals was used to secure the ring to the pin. It may be compared with Graham-Campbell's group G3 brooches, as outlined by Dickinson (1982, 44), which include the Trewhiddle brooch, deposited after AD 868. RÓF

BIBLIOGRAPHY Armstrong 1921–2, 77, and pl. XII, fig. 4, no. 3

96 Ringed pin

Lough Ravel Crannog, Derryhollagh, Co. Antrim
Copper-alloy; L. excl. ring 11.05 cm
Irish, 9th century
UM A107, 1906

The shank of the pin is round-sectioned in its upper part and square in section towards a slightly curving tip. The head is a tightly closed loop with transverse hatching, and a collar on the shank consists of longitudinal hatching framed by transverse mouldings. The ring is a closed single-piece casting consisting of a c-shaped, round-sectioned element which terminates in two identical human heads in the round joined by the ends of their backswept hair. Each has a pointed chin and crescentic profile; the hair sweeps back to end in an upturned curl and is parted centrally and textured with parallel grooves. The nose and brow ridges are defined by pairs of triangular notches and a pointed oval notch defines the mouth. Eyebrows are suggested by hatching on a minute scale and there is no indication of the ears.

Ringed pins are simple dress-fasteners which were current in Ireland in a variety of forms from the seventh to the twelfth centuries. All such pins have a loose ring in a looped or perforated head. This example is exceptional in the fineness of its decoration.

The transverse hatching on the pinhead and the collar of longitudinal hatching on the shank appear to be without parallel among ringed pins. However, hatching occurs in the same relative positions, although on a larger scale, on the pinhead of a brooch from Scattery Island, Co. Clare (no. 88), and vertically hatched collars appear on two of the brooches in the Ardagh, Co. Limerick, hoard (cf. no. 81). All three brooches are of ninth-century date. The 'crescent moon' faces on the ring belong to an enduring type but compare in detail with profile faces in the Book of Mac Regol, an Irish manuscript of the late eighth or early ninth century. Here, as on the pin, the heads appear as detached decorative elements. CB

BIBLIOGRAPHY MacAdam 1856

Pictish metalwork: eighth and ninth centuries (*nos 97–112; see also nos 85, 129, 177–9, 183*)

This is characterised by the frequent use of silver and of distinctive forms and ornament. Brooches persist in the open ring or penannular form with distinctive animal ornament, including three-dimensional applied bird heads, and have simply constructed oval pinheads, in contrast with contemporary Irish brooches. Dotted backgrounds and a particular style of animal decoration are peculiar to Pictish metalwork which has clear links with contemporary Insular art.

The St Ninian's Isle hoard, Shetland (nos 97–107)

The hoard was found in 1958 under a stone slab in the east end of a ruined medieval church. Remains showed the existence of an important early Christian church with a stone shrine. The burial of the hoard probably marks the interruption of this phase of the site by Norse raids c. AD 800. It comprised twenty-eight decorated silver objects and the jawbone of a porpoise placed in a box of larchwood. It is remarkable for the distinctive style of much of the silver which was central to the identification of a larger corpus of Pictish metalwork (see nos 85, 108–12). The silver objects comprise eight bowls (one a hanging-bowl), a spoon and another implement, a sword pommel, two sword chapes, three cone-shaped mounts and twelve penannular brooches. Many of the objects are gilded, and the silver content of most is less than fifty per cent (Small, Thomas and Wilson 1973). SY

97 Bowl (col. illus. p. 153)

St Ninian's Isle, Dunrossness, Shetland
Silver, gilt, copper-alloy, enamel; DIAM. c. 14.3 cm, H. c. 3.6 cm, WT 90.5 g
Pictish, 8th century
NMS FC273

Silver bowl with omphalos. Turning or planishing marks resulting from the formation of the bowl have become obscured. The sides and base of the bowl are decorated with linear geometric and simple interlace patterns executed with punched dots struck from the exterior of the bowl. A subtriangular mount is fixed on to a circular silver plate and hence to the interior of the omphalos with three silver and then two bronze rivets. In each corner of the mount's border is the gilt face of a bearded man. Within the border is a gilt cast setting consisting of a central triangle filled with red enamel surrounded on three sides by panels of open interlace decoration, one of which includes zoomorphic ornament.

It is possible that the mount has been reused from elsewhere, although its technical and artistic construction is in keeping with that of other items in the hoard. There is, therefore, no reason to see this mount as an exotic import. RMS

BIBLIOGRAPHY Wilson 1973, no. 6

98 Bowl

St Ninian's Isle, Dunrossness, Shetland
Silver; DIAM. 14.4 cm, H. 4.7 cm, WT 101.3 g
Pictish, 8th century
NMS FC269

Silver bowl with omphalos. The centring point is visible on the inside of the bowl, but any turning or planishing marks resulting from forming the bowl have been removed. The sides of the bowl have been decorated with a frieze of interlaced animals. The animals were marked out with a hairline scratch before being slightly raised. They were further defined by punched dot stippling which acts as a background to the beasts. The resulting frieze was defined above by a single line of punched dots, and the animals walk on a band of interlocking linear punched ornament. The omphalos is ornamented with linear punch-dot decoration forming a circle, the quadrants of which are marked by a cross and filled with simple linear interlace. All punched decoration has been executed from the outside.

RMS

BIBLIOGRAPHY Wilson 1973, no. 2

99 Cone-shaped mount *(col. illus. p. 153)*

St Ninian's Isle, Dunrossness, Shetland
Silver; H. 4.3 cm; base-ring DIAM 3.7 cm, WT 62.9 g
Pictish, 8th century
NMS FC279

A hollow casting is soldered to the baseplate which is now broken but originally had two slots on either side of its centre. The foot of the cone is surrounded by a beaded wire ring. The side of the cone has been pierced by opposing drilled holes about a third of the way up. A tube made from sheet silver joins the two holes, one end of which can be seen protruding slightly from the surface of the cone. The surface of the cone is decorated with eight animals in a complicated interlace pattern. The decoration is carried out by means of deep engraving, which is occasionally given a three-dimensional effect by moulding. The major lines of the design are formed of two pairs of back-to-back interlaced animals. These are extremely competently executed, and apart from deliberate changes to minor details, such as paws, these four main animals are of similar design.

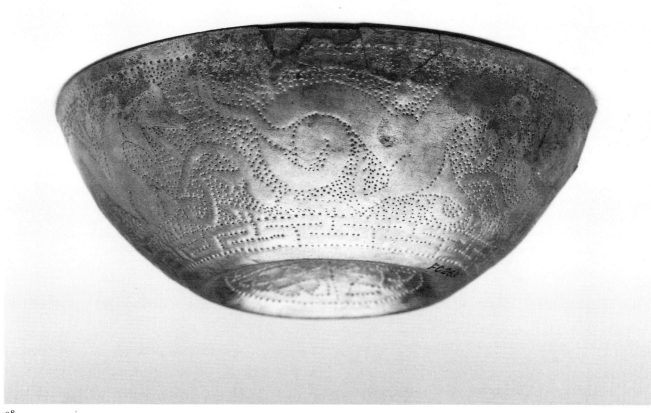

98

This is the largest of three silver-gilt cone-shaped mounts (nos 99–101), the function of which is not established. They were apparently designed to slot on to a strap of some flexible material which could be threaded through the holes in the base. RMS

BIBLIOGRAPHY Wilson 1973, no. 12

100 Cone-shaped mount (col. illus. p. 153)

St Ninian's Isle, Dunrossness, Shetland
Silver, gilt; H. 3.8 cm, base DIAM. 3.4 cm, WT 33.2 g
Pictish, 8th century
NMS FC280

A hollow casting was originally soldered to the accompanying baseplate and the soldered joint covered by a beaded wire ring. The baseplate is pierced by two semicircular slots on either side of its centre. A casting flaw at the top of the cone has been filled with a silver plug inserted from the inside. The cone is pierced near the base by opposing drilled holes made after the object had been decorated. The ornament is executed in two techniques, imitation chip-carving and engraving. There are four main arched fields surmounted by a quadrilateral area of spiral decoration at the peak of the cone. The opposing pairs of arched fields are decorated with ribbon and zoomorphic interlace.

One of three similar mounts (see nos 99, 101). RMS

BIBLIOGRAPHY Wilson 1973, no. 13

101 Cone-shaped mount (col. illus. p. 153)

St Ninian's Isle, Dunrossness, Shetland
Silver, gilt; H. 3.8 cm, base DIAM. 3.5 cm, WT 24.6 g
Pictish, 8th century
NMS FC281

A hollow casting originally soldered to its accompanying baseplate. The beaded wire ring used to cover this joint is still attached to the base of the cone. The baseplate is pierced by two subrectangular slots on either side of its centre, the resulting centre line internally reinforced with a small crossplate. The sides of the cone are pierced by opposing drilled holes made after the object had been decorated. The cone is engraved with a continuous interlocking spiral pattern. The design is based on six main trumpet spirals around the wall which lead into three spirals at the apex of the mount.

One of three similar mounts (see nos 99, 100). RMS

BIBLIOGRAPHY Wilson 1973, no. 14

102 Scabbard chape (col. illus. p. 154)

St Ninian's Isle, Dunrossness, Shetland
Silver, gilt, glass; w. 8.1 cm, WT 62.9 g
Pictish, 8th century
NMS FC282

Silver-gilt U-shaped chape cast in three parts: front and backplates and a binding-strip. The binding-strip is crimped over the crest of the two plates and, along with rivets, holds the chape together and terminates at either end in an animal mask. On the front of the chape the jaws of each of these animals hold a small fish pinched between their free-standing teeth. The eyes of both the animals and

fish were originally set with studs, although only single examples of blue glass in each of these eye studs survive. The reverse of the chape is decorated in a similar manner, although the animal terminals are plainer and do not have as full a muzzle, nor any incisors and fish.

The panels and zoomorphic figures of the chape are further enhanced with decorative engraving. The central panels of the chape have incised inscriptions in cursive minuscules. The front of the chape reads 'INNOMINEDS' and on the reverse 'RESADFILISPUSSCIO'. The first inscription is recognisable as in nomine ds ('in the name of God'). The reverse inscription was read by Jackson as resad fili spusscio, but Michelle Brown proposes a new reading, published in advance of her publication: res ad fili spus scio, contracted sp(irit)us s(an)c(t)io (corrupt), 'property of the son of the holy spirit'. It forms the second half of one inscription beginning 'in the name of God'. Christian invocations were regarded as appropriate to arms and armour, as the similar inscription on an Anglo-Saxon helmet from York shows (Hall 1984, 34–42). RMS

BIBLIOGRAPHY Wilson 1973, no. 14; Jackson in Small, Thomas and Wilson 1973, 167–73

103 Scabbard chape (col. illus. p. 154)

St Ninian's Isle, Dunrossness, Shetland
Silver, gilt, glass; w. 8.2 cm, WT 69.6 g
Pictish, 8th century
NMS FC283

Silver-gilt U-shaped chape cast in two pieces and joined by rivets at the animal-headed terminals. The rivets are finished to be flush with the surface. The snouts of the animal-headed terminals are slightly upturned. Each animal holds its tongue between protruding incisors. The eyes of these animals are set with blue glass, two of which also have red inclusions. The two sides of the chape are decorated with carved spirals and interlace, the interlace on one side being predominantly geometric and on the other zoomorphic. RMS

BIBLIOGRAPHY Wilson 1973, no. 16

104 Penannular brooch (col. illus. p. 155)

St Ninian's Isle, Dunrossness, Shetland
Silver, gilt; hoop DIAM. 10.8 cm, pin (reconstructed) L. 19 cm, hoop WT 149.7 g, pin fragments WT 22.7 g
Pictish, 8th century
NMS FC284

Penannular brooch with expanded subtriangular terminals. The panel at the top of the hoop has a central square setting and there is a central circular setting in each of the terminals. All three settings are now empty. The hoop and terminals of the brooch are divided into a series of panels which are filled with imitation chip-carved interlace. Most prominent of these are the cusps at the junction between the terminals and the hoop of the brooch, and the semicircular panels forming the ends of the cartouche. The curved borders of these particular fields rise 7.9 m above the rest.

The silver pin of this brooch (not illustrated) is now in a number of pieces and has disintegrated towards the point. The face is decorated with a series of chip-carved interlace ribbons. RMS

BIBLIOGRAPHY Wilson 1973, no. 17

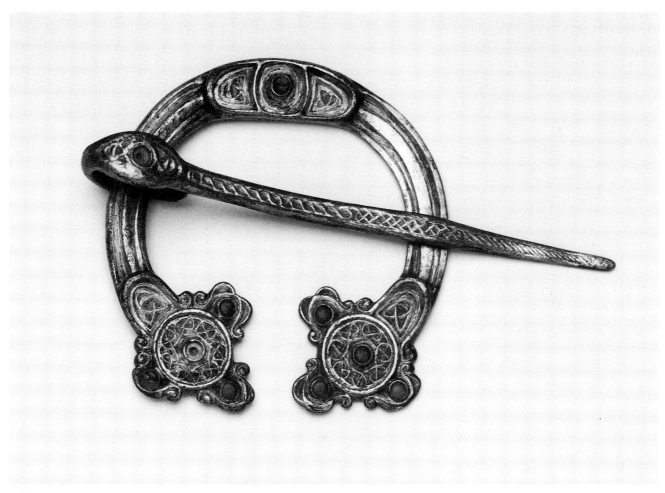

106

105 Penannular brooch (*col. illus. p. 155*)

St Ninian's Isle, Dunrossness, Shetland
Silver, gilt, glass; hoop DIAM. 7.5 cm, pin L. 14.6 cm, WT 69.6 g
Pictish, 8th century
NMS FC286

Cast silver-gilt penannular brooch with squared terminals. It is heavily worn and the gilding survives only in the recessed panels of decoration. The brooch was originally decorated with five studs, one in the panel and one in each of the cusps and terminals, but of these only the glass settings in the terminals survive, the right one being blue and the left brown. There are three further bosses cast as part of the brooch plate within each terminal, which, with the setting in the cusp, are joined by linear decoration to form a cross pattern within the terminal. The remaining fields of the terminals and hoop panel, together with the pin, are decorated with deeply engraved and chip-carved-style interlace patterns. The pinhead is lentoid with a central repoussé boss, which has been divided into quadrants. The hoop has lost much of its gilding and is plain apart from an incised cable-pattern border.

Had the cast bosses on the terminals been drilled out, they too could have formed further settings for studs. RMS

BIBLIOGRAPHY Wilson 1973, no. 19

106 Penannular brooch

St Ninian's Isle, Dunrossness, Shetland
Silver, gilt, glass; hoop DIAM. 7.1 cm, pin L. 11.2 cm, WT 57.9 g
Pictish, 8th century
NMS FC293

Silver-gilt penannular brooch with rounded terminals. Much of the gilding has been worn away. The brooch was originally set with ten studs: one in the panel at the top of the hoop, one in the face of the pinhead and four in each of the terminals. Of these, eight glass studs – seven brown and one green – survive. The main field of the terminal is circular with a central stud surrounded by carved ribbon interlace decoration. From each of these circles project three lobes, each containing a glass stud within a border of simple scrolls. The cusps at the junction between the terminal and hoop are filled with a simple ribbon-interlace pattern as are the semicircular panels of the hoop panel. The hoop is relatively plain with incised margins. The pin has a lentoid head with an empty setting for a stud and engraved ribbon-interlace running down the front. RMS

BIBLIOGRAPHY Wilson 1973, no. 26, pl. XXXV B (misnumbered as C on plate)

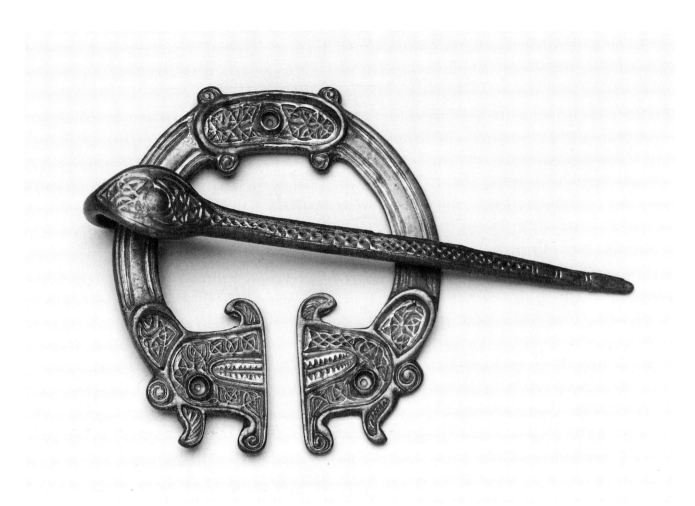

107

107 Penannular brooch

St Ninian's Isle, Dunrossness, Shetland
Silver, gilt; hoop DIAM. 7.1 cm, pin L. 1.2 cm, WT 68.3 g
Pictish, 8th century
NMS FC295

Silver-gilt penannular brooch, with zoomorphic terminals. The brooch was originally mounted with three studs, one in the panel at the top of the hoop and two filling the eyes of beasts portrayed in the terminals. All three of these studs are now missing. The terminals depict beasts with serrated teeth and back-curled lips. Their lips and ears project from the terminal, and there is also a projecting coiled lappet behind each beast's ear. The faces of the beasts are infilled with ribbon interlace decoration, as are the cusps at the junction of the terminals and arms of the hoop, and the panel at the top of hoop. The hoop itself is plain with engraved margins. The pin has a lentoid-shaped head with a central repoussé boss enclosed within ribbon interlace which extends down the face of the pin. RMS

BIBLIOGRAPHY Wilson 1973, no. 28

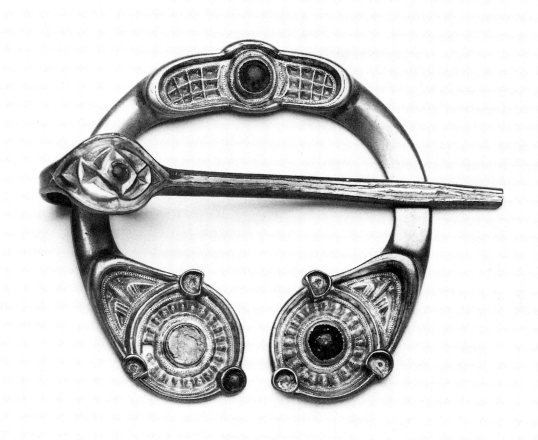

108

108 Penannular brooch

Aldclune, Blair Atholl, Perthshire

Silver, gilt, glass; hoop DIAM. 6.5 cm, broken pin L. 7.7 cm (originally *c.*
 11 cm), WT 32.1 g

Pictish, late 8th–early 9th century

NMS FC304

Cast silver penannular brooch with rounded terminals. The brooch
is ornamented with studs of blue and amber-coloured glass and
panels of gilded, imitation chip-carved decoration. At the centre of
the terminals were circular studs surrounded by radiating chip-
carved and gilded decoration. Of these two studs only the right-
hand one, which is of translucent amber-coloured glass, remains.
Around the studs and radiating decoration are circular mouldings
picked out with double rows of punched dots. On the edge of each
terminal are three D-shaped collets, one of which retains a blue glass
stud. The cusps between the terminals and the arms of the brooch
are also filled with radiating chip-carved and gilded decoration. The

arms themselves are plain, but there is a panel at the top of the
hoop with a central circular stud of amber-coloured glass. This stud
and surrounding ring are supported on either side by fields filled
with a grid pattern of chip-carved and gilded decoration. The reverse
is undecorated and shows marks from the casting. The tip of the
pin is missing. It has a lentoid head with a small central stud of
amber-coloured glass set within a lattice of chip-carved gilt decor-
ation. The back of the pinhead is bent in a hook that can move
freely around the arms of the brooch.

The brooch was found in post-occupation layers during the
archaeological excavation of the southern of two small hillforts at
Aldclune in 1980. The use of fine punch-dot decoration on the
terminals is reminiscent of the *pointillé* work found on some of the
items in the St Ninian's Isle hoard and on the Monymusk reliquary
(nos 97, 98, 129). RMS

BIBLIOGRAPHY Triscott 1980, 82–3; Stevenson 1985, 233–9

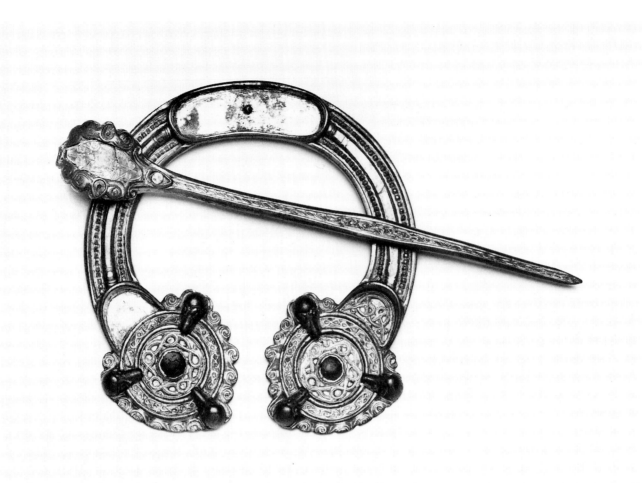

109

109 Penannular brooch

Near Clunie Castle, Dunkeld, Perthshire
Silver, gold filigree, glass; hoop DIAM. 8.2 cm, pin L. 13.9 cm, WT 111.3 g
Pictish, 8th–9th century
NMS FC177

Silver-gilt penannular brooch with expanded rounded terminals. The panel on the hoop and one of the cusps are empty, their filigree gold insets having been removed and melted down in the nineteenth century. The ring of the brooch is decorated with two rows of beading set in sunken gilt panels and separated by a raised semi-cylindrical band. The surviving tray of lightly beaded gold filigree work in the right-hand cusp consists of two interlaced serpents. The circular terminals have a chased border of s-scrolls into which are set three inward-facing animal heads. The muzzles of these animals project towards the centre of the terminal, dividing the next circuit of interlace decoration into three. There is then a complete ring of interlace decoration around a central boss of red glass. This glass

boss is mounted on or covers a rivet which can be seen on the back of the brooch. Each of the inner fields of filigree decoration is executed in beaded gold wire and set on trays of gold sheet. The stem of the pin is decorated with a cast interlace pattern similar to that used on the terminals. The lentoid face of the pinhead is decorated with a chased border and a central panel of filigree goldwork (now damaged). The reverse of the brooch is undecorated and shows casting marks plus the ends of rivets used to secure decorative panels and studs to the front of the brooch.

Although originally recorded as being from 'near Perth', it has recently been demonstrated from manuscript sources that this and the other 'Perth' brooch (no. 110) were found near Clunie Castle, between Blairgowrie and Dunkeld. However, the exact circumstances of the find remain unknown. RMS

BIBLIOGRAPHY Anderson 1879–80a, 449–52; Wilson 1973, 89, 96–9; Stevenson 1985, 236

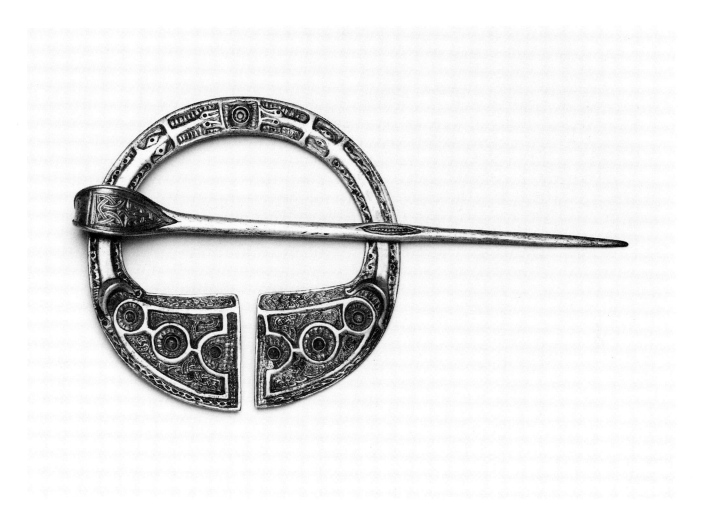

110

110 Penannular brooch

Near Clunie Castle, Dunkeld, Perthshire
Silver; hoop DIAM. 11.6 cm, pin L. 21.8 cm, WT 186.9 g
Pictish, 8th–9th century
NMS FC176

Cast silver penannular brooch with zoomorphic and interlace decoration produced as an integral part of the casting. At the top of the brooch hoop there is a small boss with an empty setting. Facing this boss on either side of the hoop are serpents with semi-cylindrical bodies set against a background of simple scroll decoration. The tails of these serpents form cusps for the terminals of the brooch. The layout of fields on the terminals is defined by raised borders in the casting. There are three settings for studs aligned by the mid-line of the terminal and enclosed within panels of crudely represented ribbon interlace decoration. The three borders of each terminal are filled with different attempts to replicate cable interlace and perhaps twisted wire filigree. Although the layout of the two halves of the brooch are similar, the cast decoration has not been copied from one side to the other with any precision.

The pin moves freely around the ring of the brooch and is decorated with a triangular panel of interlace on the face of the pinhead and some cable decoration at the middle of its shank. The interlace work on the pinhead is more competent than any on the terminals of the brooch and the pin may be a replacement. The reverse of the brooch is undecorated and shows that a casting flaw has been infilled.

Although originally recorded as being from 'near Perth', it has recently been demonstrated from manuscript sources that this and the other 'Perth' brooch (no. 109) were found near Clunie Castle, between Blairgowrie and Dunkeld. However, the exact circumstances of the find remain unknown. RMS

BIBLIOGRAPHY Anderson 1879–80a, 449–52; Wilson 1973, 89, 96–9; Stevenson 1985, 236; Close-Brooks 1986, 163

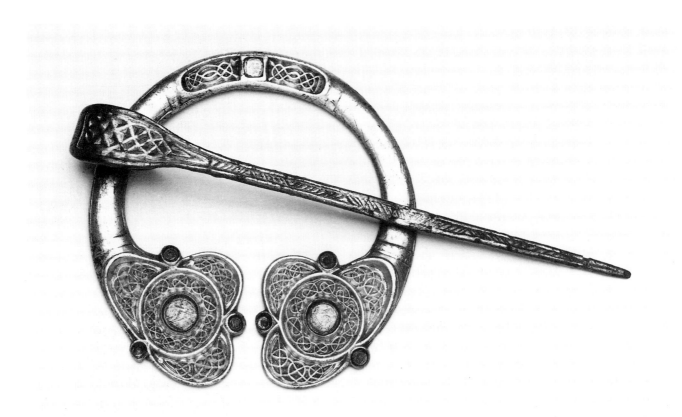

112

111 Penannular brooch (col. illus. p. 156)

Rogart, Sutherland. Part of a large hoard, mostly destroyed, found by
workman during railway construction work in 1868 (see no. 112)
Silver, gilt, glass; hoop DIAM. 12 cm, pin L. 19.3 cm, WT 271.4 g
Pictish, 8th century
NMS FC2

A silver penannular brooch with cast gilt imitation chip-carved
interlace. There are settings for central decorative studs of red glass
in the hoop panel and each of the terminals (one now missing). The
panel and terminals consist of a central circular field divided into
quadrants and flanked by semicircular fields, two for the cartouche
and four to each terminal. The quadrants are decorated with carved
and gilded interlace decoration of alternating pattern, while the
semicircular fields have been filled with bird heads mounted in full
relief. The birds face inward and their broad bills dip into the central
circular discs of decoration. The bird heads were also gilded and
their eyes set with small studs of green glass. The hoop of the brooch
is divided longitudinally and transversely into four fields, each of
which is filled with further carved and gilded interlace. The face of
the pinhead has a central setting surrounded by carved gilt interlace.
The face of the shank is decorated in a similar manner with a very
tight interlace pattern. The reverse of the brooch is undecorated
and shows casting marks and rivet marks.

Bird heads in relief are distinctive features of Pictish metalwork
and a mould for their manufacture was excavated at Birsay, Orkney
(no. 179). RMS

BIBLIOGRAPHY Donations 1870, 304–9; Anderson 1881, 6–10; Wilson
1973, 81–2

112 Penannular brooch

Rogart, Sutherland. Part of a large hoard, mostly destroyed, found by
workman during railway construction work in 1868 (see no. 111)
Silver, gilt; hoop DIAM. 7.7 cm, pin L. 13.3 cm, WT 59.1 g
Pictish, 8th century
NMS FC1

A silver penannular brooch with cast gilt chip-carved interlace
decoration. There are settings for nine decorative studs, a square
one on the hoop and four circular studs on each of the terminals.
All of these settings are empty. Around the large central setting is
a ring of gilt interlace decoration cupped around three panels filled
with similar decoration. The hoop of the brooch is semicircular in
section, with a lightly incised border line and a slightly raised
cross-bar where the terminals and apex panel meet the hoop. The
cartouche is also filled in with gilt interlace on either side of the
empty setting. The front of the pin shank and head have been
decorated with carved interlace over which there are traces of
gilding. RMS

BIBLIOGRAPHY Donations 1870, 304–9; Anderson 1881, 6–10; Wilson
1973, 81–2

Harness, handles and mounts (*nos 113–17*)

Navan harness mounts, Co. Meath (no. 113)

The full extent of this assemblage is unknown and how many of the objects were associated. The mounts were said to have been found in dark soil along with human and animal bones. Contemporary accounts also mention the discovery of horse trappings of silver and iron, buckles, buttons and headstalls which cannot now be identified (Wilde 1849, 1850). Graham-Campbell (1976,60) considers the find to represent a Scandinavian burial. The selection shown here consists of an animal-headed mount and seven decorated plaques.

113 Harness mounts

Near Navan, Co. Meath. Found in July 1848 in railway cutting
Copper-alloy, gilt and tinned, enamel, iron; animal-headed mount DIAM.
9.4 cm; largest plaque L. 6.9 cm
Irish, 8th–9th century
NMI W.143,W.558–64

The mount (W.143) is of complex construction. The animal head is cast and is fitted at the back with a tapering iron tang which fits into a circular slot at the centre of a tinned, copper-alloy disc mounted on an iron backing and held in place by a transverse pin. The disc in turn was secured by three rivets around the edge. The rivet holes are buckled, suggesting that the disc was removed with some force. The animal head is more simply modelled than that of the Donore handle (no. 64). The ears are erect and the eyes are filled with red enamel. The teeth are incised and are continued on to the flat snout where they are shown grasping a human head. The beast head has a solid ring threaded through its jaws to which a short chain composed of a pair of folded-over loops and a ring of copper-alloy are attached.

The plaques are all of cast copper-alloy with traces of gilding. Many have a marked concavity at the back, some in two planes, and all have short loops for attachment to a backing. Of the seven two are almost identical, cruciform in shape with a central circular panel of interlace and the arms formed of single knots. There are three oblong mounts, two with pelta-shaped projections, one of the latter containing a pair of backward-looking animals with spiral hip-joints. The two remaining mounts were designed to engage one with the other. A cruciform mount with a lunate projection fits a concave recess in a rounded mount. The former has a central stud setting surrounded by interlace, with backward-looking animals with hatched bodies and spiral hip-joints in two of the arms and one s-scroll in the other. The curved mount consists of a border of spirals and curvilinear ornament enclosing interlace and spiral work around a central triangular space which contains a backward-looking animal.

The decorated plaques belong to a well-known series of which those from Soma, Norway (no. 114), are the most extensive. It

113

is suggested that they were used as harness mounts and this is strengthened by the presence of a snaffle-bit in the Navan assemblage. Although the shapes of the mounts are similar, the decoration varies considerably between sets. Some of the mounts appear to be cast from the same model and finished by hand. It is interesting that multiple moulds for somewhat similar mounts were found in the excavations at Moynagh Lough Crannog (no. 167) – a site which lies only twenty kilometres north of Navan. The animal ornament has been compared with that on the back of the 'Tara' brooch, and an eighth-century date has been suggested for this and similar mounts. Their occurrence in ninth-century graves in Norway, not adapted as brooches, raises the question as to whether such mounts continued to be made into the ninth century.

Wilde (1861, 611) suggested that the animal-headed mount may have been fixed to a yoke on a chariot, the reins being attached to the plain ring. Certainly the tab on the Killua Castle ring (no. 68) appears to have been fixed to a thin strap, presumably of leather. It is doubtful, however, whether these mountings would have been strong enough for such a purpose. Nevertheless, the Navan association with horse trappings and the decoration on the margins of the Killua Castle piece, which resembles so closely the series of chip-carved harness mounts, does suggest that these animal-headed mounts were related in some way to horse gear. RÓF

BIBLIOGRAPHY Wilde 1849, 114; Wilde 1850, 134–5; Wilde 1861, 573–5, 592–3, 611, 619–20; Coffey 1909, 69–70, and figs 70–1; Armstrong 1922; Mahr 1932, pl. 33; Bøe 1940, 76; Raftery (ed.) 1941, 136; Haseloff 1979, 240, no. 175

114 a–e Harness mounts (col. illus. p. 157)

Soma farm, Høyland, Sandes, Rogaland, Norway; found in woman's grave
 of second half of 9th century
Copper-alloy, gilt, ?amber; (a) 5.4 × 5.2 cm; (b) 4.8 × 3.5 cm;
 (c) 5.1 × 2.6 cm; (d) 5.1 × 2.2 cm; (e) 4.2 × 2.1 cm
Irish, 8th–9th century
Universitetets Oldsaksamling, Oslo c 1950

Cast mounts with gilding, the largest (a) a cruciform strap-distributor with a central setting with fragments of ?amber, and three types of interlace in low relief, each strand with a central groove; b, with three arms, has more sharply faceted interlace, a pair of spirals and a central triskele; c, a symmetrical but damaged I-shape, is dominated by zoomorphic ornament, two panels of elegant interlaced s-shaped beasts and peripheral bird heads. Interlace surrounds a central setting; d, in contrast, is the same I-shape but with an undulating outline and crude interlace and animal decoration; e is incomplete and has a central roundel with paired scrolls divided by ribs. There is a large crescentic panel with triquetras at one end and marginal scrolls and interlace at the other.

These mounts are selected from twenty-two associated with a horse bit; all are damaged. They represent at least two sets of harness mounts, probably bridle fittings, and two have been turned into brooches. The group includes one set of five matching mounts similar in outline to b, indicating multiple production as seen in the moulds for Moynagh Lough (no. 167). All the ornamental motifs are found on contemporary jewellery; mounts c and d in particular recall the Londesborough brooch (no. 71), while the central panels

of a and c carry the designs of stud mounts found on both religious and secular metalwork (see nos 129, 166).

The closest parallels are to be found in the other set of fine harness mounts, found at Gausel in Norway (Wamers 1985, no. 90), which is even more richly decorated. The Navan mounts (no. 113) have many of the same forms and were also associated with an iron bit.

BIBLIOGRAPHY Petersen 1940, 33; Wamers 1985, no. 91 SY

115 Harness mounts (col. illus. p. 158)

Oseberg, Slagen, Sem, Vestfold, Norway
Copper-alloy, gilt; (a) L. 6.7 cm, w. 2.2 cm; (b) L. 5.8 cm
Irish, 9th century
Universitetets Oldsaksamling, Oslo, Oseberg finds 106h and i

Two subrectangular cast gilt-bronze mounts, probably from a horse harness. The ends of a terminate in two oval projections one of which articulates with one of two equivalent recesses in b. The upper surfaces of the mounts are decorated with cast mesh interlace and animal decoration.

Two of a set of four from the ship-burial of a Viking noblewoman at Oseberg, the mounts date to the ninth century. A closely similar piece was found at Markyate, Hertfordshire (no. 116). Along with many other mounts of similar function, they demonstrate both the importance of horsemanship and its accoutrements in Ireland, and its popularity abroad. LW

BIBLIOGRAPHY Grieg 1928, 75, 239 ff.; Petersen 1940, 25; Wamers 1985, no. 116; Haseloff 1987, 52, fig. 11

116 Mount

Markyate, Hertfordshire
Copper-alloy, gilt; L. 6.1 cm
Irish, 8th–9th century
BM, MLA, Loan 13

Heavy casting of a decorative gilded plate with a pair of projecting terminals in the shape of bearded heads, behind which are deep, pierced lugs. The central field has chip-carved-style ornament of

116

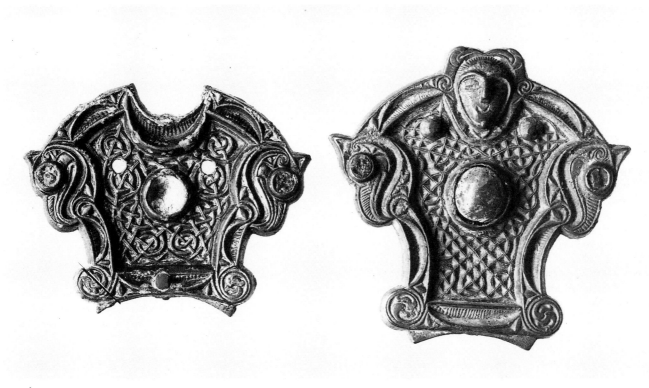

117a, b

two confronted fish, their bodies interlaced in the centre, tails below one head, long hatched jaws below the other. Two central recessed panels are filled with faceted interlace. The edges of the mount along the central plate are bevelled in towards the decoration. There is worn gilding and slight damage to the upper surface.

The recovery of a matching pair of mounts from a Viking burial at Oseberg (no. 115) explains the unusual shape of this piece which must have been one of a series of mounts designed to link one into another, at the same time being attached to leather by sturdy lugs. A similar arrangement is seen on the Crieff mounts (no. 117). The arrangement of pegging the terminal into the recess in a plate suggests that these long mounts were designed to be uncoupled and also as a means of articulating something made from rigid elements. The same distinctive holes for keying are found on Irish harness mounts found in Norway (Mahr 1932, pl. 35, nos 7, 8).

The fishes on this mount are clearly identified by their tails and are very similar to the Oseberg pair. The heads seem to be influenced by the almost ubiquitous bird head with beak. Fish in different decorative traditions decorate a unique early penannular brooch from Bath (Cunliffe 1988, 23, 50) and the openwork mounts from Faversham, but this sinuous type is one found in the trio of fish, beast and bird, the hierarchy of the natural world, depicted on the 'Tara' and Hunterston brooches and the crozier fragment (no. 149). The fish continues to appear on brooches as late as a ninth-century Ardagh brooch (Ryan (ed.) 1983, no. 51d). Interlace panels of the Markyate type are common to almost all insular art of the period. For a discussion of the bearded head see nos 135 and 168 (a mould).
SY

BIBLIOGRAPHY Bruce-Mitford 1964

117a, b Two decorative mounts

Near Crieff, Perthshire
Copper-alloy, gilt, rock-crystal, glass; (FC3) 5.8 × 5.5 cm; (FC4) 4.3 × 5.5 cm
Irish style, 8th century
NMS FC3 and 4

Two gilt-bronze mountings ornamented with human and zoomorphic masks, ribbon interlace work and set with crystal and amber-coloured glass. Both have a central panel of cast low-relief interlace, the centrepiece of which is a setting for a large stud. A hemispherical translucent crystal still fills this position in the larger of the two mountings (FC3). The larger mount also retains two conical-headed red copper-alloy nails which have been inserted into the decorated interlace panel. That there were similar nails inserted into the smaller mounting (FC4) is suggested by the presence of drill holes in a comparable position.

The central decorative panel is surrounded by an elaborate scallop decorated border cast in high relief. The main feature of the border of the larger of the two mounts is a smiling human face-mask which is also cast in high relief. The mask has lenticular eyes, a prominent nose and an out-turned pointed beard. The equivalent position on the smaller of the two mountings is recessed and the gap is further emphasised by a crescentic decoration. The mounts do not, however, fit together. They must represent half of two matching pairs. Both have elaborate eagles' heads cast in profile on either side of the border. The eyes of these eagles have been filled with amber-coloured glass studs of which three survive in a fragmentary condition. A pair of smaller incised bird heads support the human head on the larger mount. The remaining panels of the borders are filled with decorated scalloped crescents and smaller spirals.

A copper-alloy nail similar to those in the central decorative panel of the larger mounting has been inserted through one of the crescents in the lower margin of the smaller mounting. The position of all the copper-alloy studs and related drill holes is not integral with the interlace or margin patterns. This suggests that both plaques have been reused. There are the stumps of what may have been rectangular lugs integral with the casting on the back of the mounts. Such lugs may have been part of their original method of attachment (see no. 116).

The history of these mountings is unknown other than that they were bought in Crieff in the second half of the last century. The position of the human head on the larger of the two mounts is such as to suggest a human or cruciform outline for that mount. If so, the overall effect may be intended to reflect a man in an ornate costume such as ecclesiastical vestments. It has been suggested that the symbolism of the birds identifies the head with that of Christ (Bourke, Fanning and Whitfield 1988, 94–5). These mounts are of exceptional quality with deep faceting and rock-crystal, a rare material employed also on the Derrynaflan strainer (no. 126) and the Ardagh chalice. RMS

BIBLIOGRAPHY Donations 1889, 122–3; Catalogue 1892, 201; Bourke, Fanning and Whitfield 1988, 94–5, pl. XIb

Vessels (nos 118–23; see also nos 32–4, 42, 127)

118 Strainer

Moylarg Crannog, Co. Antrim. Found in 1893 in excavations
Copper-alloy, iron; L. 21.8 cm, bowl 10.7 × 12.5 cm
Irish, 8th–9th century
NMI 1905:181

Strainer consisting of a circular bowl of beaten and polished copper-alloy and a handle of iron. The bowl, which is crumpled and distorted, has a round-bottomed base and a simple out-turned rim. The centre of the base is pierced with a series of drill holes arranged in a decorative pattern. This consists of a series of three triskeles, the ends of the spirals broadening into trumpet patterns. The design was first incised on the surface of the metal and subsequently pierced. The iron handle, which appears to be original, is attached to the bowl by three bronze rivets. It is flat, rectangular in cross-section with hammered-up edges. The sides are slightly convex.

The pierced ornament, combined with an incised pattern, is remi-

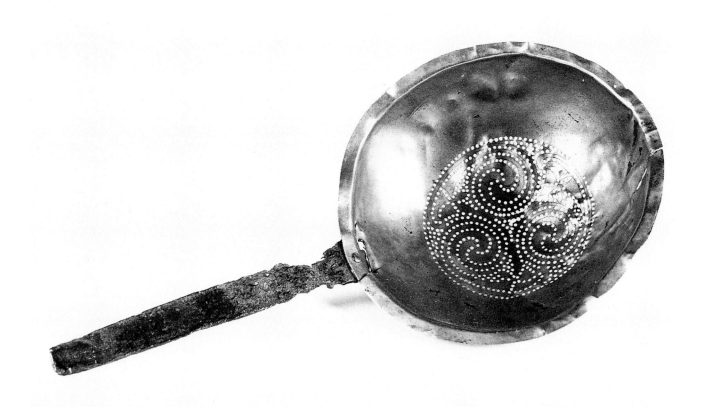

118

niscent of that on the strainer plate from Ballinderry 1 (Hencken 1936, fig. 45E), as well as that on the Derrynaflan strainer (no. 126). The Moylarg strainer is ultimately derived from late Roman skillets with strainer plates such as that from Kyngadale in Wales (Wheeler 1925, fig. 91) rather than from the elegant long-handled strainers of late antique times. RÓF

BIBLIOGRAPHY Buick 1894, 317–19; Lucas 1973, 56, and fig. 38

119 Ornamented bucket *(col. illus. p. 159)*

Clonard, Co. Meath. Found in 1839 during drainage works on the river Kinnegad
Yew, copper-alloy, amber; H. 14.0 cm, rim DIAM. 14.0 cm, base DIAM. 12.0 cm
Irish, 9th century
NMI R.2977;Wk.411

Wooden bucket with applied mountings of copper-alloy. The vessel is carved from a single block of yew with a separate disc of yew added to form the base. The rim is strengthened with an inverted U-shaped binding. The handle is semicircular in shape with a central expansion, U-shaped in section. Its disc-shaped terminals were attached to the attachment plates with rivets, one of the attachments being a later repair. The plates are triangular in shape resembling stylised birds with fan-shaped tails. They are attached to the bucket with three rivets concealed originally behind amber studs, two of which survive. They are decorated with crudely engraved spiral and interlace devices. The attachment plates are backed on the inside of the vessel with thin sheets of copper-alloy, one of which is a later replacement.

The outside of the vessel is covered with a series of four sheets of metal. Three are decorated with poorly executed openwork patterns. The top band contains a row of pierced triangles and dots above a series of hollow circles linked by semicircular loops. The central band is decorated with circles joined with spirals above a diagonal lattice pattern. The lower band bears a further row of triangles and dots above a series of linked s-scrolls. The base is strengthened by a broad, plain L-shaped sheet of copper-alloy.

This is a less elaborate version of the insular series of copper-alloy bound wooden buckets, best exemplified by the example from Birka (no. 120). There are eight complete examples and many fragments of Irish provenance. In contrast to the Birka bucket, which is of Pictish or Northumbrian manufacture with plant and bird motifs, the Irish buckets tend to have engraved or openwork ribbon inter-lace and geometric patterns. Similar openwork devices are found on examples from Derrymullen, Co. Laois (Ryan (ed.) 1983, no. 59), and Annagassen, Co. Louth (Raftery 1956). Such buckets were almost certainly used for domestic purposes – handles have been found on domestic sites at Raheennamadra ringfort, Co. Limerick (Stenberger 1966–7, 46), and at Knowth, Co. Meath. None are known from an ecclesiastical context, although two were found along with a plain hanging-bowl at Derreen, Co. Clare (Raftery 1941), not far from where the decorated basin (no. 123) was discovered, which could be interpreted perhaps as loot from a church site. The small size of these vessels would suggest that they were used for serving liquid in small quantities – perhaps wine. The poor quality of the engraved ornament is found on other objects including

buckles (Wamers 1985, pl. 28, Scharff 1906, 71) and brooch-pins (Raftery 1940, pl. IV, 1).

These insular buckets may be either stave-built or carved from the solid (as in Raftery (ed.) 1941, 151). RÓF

BIBLIOGRAPHY Wilde 1849, 58–9; Carruthers 1856–7, 49; Coffey 1909, 73, and fig. 83; Henry 1947, fig. 29

120 Bucket

Birka, Uppland, Sweden
Copper-alloy, tinned, on birchwood; H. 18.5 cm, max. DIAM. at rim 19.5 cm
Northumbrian, 8th century
Statens Historiska Museum, Stockholm, BJ.507

Bucket consisting of a birchwood body (the base missing), covered with tinned copper-alloy sheets, and cast copper-alloy fittings. The sheets are decorated with three zones of lightly incised ornament on a hatched ground: above, a series of 'Tree of Life' motifs in which spiral-hipped birds inhabit the paired tendrils of vine bushes; in the middle, a procession of similar birds enmeshed in a horizontal vine scroll; below, a running trumpet scroll.

From a rich ninth-century female grave (no. 501) in the cemetery

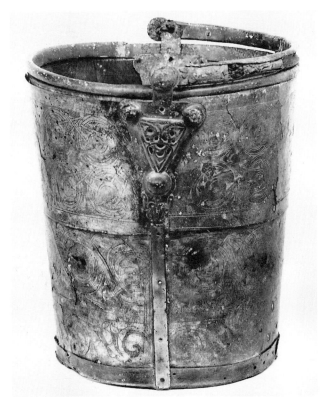

120

of the important Viking trading centre at Birka, Sweden, this bucket is evidently of Insular manufacture. Metal-covered buckets occur both in Ireland (for example, no. 119) and in Northumbria (for example, at Hexham, Bailey 1974, 141–50, pl. XXV), but the vine-scroll decoration of the Birka bucket clearly suggests a Nor-

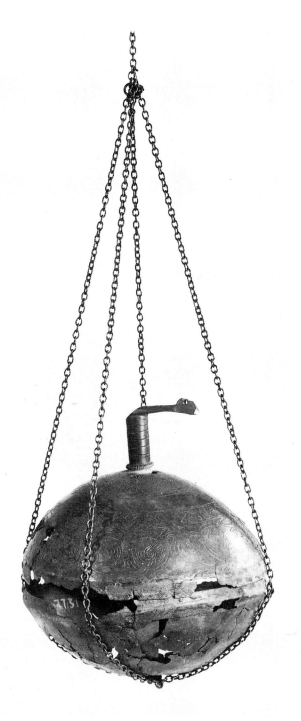

121 *(the suspension chains are modern)*

thumbrian origin (see also no. 121). Its original use is as likely to have been ecclesiastical as secular, and, like the Vinjum sprinkler (no. 121), it could well have originated in a Northumbrian monastery. It exemplifies the close relationship of Irish and Northumbrian art in the seventh and eighth centuries. LW

EXHIBITION *The Vikings*, British Museum, London, 1980

BIBLIOGRAPHY Arbman 1940–3, fig. 94, 10, pl. 204; Bakka 1963, 27–33, fig. 23; Henry 1965a, 188–9, fig. 25, a–b; Wilson 1970, 8–9; Graham-Campbell 1980, no. 318; Bakka 1984, 233–5

121 Sprinkler

Vinjum, Vangen, Aurland, Sogn og Fjordane, Norway
Copper-alloy, ?tin; DIAM. 12 cm
Northumbrian, 8th century
Historisk Museum, University of Bergen, B7713

Copper-alloy sprinkler consisting of a two-part spheroidal body of beaten metal, with delicately incised ornamentation on the tinned upper half and around seven pierced holes on the base. From the top rises an open-ended tube with a solid handle projecting at right angles from the top and terminating in a stylised animal head. The tube is cast separately and soldered to the lid. The decoration on the upper half is in three zones: at the top, a zone of fine trumpet spirals; in the middle, knotted interlace; below, a stylised vine scroll inhabited by animals with spiral hips and gaping jaws.

Found in a Norwegian female grave of the second half of the ninth century, this remarkable object is clearly a product of Viking traffic with the British Isles. Until recently, when a closely similar object was identified in an Anglo-Saxon woman's grave at Swallowcliffe Down, Wiltshire (no. 42), it was thought to be unique. Most scholars had concurred in identifying it as a censer; but a recent study on the Swallowcliffe Down object has convincingly argued that both these objects are designed as water sprinklers for ecclesiastical or possibly domestic use; for a discussion of their operation and usage see no. 42.

This Vinjum sprinkler's ornament, with its elegant procession of interlacing creatures in running scrolls, is clearly to be dated later than the Swallowcliffe Down piece, perhaps by as much as a century. A Northumbrian origin is possible, given the similarity of its processional animal motifs to certain eighth-century Hiberno-Saxon manuscripts (for example, the Lichfield Gospels). In this it recalls the Birka bucket (no. 120), another piece of specialised metalwork which found its way into a Viking grave. In the absence of other like objects the question of origin of form remains uncertain; the Swallowcliffe object may, from its context, represent either Celtic or Mediterranean contacts, with Vinjum as an Insular descendant, through Northumbrian contacts either with Ireland or the Mediterranean. LW

BIBLIOGRAPHY Petersen 1940, 58–9, fig. 63c; Bakka 1963, 33; Wilson 1970; Wamers 1985, no. 67

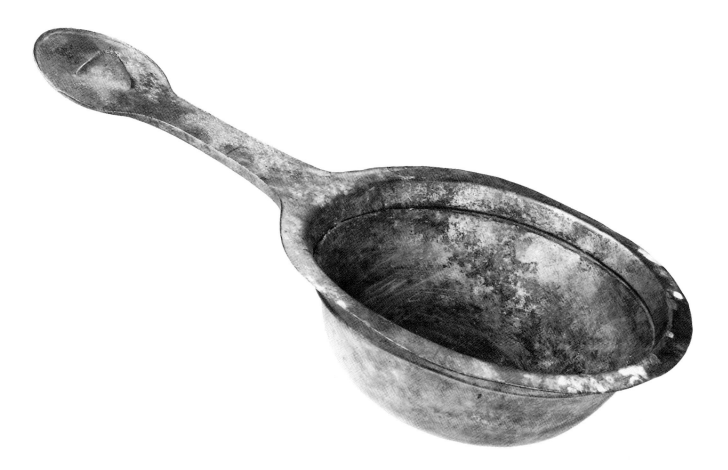

122 Ladle

River Suir at Doornane, Co. Kilkenny. Found *c*. 1954 in sandbank
Copper-alloy; L. 37.5 cm, bowl DIAM. 21 cm, bowl D. 7.0 cm, terminal DIAM.
7.55 cm
Irish, 8th–9th century
NMI 1968:12

Ladle of beaten and polished copper-alloy. It has a circular bowl
with flattened base, the lip turned out to form a broad, flat rim and,
below, a ridge hammered out from the inside. The short handle is
flat with a large circular terminal. The edges of both are flanged. In
the centre of the terminal is a raised pyramidal boss.

Plain ladles, of which over thirty examples are known from
Ireland, Britain and Scandinavian graves, can be divided into two
groups: those with long handles and small bowls and those with
short handles and relatively large bowls. This example belongs to
the latter group, and it is distinguished by the pyramidal boss which
occupies the same position as the crystal setting on the Derrynaflan
strainer. Apart from those found in Scandinavian graves, ladles
have been found on ecclesiastical sites such as Whitby (Peers and
Radford 1943, 66–7) and settlement sites at Iniskea North, Co.
Mayo (Henry 1952, pl. xxvii), and at a ringfort at Lissue, Co. Antrim.
The Iniskea example was found in a hut site associated with *purpura*
shells which Henry suggested were collected for the manufacture
of purple dye. A tinned copper-alloy penannular brooch considered
by Henry to be later seventh or eighth century but now perhaps to
be dated much later in the eighth century was found in the same
structure. RÓF

BIBLIOGRAPHY NMI 1971, 222, and fig. 15

123

123 Basin

Derreen, Co. Clare
Copper-alloy; DIAM. 35–6 cm, H. 16.8 cm
Irish, 8th–9th century
NMI 1960:511

Circular vessel of beaten and spun copper-alloy. The upper edge is folded inwards to produce a sloping rim with a ridge hammered up from the inside immediately below. Further down there is a wide groove, bordered by a ridge on either side. In the centre of the interior of the base there is an incised, compass-drawn marigold device enclosed in a circle. This is encircled by four bands, each consisting of three concentric circles, the outermost occurring at the angle of base and side. The area between the two outer bands is decorated with a radial pattern of short, incised strokes.

An undecorated vessel of similar size and profile was found in a bog at Thomastown, Co. Meath. The ribs on the bowl served a double function as decoration and to strengthen the vessel. There may be more than one, as here, or they may occur singly, as on the Derrynaflan basin (no. 127). The compass-drawn marigold design is not unusual on such vessels. It occurs, for instance, on the hanging-bowls from Ballinderry 1 (Hencken 1936, fig. 4,5E) and Miklebostad in Norway (Rygh 1885, 727), and on the backs of brooches, as on the zoomorphic penannular from Ballinderry 2 (no. 19) or the silver brooches from Ervey (no. 54) and Tara (no. 77), both Co. Meath.

This basin was found in a bog in 1960 at a depth of 1.5m, 'within a few feet' of where a bronze bowl and two decorated wooden buckets were found in 1938 (Raftery 1941). RÓF

BIBLIOGRAPHY NMI 1962, 153, and fig. 8

Church metalwork in the eighth and ninth centuries
by Michael Ryan

The introduction of Christianity to Ireland in the fifth century placed new demands on native craftsmen. In order to celebrate the rites of the Church novel objects were required. These included sacred vessels for the Eucharist: the chalice for the wine and the paten or plate for the Communion bread. Christianity required books, copies of the scriptures and collections of readings for the celebration of the liturgy, together with texts for teaching Latin, the language of the rituals. Lamps, bells, censers, book-covers and bindings all were needed, as well as simpler objects – for example, basins and towels for the ablutions associated with the Mass. The celebrants wore vestments and altars were covered with cloths. All of these demands were for relatively small objects, but Christianity also required special buildings, churches and dwellings for the clergy. Christians had distinct burial preferences and enclosed cemeteries attached to churches became the norm, and the practice of marking graves led in time to a tradition of carved stone memorials.

The first missionaries can have carried only a limited number of liturgical objects with them, although St Patrick is represented by his seventh-century biographer, Tírechán, as bringing across the river Shannon 'fifty bells, fifty patens, fifty chalices, altar-stones, books of the law, books of the Gospels', and leaving them in 'new places' (Bieler 1979, 122–3). The same writer also refers to Assicus, a companion of Patrick, a coppersmith who made altars and covers for patens. The literal truth of these entries for the fifth century does not matter – Tírechán describes objects traditionally thought to be old, and if Assicus was an ecclesiastic then he belonged to a tradition of craftsmen-clerics which was widespread in medieval Europe. Native lay metalworkers must also have been commissioned to work for the Church at an early stage, and they would have brought their distinctive approach to the problems of fabricating church utensils and ornaments based on imported models. Many of the objects mentioned by Tírechán may have been such hybrids.

Although the simplicity of church vessels and furnishings was often used as a metaphor for sanctity, there was a certain standard below which a foundation must not fall. The *Rule of Patrick*, an eighth-century text, states 'For the church which has not its proper equipment is not entitled to the dues of God's church, and it is not a church but its name according to Christ is a den of thieves' (O'Keeffe 1904, 223). Many important churches were equipped with costly liturgical instruments and providing these must have been expensive, although it is difficult to assess the contemporary economic significance of an import-

ant reliquary or piece of altar plate. Costs, including manpower, simply did not have the same meaning as they would have today. Artistic work, especially if carried out by clerics, would have been a form of religious devotion.

By the end of the seventh century the Irish Church had come to be dominated by great monastic foundations, many of them ruled by aristocratic abbots. Later lives of the saints make it clear that monasteries maintained craft workshops (Ryan 1989), and archaeological excavation has revealed evidence for metalworking at, for example, Armagh (Gaskell-Brown and Harper 1984), Nendrum, Co. Down (Lawlor 1925), and Movilla, Co. Down (Yates 1983, Ivens 1984). It is very likely that most religious objects were made in monastic workshops.

Most of what we know about workshop practices must be inferred from the surviving objects. It is, for example, a striking characteristic of the best metalwork of the eighth and ninth centuries that large and complex objects were fabricated as elaborate assemblies of individual components. The Donore handle (no. 64) reproduces the appearance of something which on mainland Europe would have been made by means of a substantial one- or two-piece casting. It seems that the technology available to the craftsman was limited and it was necessary therefore to break down ambitious attempts to copy unfamiliar or large objects into easily manageable stages. Workshops may never have been organised on the quasi-industrial lines suggested by the famous plan of the Carolingian monastery of St Gallen (Schwind 1984, 105–11), a suggestion which is fully in accord with the more informal work areas revealed by excavation. This approach to construction reaches its ultimate complexity in the three great pieces of altar plate made in Ireland in early medieval times – the Ardagh chalice and the Derrynaflan paten (no. 125a) and chalice (no. 124).

It is also likely that precious metals were in short supply in both Ireland and Scotland in the eighth century. Irish texts speak of gold as imported, while silver was used sparingly except on very special prestige objects such as the finest altar vessels and annular brooches. The silver in the Londesborough and St Ninian's Isle brooches is very debased (nos 71, 104–7), while that of the Derrynaflan chalice is about seventy per cent pure. Gemstones are very rare – the rock-crystal in the finial of the handle of the Derrynaflan strainer (no. 126) and that on the underside of the Ardagh chalice and on the Crieff mounts (no. 117) are notable exceptions – and one may suspect that they were imported on other objects and later recycled. The mica identified on the Moylough belt-shrine is unique in Irish metal-

work. Amber is much more frequent, especially on annular brooches of the ninth century. It occurs earlier on the Hunterston (no. 69), Westness (no. 70) and 'Tara' brooches and in very small amounts on the Ardagh chalice. Instead cast studs of inlaid glass and enamel sometimes with inset decorative grilles of metal take the place of jewels.

Techniques designed in the main for the production of multiples seem to have been favoured and decorative components were often cast or stamped. Thus a form or a die could have given rise to many duplicates for use on objects of different type. The bosses which decorate the newly discovered Lough Kinale book-shrine could equally well embellish the arms of a free-standing metal-covered cross. A similar boss – detached from its parent object – was found at Clonmacnoise in the last century (no. 142), and other examples of the same general type were found in Viking-Age contexts in Norway. Fragments of the roof finials of a very large shrine found at Gausel in Norway have their exact counterparts in the well-preserved objects in St Germain (no. 138). Are they from the same shrine or are they cast from the same pattern? There are twelve identical beautifully stamped foils on the Derrynaflan paten and eight of a different pattern on its stand. The Ardagh chalice and Moylough belt-shrine also carry numbers of stamped foils. Exceptional craftsmen used these techniques creatively on great objects, but the same approach could give rise to repetitive and pedestrian products. The surviving sample of objects is small and we have yet to establish mould- or die-siblings on different objects, but they are likely to have occurred. It can be argued that a form of press was needed to achieve the precision and accuracy of the Derrynaflan paten foils, and the bowls of the Ardagh and Derrynaflan chalices were polished on a lathe. Thus simple machinery was in use in the monastic workshops.

In examining the metalwork of the period three preoccupations – influence, provenance and dating – stand out as the most discussed and disputed issues. Of these dating is crucial to the understanding of the relationship between objects and to placing them in their correct historical context. Regrettably, there is no surviving metalwork from the eighth or ninth century with a contemporary inscription which could provide firm evidence of its date of manufacture, nor is the evidence of excavation of much help in sorting the material into fine chronological order. We are forced to rely on comparisons with works in other media for which dates have been proposed. Of these the most often quoted are illuminated manuscripts – especially gospel books – some of which have statements identifying their scribes. In few cases are these contemporary, and one must make a judgement, often little more than a guess, as to the occasion and place for which a manuscript was illuminated. There is a consensus that the tenth-century ascription of the Lindisfarne Gospels to Bishop Eadfrith (who died in AD 721) is reliable, but it remains a hypothesis that it was painted for the translation of the relics of St Cuthbert in AD 698. It is probably best, in the light of present evidence and in the absence of unequivocal evidence of date and attribution, to treat objects in broad period styles.

The issues of the artistic influences affecting metalwork styles and the questions of provenance are closely bound up. Prov-

enance is no longer as intensely argued as it once was, now that it can be seen that closely related high-quality metalwork was produced both in Ireland and in northern Britain in the seventh and eighth centuries (Cramp 1986) and that there was evidently a good deal of exchange of techniques, objects and probably even craftsmen between the two regions. The seventh century was the great period of Irish missionary activity in Scotland and northern England, and it is largely in the monasteries of Northumbria and in the close relationships between churchmen in Ireland, Pictland and England that the arts of the Anglo-Saxons began to make a strong impact on the products of the Celtic metalworkers. Not only were Irish monks active in Northumbria, there were at least two Anglo-Saxon monasteries in Ireland. Mayo, Co. Mayo, was the house of English monks who had withdrawn from Northumbria with their Irish colleagues after the Synod of Whitby. Bede mentions the important Anglo-Saxon foundation of Rath Melsigi, perhaps in Co. Carlow, from where the Saxon mission to the Frisians was organised. Not all contacts were religious. Political exiles from Northumbria found refuge amongst the Irish of Dál Riada in Scotland and their allies in Ireland, the Uí Néill. Northumbrian *athelings* (princes) are recorded as fighting in battles in Ireland, and Aldfrith, who became king of Northumbria in AD 685, had an Irish mother and had been educated in Ireland (Moisl 1983).

In decorative style Anglo-Saxon influence takes the form of animal ornament in which the beast motifs are much more dominant than the occasional bird head in the earlier curvilinear style. The technical range of the craftsman was expanded by the adoption of filigree and the use of cast studs and inlaid enamel to approximate the garnet and glass settings of Anglo-Saxon jewellery. This process was well under way in Ireland in the seventh century, as the experimental filigree mount from a structural phase of Lagore Crannog (no. 222) and the developed ?Irish inlaid stud from the Anglo-Saxon burial of Roundway Down, Wiltshire (no. 40), show. However, Anglo-Saxon imports to Ireland are almost non-existent and we merely see the effect of their art on native pieces. The same period may also have seen the naturalisation in Irish workshops of filigree (Whitfield 1987, 80–2) and iconographical fashions which were Frankish and Mediterranean in origin. This would not be surprising given the close contacts between the Church in Ireland and the Irish missionary houses founded amongst the Franks, Burgundians and Lombards from the late sixth century onwards. Here, deductions are based on later objects – there are no relevant imports. By the end of the century lavish polychrome objects, remarkably inventive in technique, had appeared, testifying to the eclecticism of the insular artists.

It is not known what kinds of models were introduced by the first Christian missionaries, but since missions to Ireland originated in fifth-century Gaul and Britain it is probable that late Roman types and ornament served as exemplars for native workers to copy. St Augustine's mission (from AD 597) to the Anglo-Saxons ensured that there was a strong and up-to-date Roman bias in English Christianity and its arts. It can be assumed that the church metalwork brought by the Irish Bishop Aidan to Northumbria from Iona in AD 635 followed the style of secular work among the Irish and, perhaps, Picts. In the later

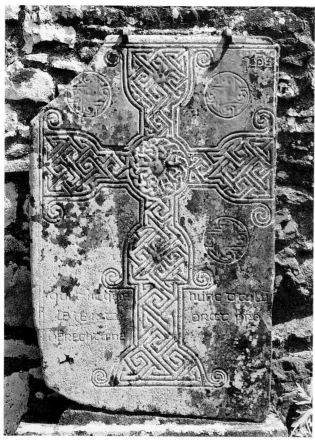

Fig. 3 Grave slab, Tullylease, Co. Cork, 8th or 9th century AD, commemorating a man with an Anglo-Saxon name, *Berechtuine*. The form of the cross is comparable with that of the famous cross-carpet page in the Lindisfarne Gospels.

seventh century the Romanising monastery of Monkwearmouth and Jarrow introduced even newer and fresher influences from the Mediterranean world. These remained very strong in Northumbria and in the visual arts are best seen on the remarkable carved stone crosses of the eighth and ninth centuries and in manuscript illumination. The same influences are less obvious but widespread in Ireland, and it is sometimes difficult to decide if they derive from direct contact or from secondary sources such as Northumbria or Merovingian Gaul.

The ornamental style which was to dominate the arts of the Church in Ireland, Scotland and parts of Northumbria reached maturity in the later seventh century with the illuminations of the Lindisfarne Gospels. Its splendid interlaced animal style and its marriage of the Celtic trumpet scrollwork to a strange variety of beast heads ultimately derived from the version of Germanic ornament known as Salin Style II are mirrored exactly on the 'Tara' brooch from Bettystown, Co. Meath (col. illus. p. 77), the Donore hoard (nos 63–6), also from Co. Meath, and the Hunterston brooch (no. 69) found in Ayrshire but of Irish annular type. It is clear that the 'Tara' brooch and the Lindisfarne Gospels together define an approximate date horizon in the later seventh and earlier eighth centuries when a common

ornamental style was practised in the Irish midlands and in monasteries of Irish origin in northern England and Scotland.

The full development of this insular style consisted of animal interlace in which beasts, though fabulous, had believable anatomical detail, and were shown as interlaced, long-bodied quadrupeds in profile. Trumpet scrolls and triskele ornament were combined with animal-head elements. On the margins of the reverse of the 'Tara' brooch there is a frieze of birds which would not be out of place on the canon-table arcades of illuminated manuscripts of the time. The Donore handle, derived from classical lion-head forms, shows how at this stage the Irish artist adopted Mediterranean influences and rendered them in a somewhat abstract form. This is in contrast to the metalwork of Northumbria, which, under increasing Mediterranean influence, tended to emphasise naturalistic plant elements in its designs (see Bakka 1963).

Compass-work had formed part of the insular metalworking repertoire since the Iron Age, but the compass-constructed designs of the Donore objects approach as near as metalwork can the effect of painting. The method of layout matches closely that used on the Lindisfarne Gospels (Bruce-Mitford 1960, 226–31). The use of tinning cut away to reveal the contrasting bronze underneath is a favourite trick, while dot-outlining and texturing mimic an effect of manuscript illumination but one which also harks back to Iron Age traditions. It appears in various forms on pieces as diverse as the Monymusk shrine (no. 129) and the St Ninian's Isle bowls (nos 97,98). Background hatching became a standard feature on tinned and engraved Irish and other Insular eighth-/ninth-century objects and may also have an Iron Age origin. Similarly it occurs in manuscript illumination.

The Tara-Lindisfarne animal style was very influential. Derivatives of it were employed throughout the eight and ninth centuries in Ireland in stone sculpture, manuscript illumination, in cast and engraved bronze and in filigree work.

Altar plate

Five chalices and one paten of eighth- or ninth-century insular manufacture survive. Of these the paten and four of the chalices were found in hoards. The find circumstances of one, the vessel in the Ulster Museum (no. 61), were unrecorded. The chalice from the Trewhiddle hoard (Wilson 1984, 96) was found with other metalwork and coins which date its deposition in Cornwall to before *c.* AD 868. Two chalices were found in the Ardagh hoard – a great silver vessel (col. illus. p. 160) with elaborate ornament and a smaller plain bronze vessel, the bowl of which is remarkably like that from the Ulster Museum.

A domed foot with a marked flat rim is one of the chief characteristics of surviving insular Communion vessels, occurring on the Trewhiddle chalice and in an elaborate variant form on the large Ardagh and Derrynaflan chalices (no. 124). The majority of the insular chalices are also assembled in a similar fashion, their bowls and separately made hollow stems united to the feet by means of a pin or pins passing through them. The Ulster Museum vessel, uniquely, has a solid-cast knopped stem which was nevertheless riveted to the bowl. The disc-shaped

decorated foot of this vessel is unusual but not unprecedented in medieval Europe. The funnel-shaped foot and the bowl of the plain Ardagh chalice were damaged at the time of discovery, and the method of attachment of the two is unknown.

The surviving chalices appear to have been made to fulfil a variety of liturgical functions – the larger ones could have been used to serve Communion wine to the congregations, and the plainer ones of medium size may have been intended for daily use, for the celebrant of Mass or for serving smaller congregations.

The elaborate strainer-ladle found in the Derrynaflan hoard was no doubt intended for the ritual purification of the wine intended for the Eucharist. In Rome in the seventh and eighth centuries the chalice used on solemn occasions was filled at the Mass by pouring wine from a ewer through a sieve (Andrieu 1948, 93). This ritual must have been known in Northumbria; indeed, much of our knowledge of early Roman liturgy derives from manuscripts ultimately dependent on northern English sources. The southern Irish Church was also insistent on its Romanist purity, and the impression given by the great altar plate is a determination to provide sacred vessels of which the greatest churches in Christendom could be proud.

The Ardagh chalice (Organ 1973) and Derrynaflan paten (no. 125a) share many traits of technique and style: the discrete filigree panels of animal and abstract patterns match their cast and inlaid studs; the use of knitted silver- and copper-wire mesh and of accomplished die-stamped ornaments. All this marks them as masterpieces from the same workshop traditions. Their filigree patterns owe much to Mediterranean-style vine-scroll motifs of eighth-century Anglo-Saxon art, although they show characteristically Irish stylisations. Both vessels were probably made in the mid-eighth century.

The Derrynaflan paten surpasses the Ardagh chalice in its range of ornaments. Among its tiny filigree panels are to be found remarkably naturalistic animals including in one case a stag-and-snake scene almost certainly from the *Physiologus* tradition of allegorical stories about beasts (Ryan 1987b, 72–3). The Ardagh chalice bears the names of the Apostles. The lettering is of the imposing type which is used in the Lindisfarne Gospels; however, as the names are rendered in two different grammatical cases, it is possible that the engraver did not understand fully his task and may therefore have been illiterate. The Derrynaflan paten, in contrast, was assembled in accordance with a code of letters engraved on its components which implies that a literate person, probably a cleric, participated in its design. Both are extremely complex assemblies with upwards of 200 parts in each. They give the impression that precious raw materials may have been in short supply but artistry, to compensate, was not.

The Derrynaflan paten with its rim ornament of filigree beasts and manikins quite clearly derives from late Roman figured dishes (Toynbee and Painter 1986), such as were still to be seen in Merovingian treasuries in continental Europe (Ryan 1987c). Similar dishes are known to have been imported into Anglo-Saxon England. The origin of the form of the great chalices probably also harks back to common late Roman types, as do all European Communion vessels. Theories that the Irish chalices derive from Syria or Byzantium lack firm evidence. The shape of their cups clearly belongs to the native hanging-bowl tradition, while their elaborate construction is without parallel in early medieval Europe.

The altar vessels are supreme in their tradition – they are matched in eighth-century work only by the 'Tara' and Hunterston brooches – but their excellence should not blind us to the fact that the basic motifs used in their ornament were shared with many humbler objects. These were patterns which had been in use in Ireland for perhaps as much as a century in some cases and for very much longer in others. To some extent this is also true of the Derrynaflan chalice which stylistic evidence suggests should be dated somewhat later, probably as late as the early ninth century. It is remarkably like the Ardagh chalice. The layout of its ornament is similar, if less complex. However, the later chalice lacks all enamels, die-stamped and wire-mesh ornament. Instead, it carries a large number of filigree panels and amber studs – its more lavish use of precious materials is striking. It bears no animal interlace: the filigree and cast beasts which decorate it are in the main single animals often in backward-looking pose. Many of them are bird-headed – that is, wingless griffons. Sometimes isolated bird heads together with the beasts suggest decayed versions of well-known Christian iconographies such as the Tree of Life. The spirit of the ornament has little to do with the fantasies of the earlier objects. Its style is overwhelmingly naturalistic, and while the execution sometimes falls far short of the ambition, some motifs are sketched with remarkable economy. It is a great piece and one which was probably commissioned during the early part of the Viking period. It is a testament to the vitality of Irish society that fine metalwork, albeit changed in style, continued throughout the ninth century when the Scandinavian attacks were at their height.

The range of church equipment made was very wide. Two possible holy-water sprinklers come from an Anglo-Saxon burial at Swallowcliffe Down (no. 42) and from Vinjum in Norway (no. 121). No censers are known. Bells (Bourke 1986) were simple hand-held forms not unlike cow-bells. Some were made of folded sheets of iron dipped in bronze, while others were cast bronze, sometimes lightly incised with ornament. Furnishing included large crosses; fragments of pyramidal mounts from Irish metal and wood crosses have been found both in Scandinavia and Ireland. A complete enamelled cross with small bosses of this type is preserved in the Hunt Collection in Limerick (Harbison 1978). Fragments of an eighth-century crozier (no. 148) found in Ireland show the emergence of a type of bishop's staff standard in Ireland and also in later centuries in Scotland. A finial of unusual form from Helgö, Sweden (no. 147), might conceivably be from a crozier, but this is uncertain.

Reliquaries

Christianity developed a great many secondary accretions, some of which appear strange to modern eyes but which must have seemed fundamental in early medieval times. The most striking of these was the cult of relics. The veneration of the bodies – or portions of the bodies – of saints or of objects associated with

them can be traced almost to the beginnings of the Church. This did honour to the saint's Christian witness and it provided a focus – but not a substitute – for the worship of God. Reverence of martyrs was especially important. Tales of miraculous happenings connected with relics gave rise to widely held expectations that the intercession of saints could bring divine favour to supplicants. As a result the practice of pilgrimage to shrines grew up and devotion to relics inspired some of the finest expressions of medieval art.

In Ireland the cult of saints and relics was given a special flavour because of the intensely familial nature of early Irish monasticism. Saints were described in heroic terms appropriate to the world of warriors. The holy founders were often thought of as having a special and continuing relationship with the communities which they had founded: this was thought of as reflecting that obtaining between a secular leader and his dependants. Such a conception was reinforced by the way in which monasteries tended to be dominated by the families, often aristocratic, of founders. The monastery of Iona is a good example of this – the majority of its early abbots were drawn from the royal dynasty to which the founder Columba belonged. Possession of the relics of a saint conferred prestige on a foundation and helped its economy by attracting pilgrims.

Certain relics – those of St Patrick, for example – enjoyed such esteem that they were frequently brought to solemnise major political agreements (Lucas 1986a). Relics were carried on circuit to collect dues and some, the Monymusk shrine (no. 129) and the later 'Cathach' (battler) both associated with St Columba, were later used as battle talismans. Relics were equally effective when solemn cursing was required. Complete portable reliquaries and fragments are amongst the most numerous objects to survive from the early Irish Church. There are a few surviving portions (no. 138) of what may have been large shrines of sarcophagus proportions such as those described at Kildare in the mid-seventh century (Connolly and Picard 1987, 25). One of the most numerous objects in the early Church in Ireland and Scotland seems to have been the house-shaped reliquary, an insular version of a common continental form. The native type seems to have become standardised at an early stage and takes the form of small models of hip-roofed buildings with prominent gable finials and applied decorations of metal. They bear a strong resemblance to the representation of the Temple of Jerusalem in the Book of Kells, to the finials of ninth- and tenth-century sculptured Irish high crosses and to some surviving Irish oratories of stone. The early forms seem to fall into two basic types – those made of wood inlaid with metal and those made of wood covered with metal plates (Blindheim 1984, 33–52). In all cases the shrines were made to be carried hung around the neck on straps. Their backs are therefore usually plainer than their fronts.

Irish missionaries brought reliquaries on their journey through Europe. Fragments of what may be one of the oldest of these to survive are preserved in the Museo del'Abbazia of the great monastery of Bobbio, Italy, founded by St Columbanus in AD 614. These consist of two tinned or silvered bronze plates with reserved lyre patterns made up on interlocked scrollwork seen against a hatched background. One may be a roof plate,

the other a sideplate from a house-shaped reliquary. They had been buried in a box of relics collected and reinterred in the fifteenth century during a translation of the bones of the founding saints. It is difficult to date the decoration but it could be seventh century. Some stylistic peculiarities suggest that it may have been made abroad in the Irish manner.

A perfectly preserved example of an eighth-century shrine of inlaid wood still containing bones has been kept since medieval times at Abbadia San Salvatore near Monte Amiata in Tuscany (no. 128).

Its closest comparison is the Emly shrine from Co. Tipperary, now in the Museum of Fine Arts, Boston (Swarzenski and Netzer 1986, 32–3). The Abbadia San Salvatore shrine contains apparently original bones and this is a strong indication that the other house-shaped reliquaries also contained bodily relics. The 'Copenhagen' shrine (no. 131) also has associated relics, some of which certainly date from the late Middle Ages. A tenth-century runic inscription states that the casket was owned by a woman called Ranvaik, and this has often been taken to mean the reliquary was used for profane purposes, having been carried off by a Viking in the ninth century or later.

The dot-outlined animal interlace on the eighth-century Monymusk reliquary shows a Pictish element in the production of this shrine.

The Bologna shrine (no. 132), an intact ninth-century example, has a broad field of engraved ornament which is reminiscent of the Monymusk reliquary. The crouching animal of its ridge endings is closely matched on a mount (no. 113) from the Navan, Co. Meath, find. A roof plate of a shrine which must have been very similar to the Bologna one is preserved in the Musées Royaux in Brussels (Ryan 1986).

In addition to the portable reliquaries elements such as large decorative bosses and figures (nos 134–6, 139–46) survive from much larger shrines and crosses, and other major items of church furniture. The very large objects preserved in St Germain (no. 138) and those from Gausel, Norway, are almost certainly parts of the gable finials of the same exceptionally large shrine. Antique lion-head door-handles on which the composite Donore handle (no. 64) is based frequently occurred in funerary contexts. It is possible, therefore, that the Donore piece was originally one of the fittings of such a large sarcophagus shrine rather than, say, a church door.

A recent find of the dismantled components of a large bookshrine from Lough Kinale, Co. Longford (Ryan and Kelly 1987), probably dates to the eighth century. It shows that manuscripts were being enshrined at an early stage, perhaps suggested by the Roman rite where the gospel read at the altar was kept in a case and returned to a secure place after the readings (Andrieu 1948, 65).

Other reliquaries of the eighth century are rare – the vicissitudes of the Viking raids and the re-enshrinement of relics in later times have meant that early examples are few. Of these the most complete is the belt-shrine from Moylough, Co. Sligo, found in a peat bog in 1944 (no. 47). This was made in four hinged sections to preserve the girdle of an unknown saint with fittings modelled on Frankish, or, less likely, antique belt fittings. There is also a great deal of dispute on art-historical grounds

about the date of this remarkable object with estimates ranging from the later seventh to the early ninth centuries.

The crest of a reliquary formerly preserved in Killua Castle, Co. Westmeath (no. 137), has often been identified as the top of a bell-shrine. Unusually for metalwork of this period it shows on one face an elaborate, partly openwork iconographical scene, consisting of an *orant* hooded figure placed between two beasts. The simplicity of the representation seems to reflect the iconography of the Daniel openwork buckles of the continental and related series of the sixth to seventh century (Kühn 1941). It is in a tradition of representation which appears to be quite distinct from the lavish and more naturalistic Daniel, and Eucharistic, iconographies of ninth-century insular sculpture.

Our understanding of religious metalwork is very imperfect, but two things seem to be clear. The first is the remarkable correspondence between the decoration of religious objects and personal ornaments. The second is that technological innovation after the seventh century was limited and native skills were pushed to the limit to produce desired effects: the solutions in many cases are what impart the special flavour and beauty to church metalwork of the period.

The Derrynaflan hoard (nos 124–7)

This treasure was discovered in 1980 on the monastic site of Derrynaflan and settling its ownership became something of a *cause célèbre*. It was finally declared treasure trove (state property) by the Irish Supreme Court in a landmark decision in December 1987.

Derrynaflan was a very important monastery in eighth- and ninth-century Ireland. Some of its clerics – notably the 'Flanns' from whom it derives its name – were the confidants of leading reformist churchmen and scholars of the time, and in the early ninth century it enjoyed the patronage of Fedlimid mac Crimthann, King-Bishop of Cashel, one of the leading rulers of the day.

The hoard consisted of a great silver chalice, a large paten and its stand or footring and a liturgical strainer-ladle, all placed in a pit and covered by a basin. It was concealed near the ancient pre-Romanesque church within the monastic enclosure. The chalice stood upright in the pit, the paten lay against it and many of its components became detached at the time of discovery. It has since been reconstructed in the British Museum Conservation Department. Like the Ardagh hoard, there is no independent evidence of the date at which the objects were concealed, but the latest object in the group is the chalice which was intact and bore little wear when deposited; it is therefore likely that the hoard was buried in the later ninth or tenth century. The same is probably true of the Ardagh hoard which included two chalices and four brooches (see nos 76, 81). Coin-dated hoards of Viking-Age silver are relatively common from the early tenth century onwards probably because of the wars of that time, and the concealment of native metalwork probably belongs to that phase.

The objects were made at different periods and do not comprise a uniform Communion set but they nevertheless give a good idea of the more sumptuous liturgical equipment of an important church. MR

124 Ministerial chalice (col. illus. pp. 160–1, front cover)

Derrynaflan monastic site, Co. Tipperary
Silver, gold, amber, gilt copper-alloy; max. H. 19.2 cm, min. H. 18.75 cm, rim DIAM. 20.7–21 cm, bowl D. 11.5 cm, foot DIAM. 16.7 cm, rim TH. 0.8–1 mm, WT 1.223 kg
Irish, probably early 9th century
NMI 1980:6

Made of beaten lathe-polished silver, the bowl is of an alloy with 83 per cent silver and 15 per cent copper, the foot 75 per cent silver, 23 per cent copper. The bowl is hemispherical with an everted rim, the stem is gilt copper-alloy cast in three pieces and the foot a truncated cone with a broad rim. The bowl is set slightly off centre on the stem producing a lopsided effect. The bowl stem and foot are held together by a large pin which locks on a decorative catchplate on the underside of the latter and this is supplemented by a system of rivets concealed under studs. A pair of handles and a

girdle of filigree and amber within half-round mouldings are applied to the bowl. Filigree panels also decorate the handles, girdle, stem and foot – there are eighty-four in all. Fifty-seven gem-set amber studs, cast interlace and animal patterns complete the inventory of decoration. The filigree is relatively simple, consisting of twisted round and beaded wires, soldered to flat gold-foil backing plates, but a few motifs are of ribbon-on-edge capped by beaded gold wire and in two instances twisted plain wires are capped by gold granules. In one or two places the backing foil is pressed up to simulate gold granules. Most of the filigree panels are held in place by stitching, but those on the bowl girdle are fastened by the pressure of their frames.

Animal ornament occurs on forty-nine filigree panels and twenty of cast copper-alloy. Many of the beasts are shown in profile with raised forepaw and backward-looking pose; some are contorted to fit their panels, others are upright and elegantly sketched. Many are intended as lion- or dog-like beasts, and a couple are shown bounding at full stretch or biting their own bodies. At least fourteen filigree beasts are bird-headed, sixteen in imitation chip-carving are long-snouted, and all may be intended to be read as griffons. Ten filigree panels have, in addition to the beasts, disembodied bird heads placed behind the rump or head. A few panels carry patterns made of beast heads, and one on the bowl shows two human faces with beast and bird heads. Four crouched faceted beasts on the top ring of the stem, concealed by a decorative skirt, are very like those on the reverse of the Killamery brooch (no. 80). A number of the cast copper-alloy components are decorated with interlace. Some features of the decoration, such as the placing of some panels inverted, the failure to complete obvious symmetrical sequences and badly corrected errors, suggest an element of haste in the assembly of the piece.

The Derrynaflan chalice is an ambitious object executed partly in the taste of the annular brooches of the ninth century. It contrasts markedly with the great pieces of the eighth century which emphasised polychrome effects to a much greater extent. It also contrasts with them in its lack of animal interlace and within the limitations of its craftsmanship its strong emphasis on naturalism. The use of disembodied bird heads suggests that here we may have decayed early Christian iconographies of the 'Tree of Life' variety. The appearance of the griffon is also suggestive of this. Other motifs, for example, the combinations of animal heads, are a commonplace of insular art. The iconography of the chalice may be a complex mixture of surviving early Christian traditions, long naturalised in insular art, combined with an Irish reflection of the naturalism of the Carolingian styles which made their effect felt in Ireland on the ninth-century stone high crosses.

Typologically the chalice is closely related to the famous Ardagh chalice. Both represent adaptations of native vessel forms of hanging-bowl type to the problem of creating a great Communion chalice. The highly complex technique of manufacture is in part a result of the nature of the ornament and in part suggested by the variety of models the craftsmen had before them. The approach to construction is not unlike that used in creating the Byzantine chalices of semi-precious stone in San Marco in Venice. It is also argued at times that the two great Irish chalices match closely those from Syrian Byzantine silver hoards of the sixth and seventh centuries, but this is more likely to be the result of convergence rather than a direct relationship – Christian altar vessels in both the East and West were derived from late Roman tableware. The chalice is of a size which suggests that it was ministerial – that is, used for serving Communion wine to the faithful. It would therefore have been one of a range of chalices required by a church and other, smaller ones for the celebrant, for daily use, etc., would have been needed. it is conceivable that the Derrynaflan chalice was made entirely as a votive object because of the difficulty of waterproofing the stem-bowl joint and the risk of leakage of the Eucharistic wine.

The lavish use of silver and amber and the artistic ambition of the piece suggest that major ateliers were still active in Munster well into the ninth century despite the Viking raids. MR

BIBLIOGRAPHY Ryan 1983; Ryan 1984a; Ryan 1985, 9–19

125a, b Paten and stand (col. illus. pp. 160, 162)

Derrynaflan monastic site, Co. Tipperary
Silver, copper-alloy, gold wire and foil, tinning, glass, enamels; max. DIAM. 35.6–36.8 cm, max. H. incl. foot 6.85 cm; footring D. 3.5 cm
Irish, 8th century
NMI 1980:4,5

Made in two parts: the paten proper and a footring or stand which was riveted to it. The paten is a lathe-polished, hammered silver plate with a flattened rim (there is a centring hole in the plate). This plate is attached by soldering, stitching and locking pins to a complex, double-walled hoop of copper-alloy which carries decorative features on the outside. Mouldings raised on the silver and on the hoop are sheeted in knitted silver and copper wire mesh sewn in place. The upper surface of the rim bears twelve cast, gilt copper-alloy frames in each of which there are two apertures for the display of filigree panels. In the centre of each frame is a large cast enamel stud and, where each frame touches, twelve smaller studs in elaborate settings which cap the locking pins of the assembly (one is a modern replacement). The studs carry a variety of polychrome inlays, inset metal grilles in imitation of cloisonné work and cast relief interlace. Some have sunken settings for filigree ornaments on gold-foil platelets. On the outer face of the hoop are twelve gilt copper-alloy settings for rectangular inlaid red, yellow and blue enamels. The settings help to hold in place twelve die-stamped gold foils bearing trumpet scrolls and spirals in a cartouche within a field of double-contoured billeted interlace. The technical perfection of these is remarkable. A series of small silver die-stamped panels and discs of interlace and trumpet scrollwork were soldered on the underside at the points where the locking pins emerge.

The filigree panels are especially fine. Extremely complex effects have been achieved by using combinations of beaded gold wires, gold strip on edge capped by complex wires. The patterns in many cases were executed on stamped foil with the background cut away so that the filigree could be shown in relief against a gold or silver backing – the so-called hollow-platform technique. Granules of gold are used to emphasise detail. Of the twenty-four panels four depict kneeling men back to back, ten show fanged beasts, one eagle, two interlaced snakes, one plain interlace and two with elaborate spiral and trumpet compositions. In addition to the pairs of men three panels have pairs of affronted beasts and one has two thin-bodied quadrupeds with crossing necks. The paired beasts and men are in fields of interlace springing from tongues, hair, beards or lappets as appropriate. Two panels portray stags, one standing looking

backwards in a field of interlace and one shown walking with a snake rearing in front of it and another serpent behind. The paired beasts owe a great deal to Anglo-Saxon plant-scroll derivatives of the eighth century, while the stags and eagle are clearly derived from early Christian iconography.

The paten is a complex object assembled in accordance with a code of letters and symbols engraved on the surface of the silver and on some of the detachable components. In approach to construction, filigree, wire mesh, enamels and foils the paten stands very close to the Ardagh chalice, and the two are likely to belong to the eighth-century climax of metalworking in Ireland.

The paten stand is a tinned copper-alloy flanged hoop decorated with eight long die-stamped silver panels and eight smaller bronze sheets which serve as the settings for rectangular inlaid enamels – one of which is now missing. These are held in place by milled mouldings running along the top and bottom and square frames composed of short copper-alloy bars riveted in place around the enamel settings. The rivets are concealed by enamel studs. The silver foils seem to have been stamped in three stages. The pattern consists of a central cartouche with an elaborate spiral and trumpet composition in a field of tightly woven interlace. This is flanked by two panels of interlace arranged in discrete blocks to suggest a cross pattern. The ornament of the settings for enamels consists of very fine pelta scrolls with bossed spiral endings. The enamels are blue, green, red, yellow and white and are principally angular motifs. One, however, is an elaborate s spiral scroll with suggestions of triskeles and trumpets.

The remains of pins on the upper surface mate with holes under the paten. When found the stand was lying inside the paten.

Large patens were common in the late Roman world – Byzantine examples up to 60 cm in diameter survive. Patens with decorative feet are preserved in San Marco in Venice. Large-footed patens seem to have gone out of fashion in western Europe with the change from loaves to wafers for the Eucharist and the gradual adoption of the ciborium to carry sufficient for larger congregations. The fashion for small patens made to match their chalices and designed to stand on the cup rim became universal until the Reformation. It is unlikely that the Derrynaflan paten was actually used – the wire-mesh rims would, by trapping particles of the sacred bread, have created practical problems – and it is likely to have been a votive piece. The use of a letter code in its assembly gives us an insight into the planning required for such a major object and suggests that a literate person, probably a cleric, was concerned with its manufacture.

The stand falls short of the artistry and technical accomplishment of the paten and may have been a later addition to it. MR

BIBLIOGRAPHY Ryan and Ó Floinn 1983; Ryan 1985, 19–20

126 Strainer-ladle *(col. illus. pp. 160–1)*

Derrynaflan monastic site, Co. Tipperary
Copper-alloy, silver, gilt tin-bronze, rock-crystal, *millefiori* glass, enamel;
L. 37.8 cm, bowl DIAM. 11.5 cm, bowl D. 4.7 cm
Irish, 8th century
NMI 1980:7

A long-handled ladle to which a pierced plate has been added for use as a strainer. Analysis of the metal shows that it is a tin-bronze, composed of 84.5 per cent copper, 15.0 per cent tin and 0.3 per

cent lead. The bowl is hemispherical with a flattened base and a broad, horizontal flanged rim. The handle is of rectangular section with a small disc-shaped terminal and angular expansions at either end which have metal plates soldered to their upper edges. The inside of the bowl is inscribed with two pairs of concentric circles. The upper face and sides of the handle are also decorated with incised lines. The rim bears stamped silver foils with a herringbone pattern. These are held in place by openwork frames of copper-alloy secured to the rim by a series of six dome-headed rivets.

The bowl is bisected by a decorative cross-member to which a pierced strainer-plate is attached, secured to the rim with rivets at either end. These rivets are masked by rectangular red enamel studs with inset silver grilles, cruciform in shape with stepped terminals. At the centre of each stud is a *millefiori* platelet with a star pattern of red enamel surrounded by blue glass. There is a circular stud at the centre of the cross-piece made of blue glass with cells of red enamel separated by a silver grille; the pattern consists of a cross-in-circle containing a square with quadrant shapes at the corners. Between these studs strips of stamped silver foil are set into channels along the surface of the cross-piece. These are decorated with rows of bosses connected by c-scrolls.

The strainer-plate is attached by rivets to three metal tags on the underside of the cross-piece. Cut to fit the profile of the bowl, it is decorated on both faces with incised ornament, the neatly drilled perforations being added later. The design consists of three compass-drawn concentric circles, linked at the top by equilateral triangles and at the bottom by swelling curves. The edges are outlined by incised lines.

The handle terminal is fitted with a domed setting of gilt copper-alloy. At its centre is a polished rock-crystal backed by silver foil. The sides contain alternate blue and red glass settings. This setting is surrounded by a raised gilt copper-alloy mount decorated with a cable pattern. A suspension loop was fitted to the back of the terminal but was detached when found.

This object is an elaborate version of insular ladles represented by that from Doornane (no. 122). The Derrynaflan ladle is more robust than most, the majority of which are made from thinner sheets of metal. The soldered plates on the handle have the same metal composition as that of the rest of the vessel, and it is clear therefore that the decorative elements are not later additions. Some features of the Derrynaflan vessel are found on the plain ladles: simple bosses occur on ladles from Castlederg, Co. Tyrone, and from Steinvik in Norway (Petersen 1940, 107), while inscribed concentric circles occur on many of the bowls.

Although conceived as a unit, the decorative elements do not fit well on the piece. The arrangement around the rim is reminiscent of the foot flange of the Ardagh chalice, although on a less ambitious scale. The herringbone pattern on the silver foils may be an attempt to imitate the knitted silver wires of the latter. The silver foils and polychrome studs are closer in style to the standard of workmanship found on the Moylough belt-shrine (no. 47). Both objects also contain *millefiori*, not found on the Ardagh chalice and the Derrynaflan paten. These differences emphasise the fact that the objects in the hoard were not made as a set. The polychrome studs, silver foils and *millefiori* plaques would all suggest that the object should date to the eighth century. RÓF

BIBLIOGRAPHY Ó Floinn 1983a; Harbison 1985–6

127

127 Basin (col. illus. p. 160)

Derrynaflan monastic site, Co. Tipperary
Copper-alloy; rim DIAM. 44.0–46.0 cm, H. 18.0–19.0 cm
Irish, 8th–9th century
NMI 1980:8

Large circular copper-alloy vessel made of a single sheet of metal. The rim forms a ridge and is folded over towards the inside. The neck is concave with a ridge at its lower edge hammered up from the inside. The vessel has a rounded base with a central boss raised from the outside so that it lies flat. At the centre of the boss is a small perforation indicating that the vessel was finished on a lathe. Although badly corroded, the original polished surface is visible in places.

This is one of a group of large vessels which by virtue of their size – over 30 cm in diameter – can be isolated from the hanging-bowl series to which they are clearly related. Apart from two others found in Ireland, the rest come from Viking graves in Scandinavia. Some have applied mounts for suspension but the majority do not. It is likely that these vessels were not exclusively for ecclesiastical use – a smaller example with the same profile as this one was

recently found on a crannog in Lough Lene in the Irish midlands. A basin from a grave near the Viking trading settlement of Kaupang in Norway had a runic inscription which has been translated as 'in the handbasin' (Liestøl 1953). Sets of vessels including bowls, basins, ladles and buckets sometimes occur in female Viking graves and a similar set comes from a bog find at Derreen, Co. Clare (Raftery 1941). It is unlikely that these large basins could have been suspended when filled with liquid, and it is possible that the suspension mounts which occur on some were used for hanging them on a hook or a nail when not in use. Like the strainer-ladle the basin must be regarded as a secular vessel form adapted to ecclesiastical use. Unlike the strainer-ladle, the basin has no additional embellishment and may simply have served as a convenient protective cover for the other objects in the hoard. The profiles of these large basins, however, are identical with those of the later hanging-bowls and ladles, with concave necks and strengthened ribs, and suggest that all are of similar date, which is likely to lie somewhere in the eighth or ninth century.

RÓF

BIBLIOGRAPHY Ó Floinn 1983b

House-shaped shrines
(*nos 128–32*)

128 House-shaped shrine *(col. illus. p. 163)*

Abbadia San Salvatore, Siena, Italy
Wood, lead, gilt copper-alloy, garnet, gold foil, glass; contents bone, wax;
 L. 12.1 cm, W. 4.87 cm, H. 10.75 cm
Irish style, 8th century
Abbazia del Ss.mo Salvatore, Abbadia San Salvatore, Italy

Box and pointed lid each apparently fashioned from a solid piece of wood, probably yew; there is a backing-sheet of wood inside the front of the lid which is shaped like a gabled roof. All corners are bound with gilt copper-alloy, and two hinges of the same metal are let into the back of the shrine. One of two sets of copper-alloy carrying hinges remains on the short side of the box and part of the baseplate of the other set. The surfaces of these solid plates are undecorated. The lid carries a thicker cast copper-alloy ridge fitted with integral terminals of inturned animal heads with curled snouts and eyes set with garnet on gold foil (missing on the back). A simple interlace knot links the beasts at the centre of the ridge. The front surfaces of lid and base are inlaid with a grid of squares of lead inside undecorated borders. The materials of the casket have been kindly identified by the Opificio delle Pietre Dure di Firenze during recent restoration work, in advance of publication.

Three applied circular mounts of gilt copper-alloy decorate the front. Each has a ring of geometric interlace inside a raised rim, and a central circular setting. The two settings on the base contain purple glass, the left one cracked. Cracks in the wood have been repaired in antiquity by three plates, one on the front, two on the back of the lid. The shrine was closed by a pin through a hole at the front of the left end of the box pushed through internal loops on lid and box. Part of the rod remains in the box loops and the box is strengthened on that corner. The contents of the shrine comprise bones and the string and wax seal of an abbot, these originally bound round the shrine. The relics have been tentatively associated with St Columbanus, the only Irish saint mentioned in the records of the reconsecration of the Abbey church in 1036, but there is no documentary evidence.

This is one of nine complete reliquary shrines of a distinctively Irish form, usually considered to be derived from late-antique sarcophagi or to be house-shaped. The one eighth-century Irish manuscript depiction of such a building represents the Temple at Jerusalem (Book of Kells, f. 202v), and the form and decoration of the Kells depiction echo the seventh-century Ashburnham Pentateuch miniature of the Tabernacle in the form of a temple (Weitzmann 1977, pl. 47). It is probable that the reliquaries were also modelled on a traditional representation of the long-demolished Temple, a building which was of particular significance in both the Old and New Testaments. It is noteworthy that apart from crosses integral to more complex patterns these shrines bear no specifically Christian iconography.

The Abbadia San Salvatore example, like the others, is a small portable shrine designed with strong attachments for a strap. It has a plain back like the Melhus shrine, whereas later shrines are decorated front and back. Melhus also has similar distinctive hinges let into recesses in the surface of the wood. The Emly shrine may also have had a plain back but the rear of the base is a modern replacement (Swarzenski and Netzer 1986, 32; Blindheim 1984, 36–7). The fact that they were designed to be carried does not make them necessarily personal items; the Irish annals record that relics were regularly carried in procession around monastic lands and also to battle.

In decoration the Abbadia San Salvatore shrine is closest to the Emly piece: both have geometric patterns inlaid into the surface of a wooden box and lid in imitation of garnet cloisonné work, an idea still evident in the slightly later applied decorative grid on the Copenhagen shrine (no. 131). The zoomorphic ridge-pole is similar to the others but has some interesting differences; the beast heads are integral and not separate attachments as possibly on the Emly shrine and elsewhere. They are linked by a strong horizontal line to fat, rounded interlace enhancing the dolphin-like appearance of the animals. Most of the other shrines have a small panel resembling a miniature house-reliquary at this point. The applied roundels have closest parallels on the front of the roof of the larger Lough Erne shrine (no. 130b).

The inlaid decoration and decorative details suggest that this shrine is early in the series. Constructional similarities, especially with the hinges on the Melhus shrine which was found in a grave with material dating to *c.* AD 800, give a date somewhere in the eighth century for this reliquary and perhaps place it near the head of the series (Schwarzenski 1954; Blindheim 1984).

It is remarkable that the Abbey of San Salvatore also counted among its treasures the magnificent Codex Amiatinus, written and illuminated in Northumbria *c.* AD 710 and taken in 716 as a gift to the Pope (Alexander 1978, 32–5). SY

BIBLIOGRAPHY Mancinelli 1973–4; Blindheim 1984, 47–8

129 House-shaped shrine, the 'Monymusk'
reliquary *(col. illus. p. 163)*

Scotland
Silver, copper-alloy, wood, enamel; L. 10.8 cm, H. 9.8 cm, W. 5.1 cm
Pictish/Irish style, 8th century
NMS RE14

The core of the house-shaped reliquary has been simply carved from two blocks of wood and consists of a rectangular casket and a hinged lid in the form of a hipped roof. The surface of the wooden casket is covered with thin sheets of metal: those on the lid and front of the casket are of silver, the rest are of copper-alloy. The edges of the reliquary are bound with tubular bronze fittings, and the roof ridge is sealed by a gilt metal bar with decorated central panel and terminals. The silver plates on the front and lid of the casket are decorated with lightly incised interlaced animals against a stippled background of fine punch marks.

At one end of the casket is a hinged bronze arm which is attached to the side of the casket by a semicircular plate decorated with a yellow enamel star against a red enamel background. The arm is decorated with cast s-scrolls and triple spirals picked out against a background of red enamel. The top of the hinge has a socket for a decorative stud and three rivet holes. It is likely that a similar hinge had existed on the other side of the casket allowing it to be carried suspended from a strap.

There were originally six gilt-bronze and enamel plaques mounted on the casket. Of the three plaques on the lid the central one is circular and those on either side are rectangular. Only the left hand of the three plaques that were attached to the front of the casket survives. However, it is apparent from the attachment marks on the face of the casket that the layout of these plaques was the reverse of that on the lid, with two circular and one central square plaque. The surviving circular and square plaques are broadly similar to one another in size and form, although they differ in detail. Their borders are decorated with segments of red enamel, and their interiors are filled with relief interlace with central rosettes or rectangular bosses as appropriate.

The reliquary is an important member of this small group of portable shrines which are distinctively Irish in shape and decoration. In common with the majority the wooden core is entirely concealed by metal plates and is decorated both back and front, contrasting with the Emly and Abbadia San Salvatore examples. Monymusk is unique because the ornament incised on its plates is characteristically Pictish, both in the style of the beasts and the distinctive *pointillé* technique used, features found also on the St Ninian's Isle bowls (Small, Thomas and Wilson 1973). It is therefore the product of the fusion of two close but distinctive artistic traditions, unsurprising in the light of Irish missionary activities among the Picts, known from the time of St Columba, and contrasting with the annal records of violent events in the history of the rival royal dynasties of Pictish Scotland.

The casket is empty, and it is not known whether it originally contained a physical relic of the saint or gained its importance by being closely associated with his cult, perhaps as a container for the Eucharist and holy oils.

Believed to be the 'Brecbennoch of St Columba', one of the military vexilla, or sacred battle ensigns, of the Scottish army, the Brecbennoch has long been associated with the lands of Forglen in Banff, where the church is dedicated to St Columba's successor, St Adamnan. The Brecbennoch and lands of Forglen were granted to the Abbot and monks of Arbroath by William I shortly before 1211. In return the community was obliged to perform the military service due from the Brecbennoch and the lands of Forglen. The Abbot rendered this military service, with the 'palladium' of Scotland, at the Battle of Bannockburn in 1314. Following the battle, the Abbot passed the military service due from the Brecbennoch and lands of Forglen to Malcolm of Monymusk. The stewardship of the Brecbennoch and its associations with Forglen and Monymusk can be traced intermittently through the documentary sources until its acquisition by the then National Museum of Antiquities from the Grants of Monymusk in 1933. RMS/SY

BIBLIOGRAPHY Anderson 1879–80b, 431–5; Anderson 1909–10, 259–81; Eeles 1933–4, 433–8; Wilson 1973, 128–30, fig. 41; Stevenson 1983, 473–4; Blindheim 1984, 36–9

130a, b Two house-shaped shrines

Lower Lough Erne, near Tully, Co. Fermanagh. Found together in 1891 in water at a depth of 7.3 m
Yew wood, gilt and tinned copper-alloy, amber, glass; smaller shrine (a) L. 10.6 cm, W. 3.2 cm, H. 6.8 cm; larger shrine (b) L. 17.7 cm, W. 7.8 cm, H. 16.0 cm
Irish, both late 8th–early 9th century; (b) with 10th-century addition
NMI 1901: 46a, b

Two wooden house-shaped shrines, the smaller (a) found inside the larger, both restored after discovery. Each is composed of a lower box-like base with a hinged lid in the form of a hipped roof. The smaller shrine consists of metal plates now attached to a modern block of wood. The base and short sides are composed of a single piece of metal, the short sides fitted with plain triangular strap hinge-plates secured by three rivets. One of the long sides of the box survives, as do the two long sides of the lid. The metal sheets were fitted together by a mortice-and-tenon-like arrangement of slots and projections along the edges and were secured by soldered binding strips. It appears that the shrine consisted of metal sheets only and that it never had a wooden core. The roof was originally attached at the back by a pair of hinges, now missing, and secured on the front by a hinged clasp. Perforations along the roof-line suggest that a ridge-pole was once present. The roof portions are partly tinned and patterns of corrosion suggest the presence of soldered mounts.

The larger shrine has a hollowed-out wooden base and lid, each made from one block of yew. These are mounted with sheets of tinned copper-alloy secured at the edges with U-shaped binding strips held in place with nails. The imitation chip-carved medallions and hinge-plates have pairs of metal tabs at the back which pass through slots in the facing plates and wooden core and are secured with iron pins on the inside. The surviving strap hinge-plate is D-shaped and decorated with a border of two-strand ribbon interlace surrounding a field of double-contoured interlaced knotwork. At its base is a circular setting containing a stud of blue glass. Two plain circular frames survive on the back of the base, one containing a worn disc with a triskele device. The medallions on the front are missing. The ridge-pole is a hollow casting, decorated and gilt on the front only. It is secured by a rivet at either end. The ends take the form of stylised animal heads; the 'eyes' once held studs, now missing, and there are simple triquetras in the curved ends. The centre of the ridge-pole is house-shaped and decorated with interlace which also occurs on the narrow spaces on either side. The surviving roof medallion on the front is gilt with a central amber stud surrounded by an interlaced running knot pattern. Soldered to the base of the roof on this side is an elongated metal plate decorated with an engraved pattern of angular broad band interlace. Some of the spaces between the bands are stippled. The two hinges which would have attached the lid to the base no longer survive. The lower catchplate for the hinge on the front survives on the inside, showing that like other examples of the type the shrine was locked with a hidden lateral metal rod slid in from one of the short sides.

All previous illustrations of the larger shrine have shown it incorrectly assembled. The face of the lid with the decorated medallion represents the front, not the back as in Blindheim (1984, 33), while the medallions on the base, which are smaller and plainer, are on the back.

This is the largest of the series of Insular house-shaped shrines

130a

and the only one associated with a smaller reliquary of the same type. Despite its damaged state, the imitation chip-carved work is of the highest quality. Unlike the Monymusk and Copenhagen shrines (nos 129, 131) which were probably manufactured in Scotland, the Irish provenanced examples do not have incised ornament on the metal facing plates. The interlocking plates on the smaller shrine are not found on any other example and, indeed, appear to be unparalleled in Insular metalwork. The complex method of assembly seen on the larger shrine with elements pinned rather than soldered in place is a feature noted on many other objects – largely ecclesiastical – including the Moylough belt-shrine (no. 47) and the Derrynaflan paten (no. 125a). The use of imitation chip-carving and the absence of enamelled cells and elaborate glass studs

suggest that the larger shrine should be placed at the end of the series, probably in the ninth century. The secondary binding strip with angular interlace on the front is clearly a later addition. In shape and decoration it resembles the backplates of bone combs found throughout northern Europe dated to the mid-ninth to tenth centuries (Ambrosiani 1981, 23–9, and fig. 35). The same type of angular interlace with dotted background is found as secondary engraved decoration on the back of the brooch from Tara, Co. Meath (no. 77). RÓF

BIBLIOGRAPHY: Murphy 1891–3; Murphy 1892; Coffey 1909, 42–4, and fig. 50; Crawford 1923, 82–3, and fig. 4; Mc Kenna 1931, 41–4; Mahr 1932, pls 9, 10 (1a, b); Raftery (ed.) 1941, 106–7; Blindheim 1984, 33–5, and figs 22–6

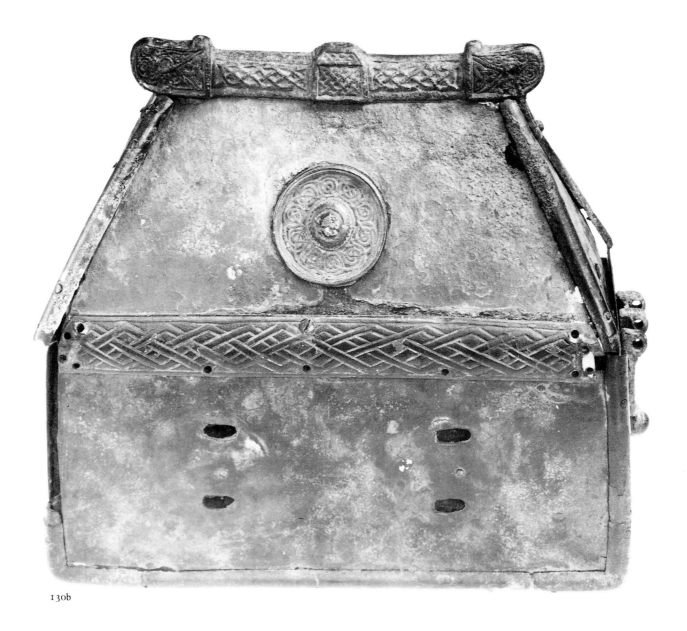

130b

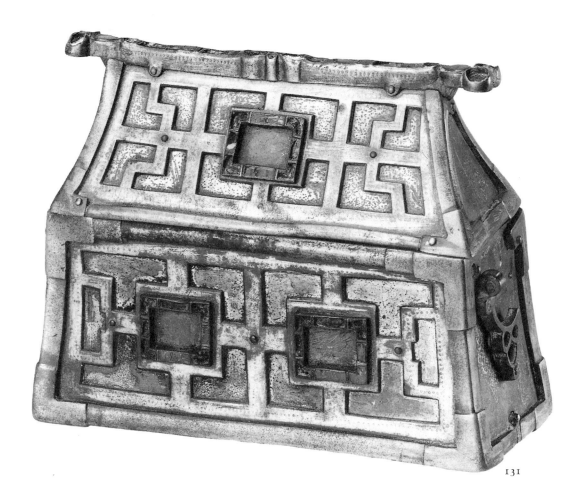

131

131 House-shaped shrine *(col. illus. p. 164)*

Norway

Copper-alloy, tin, enamel, yew wood; base L. 13.5 cm, W. 5.3 cm, H. 10 cm

Irish style, 8th century with 10th-century addition

Nationalmuseet, Copenhagen, Second Department no. 9084

Reliquary in the shape of a house with a pitched roof with gable ends. The box and lid are both hollowed from solid pieces of yew and covered with copper-alloy plates held in position by rivets and a sturdy cast alloy frame along each angle. The hinges are recessed internally and have external triangular plates each backing three rivets on the lid. The frame is thickened at each corner to give the impression of L-shaped reinforcing plates and has cast attachment lugs on the base. Additional decorative grids forming T- and L-shaped cells are riveted to the front of the box and the lid. Small punched circles decorate both grids and frame. The surfaces of the recessed cells are tinned. Only the lower parts of a pair of strap-attachment hinges remain; they are thickly cast with deep recesses, now empty. The tall ridge-pole is a single casting with integral projecting terminals, each of three inlaid lobes. It is riveted in place through external lugs. There is decorative moulding at the centre of the ridge and recesses for red enamel on the upper surface. On the front of the casket are three rectangular mounts with cells for red enamel around their frames; the central settings are missing.

Three circular mounts on the back have plain frames around separate discs ornamented with triple spirals in relief, now worn. The surface plates on the ends and back are filled with ribbon interlace on a hatched background. The back of the ridge is engraved with a narrower form of the same interlace.

The surface of the casket was originally tinned and dark and light copper-alloys deliberately contrasted on the outer framework and openwork grids. The casket was fastened by a rod passed through holes at the top front corners of the box ends, which engaged internal loops from box and lid. The rod has not survived. The base-plate acquired an inscription in Norse runes in the tenth century, *Ranvaik a kistu thasa* ('Ranvaik owns this casket'); four ships' prows and a ring-chain were also incised. In 1968 examination of the contents of the shrine proved that it was in use as a reliquary in the Middle Ages, probably in a church in Norway (Wamers 1985, 106). There is no evidence that the casket has ever been buried. It is not known how it entered the Danish Royal Collection of Art where it was first listed in 1737.

This reliquary is almost the last in a small group of Irish-style house-shaped shrines and is closest in construction and style to the Bologna shrine (no. 132): the heavy framing and hinge construction, the use of overall ribbon interlace on back and sides and the spiral appliqués on the back show a common design tradition. There

are, however, minor technical differences which indicate distinct workshop practices – in particular, the use of cast external lugs to attach the outer frame and ridge on the Norwegian example, and the basic fact that the wooden core is abandoned on the Bologna shrine. Both employ only red enamel in subsidiary decoration, and Ranvaik's casket probably originally had large glass settings of the Bologna type on the front. There are two main stylistic differences: this casket avoids all animal ornament, even on the ridge finials, and also low-relief interlace. The complete absence of animal ornament distinguishes it from all the more complete and elaborate shrines in the group (Blindheim 1984). SY

EXHIBITIONS *ROSC '71: the poetry of vision*, National Museum of Ireland, Dublin, 1971, no. 4; *Middelalderkunst fra Norge i andre Land*, Oldsaksamlingen, Universitetet i Oslo, 1972; *The Vikings*, British Museum, London, 1980; *Irlands Skatte*, Louisiana, Humlebaek, Denmark, 1984

BIBLIOGRAPHY *Antikvarisk Tidskrift*, 1843–5, 220; Petersen 1940, 79; Graham-Campbell 1980, no. 314; Wamers 1985, no. 142; Blindheim 1984, esp. 40–3; O' Meadhra 1988, 3–5

132 House-shaped shrine (*col. illus. p. 164*)

Italy
Copper-alloy, gilt, glass, enamel, iron, ?tin; L. 11.7 cm, W. 4.2 cm, H. 12 cm
Irish style, 8th–9th century
Museo Civico Medievale Bologna, Collezioni Universitarie no. 1998

Complete reliquary box and gabled lid made entirely of metal and once fully gilded. The copper-alloy plates are riveted together and attached to a cast copper-alloy outer frame. Grey areas of metal suggest either tinning beneath gilding, or the use of a high-tin bronze. The frame is reinforced on the front corners with L-shaped plates decorated with red enamel and interlace. The deep cast ridge is soldered into position and separate zoomorphic finials added. Cast interlace on the front of box and lid frames applied mounts. These mounts are alternately round and rectangular, all with heavy cast ribbing on their frames. The lower rectangular ones still hold flat blue glass settings and have distinctive egg-and-dart ornament, while the round mounts have simple running interlace in their frames. The front of the ridge has further interlace and a miniature

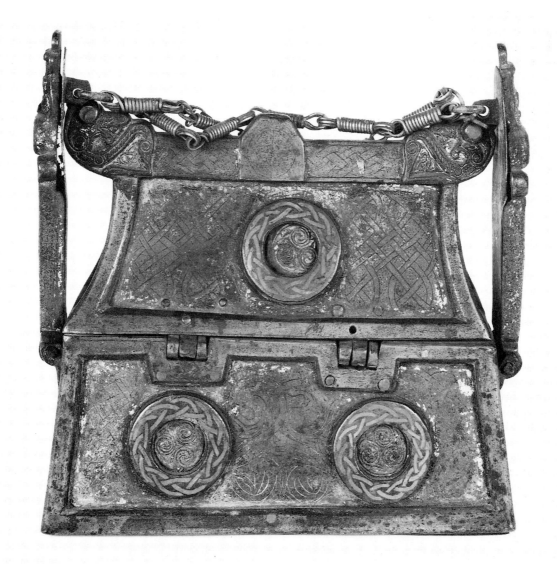

132 *back*

house-shrine shape at the centre; on the back this is engraved with an interlaced cross. Stylised animals with large red enamel eyes and backward-turned heads form the ridge finials. On the front they enclose smaller animals; on the back, triquetras.

The back and sides of the shrine box have engraved ribbon interlace with dotted decoration. Two interlaced animals with fleshy, rounded snouts and limbs are engraved centrally on the back of the box. The three back mounts have flat red enamel and interlace frames soldered on and central discs of trumpet spiral ornament. The carrying hinge attachment plates are lobed and inlaid with red enamel, while long upper plates have geometric interlace and have lost their central settings. Further lobes with red enamel inlay and large blue-green glass settings decorate the upper part of the strap attachment, and at the very top of the plates are stylised animal masks as seen from above. There are backplates to the carrying hinges, and a gap behind the upper part of the decorative plate must once have held the end of a carrying strap, but lugs were subsequently soldered on, probably in antiquity, and a chain (L. 32 cm) of tinned copper-alloy wire links attached by iron rings. Most of the decorative mounts and the carrying hinges are attached by loops which pass through the box and are fixed inside by iron pins. Holes in the upper frames of the short sides show where a rod was originally passed through to engage loops from the lid and box and thus secure it.

This shrine is the most complete of the small group of intact house-shaped reliquaries. It is unusual in having no core of wood (but see no. 130a). The heavy frame with integral recessed hinges, the use of decoration on the back and elaboration of the decorative scheme, with six mounts on the front alone, all indicate a date towards the end of the series near the Copenhagen casket to which it is closest in structure. This relative dating is supported by art-historical considerations – in particular, the style of the different animals shown on the reliquary. The entwined fleshy beasts on the back of the box resemble those on the Monymusk shrine (no. 129) and, more distantly, animals worked on bowl no. 3 from St Ninian's Isle (Small, Thomas and Wilson 1973, no. 3), both Pictish in style. The large animals on the ridge-pole with their distinctive pose and hatched bodies are similar to, but cruder, than those on the back of the Killamery brooch (no. 80) and other brooches of ninth-century date (Blindheim 1984, 19–21). The mask at the top of the carrying hinges is almost Chinese in its stylised ferocity, and is reminiscent of some of the beasts in the Book of Kells, as well as relating to isolated masks reused on Viking weights (Graham-Campbell 1980, nos 307/2, 308/5). All these considerations, including the bold, heavy style of the piece, argue for a ninth-century date. For a discussion of its function see no. 128. It is not known how the casket came into the University collections in Bologna, but it may well have been an early treasure of a north Italian church, like the reliquary from Monte Amiato (no. 128). SY

BIBLIOGRAPHY Blindheim 1984

Shrines, mounts and croziers (*nos 133–49; see also nos 47, 62–8, 156, 212*)

133 Crucifixion plaque

St John's, Rinnagan, near Athlone, Co. Westmeath. Found on early medieval church site
Copper-alloy, formerly gilt; H. 20.75 cm, w. 12.55 cm
Irish, 8th century
NMI R.554

Made of hammered copper-alloy with repoussé, engraved and chased ornament, the plaque may be one of the earliest-surviving representations of the Crucifixion in Ireland. The figure of Christ is greatly enlarged in relation to those of the flanking soldiers and angels. He is shown wearing a long-sleeved tunic with decorated cuffs, hem and vertical bands on the skirt. His breast is covered by a repoussé composition of interlocking peltae and tightly wound spirals, apparently a skeuomorph as false nail heads are depicted on it. The arms and upper part of the shaft of the cross are shown; their concavity and clearly indicated edge-mouldings suggest that they were modelled on a developed sculptural form. The soldiers and angels are shown with their bodies in profile and their heads full face. The cloak and tunic of the right-hand figure (the soldier Longinus) have a border of running scrolls. The cloak bears faint incised lines. The left-hand figure (Stephaton) has an ornamental hem on his tunic and broad decorative stripes on his cloak on which a hood may be indicated. The angels bear interlace, fret and trumpet devices, and their feathers are indicated by herringbone hachures. They hold short swords in their hands.

Thought to have been the decoration for a book-cover, the plaque could just as readily have been applied to a large composite shrine, cross or altar. Often considered to be one of the earliest examples of the mature Insular style, it has been ascribed to the later seventh century. However, its elaboration of the representation of a figured scene seems to place it more firmly in a developed than a preliminary phase. This form of representing the Crucifixion remained traditional in Ireland and areas of Irish influence in Scotland and the Isle of Man for many centuries. MR

EXHIBITIONS *Treasures of Early Irish Art* 1977, no. 29; *Treasures of Ireland* 1983, no. 47
BIBLIOGRAPHY Gougaud 1920, 131; Crawford 1923, 157; Raftery (ed.) 1941, 105–6; Henry 1965a, 114; Lucas 1973, 58, 117, 119, 170; Raftery 1980, 34; Harbison 1984

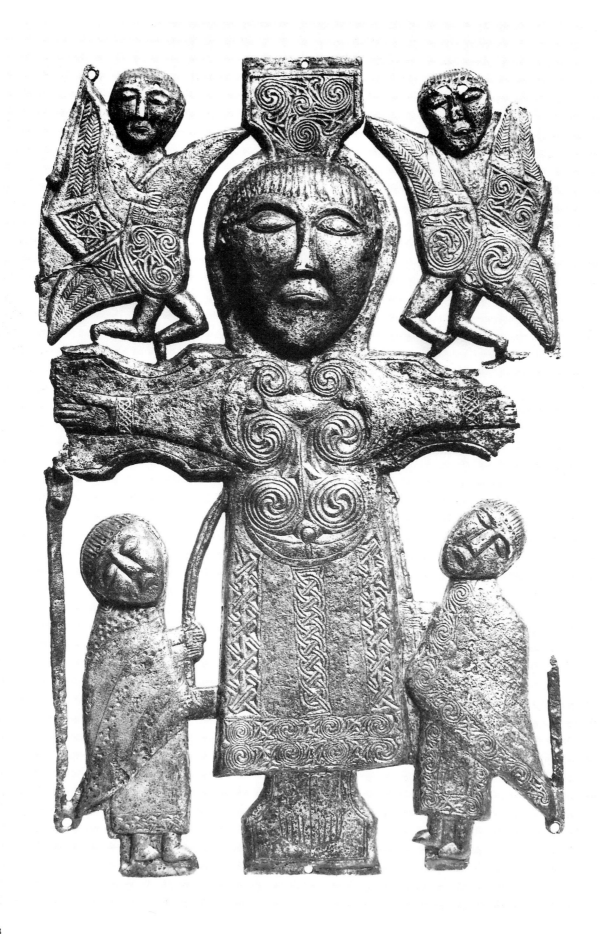

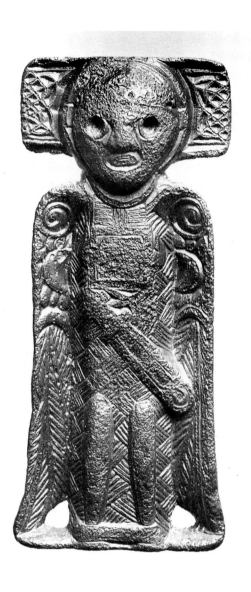

134

134 Angel mount

Rise farm, Oppdal, S. Trondelag, Norway. Found in woman's grave of first
 half of 10th century
Copper-alloy, gilt; H. 6.5 cm, w. 2.8 cm
Irish, 8th–9th century
Universitetets Oldsaksamling, Oslo c646

Cast mount in the form of an angel with a sword diagonally across
the body. The folded wings are marked by spirals, below is a pair of
semicircles, and under these hatched feathers curve out to touch
the ground. A rectangle on the chest has been described as a book
(Wamers 1985, 93), but this is not the usual attribute of an angel.
The trunk is cross-hatched and the legs stand against a cross-
hatched background. A block represents the feet, with holes at either
side for attachment, not necessarily original. The head is almost
circular with an outer frame running round to form a collar round
the neck. The eyes are deeply recessed, probably for inlay; the mouth
is almost rectangular. Behind the head is a decorative band of
faceted interlace, the design is incomplete and runs off to left and
right.

This figure, like a nearly contemporary figure of an ecclesiastic
from Aghaboe, Co. Laois (Ryan (ed.) 1983, 46, pl. 32), was probably
one of a number decorating a shrine, like the much later examples
on St Manchan's shrine, Boher, Co. Offaly. The decoration behind
the angel's head was presumably continued on other mounts. The
figure with wings and sword perhaps represents one of the cheru-
bim, the highest order of the angels who guarded the gates of
Paradise alongside the flaming sword after the Fall (Genesis 3:24),
or alternatively a seraph. Seraphim were portrayed with multiple
wings, as described by Isaiah (6:2–7), but in early depictions usually
have no bodies. The angels on the Athlone plaque (no. 133), with
three pairs of wings and swords, belong to this Old Testament
iconographic tradition. It could be that the descending spirals, semi-
circles and small arches on this angel's folded wings indicate three
pairs. Later tradition armed the archangel Michael with a sword.
There was a strong cult of angels in early medieval Ireland. SY

BIBLIOGRAPHY Petersen 1940, 62–3; Mahr 1932, 145, pl. 24.2; Wamers
1985, no. 32

135 Weight

Near Furness, Lancashire
Copper-alloy, gilt, lead; H. 3.9 cm, w. 3.5 cm, WT 126.3 g
Irish or Northumbrian, 8th century, 9th- or 10th-century modification
BM, MLA 1870,6–9,1, gift of R. Hinde

Hollow copper-alloy casting of the front of a head, a mask extending
from just behind the ears and half the crown. At the top is an
ungilded circular recess. The hair is represented by fine grooves
running down to a row of chevrons and terminating in a tightly
scrolled fringe of curls parted in the centre. Eyebrows and full facial
beard are finely detailed. The ears are free-standing and with a
pelta detail, the mouth is downturned, and the eyes are large and
originally inlaid. Much of the original gilding has been worn off and
parts of the crown and cheek are damaged. A solid plug of lead fills
the back of the head, undercut and shaped into a cushion-like base.

This head, like the Ixworth one (no. 136), must once have formed
part of an impressive piece of ecclesiastical furniture. The recess at

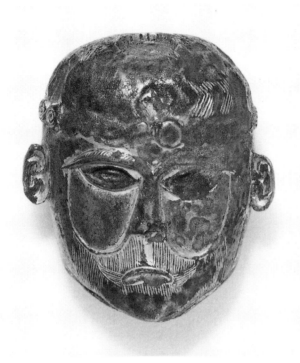

135

136

the top implies that the whole figure was fitted into a niche or frame, the rest being half round. The ears and stylised facial hair recall the crucified Christ figure from Hofstad, Norway (Wamers 1985, no. 24), but in detail it most closely resembles those at the corners of the St Germain mounts (no. 138) where the same lozenge space is left between the central fringe curls. St Mark on the Lichfield Gospels is a good manuscript parallel of eighth-century date. A bearded head appears in miniature on the Markyate mount (no. 116) and may in the case of the Furness piece represent a saint, if not the figure of Christ. It suffered the same fate as the Ixworth find – reuse as decoration on a Viking-period weight. SY

BIBLIOGRAPHY Henry 1965a, 113–14, pl. 69

136 Weight

Ixworth, Suffolk
Copper-alloy, gilt, lead; L. 3.2, W. 2.0 cm, H. 2.1 cm, WT 100.825 g
Irish, 8th-century, head adapted as a weight in 9th or 10th century
St Edmundsbury Museum Service (Moyse's Hall Museum), Bury
St Edmunds 1987-27.1

Gilded casting of a bearded head with stylised fringe below a band and curling locks behind the ears, the beard and moustache trimmed and groomed. The heavy eyebrows and the nose stand out from the plane of the face. The nose tip is missing. The lead base added in the Viking period is undecorated.

The fillet above the brow may indicate a tonsure or head cover; the metal beyond is smooth in contrast with the Furness head (no. 135). While the mask-like quality of the representation is common to both, the stylisation is very different and resembles most closely the head of the crucified Christ on a mount found at Hofstad,

Norway, where hair, beard and ears are depicted in much the same way (Wamers 1985, no. 24). The Ixworth head is about half as big again as the Hofstad one. It is not possible now to see if it was originally fully in the round but it was probably mounted flat like the Furness example and the heads on the later Lismore and 'Kells' croziers. The original function is uncertain – the head may have come from a shrine. Many fine fragments of Irish metalwork were reused to decorate Viking weights such as those from Islandbridge, Ireland (Graham-Campbell 1980, 89, pl. 308), and the Furness head. The face must have added authority to the weight and epitomises the dispersal of fine Irish metalwork through the trading networks of the Viking world. SY

BIBLIOGRAPHY *Proceedings of the Suffolk Institute of Archaeology and History,* XXXVI (1988), 310, pl. XIXa

137a–c Bell-shrine fragments *(col. illus. p. 165)*

Ireland
Copper-alloy, gilt, white-metal plating, amber; (a) L. 13.2 cm, W. 5.96 cm, TH. 3.36 cm; (b) L. 4.0 cm; (c) DIAM. 1.64 cm
Irish, 8th–9th century
NMI 1920:37a–c, Chapman Collection, ex Killua Castle Collection

(a) Generally presumed to have been the crest of a bell-shrine – that is, the part of the reliquary designed to accommodate the handle – this object is D-shaped in outline, the two main faces being semicircular and the side being a broad, plain groove between vertical rims. Projections from each side of the rims bear large, cast tubular lugs for suspension. It is heavily gilt and silvered in places on one face, and only silvered on the other. On the gilded face there is an enigmatic composition partly in openwork, its main element

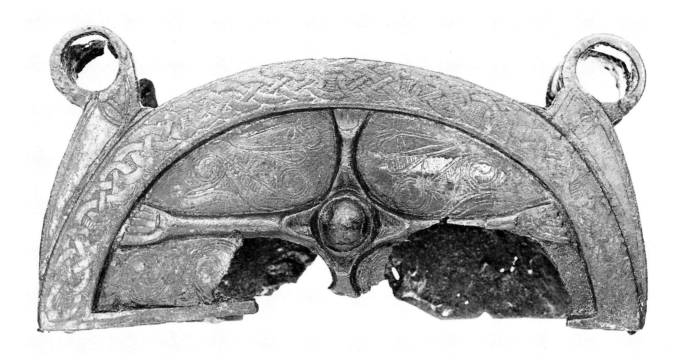

137 *back*

consisting of a stylised *orant* human figure flanked by long-necked beasts which appear to be whispering into his ears. On either side of the man is a roundel divided by a cross into panels of faceted knotwork. In the centre of each cross is a low amber stud riveted in place. The man appears to be wearing a hood or cowl indicated by a sharp lozenge-shaped ridge about the face; his ears, however, protrude through it. His body is divided by a moulding into two panels, each in turn divided vertically with plain incised triangles showing against a hatched background. His arms are short, the hands are simply indicated, and the arms spring awkwardly from the shoulder. The foreparts only of the beasts are shown: their legs are bent up towards their faces; their necks and cheeks are hatched; and their joints are indicated by spirals. Trumpet scrolls occur on their lower jaws, and at the joint spirals.

The reverse is differently decorated. The edge of the plate is marked by a broad, flat moulding in low relief with plain two-strand interlace against a hatched background. The inner part of the plate is recessed and is divided into four panels by a cross of unusual design. It is in relief and formed of four human arms, palms upwards with the fingers towards the edge. The ends of the arms towards the centre are markedly cusped, and in the middle of the crossing is a round amber stud in a plain setting. One arm is broken off. The upper two background panels formed by the arms contain incised animals with backturned heads, long snouts and forelegs bent back under their bellies. Their joints are indicated by tightly wound spirals. Lentoids form trumpet scrolls on their noses, trunks and legs. The lower panels are now very badly damaged, but sufficient survives of that on the left to show an elaborate composition of tightly wound spirals, trumpet devices and triskeles seen against a hatched background.

Three of the projections bearing the lugs are half crescents, one

is semicircular. All are silvered on their outer aspects and all have incised borders, the longer examples having, additionally, engraved lentoids.

The crest was attached by means of internal riveted tags to the rest of the object. A surviving fragment of a copper-alloy plate attached inside may have been a backing for the openwork.

While it is by no means certain what the object was originally, it is likely to have formed part of a shrine, most probably a bell-reliquary. The ornament is accomplished but not the finest of its time. The attitude of the beasts shown on it, the use of amber, the absence of enamels and glass, the double-contoured imitation chip-carved knotwork of one of the roundels all might suggest a date after the high point of eighth-century accomplishment, perhaps in the earlier part of the ninth century. The openwork figure composition may have its origin in the Daniel – and related – buckles of the Burgundian and neighbouring regions in the later sixth and seventh centuries. Iconographic parallels suggest that it is intended to represent Christ between two living things as described by the prophet Habakkuk.

(b, c) A small gilt copper-alloy, originally square, plaque is said to have been associated with the piece. It bears a saltire cross, the arms ending in settings for amber studs, one of which survives. A large amber stud occupies the centre. Between the arms are high-relief scrolls. The third fragment is an amber stud in a gilt copper-alloy setting with two right-angled fragments of rim-moulding projecting.

EXHIBITION *Treasures of Ireland* 1983, no. 59 MR

BIBLIOGRAPHY Armstrong 1921; Crawford 1923, 163; Mahr 1932, 56; Raftery (ed.) 1941, 99, 121–2; Henry 1965a, 114–15, 254; Werner 1978, 526

138a,b Pair of mounts *(col. illus. p. 166)*

UNPROVENANCED

Copper-alloy, gilt, modern wooden base; 20.7 × 10.0 cm, TH. 2.6 cm

Irish, late 8th–early 9th century

Musée des Antiquités Nationales, St Germain-en-Laye, France, 52.748(a)
 and (b). Acquired 1909 from the collection of Victor Gay

Each of these identical mounts is composed of three gilt-bronze plates – two are asymmetrical and D-shaped, held together on a (modern) wooden base by a third rectangular fixing plate with modern screws. Decoration on the mounts forms a mirror-image, virtually identical except for minor details. The principal faces have cast imitation chip-carved ornament of bosses topped with triskeles which spiral downwards into a swirl of snakes in bold relief; variously equipped with human, bird and beast heads, these bite and twine with one another's bodies against a background of geometric interlace and spiral ornament. Almost in the centre of each face is a slotted circular fixing of unknown function. The secondary faces have elaborate spiral decoration with trumpet scrolls and triskeles in openwork, the details lightly incised. Each rectangular plate has settings for inlays (now empty), and panels of interlace, geometric ornament and animal motifs; they terminate in a pair of beast heads modelled in the round (one now missing).

The history of these extraordinary objects is unknown prior to their appearance in Victor Gay's collection. Their original function, for long a source of diverse speculation, is now generally accepted to have been as paired finials to the gable end of a massive house-shaped shrine, following Hunt's original identification (Hunt 1956, 153–7). Bakka has since shown that two badly damaged similar fragments from a rich Viking woman's grave at Gausel, Norway,

are from the same model; it thus seems possible that the Gausel fragments come from the corresponding finials at the other end of the gable (Bakka 1965, 39–40). The shrine was presumably dismantled during the Viking period, when one pair of finials went north, eventually to be buried in Norway; the good condition of the St Germain pieces suggests, however, that they were never buried but remained in safety until their eventual re-emergence in a collection in France.

The swirling boss and snake-relief decoration recalls pieces such as the Romfohjellen mount (no. 139); while the combination of human and animal heads and fine geometric interlace suggests comparison with objects such as the Co. Cavan and larger Ardagh brooches. A date near the beginning of the ninth century seems likely. LW

EXHIBITION *Trésors d'Irlande*, Galeries Nationales du Grand Palais, Paris, 1982–3, nos 93–4

BIBLIOGRAPHY Henry 1938, 65–91; Hunt 1956, 153–7; Bakka 1965, 32–40; Haseloff 1979, 239–40

139 Mount fragment

Romfohjellen farm, Sunndal, Møre and Romsdal, Norway

Copper-alloy, gilt, amber and glass; L. 8.8, w. 4.8 cm

Irish, early 9th century

Universitetets Oldsaksamling, Oslo, c.6185

Rectangular cast gilt-bronze fragment with high-relief decoration and glass and amber inlays. The mount has been cut off at one end; the surviving original edges form a deep frame enclosing a

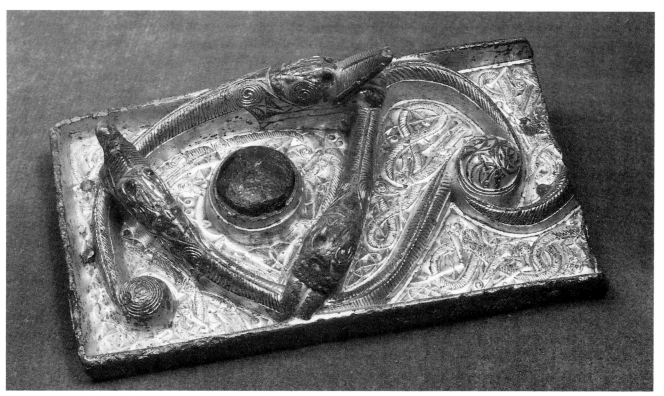

139

curvilinear pattern of lizard-like creatures in bold relief which swirl out from three bosses, two of bronze and one of amber. The creatures rear up and snap at one another with gaping jaws: their forelimbs rest on each other's backs and their eyes are set with blue glass. They are set against a background of geometric interlace and intertwining animals with ribbed bodies.

The mount is probably from a Viking-period cremation. It has no certain associations. Its strong, animated decoration is clearly linked to the St Germain mounts (no. 138), through its combination of bold relief and swirling bossed ornament – a three-dimensional zoomorphic translation of traditionally flat, abstract spiral motifs. The background of dense animal ornament resembles that on the Phoenix Park mount (no. 145). A date in the early ninth century is likely. LW

BIBLIOGRAPHY Petersen 1940, 61, pl. 67; Graham-Campbell 1980, no. 313; Wamers 1985, no. 37; Haseloff 1987, 52–5

140 Decorative boss (col. illus. p. 167)

Steeple Bumpstead, Essex
Copper-alloy, gilt, niello; H. 3.6 cm, DIAM. 12.8 cm
Irish, first half of 8th century
BM, MLA 1916,7–5,1; gift of H. Oppenheimer

Cast hemispherical boss with a flange, half of which is now missing. The flange has a plain outer rim and originally eight cast panels, each of four trumpet spirals, divided by alternating oval and circular gem-settings and bordered on the inner edge by a plain rectangular step. The boss itself is divided into three principal concentric ornamental zones, the first two richly ornamented, in ascending order, with animal interlace and then trumpet spiral ornament. Four beasts cast in the round divide these bands of ornaments into four segments and further large settings subdivide the panels. Each beast rests its jaws against a raised circular collar of deep rectangular settings, some filled with niello in which traces of three inlaid patterns remain, although much of the niello surface is damaged. Inside this collar are four plain recessed panels divided by circular settings; these gilded but undecorated spaces must once have held filigree or other foil panels, and a few 'stitches' remain for holding the foils in place. A high ribbed collar around a central void (average DIAM. 2.4 cm) must originally have held a large gem such as a cabochon of crystal or amber. Use in modern times as a backplate to a church door-handle would account for the lopsided wear on this ribbed collar.

Of the multiple attachment holes through the flange the original ones are probably those behind the large circular settings and the ovals below each three-dimensional beast, where the holes are large, worn and recessed at the back. The inside of the boss shows that the model of lead or wax from which it was cast was constructed in more than one stage. There is a hollow behind each of the four animal ribs with locating v nicks on each side where four separate animal castings were incorporated into the undecorated boss model. The zigzag, 'rocker' action around one of these shows that it was let in as a replacement and the join worked over on the model. The four beasts were not set exactly at right angles, and the small variations in length in the animal interlace panels around the bottom of the boss show that this ornament was skilfully adjusted to accommodate the slightly different panel lengths this error

produced, and also, therefore, that they were worked after the beasts were in place.

The pairs of animals which interlace in the panels around the base of the boss dome have many stylistic features in common with other metalwork and manuscripts dating from c. 700 and later in the eighth century; the curling crest or 'lappet', spiral-hip joints, ball-and-claw feet, bold hatching of the body within a linear outline – all these features can be seen, for example, on the ornament of the 'Tara' brooch back panel (col. illus. p. 77), the front of the Cavan brooch (no. 73), the Londesborough brooch (no. 71) and on the two-dimensional animals on the Romfohjellen mount (no. 139), while the late seventh-century animals in the Lindisfarne Gospels are close (and dated) in another medium (Kendrick et al. 1960, 201–6). The Steeple Bumpstead spiral ornament shows the evolution of the internal scrolls of the triskele into animal or bird-like heads, again a feature of ornament on the back of the 'Tara' brooch and of the Donore disc 2 (no. 64), and well known from Insular manuscripts (Kendrick et al. 1960, 207–8).

This boss must have been a most brilliant piece when in pristine condition, thickly gilded and the whole piece dominated by glass or amber in the now empty settings, twenty-four minor and one major. A comparable gilt mount with intact pointed oval settings uses eye-catching glass cabochons (no. 141), while amber settings are used on circular and oval settings on the 'Tara' brooch and other contemporary luxury metalwork. The large central setting could have been rock-crystal, on the analogy of the stone beneath the foot of the Ardagh chalice and the Crieff mounts (no. 117); but although there are no close parallels to the decorative scheme of the Steeple Bumpstead boss, a much smaller boss from Flahammer, Norway (Wamers 1985, no. 57), bears two concentric orders of ornament, one of which is of spirals, which are divided into four segments by raised (possibly zoomorphic) ribs ending in tear-drop settings. This boss has a large cabochon amber setting in the centre.

The exquisite animal and spiral designs which now attract the eye on the Steeple Bumpstead piece were once secondary background elements in the design, less eye-catching probably than the missing filigree or embossed panels from the top. The niello inlay is unparalleled in association with filigree work of the period (personal observation by N. Whitfield), and it is tempting to speculate that the rectangular cells originally held amber, as on the front of the 'Tara' brooch, before being replaced in antiquity, but niello is present on other contemporary pieces. The four highly stylised beasts, now bare of much of their gilding, deserve attention: their bodies are in the round with long stiff legs each ending in a three-toed foot, and the tail of each curls forward to form a flat loop, three of which survive. The loops look worn, as though used for small attachments, but given the present condition of the boss and its chequered history it is difficult to be certain that this reflects use in antiquity. The animals have rounded ears, now flat, large oval eyes (misread in Smith 1915–16, fig. 5, and Small, Thomas and Wilson 1973, vol. II, fig. 23a) and blunt, now worn, snouts. Hips are decorated with spirals with further curvilinear patterns on the face; neck and flanks have a strong, low-relief pattern of striped crescents representing a stylised mane. Minor casting differences distinguish two pairs of animals. Despite their frog-like appearance, Smith's identification as lions must be correct. He mentioned the flattened dog-like beast in the chi-rho page of the eighth-century Stockholm gospels (Stock-

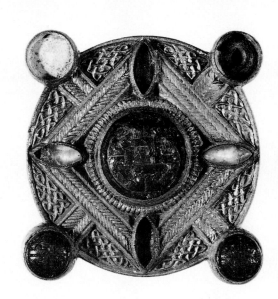

141

holm, Royal Lib. A135, f. 11; Alexander 1978, pl. 152), but the best parallels in contemporary metalwork are the two sets of four beasts rearing up from a flat mount found at Meløy, Nordland, Norway (Wamers 1985, no. 8), whose flanks bear similar manes. Much might be said about the symbolism of the four lions on the boss, but it is worth noting the particular Irish preference for putting four lions around Daniel on the scriptural crosses, as at Ahenny North and on three of the Kells crosses.

The whole boss is a piece of exceptional quality in both the fineness and ambitious nature of the basic cast ornament. There are several detached bossed shrine mounts, many of them found in Norway (for example, Wamers 1985, nos 23, 109, 127 and 129), but none matches the original complexity and polychrome appearance of the Steeple Bumpstead piece. It was said to have been found during the construction of a vault in the east end of St Mary's Church and was later removed from a chest in the vestry and attached to the chancel door where its presence was noted in 1842 (Smith 1915–16). SY

BIBLIOGRAPHY Smith 1915–16; Smith 1923, 137–40, figs 184–6; Henry 1965a, 99, 106, 109, pl. 43; Wilson in Small, Thomas and Wilson 1973, vol. I, 136–7; vol. II, fig. 39

141 Decorative mount

Ireland
Copper-alloy, gilt, glass, ? base silver, disc DIAM. 3.9 cm, max. W. 5.3 cm
Irish, 8th–9th century
BM, MLA 1920, 10–22.1, Chapman Collection, ex Killua Castle Collection

Circular disc with four projecting settings for dark blue glass studs with recessed stepped pattern on surface (two now missing). A raised, larger blue stud fills the centre, its surface damaged but bearing traces of base silver inlay in a recessed pattern forming L-shaped and rectangular cells. This stud sits in a plain collar above

a ribbed one and is framed by a rectangle with cast imitation filigree chevron and oval corner settings in which two slightly opaque glass cabochon settings remain. Extensions from the rectangular frame link it to the outer blue studs. The rest of the field is filled by panels of interlace. The back is recessed with a sturdy rectangular shank (L. 1.5 cm) projecting from the centre and pierced by a large subrectangular hole at the outer end.

This mount shows the polychrome effect of some inlays alongside the boss from Steeple Bumpstead which has similar oval mounts, all empty. The interlace ornament and imitation filigree plaitwork on this piece are from a broadly based Insular repertoire, only the probable Irish find-place indicating Irish manufacture. The long and sturdy shank shows that this mount was attached to a thick piece of wood, such as a shrine panel or casket, by passing the shank through a hole in the wood and securing it with a pin on the inside. This would allow reuse and repair. It is a very common means of attachment, used, for example, on the house-shaped shrines (nos 128, 129).

The extensive collection held at Killua Castle included the bell-shrine mounts (no. 137). Most of the material seems to have been acquired locally and on the estate. SY

BIBLIOGRAPHY Hencken 1950, 130–1

142 Hemispherical boss

Clonmacnoise, Co. Offaly. Found on monastic site and procured by Dr George Petrie
Copper-alloy, gilt; DIAM. 4.7 cm, H. 1.7 cm
Irish, 8th century
NMI P.1245, Petrie Collection

Hollow cast hemispherical boss, the gilding on the raised surfaces is worn away. There is a slight flange at the bottom which also shows traces of wear and which contains three unevenly spaced

rivet holes. At the top is a raised setting for a stud, now empty. This is surrounded by a collar decorated with hatching. The curved surface is ornamented with a continuous pattern of linked curvilinear elements, consisting of three triskeles with rounded or trumpet-shaped terminals. These are joined by a complex series of trumpet patterns with pointed oval bosses. Some of these elements are diagonally hatched.

Described by Raftery ((ed.) 1941, 103) as perhaps the base of a chalice, the recent discovery of the book-shrine from Lough Kinale, Co. Longford (Ryan and Kelly 1987), shows that it must have formed part of a similar object. The book-shrine cover is ornamented with five bosses arranged in the form of a cross which are almost identical in size and decoration with the Clonmacnoise example. The hemispherical shape is also reminiscent of the bosses of high crosses, and ornamented metal crosses of the period are known (Harbison 1978). The Clonmacnoise boss is undoubtedly of Irish manufacture, but similar objects were being produced in Britain, examples of which are known from Viking graves in Norway (Wamers 1985, no. 45). RÓF

BIBLIOGRAPHY Mahr 1932, pl. 18, 4; Raftery (ed.) 1941, 103

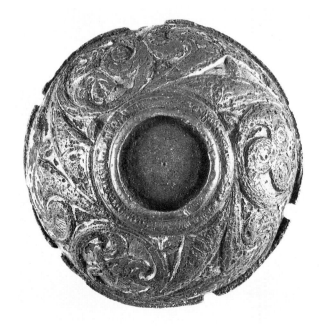

142

143 Decorative mount

Norway
Copper-alloy, gilt; L. 7.5 cm, H. 3.1 cm
Irish, 8th century
Nationalmuseet, Copenhagen, Prehistoric Department no. 624

Hollow casting, in the form of a tetrahedron but faceted to give intermediate surfaces. The top is truncated and has a disc with a deep rim flanked by three lobes. The central ornament consists of three trumpet scrolls with an additional central scroll making an asymmetric design. The three tapered panels on the shoulders of the mount also have roundels of scrollwork, all different, but here in a flat style with fine line decoration and a more zoomorphic style. The long side panels each have a central ribbed stud which, combined with a tight pair of symmetrical scrolls, resembles a face-mask. Interlace fills the panels. The mount corners are concave, presumably to fit further panels of decorative metalwork, suggesting it was once part of a fitting for a substantial box.

This mount is of interest because of its unusual pyramidal form. A number of hemispherical bosses also have decoration divided into three major zones (for example, a boss from Valle, no. 144). The discs of curvilinear ornament are noteworthy because they combine the 'traditional' late Celtic trumpet forms, often described as Durrowesque, and the flatter style, almost openwork in effect, which can be seen developed in the Lichfield and Kells decorated gospel books. This serves as a reminder that style could be a matter of choice and need not be a firm indicator of date. Paired, finely wound spirals have a zoomorphic dimension in the Book of Durrow and are particularly dominant on the opening decoration of St Mark's Gospel. In metalwork a similar design is used on a truncated rectangular pyramidal mount from Vikesdal, Norway (Wamers 1985, no. 103). The motif of a circle flanked by three lobes is also found on eighth-century annular brooches, such as the Breadalbane (no. 72), and related examples, which suggests an eighth-century date for this piece. The mount presumably came to Norway, like nos 131, 134, etc., as Viking loot. SY

BIBLIOGRAPHY Wamers 1965, no. 141

144 Mount

Valle, Aust-Agder, Norway. Said to have been found in 1843 in a grave, probably at the vicarage
Copper-alloy, gilt; DIAM. 6.7 cm, W. 2.9 cm
Irish, 9th century
Universitetets Oldsaksamling, Oslo c. 30540

Hemispherical boss of cast copper-alloy, divided by narrow ribs into four principal fields: a central subtriangular field terminating in semicircular fields at the end of each arm, surrounded by three side panels. Each main panel has a circular central setting (now empty), the lateral ones descending from the central field's borders by means of a curved triangle. The whole surface is decorated with sinuous intertwining animals with long snouts and median lines.

The boss is likely to have come from a large shrine. Its distinctive decoration links it to the horse-harness mounts from Gausel, Rogaland, and like some of the other finds from that rich grave, it must represent Viking loot from an Irish monastery. LW

BIBLIOGRAPHY Petersen 1940, 26; Bakka 1965, 39, pl. 3; Wamers 1985, no. 109

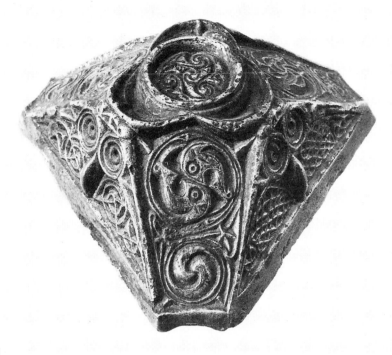

143

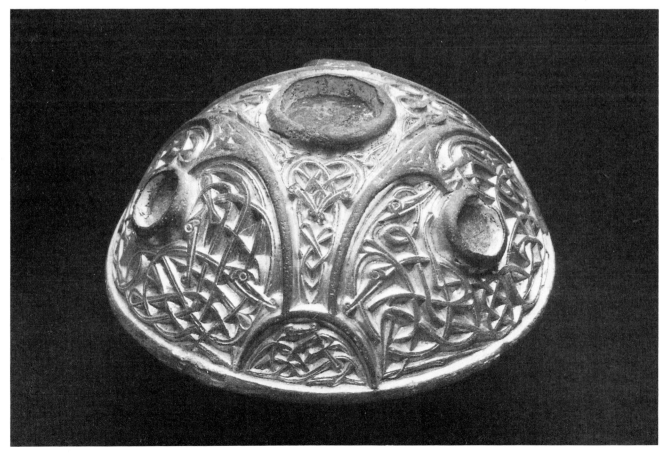

144

145 Openwork mount (col. illus. p. 167)

Phoenix Park, Dublin
Copper-alloy, gilt; straight side L. 8.2 cm, TH. 1 mm
Irish, 8th century
NMI P. 782a, Petrie Collection

Triangular mount of cast, gilt copper-alloy with two straight sides, the third concave. The front is decorated with an openwork design of spirals and zoomorphic interlace surrounded by a plain border. It has been cut at each narrow end. The back is plain except for incised lines around the edge of the central roundel. There are four nail holes for attachment to a backing – two large perforations at the centre of the curved edge and at the right-angled corner and two smaller ones at each narrow end. The design on the front is dominated by an openwork roundel occupied by a three-legged whirligig, the spaces between having crescent shapes connected by lentoid devices to the frame. At the centre of the whirligig is a triple spiral connected by trumpet shapes. The legs of the whirligig and the crescent shapes are diagonally hatched.

On either side of this are pairs of addorsed animals facing inwards towards the roundel. They have hatched, double-contoured bodies, spiralled hip-joints, round eyes and long, thin jaws with ribbed and spiralled snouts. The fore and hind legs are attenuated and interlaced, the bands of interlace having a v-shaped central groove. The lappets extending from the back of each animal head are executed in a similar manner. There is a third animal in the narrowest portion of each side of the same character as the others. The clipping of one end has removed the animal head which may, however, have continued on to an adjoining mount. A single spiral and interlace occupy the space between the roundel and the angle of the piece.

Stokes (1894, 111) gives the find-place as Clonmacnoise, but the entry in the Petrie Collection manuscript catalogue gives the provenance as the Phoenix Park in Dublin. This formed part of one of the Viking cemeteries of Dublin, and a smaller mount of the same shape as this example was found here in the nineteenth century (Hall 1974) adapted as a brooch.

It has always been assumed that this mount was attached to the corner of a book-cover in the same manner as the eighth-century Hiberno-Saxon mountings on the Codex Bonifatianus 1 at Fulda (Wilson 1961, pl. XXXVI). This is a very attractive hypothesis, but the mount could equally have been attached to a book-shrine or portable altar.

The quality of the work on a casting as thin as this is exceptional and may be compared with that on the Donore disc (no. 63). In particular, the curved hatching on both is strikingly similar. The animal ornament is quite different, however. The chip-carved bands with central groove are an exceptional refinement of the technique and occur on only one motif piece, the reused axehead from Mul-laghoran, Co. Cavan (O'Meadhra 1979, no. 133). On metalwork it is confined to a small group of objects: on the large brooch from Ardagh (no. 76), on one of the brooches from the St Ninian's Isle hoard (no. 104), and on some of the harness mounts from Gausel in Norway (Wamers 1985, no. 90). Perhaps the closest parallels for the combination of elements, imitation chip-carving with v-shaped central groove, long-snouted animals with curving hatched bodies and spiral ornament, are to be found on a mount from Seim, Norway (Wamers 1985, pl. 16,5), and on the Londesborough brooch (no. 71). RÓF

BIBLIOGRAPHY Stokes 1894, 111, and fig. 50; Mahr 1932, pl. 50, 2; Raftery (ed.) 1941, 141

146 Decorated plaque

Inchbofin Island, Co. Westmeath (Lough Ree, river Shannon)
Copper-alloy, glass, formerly gilt; 9.25 × 9.32 cm, max. TH. 1.08 cm
Irish, probably early 9th century
NMI 1981:295

A heavy casting roughly square in shape, most of the front is occupied by a low, truncated pyramid with a setting, which is not centrally placed. The edge is defined by a pronounced flange. The reverse is plain and hollow. Three holes are drilled through the metal, one on each side of the pyramid and one beneath the central setting. The front is heavily decorated with animal ornament in low-relief casting. A procession of beasts surrounds the pyramid and these are shown as crouching: they have hatched ribbon-like bodies, long snouts, forward-pointing fore and hind legs lifted across the back. Each grasps the trunk of the beast in front of it. In many cases a tail is shown. On two sides the design is cramped because of the mispositioning of the pyramid. The top of the pyramid is divided into four sunken panels by a cross of four arcs of rope-moulding, in the centre of which is a square setting now distorted to hold a round blue glass stud. In the sunken panels are two motifs of single contorted beasts and two of pairs of beasts with crossing necks. Variations of key patterns decorate the side of the pyramid.

The purpose of the object is unknown but it was presumably designed to be attached to a wooden background, perhaps a large cross or altar decorated with metal plates.

The layout of the border of animal ornament recalls the decoration of the Book of Durrow and pieces of the earlier eighth century where beast processions occur. Details of the animal ornament are closely comparable with that on the plate of a buckle from the Islandbridge Viking-Age cemetery.

The plaque was found in a church on an early monastic site. Other metal objects, including what may be the foot of a large shrine, were found at the site during conservation work in 1911–12 (de Paor 1962). MR

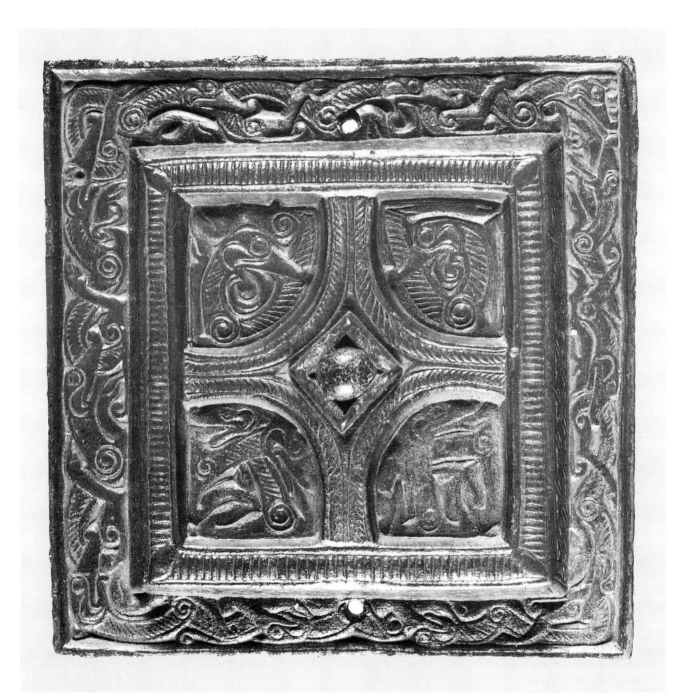

146

147

147 Terminal, probably from a crozier

Helgö, Ekerö, Uppland, Sweden
Copper-alloy, glass and enamel; H. 9.3 cm
Irish, 8th century
Statens Historiska Museum, Stockholm, Z5075:1000

Copper-alloy socketed crook, inlaid with yellow enamel in key and lozenge pattern, blue glass settings and inlaid glass studs. The crook consists of an open-jawed creature disgorging or biting on a human head. Subsidiary beasts unfurl from its back.

From the mainly pre-Viking manufacturing and trading settlement at Helgö, Sweden, which was the immediate predecessor of Birka (see no. 120). The crook is one of a number of splendid and exotic objects – including an eastern Mediterranean ladle and a north Indian bronze Buddha – which made their way to this prestige site. Although, as has been pointed out (Graham-Campbell 1980, no. 315), it bears little resemblance to identified Irish croziers of the eighth to eleventh centuries, its resemblance to the later Aghadoe finial and their shared Jonah iconography (Werner 1978, 519–30) suggest that Holmqvist's original identification as a crook is correct.

I.W

EXHIBITIONS *Sveagold und Wikingerschmuck*, Mainz, 1968; *The Vikings*, British Museum, London, 1980
BIBLIOGRAPHY Holmqvist 1955; Werner 1978; Graham-Campbell 1980, no. 315; Bourke 1987, 1–8

148 Crozier drop and ferrule

Churchyard at Shankill, near Belfast, Co. Antrim
Copper-alloy, gilt, amber; drop H. 5.4 cm, crook DIAM. 2.5 cm, ferrule
 L. 5.7 cm
Irish, late 8th–9th century
NMI 1893:19,20, Bateman Collection, ex Carruthers Collection

Two portions of a crozier: the drop (1893:20) and an incomplete ferrule (1893:19). They both have pitted surfaces and much of the detail is now missing. The drop is cast in one piece with a portion of the crook. The latter is circular in cross-section with a raised border at the open end decorated with a band of two-strand interlace. This decorated border continues along the crest of the crook and around the sides of the drop. The rest of the crook and back of the drop are otherwise plain. There are six rivet holes around the open end for attachment to the remainder of the crook. The drop itself is wedge-shaped in outline with a semicircular upper edge. It is framed by a raised band of three-strand ribbon interlaced with L-shaped cells at the lower corners. This border encloses a panel of double-contoured ribbon interlace which surrounds a rectangular amber stud with convex surface. The base of the drop is D-shaped and plain.

The ferrule is circular in cross-section with a biconical base which flares outwards at one end and is divided into horizontal rows by a series of plain ribs. The wider end contains three rivet holes for attachment which pierce the decorated surface. The biconical element is decorated with a frieze of triskele devices, while the flared element bears bands of interlace.

These fragments are decorated with spirals and imitation chip-carved interlace similar to the crozier ferrule from the Petrie Collection (no. 149). Comparisons have been drawn between the

148

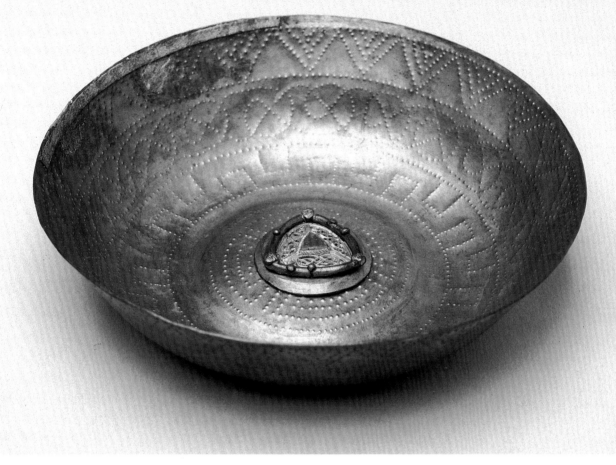

Above 97 St Ninian's Isle hoard, bowl no. 6.

Below 99–101 St Ninian's Isle hoard, set of mounts.

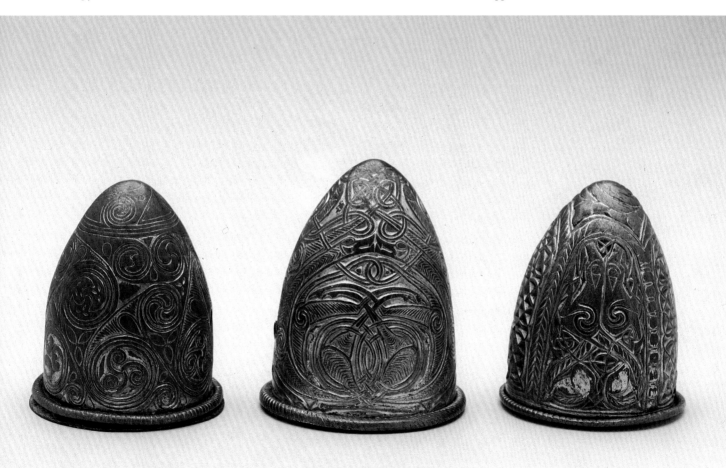

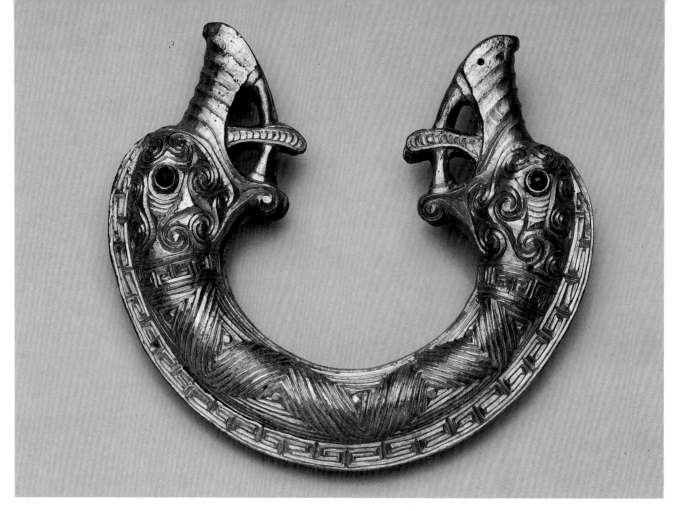

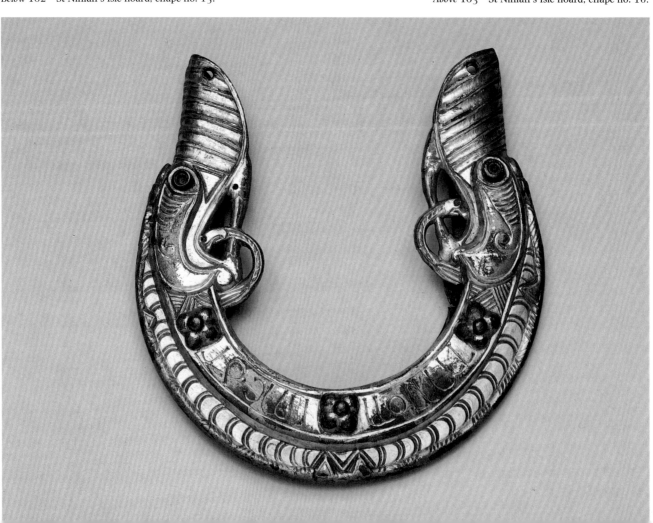

Below 102 St Ninian's Isle hoard, chape no. 15.

Above 103 St Ninian's Isle hoard, chape no. 16.

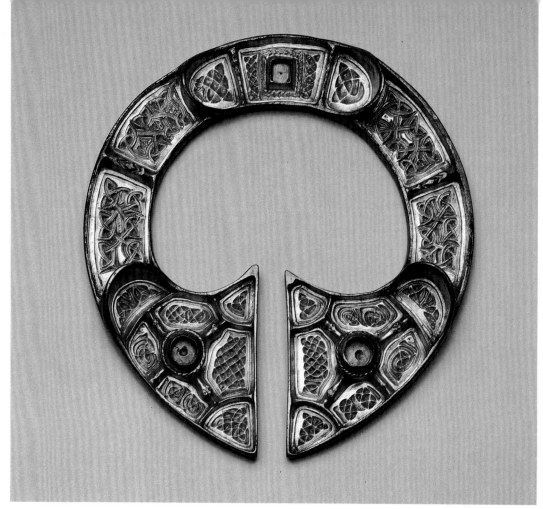

Above 104 St Ninian's Isle hoard, brooch no. 17. *Below* 105 St Ninian's Isle hoard, brooch no. 19.

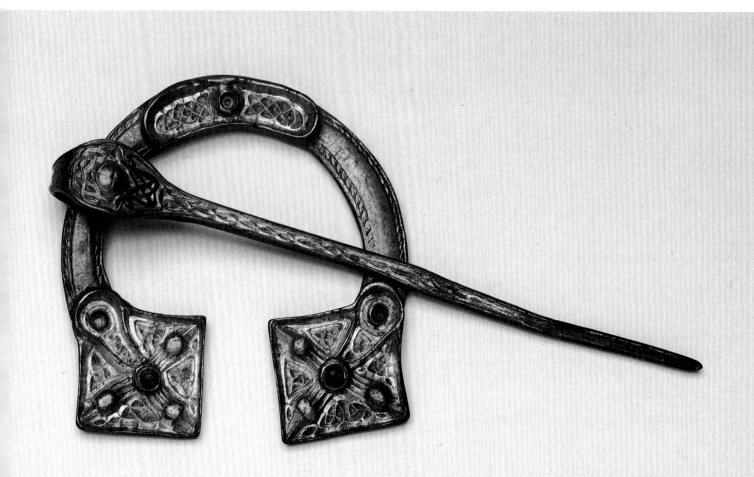

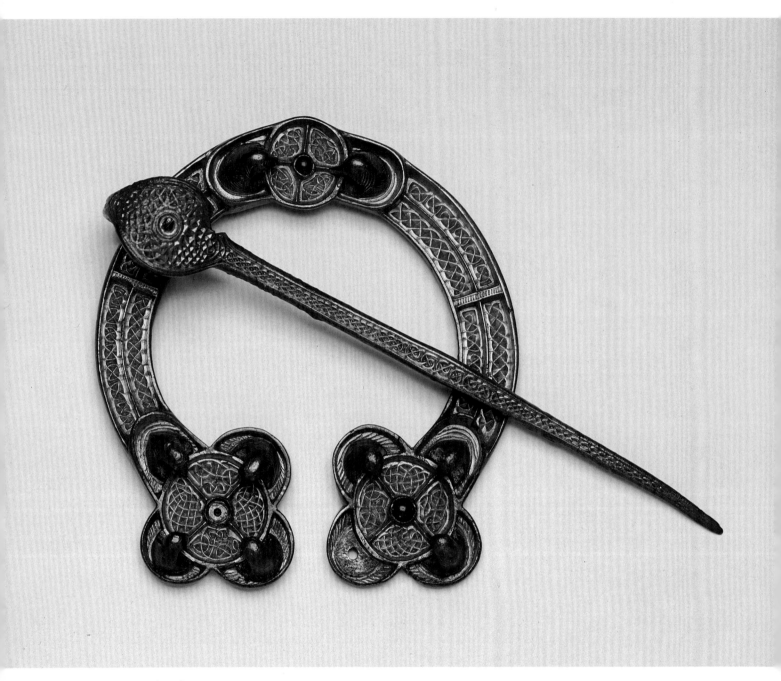

Above 111 Rogart brooch, NMS FC2.

Opposite 114 Soma harness mounts.

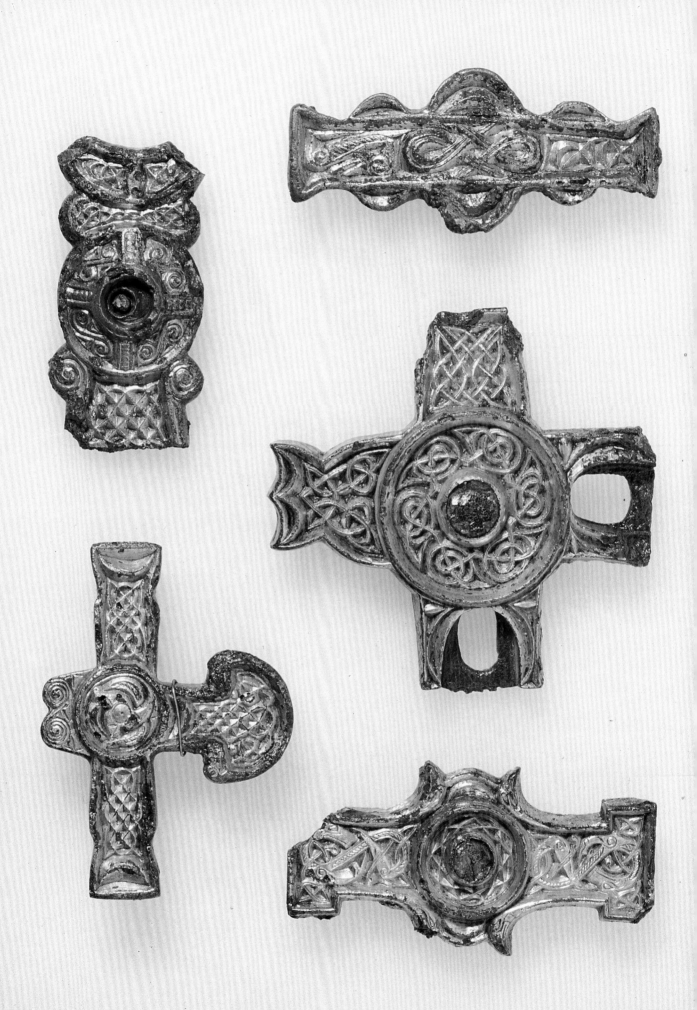

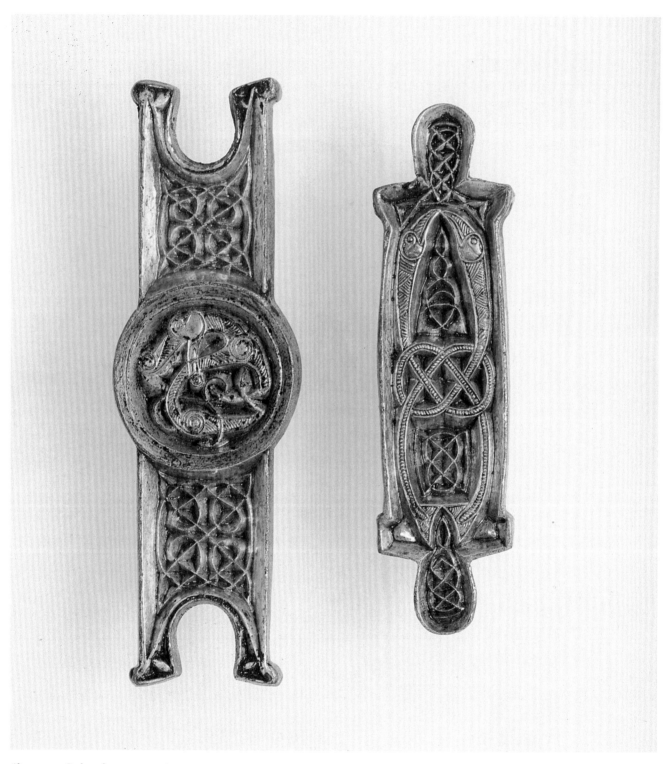

Above 115 Oseberg harness mounts.

Opposite 119 Clonard bucket.

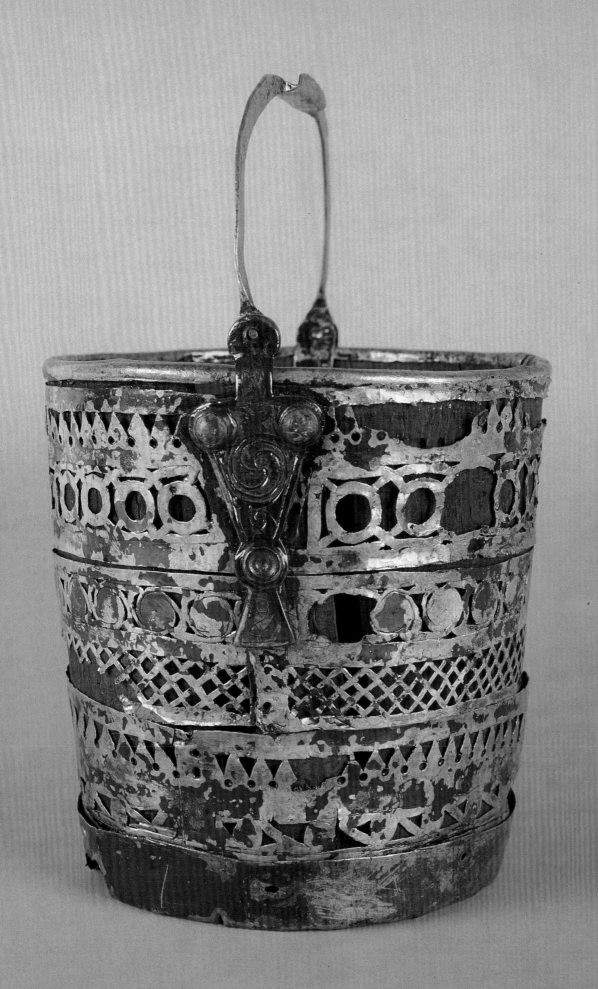

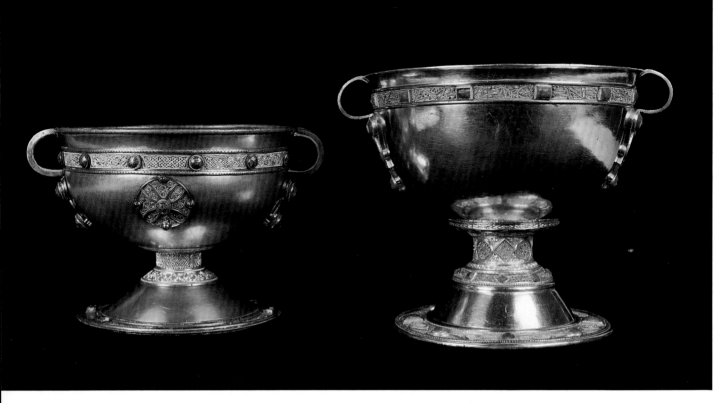

Above The Ardagh chalice (*left*, NMI 1874:99) found with nos 76 and 81, and the Derrynaflan chalice (*right*), no. 124.

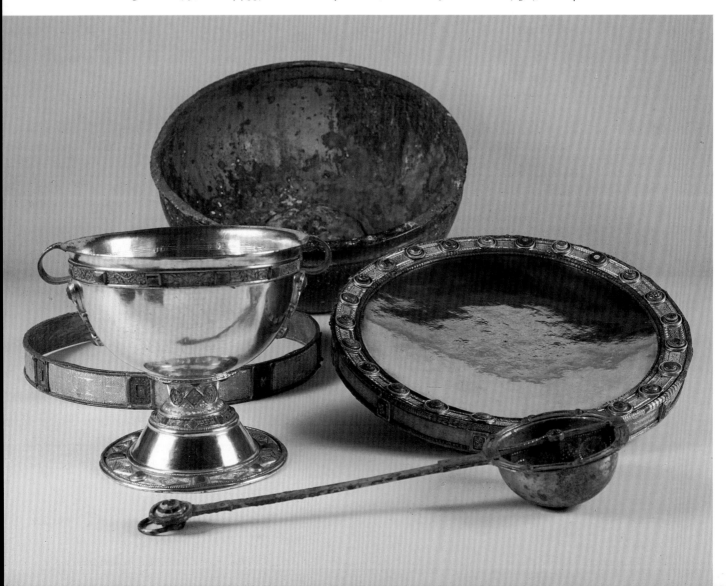

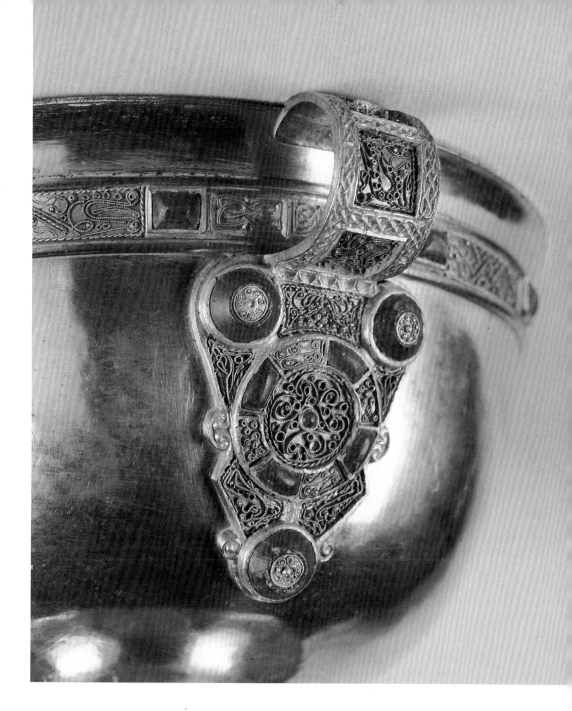

124 Derrynaflan chalice,
detail of handle.

126 Derrynaflan,
detail of strainer-ladle bowl.

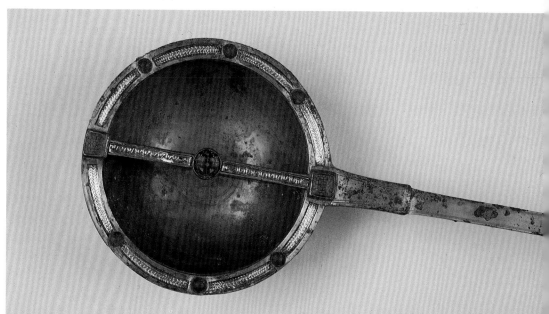

Left 124–7 The Derrynaflan hoard.

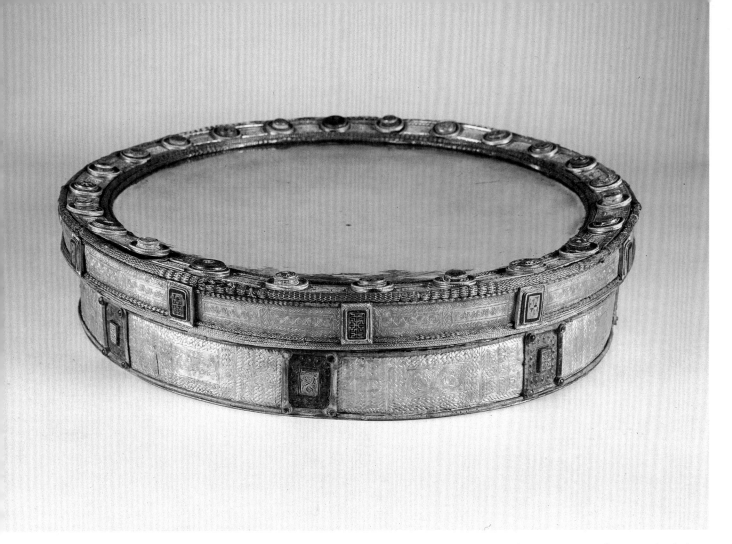

Above 125a, b Derrynaflan paten and stand.

Below 125a Derrynaflan paten, detail of rim.

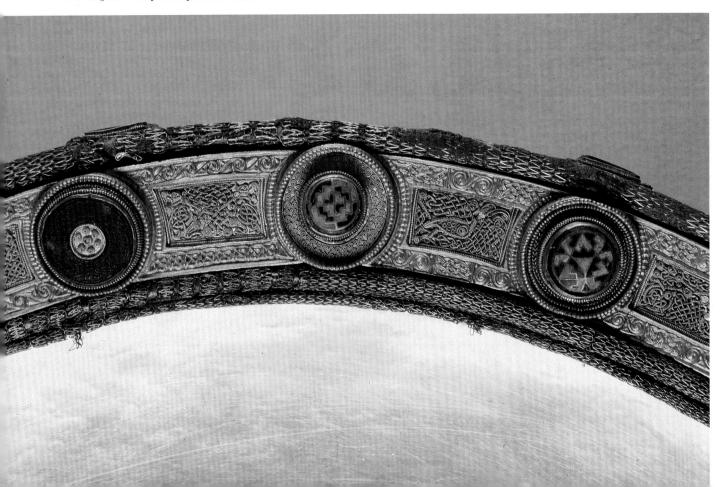

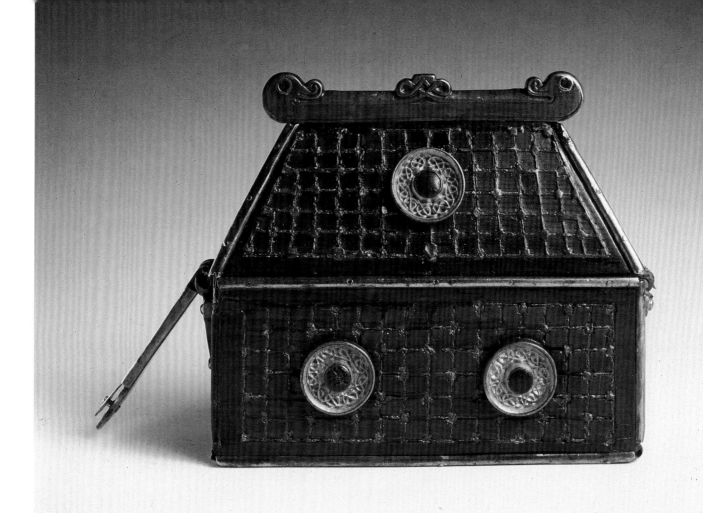

Above 128　Abbadia San Salvatore house-shaped shrine.

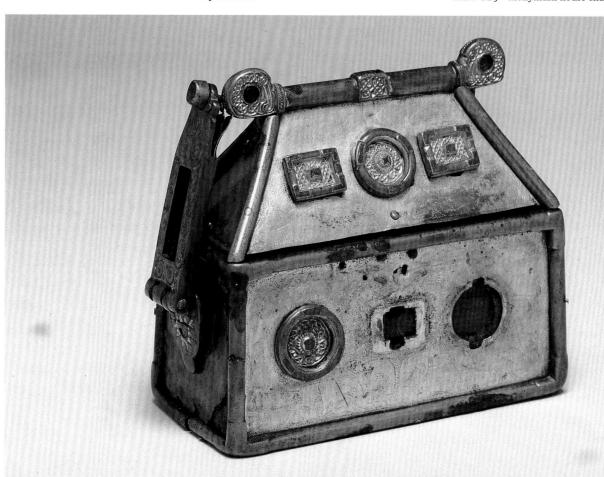

Below 129　Monymusk house-shaped shrine.

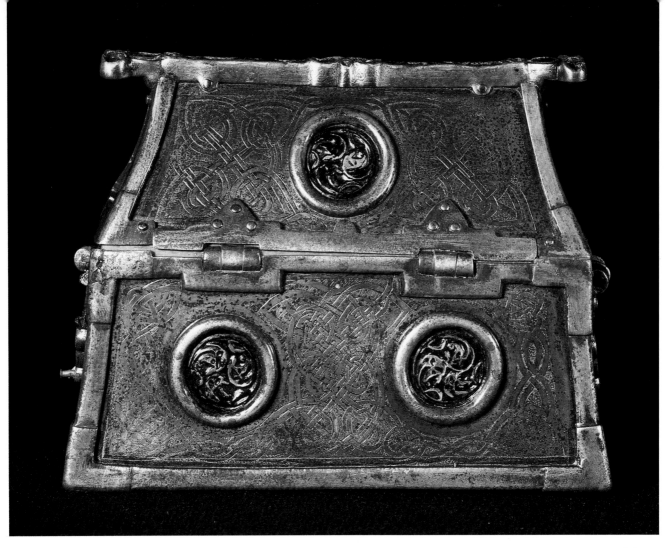

Above 131 Copenhagen shrine, back view.

Below 132 Bologna house-shaped shrine.

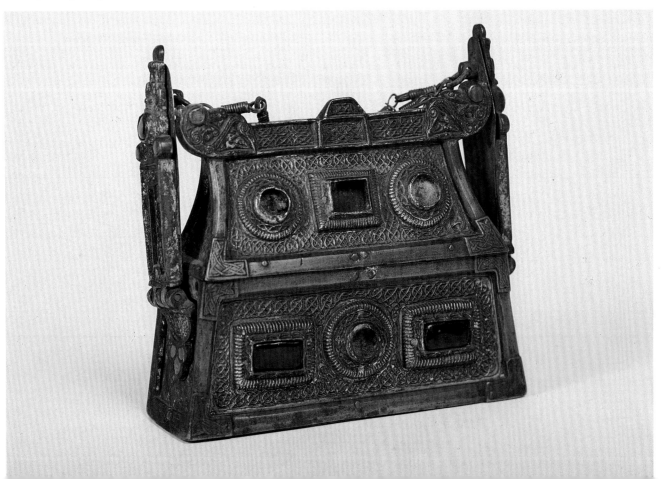

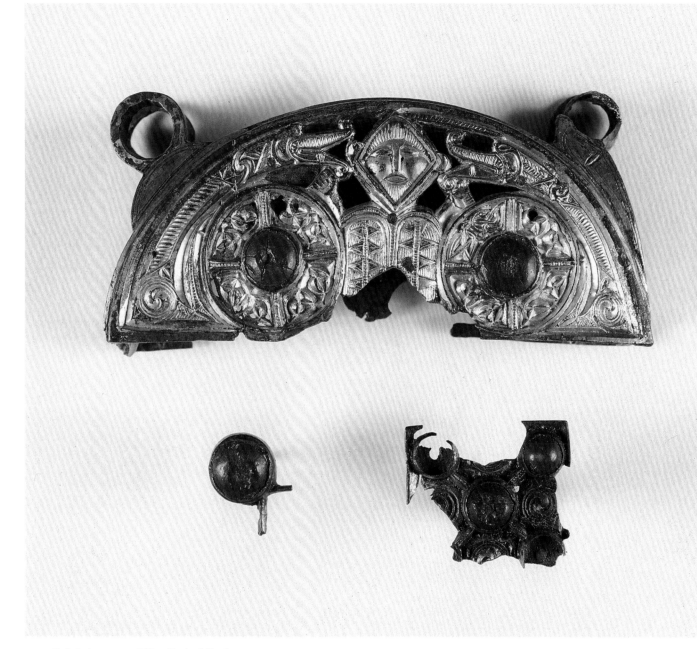

137 Bell-shrine mount, Killua Castle Collection.

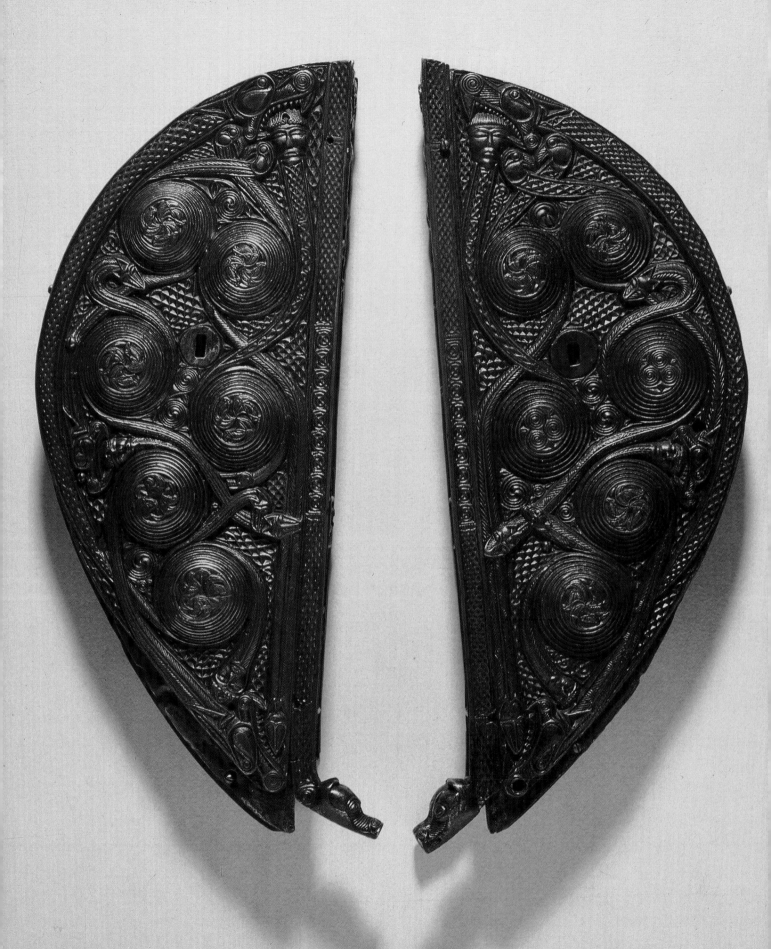

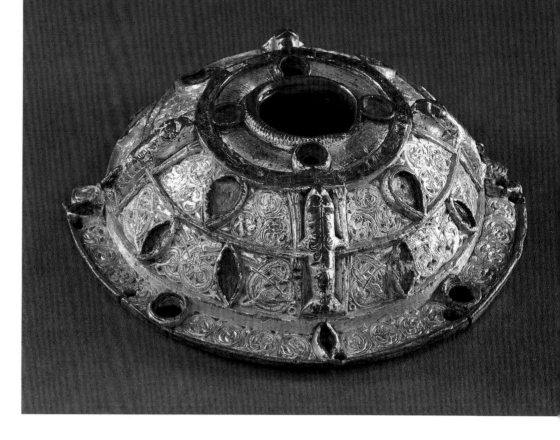

Left 138 Shrine mounts, St Germain.

140 Steeple Bumpstead shrine boss.

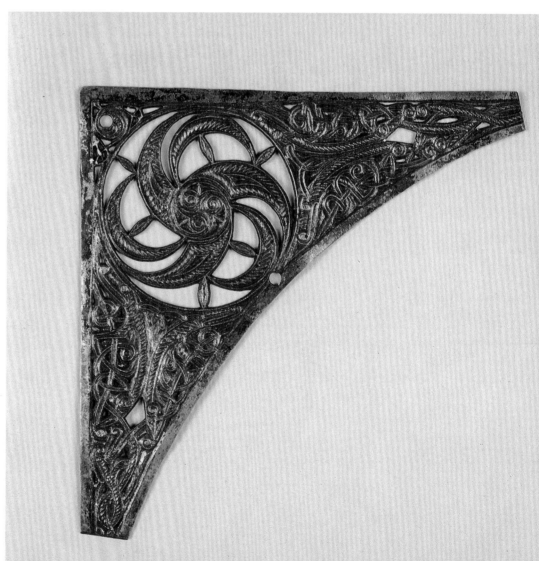

145 Phoenix Park openwork mount.

217 Garryduff gold filigree mount.

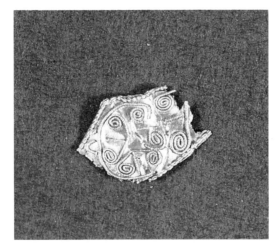

218 Moynagh Lough gold filigree mount.

Shankill drop and that of other croziers considered to be of early ninth-century date (Bourke 1987, 170). The rectangular amber stud is of the same size and shape as those on the rim of the Derrynaflan chalice (no. 124). The chip-carved decoration, however, is of little chronological significance, and a date in the later eighth or ninth century is possible.

The ferrule or the cylindrical knop referred to below may be the piece exhibited by the Belfast collector James Carruthers in 1852 as a 'bronze socket of a candlestick, elaborately ornamented, found in Shankhill Churchyard, Co. Antrim' (Belfast 1852, 18). A third fragment, consisting of a tubular knop and said to be from the same site, was acquired in 1955 and may well be part of the same object (Bourke 1987, 168–170). RÓF

BIBLIOGRAPHY Crawford 1923, 173; Raftery (ed.) 1941, 124, and pl. 93, 4–5; Henry 1967, 116; Bourke 1987, 166–70, and pl. II, b, d

149 Crozier ferrule

Ireland
Copper-alloy, gilt, amber; L. 19.9 cm, upper knop w. 4.2 cm, lower knop w. 3.0 cm, upper knop int. DIAM. 3.3 cm, foot DIAM. 2.6 cm
Irish, 8th century
NMI P.1019, Petrie Collection

Ferrule consisting of three separate, articulated castings held together with timber and rivets, the latter apparently of recent date. The upper knop is cube-shaped with rounded corners. Each face contains a roundel with raised, billeted border and central raised setting with circular amber stud (two of which are now missing). These are surrounded by an interlaced running knot pattern. In the spaces between each roundel are opposed pairs of fish-tailed snakes, their heads viewed in plan, with double-contoured bodies. These are enmeshed in pairs of interlaced closed loops. The central portion consists of an octagonal shaft surmounted by a biconical collar and tubular ring. The latter two bear a variety of ribbon interlace patterns. The collar interlace is separated by a central band of egg-and-dart ornament. The shaft is divided into panels with alternate ribbon and animal interlace patterns. The latter consist of quadrupeds with bodies contorted into figure-of-eight shapes. At the wider end is an unusual band of interlaced knotwork against a pelleted background. The ferrule proper consists of a cube-shaped knop with rounded corners bearing roundels with triskele devices and interlocking animal-headed spirals surrounded by a continuous mesh of interlace. Below is a tapering, cylindrical foot decorated with groups of incised lines.

This object is of importance in that it belongs to a small group of crozier fragments, decorated with imitation chip-carving, which are thought to be early (Bourke 1987). The biconical collar, divided medially and carrying three bands of continuous ornament, is a feature of the knops of these early croziers. It is only later that the panelled arrangement so characteristic of the eleventh- and twelfth-century croziers is developed. Most writers consider this example to be of ninth-century date, but there are some features which suggest that it might be earlier. The fish-tailed beasts on the upper knop are rare in ninth-century and later insular metalwork. They do occur on the margins of the 'Tara' and Hunterston brooches, on mounts from the Oseberg ship burial and from Markyate (nos 115, 116); in filigree on the brooch fragment from Dunbeath (no. 44); and in the

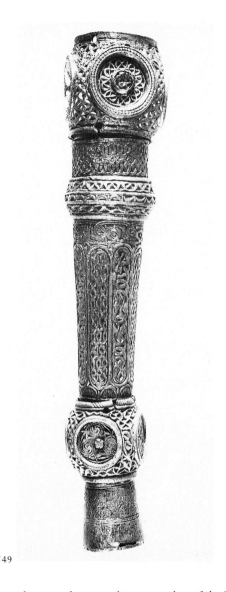

149

die-impressed square plaque on the counterplate of the Moylough belt-shrine (no. 6), all of eighth-century date. The animal interlace, although much worn, is composed of long-snouted beasts with closed jaws and comma-shaped compound eyes of the type found on the 'Tara' brooch, although they lack the spiral hip-joints and hatched bodies of the latter. The tubular shaft portion immediately below the upper knop with its vertically arranged ribbon interlace is reminiscent of the decoration on the stem of the Ardagh chalice.

If an eighth-century date is likely, this fragment would be the earliest in the series of insular croziers, as the mount from Helgö (no. 147) and another from Stavanger (Bourke 1987, pl. I, a) cannot be identified with certainty as parts of croziers.

The fragment was purchased by Petrie from a Mr Joshua Abell who said it had belonged to the antiquary Dr Edward Ledwich, Dean of Aghaboe, Co. Laois, who died in 1782. RÓF

BIBLIOGRAPHY Stokes 1894, fig. 41; Coffey 1910, 64; Crawford 1923, 173; Raftery (ed.) 1941, 123, and pl. 91, 3; Henry 1967, 116; Bourke 1987, 166, 170

Metalworking techniques
by Paul T. Craddock

A very wide range of techniques and materials were used with great assurance by Celtic smiths on metalwork. To maintain and pass on this continuing tradition of skills presupposes centres of stability where training could be given and long apprenticeships served. The so-called 'schoolroom at the monastery of St Mochaoi of Nendrum with its associated clumsily executed motif pieces (Lawlor 1925, especially p. 144) is the only centre to be claimed as such so far but many more must have existed both in monastic and royal workshops. This is not to suggest that these were the only centres, as work of high quality for distribution over a considerable area was also produced in workshops attached to relatively small establishments such as Moynagh Lough (Bradley 1984).

Materials

The sources of the various metals and other materials used are problematic. Tin was almost certainly imported from Cornwall and amber came from the North Sea area. Although glass was extensively used in jewellery, both as enamels and as inlays, there is little or no evidence for the manufacture of glass vessels in Ireland at this time, and the glass itself would certainly have come from outside Britain and Ireland, the red glass of Celtic enamels probably from the Mediterranean (Brill 1967). Iron was smelted in Ireland, and the ores of other metals – copper, lead, zinc, gold, silver and even mercury – are found in Ireland and Scotland (except for mercury); but evidence for their exploitation in the first millennium AD is presently lacking, although there is documentary evidence for silver and copper mining in medieval Ireland (Jackson 1980), and the Irish language is rich in terms and references to goldworking and refining, suggesting a long tradition in those subjects (Scott 1981).

It has sometimes been assumed that following the withdrawal of the Romans the inhabitants of Britain had to make do with whatever metals they left behind. Obviously scrap would not have been ignored, and there must have been considerable quantities from a materially rich society such as that of the Romans; but there are indications that this was not the only or even the main source. In ninth-century Northumbria the so-called *styca* coinage was made from silver, then brass with a regular composition. In addition, the brass, an alloy of copper and zinc, was itself of reasonably consistent composition. Gilmore and Metcalf (1980) estimate that many tons of brass must have been available to the moneyers and that the only feasible source for such a large quantity was freshly smelted metal, either made in Britain or imported.

In Ireland, although few copper-alloys have yet been analysed, the situation of metal supply seems somewhat similar, despite the actual metals and alloys used being different. Thus it seems that bronze, the alloy of copper and tin, was prevalent, usually with a rather high tin content, typically over ten per cent (Oddy 1983a, 955). By contrast the Roman copper-alloy scrap, such as is frequently encountered in early Anglo-Saxon brooches, tends to contain small but highly irregular amounts of tin, lead and zinc. The limited analyses performed so far therefore suggest that Irish smiths were using in the main freshly smelted copper to which they added the required quantity of tin. Similarly, Irish silver was usually alloyed with considerable quantities of copper, but in Anglo-Saxon silver, brass or bronze was frequently included with the copper (Leigh, Cowell and Turgoose 1984). Although considerable quantities of scrap silver were available (the hoard from Coleraine is one example), it does seem that the Irish smiths, from whatever source, could command supplies of reasonably pure silver to alloy and work as they chose. Silver and copper were usually distributed in the form of bar ingots, several of which have been found, as have numerous flat ingot moulds usually carved in stone (nos 150–1, 163).

Design (*nos 152–6*)

The intricate designs were often worked out and developed on bone or slate. These were not executed free-hand but on to a carefully prepared and quartered grid with extensive use of compasses – evidence of which sometimes survives where the design was abandoned before completion, as on bones from Ballinderry Crannog 2 (O'Meadhra 1979). In general these seem to be no more than trial pieces, but some could have been patterns or dies into which gold or silver foils were pressed to reproduce the design directly.

Fabrication (*nos 157–95*)

CASTING – Much of the metalwork was cast and very many moulds have been found on sites throughout Britain and Ireland. At Mote of Mark, Dumfries-shire, heaps of sand and clay were found in the metalworking area for making moulds (Laing 1987, 16). Most castings were made in two-piece moulds. The procedure has been recreated based on finds from Birsay in Orkney for casting penannular brooches (nos 177–8). The prepared clay was made into two balls and one face of each was pressed perfectly flat against a board. A template or pattern of the piece to be cast was then made in wax or lead (several of

the latter survive), and then one side of this would be pressed into the soft clay of one of the flat faces. A funnel-shaped pattern for the pouring channel was also pressed into the clay which was keyed up with a knife. This half of the mould was then left to air-dry for several hours, after which the flat surface of the second piece was pressed against the first and the impression taken of the other side, and the raised keying points picked up on the surface. The moulds were then parted and the pattern carefully removed; the mould was next fitted together, fired and the metal poured in. Heavy decorative pinheads like that on the Ballinderry 2 brooch (no. 19) could be cast on to the bronze hoop, although the model from Clogher (no. 188) shows that they were also made separately and sprung on.

It appears that the moulds were seldom reused, as some sites have produced hundreds of fragments, some from identical patterns. Where repeat castings were required, usually a fresh impression was made each time with the pattern. This was probably due to inevitable degradation of the mould surface after contact with hot metal. The castings would require filing, scraping and polishing so that even castings from the same pattern are not necessarily identical.

Two-piece casting works well for the rather flat two-dimensional shapes that characterise much Dark Age metalwork but not for more complex shapes, especially those with undercuts where it would be difficult to make an impression or pull the mould from the pattern. For these lost-wax casting would be necessary. The technique has a very long history and was surely used at this time, although direct evidence in the form of mould fragments is not common, and it appears that two-piece moulds were much more prevalent. By contrast, in the pre-Roman Iron Age lost-wax casting was more usual – for example, the hundreds of mould fragments from Gussage All Saints, Dorset, which were the debris of casting horse-harness fittings in the third century BC and are almost all made by the lost-wax process (Foster 1980). It seems that the Romans introduced the preference for two-piece moulds to make small metalwork castings (Bayley 1988). In the lost-wax process the pattern in wax or lead, with the addition of a pouring channel also modelled in wax or lead, would be coated in fine clay of the consistency of a batter mixture and dried. After several such dippings the inner mould so formed would be wrapped in ordinary clay and fired to bake the clay and melt out the pattern leaving the mould empty for the metal to be poured in. The mould was then broken up to release the casting and discarded.

The metal was melted in crucibles, and these survive in large numbers. Almost all are of ceramic, sometimes lined and relined on the inside, although there are a few stone crucibles from Garranes (Ó Ríordáin 1941-2). Some of the crucibles were heated from above, while others were heated from the sides and beneath, as found at Dinas Powys (Alcock 1987, 122-5). The workshop at Nendrum produced a series of small stones, heavily burnt and hollowed in their free-standing upper surfaces, which apparently held crucibles while they were heated. The crucibles could be lifted more easily with the tongs gripping the stone rather than the fragile ceramic of the crucible itself (Lawlor 1925, pl. XI and 142-3). Iron tongs have been found on a number of sites, such as Garranes.

There was a proliferation of crucible shapes (fig. 4). The small deep cylindrical and triangular crucibles of the Iron Age continued but were joined in the early medieval period by other types mainly derived from Roman examples. These include broad, shallow and lidded crucibles. It has been claimed that the lidded crucible was a product of Romano-Celtic Wales, but in fact lidded crucibles have been found on many Roman sites throughout the Western Empire and must be seen as another Roman introduction. One reason for the increased number of types is the greater range of metals and alloys cast. Bronze was cast in the Iron Age, and this was augmented later on by brass, silver, lead and even gold, all with different requirements: for example, zinc tends to evaporate rapidly from molten brass unless there is some covering such as a lidded crucible would provide. All the crucibles seem small, typically under 100 ml in capacity, but casting experiments using replica crucibles showed that they contained sufficient metal for several typical castings (Curle 1982, 41).

WROUGHT WORK – Many pieces were made by hammering the metal to shape. Vessels such as bowls and bases of chalices were raised by beating out from a disc. The roughly hammered piece would be finished by repeated blows with a small hammer against a stake (see no. 231), a technique known as planishing, giving a faceted appearance. The planishing marks could be polished out with a smooth fine-grain stone rubber, or the piece could be turned and polished on a lathe. At Garranes and Nendrum stone moulds or matrices were found with cylindrical depressions carved in them. It seems likely that sheet metal was hammered into the matrix to produce the cylindrical bodies. This technique was widely used until quite recently in the north of Scotland to produce lamps from sheet iron.

Joining

Most Celtic metalwork was assembled from a number of pieces, and the craftsmen were certainly familiar with all the available joining techniques of soldering, riveting, cements and mechanical joins such as folding. A wide range of solders was used, but in general they were used only for holding together minor components such as the filigree and granulation on the foils. Riveting seems to have been the preferred method for the most major joins. All important pieces such as the Ardagh and Derrynaflan chalices are of very complex construction utilising bolts and rivets with heads covered by heavily decorated bosses. This continues a long Celtic tradition and recalls such pieces as the Basse-Yutz flagons made nearly 1,000 years before. Comment has been made on the complex joins for the base and bowl of the great Irish chalices (Ryan 1983, 13-14), but the much smaller and simpler late Roman chalice from Water Newton (Painter 1977b) has a similar assembly of the base and bowl held together by a large bolt passing through the central stem.

Decoration

Perhaps the glory of Celtic metalwork lies in the skilled use of exuberant polychrome decoration. The range of materials and techniques is almost the full range known to man, and hence it is impossible to summarise them adequately. Of the techniques used elsewhere only true pierced openwork, *interasile*, much

used in Byzantine jewellery, is absent from Celtic work, although cast openwork decoration was used. The open-platform technique (see below under *Filigree*) could be considered a sophisticated form of *interasile*.

Plating

The surface of the metals could be treated by tinning or gilding. Tin could be wiped on to the surface from a heated 'stick' or the object could be dipped in molten tin (melting-point 232°C). This is ordinary tinning, but some of the pieces were very carefully heated to allow the tin to commence dissolution into the bronze beneath. If the process was carried out at just the right temperature for exactly the right length of time, then a high-tin bronze intermetallic compound would be created at the surface giving a very silvery appearance and capable of taking a good polish (Meeks 1986). (NB This is frequently confused with silvering for which there is no evidence at this time.)

Mercury gilding (also known as parcel gilding or fire gilding) was the usual gilding technique. Powdered gold was mixed with mercury to produce the aptly named 'butter of gold', which was then spread over the cleaned metal surface and heated to about 350°c to drive off the mercury (Oddy 1980).

Filigree (*nos 217–22*)

This very typical ornamentation was made up of wires and granules, which on the Irish material was usually soldered on to a gold foil (Whitfield 1987). The gold-foil backplates were usually flat but sometimes decorated in relief, which was created either by stamping the backplate from the front, or by hammering from behind – repoussé work. Sometimes flat and relief backplates were combined with a pierced relief plate overlying a flat backplate, known as the hollow-platform technique (as seen on the Hunterston brooch (no. 69) as well as on the Ardagh chalice and Derrynaflan paten (no. 125a)). The foil or backplate in turn was held mechanically to the object by burring over the edges of the surrounding metal or by stitching (see Glossary) or more rarely by a rivet. It seems that the foil was introduced as an intermediary because it had virtually no heat capacity compared with the main object, so that a very minimum of heat was needed to melt the solder which would cool instantly the flame was removed. Irish filigree is quite exceptionally crisp. The main lines of the design were drawn in wire and reserved areas of decoration filled with small bands of gold (granulation).

There were numerous methods of producing wire in antiquity before the introduction of the drawplate, just at the end of the period covered by this catalogue (Oddy 1977, 1983). Celtic wires were all made by block twisting, in which thin square-section rods were twisted and then rolled between two flat surfaces, leaving the distinctive double helical seam. In addition to plain wire, beaded wire was frequently used. Here the wire

Fig. 4 Crucibles: (a) Dinas Powys (reconstructed); (b) Birsay, no. 397; (c) Ballinderry Crannog, 2, no. 192; (d) Birsay, no. 392; (e–g) Lagore Crannog, nos 263, 44, 1422; (h, i) Garranes, nos 131, 463. Blow-pipe nozzle; (j) Birsay, no. 406; tuyère (k) Garranes, no. 262.

was hammered along its length between dies, sometimes single, sometimes multiple, to produce a beading effect (Whitfield 1987). The wires so produced were often used twined together or in groups, a common example being a beaded wire flanked by two smaller plain wires. However, they could be piled one on top of another or even coiled to produce the desired effect. Perhaps the most sumptuous effect was produced by trichinopoly, which gives the effect of a finely woven cord, although in Irish work this was usually of silver rather than gold (see no. 125a). It was produced in a number of ways – from continuous wire resembling French knitting, or from a basic repeating unit of a number of elongated loops of wire soldered together into a star shape. The points of this were bent forward and the next unit was threaded through and so on (Untracht 1982, 194–5).

Inlay (*nos 196–216*)

Celtic metalwork was richly inlaid with glass, stones, amber, enamel or niello. Niello is a dense black mixed copper-silver sulphide material which was much used for inlaying silver in antiquity generally, and seems to have been introduced to western Europe by the Romans (La Niece 1983). Little potential Irish material of this period has been studied, but the black inlay on the Steeple Bumpstead boss (no. 140) has recently been analysed in the British Museum Research Laboratory by La Niece and found to be a true silver sulphide niello; other pieces are suspected, although not yet tested.

The usual inlay technique was champlevé where a depression was cast or cut into the surface, rather than the technique of cloisonné, prevalent in Anglo-Saxon material, where the cells were created by soldering vertical ribbons on to the surface.

The Celtic tradition of embellishing bronzework with glass inlay stretches back into the Iron Age, but the earlier technique was not true enamelling as it is understood now, in that the glass was not melted into the cells but merely softened and pushed into place. Analysis (Hughes 1972) of the deep red 'sealing-wax' enamels used in the Celtic Iron Age showed they were a high-lead glass containing between 5 and 20 per cent of cuprous oxide (Cu_2O) and 18 to 35 per cent of lead oxide. The colour is due to large dendritic crystals of brilliant red cuprite suspended in colourless lead glass. These crystals are unstable at the temperature required to melt the enamel properly, and this is why it had to be used in semi-molten or pasty condition (Bimson 1983, 941). The Romans introduced true enamelling into the West, and the Irish smiths used it while still continuing with the older copper-rich sealing-wax red enamels which could only be softened. Early enamels are almost invariably set in copper or bronze, but there are two examples from Ireland of enamelled iron found at Lagore Crannog (Hencken 1950–1, 121, fig. 55) and at Rathmullan, Co. Down (Bourke 1985). Very often pieces of glass, either plain, coloured or *millefiori*, were cut and set as a stone, sometimes in combination with enamel to stunning effect. Although lumps of red glass and numerous pieces of *millefiori* have been found in Ireland, there is no evidence that the glass itself was actually made there, or anywhere else in Britain.

Intricate polychrome metalwork was developed extensively throughout the first millennium AD in Europe generally, reflect-

ing an interaction between the Roman Empire and the barbarian tribes. The Irish smiths were familiar with almost all the techniques currently in use throughout Europe and the Near East – probably reflecting both trade and missionary contacts. Many of the techniques used, such as filigree work, show their most advanced development on Celtic work, and far from being an isolated backwater, Celtic Ireland was very much to the forefront in metalworking skills.

Materials, design and casting (*nos 150–95*)

150 Ingot and mould fragment

Moylarg Crannog, Co. Antrim.
Copper-alloy, baked clay; ingot L. 3.7 cm, WT 11.86 g, mould L. 4.9 cm
Irish, 7th–8th century
NMI 1905:211, 233

Small, complete ingot of cast copper-alloy, oval in cross-section with rounded ends. The mould fragment, which is heat-scorched, is of a fine, sandy dark grey clay. The base is flat and the sides straight. The matrix is for an ingot of similar shape to the above. Although not directly associated, these two finds are evidence for metal casting at this important site. The mould was found with crucible fragments in excavations conducted between 1887 and 1892. RÓF

BIBLIOGRAPHY Buick 1893, 30, 33, 41

Lagore, Co. Meath (nos 59, 60, 92, 151, 153, 120–1, 201, 209, 215, 222)

This royal site, occupied from the seventh to the tenth centuries, has produced rich evidence for not only the use but also the manufacture of top-quality metalwork for aristocratic patrons.

151 Ingot mould

Lagore Crannog, Co. Meath
Sandstone; L. 13.5 cm, W. 9.5 cm, TH. 4.8 cm
Irish, 7th–10th century
NMI E14:1571

Ingot mould made from an irregular block of stone of rectangular cross-section with two principal flat surfaces. On one side is carved a matrix for a finger-shaped ingot (L. 6.7 cm), of plano-convex cross-section with convex sides and rounded ends. On the opposite face is a hollow of tapering cylindrical shape (D. 3.2 cm, max. DIAM. 4.8 cm) with concentric wear.

The object may originally have served as a pivot-stone. It is one of six stone ingot moulds found at Lagore. Similar examples are known from a number of early medieval settlement sites in Ireland and in Britain (see nos 150 and 163 below). They may contain single or multiple matrices, and ingots of copper-alloy and silver are known. Finger-shaped ingots are characteristic of Viking-Age silver hoards in Britain and Ireland and continued to be a popular means of carrying around surplus metal into the eleventh century. Often considered to be characteristically Scandinavian, they are not exclusively so and were in use in Ireland from at least the fifth or sixth century as they occurred in the excavations of the ringfort at Garranes, Co. Cork (Ó Ríordáin 1941–2, 108). RÓF

BIBLIOGRAPHY Hencken 1950–1, 170, and fig. 88, 499

Motif pieces (nos 152–5)
Motif pieces are small, portable pieces of material – usually bone or stone – bearing carved or incised patterns which include casual sketches and the dies or models of metalworkers. Large numbers have been found in early medieval contexts in Ireland. The range of formal motifs reflects that in contemporary art in all media.

152 Motif piece

Dooey, Co. Donegal. Found in excavations at settlement site
Antler; L. 12.0 cm, max. W. 4.4 cm
Irish, 5th–6th century
NMI E33:1385

Motif piece made from antler, the ends sawn and broken off. The surface is worn in parts. There are eight rectangular and four circular decorated fields. Four panels grouped together each contain three running spirals, two of single-coiled and two of double-coiled spirals with lobed terminals. The other four rectangular panels

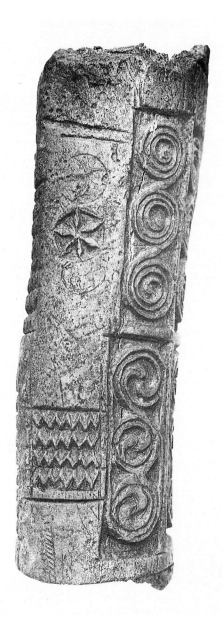
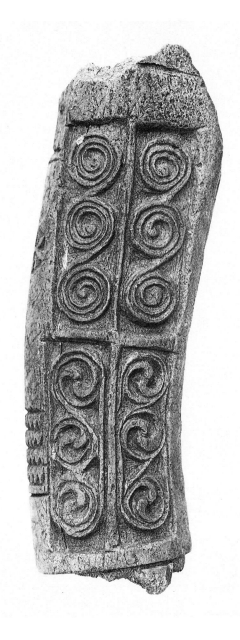

152

contain chevrons arranged in rows to suggest a field of interlocking lozenges. There are two circular panels containing marigolds and two lightly sketched fields with similar devices. All but the latter two panels are deeply carved.

This piece, regarded as the earliest of the Irish motif pieces, is difficult to date. The excavators suggested a date in 'the early centuries AD' (Ó Ríordáin and Rynne 1961, 64). Kilbride-Jones (1980a, 210) suggested that the multiple lozenge motif owed its origins to north British dragonesque brooches and pointed to its occurrence on the Dowris latchet (no. 24) and on some zoomorphic penannular brooch terminals. O'Meadhra (1987, 37) concluded that the earliest settlement phase, to which the motif piece belongs, probably dates to the fifth or sixth century. The spiral patterns and marigolds can also be paralleled on latchets and handpins which

would not conflict with such a date. The fine line of the patterns set against a relatively large recessed field marks this piece out from the others in the series, and in concept this design is reminiscent of fifth- to seventh-century metalwork which contains reserved designs against a background of red enamel. In a recent wide-ranging discussion on motif pieces O'Meadhra concluded that they were an insular Celtic phenomenon (1987, 79) with the earliest examples coming from Pictland and the north of Ireland. They are generally assumed to represent sketches or finished patterns for finished designs, especially in metalwork. However, O'Meadhra (1987, 162) has found very few on-site parallels in metalwork. RÓF

BIBLIOGRAPHY Ó Ríordáin and Rynne 1961, 64, and fig. 8; Henry 1965a, 93, and pl. 13; O'Meadhra 1979, 8, 23, 36; Kilbride-Jones 1980a, 63, 66, 210, and fig. 67, 1; O'Meadhra 1987, 36–8

153 Motif piece

Lagore Crannog, Co. Meath. Found in 19th century
Bone; L. 22.2 cm, max. w. 7.1 cm
Irish, 8th–early 9th century
NMI W. 29

Motif piece made from a portion of a long bone. The upper surface is highly polished and the majority of the patterns occur on this face. Some are lightly sketched, while some are finished designs. The sketched designs are principally triquetras and interlaced loops. The finished patterns consist of interlaced knotwork and animals, some in diagonally hatched frames. The animals have backward-pointing eyes, curled jaws and spiral hip-joints. In two cases the bodies of the animals are double-contoured and diagonally hatched.

Excavation at Lagore showed that the site was occupied in the seventh to the tenth centuries and a number of motif pieces were uncovered. This one and another related piece from the same site (O'Meadhra 1979, no. 123) are exceptional for the finished nature of some of their patterns and for the quality of the chip-carving with sloping sides which is so close to that on the finest metalwork of the eighth and early ninth centuries. The chip-carving technique is, in fact, very rare on motif pieces and apart from Lagore occurs only on a stone motif piece from Mullaghoran, Co. Cavan (O'Meadhra 1979, no. 133). The link between this piece and metalworking is therefore very close. The rectangular diagonally hatched fields containing interlaced knotwork could have served as models for a panel such as that on an unprovenanced hinge mount (Mahr 1932, P. 50, 4). The running knots, both single- and double-contoured, occur on the large Ardagh brooch (no. 76), on the frames on the rim of the Derrynaflan paten (no. 125a) and on a mount from the Kilmainham-Islandbridge cemetery (Mahr 1932, pl. 19, 7). Parallels for the animal ornament are more difficult to find. Similarities with interlaced animals on the back of the 'Tara' brooch and the belt-buckle from Lagore (no. 59) do not seem convincing. A date in the eighth or early ninth century seems likely. RÓF

BIBLIOGRAPHY Wilde 1836–40, 425; Wilde 1861, 344–8; Wood-Martin 1886, 139; Hencken 1950–1, 182–3, and fig. 95A; Mac Dermott 1955, 86, 95–6; Henry 1965a, 93, 224, and pl. 37; O'Meadhra 1979, 8, 24, 88–91; O'Meadhra 1987, 61–70

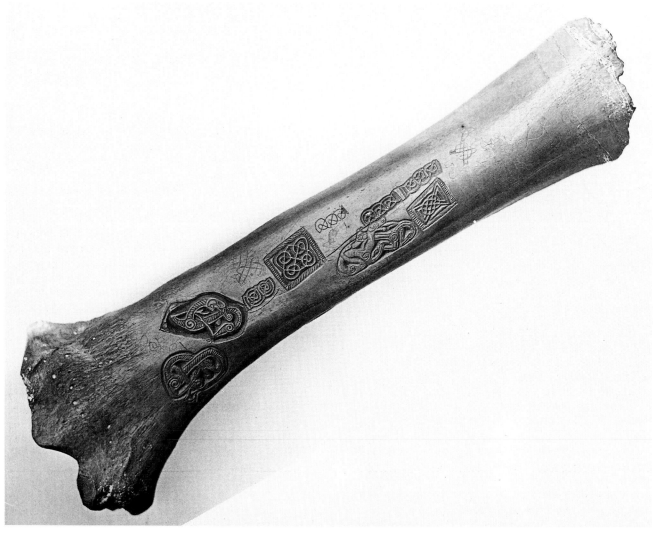

153

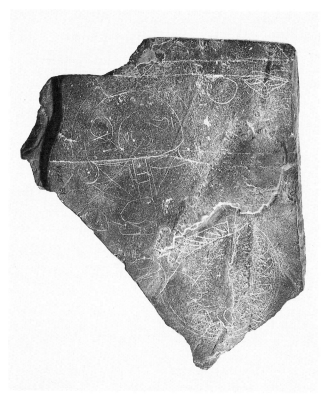

154

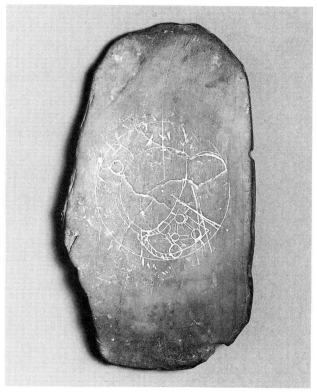

155

154 Motif piece

Nendrum monastic site, Mahee Island, Co. Down. Excavated on site of
workshop or 'school' (see also nos 175, 226)
Greywacké stone; 11.2 × 9.5 × 0.94 cm
Irish, 9th century
UM A1925.51

This stone bears a variety of incised patterns on both faces, together
with a sketch of the body of an annular brooch (cf. no. 77) and,
possibly, that of a brooch-pin (cf. no. 186). The representations on
this piece are of finished, three-dimensional objects, highly unusual
among motif pieces, which bear patterns used typically in two
dimensions as surface ornament (but see also no. 155). CB

BIBLIOGRAPHY Lawlor 1925, 144–6; O'Meadhra 1979, no. 150; O'Meadhra
1987, 71–3

155 Motif piece with brooch

Dunadd Fort, Argyll. Found during the 1904–5 excavations in Christison's
'Fort D' (see also no. 181)
Slate; L. 9.4 cm, W. 5.4 cm, TH. 0.4 cm
Irish style, 8th–9th century
RMS GP 218

A thin, subrectangular piece of slate. On one face is an incised
drawing of a penannular brooch with expanded triangular
terminals. The subdivisions of the hoop and left terminal of the
brooch are only partially marked out. The layout of the right ter-
minal is indicated in greater detail. This terminal is divided from the
hoop of the brooch by a double curved line with linear ornament.

The right terminal and the infilling between the two terminals are
divided into fields; the former is marked out with circles inter-
connected by parallel lines. A panel with a central setting is outlined
at the top of the hoop.

Inscribed in the centre of the reverse face is a rectangle which
encloses an ellipse. Along the lower edge are numerous short diag-
onal lines, while to the upper left there is cross-hatching.

This motif piece, along with that from Nendrum, Co. Down (no.
154), offers a unique insight into how brooches were designed.
A compass-drawn circle forms the outline of the ring, while a
concentrically placed arc defines the inner edge of the hoop. The
centre-point is clearly visible. Compass work is evident in met-
alwork – for example, in the layout of the ornament on the Donore
discs (nos 63, 64) and also in arranging the positions of the panels
around the rim of the Derrynaflan paten (no. 125a). The brooches
drawn on the Nendrum motif piece were produced by the same
technique and are of similar size to that on the Dunadd piece. Wilson
(1973, 88) has pointed out that the design of the terminals with
linked bosses may represent an intermediate type between brooches
of the St Ninian's Isle series and the bossed penannular brooches of
the ninth and early tenth centuries. The brooch drawn on the
Dunadd motif piece, if intended to be reproduced full-size, is much
smaller, however, but compares well in scale and design with a now
lost copper-alloy brooch from the Isle of Coll (*PSAS*, XV (1880–1),
79–80, and fig. 1). RMS/RÓF

BIBLIOGRAPHY Christison and Anderson 1904–5, 310–11, and fig. 31;
Johansen 1973, 110; Wilson 1973, 87–8, and pl. 1b; Lane 1984, 52;
O'Meadhra 1987, 79, and fig. 58a

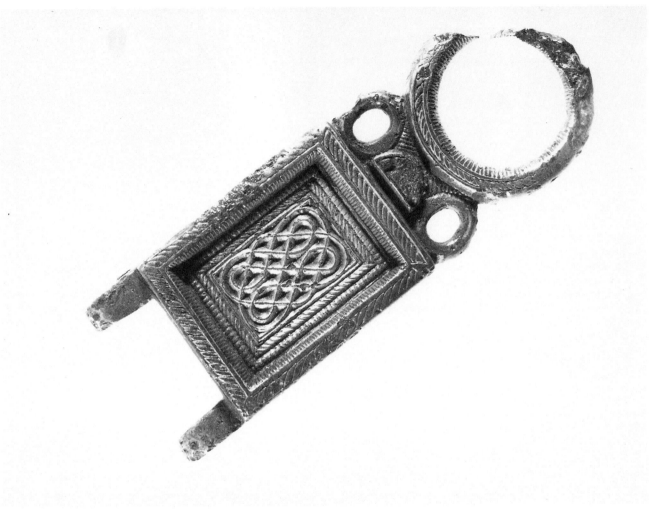

156

156 Hinged shrine mount

Ireland
Copper-alloy, gilt, amber; L. 7.3 cm, w. 2.5 cm
Irish, late 8th–9th century
NMI R.2958

Mount of cast and gilt copper-alloy made of two elements, the interlaced rectangular panel being a separate casting. The main body of the piece consists of raised rectangular and circular frames linked by a tongue of metal containing a D-shaped amber stud in a raised setting, flanked by oval loops. Frame rims are decorated with diagonal hatching, the inner edges with closely spaced vertical grooves. Two oval loops project from one end of the piece. The inset plaque lies within a double border of beaded and diagonally hatched mouldings. The central device consists of a closed loop of interlaced knotwork. At the back the frame is rebated as for another plaque. There is considerable wear.

The form of the mount suggests that it was the upper part of a hinged strap-end of a house-shaped shrine. The use of faceted interlace and amber rather than enamel or *millefiori* suggests that the hinge relates to the later series of house-shaped shrines such as that

from Bologna (no. 132) and Lough Erne (no. 130b). The finely cast grooving on the insides of the frames is of the same quality as that found on the terminals and pinhead of the Cavan brooch (no. 73). The imitation chip-carved interlace with hatched border is very near to some of the interlaced panels on the Lagore motif piece (no. 153), exemplifying the often close relationship of motif piece to finished design. A hinged mount of very similar form was found in a Norwegian grave at Gjønnes, dating from the early ninth century (Wamers 1985, no. 119). KÓF

BIBLIOGRAPHY Mahr 1932, pl. 50, 4; Raftery (ed.) 1941, 112

Moynagh Lough, Co. Meath (nos 157–68; see also 54, 197, 208, 218–19, 225, 231)

This former crannog site is set above what was once a stretch of the river Dee on two knolls occupied in prehistoric times. A sequence of occupation, consisting of two major phases, was present on a man-made platform constructed with layers of stone, peat, earth and brushwood. The uppermost phase was represented by two round houses, the larger of which (house

1) had a diameter of 11.2 m, and a small metalworking area with a bowl furnace, all of which were enclosed within a plank palisade. The lower phase, which produced the most important metalworking evidence, was represented by a double-walled round house, with a diameter of 7.5 m, and two metalworking areas enclosed within a post palisade. These metalworking areas produced a large and varied assembly of decorated clay-mould fragments with evidence for the production of small mounts, jewellery and fittings, as well as materials for hot and cold inlays of enamel and glass. Ironworking was also practised and quernstones, as well as items of leather and horn, were made at Moynagh Lough. Quantities of domestic refuse had been thrown over the side of the crannog and apart from animal bones these included a stone ingot mould, discarded worked wood and a fragment of gold filigree. The exceptional size of round house 1 and the range of finished artefacts including the gold filigree mount, a number of ringed pins, a brooch-pin, and a drinking-horn terminal indicates a household of wealth and presumably of high social standing which occupied the site from the seventh to the early ninth centuries. JB

BIBLIOGRAPHY Bradley 1982; Bradley 1982–3; Bradley 1984; Bradley 1985–6; Bradley forthcoming

157a, b Two motif pieces

Moynagh Lough, Co. Meath. From metalworking area 1
Bone; (a) 10.9 × 4.9 cm; (b) 10.4 × 3.2 × 0.7 cm
Irish, 7th–8th century
John Bradley (a) ML 1985:3049; (b) ML 1985:3076

(a) Cattle-leg bone splinter worked with a row of three triquetra knots in false relief on the outer face of the bone. Two join at one corner.

(b) Motif piece with triquetra design in false relief surrounded by a lightly incised triangle, probably cut as a guideline for the design. Close by is a lightly incised rectangle (1.5 × 1.3 cm) surrounding what may have been the beginning of another triquetra. Both surfaces of the bone bear lightly incised lines which do not form any distinctive pattern.

Considerable debate has ranged over the purposes of such worked pieces of bone and stone, whether they are trial attempts before producing models for metal casting, apprentice pieces, or were used as models for foil panels. O'Meadhra (1979, 1987) has recently argued that they are primarily exemplars or motif pieces for a variety of such purposes. They were produced on workshop sites from the seventh to the eleventh centuries, some of the earliest coming from Garryduff, Co. Cork, where there is limited direct evidence for metalworking (O'Kelly 1962–4); but the Moynagh Lough pieces were found in a workshop area. The simple three-corner knot or triquetra remained popular throughout the early medieval period.

JB/SY

BIBLIOGRAPHY Bradley forthcoming, fig. 6

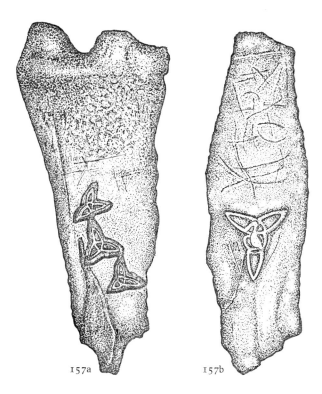

157a 157b

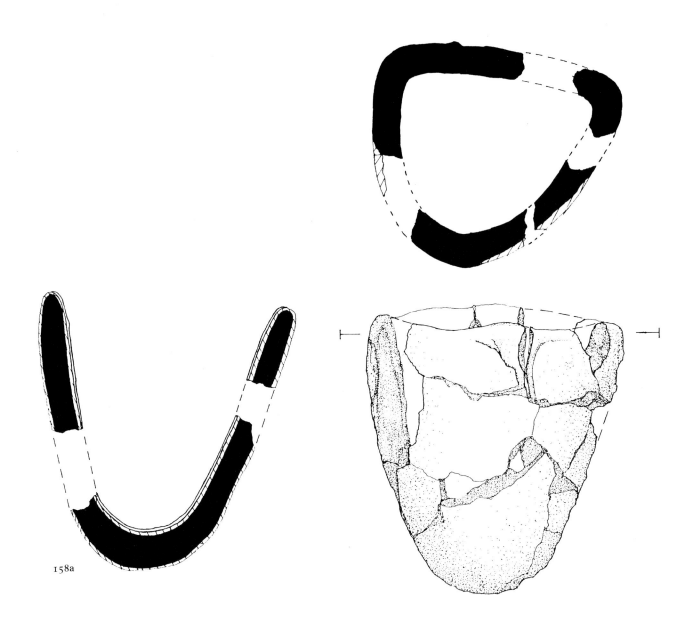

158a

158a Crucible

Moynagh Lough, Co. Meath. From fill of furnace I
Baked clay, H. 9.1 cm, mouth max. w. 8.1 cm
Irish, 7th–8th century
John Bradley, ML 1984:683

Pyramidal crucible of grey-white clay with triangular mouth and
with traces of at least two clay linings where repairs have been
made. The exterior has a thick deposit of heat-crazed green and red
molten dross. On the outside of the rounded base is a group of nine
jab marks formed by a ribbed gripping tool, probably tongs; a pair
(no. 225) was recovered outside the palisade. A number of almost
identically sized crucibles are known from Garranes (Ó Ríordáin
1941–2, 134–9). JB

BIBLIOGRAPHY Bradley 1982–3, 24

158b Crucible

Moynagh Lough, Co. Meath. From occupation area east of round house 1
Baked clay; H. 4.9 cm, mouth max w. 5 cm
Irish, 7th–8th century
John Bradley, ML 1984:700

Pyramidal-shaped crucible with triangular mouth, now incomplete. The fabric consists of grey clay with quartzite inclusions; the walls are thin by comparison with other vessels from the site, with yellow accretion on the interior. JB

BIBLIOGRAPHY Bradley forthcoming, fig. 4

158c Crucible

Moynagh Lough, Co. Meath. From occupation debris outside palisade
Baked clay; H. 4.5, mouth 3.5 × 3.2 × 2.4 cm
Irish, 7th–8th century
John Bradley, ML 1984:1693

Complete small pyramidal crucible with triangular mouth, the outside covered in heavily vesiculated green and red dross particularly thick below the pouring angle. Two pairs of jab marks: one near the top and the other at the base are tool impressions as on no. 158a.

Two sizes of this form of crucible were in use, perhaps indicating specialised functions in addition to the varied processes suggested by different types of crucible both with and without lids found on the site. JB

BIBLIOGRAPHY Bradley forthcoming, fig. 4

159a, b Handled crucibles

Moynagh Lough, Co. Meath
Baked clay; (a) H. 4.3 cm, mouth 2.8 × 2 cm; (b) H. 5.9 cm, 4.3 × 3.8 cm
Irish, probably 7th–8th century
John Bradley, (a) ML 1984:2182; (b) 1984:2309

(a) Oval-mouthed crucible with applied handle and rounded base. Most of the exterior is covered with dross but in places a grey lining appears to be present. The handle is a separate piece inserted into a hole near the base.

(b) Similar, covered externally in a layer of vitreous green glaze containing many small inclusions, the handle is formed out of the body of the clay. The interior is cracked and a yellow accretion is present. This is the only example of this type from Moynagh Lough.

Different forms of handled crucibles are known from early Christian-period sites (Alcock 1963, 141; Laing Type 8 in Laing 1975, 250–2, fig. 73). At Carraig Aille and Ballinderry 2, Co. Offaly, the handles are pinched out of the body fabric (Ó Ríordáin 1949, 91–2, fig. 20; Hencken 1941–2, 50, fig. 125). The variety of crucibles present in some workshops like that at Moynagh Lough and Dunadd (Lane 1980) does not necessarily indicate technological experiment (Alcock 1963, 143). If considered with increasing evidence for controlled metalworking processes, then the range of forms may be seen to reflect highly specialised functions such as control of the amount of oxidisation and quantities of ore or scrap required for different metals (see no. 220), matching the expertise achieved in the finished products of the period. JB/SY

BIBLIOGRAPHY Bradley forthcoming, fig. 4

160 Heating tray

Moynagh Lough, Co. Meath. Found in round house 1
Baked clay; est. DIAM. 5.7 cm, H. 1.05 cm; base TH. 0.25 cm, wall TH. 0.4 cm
Irish, 8th century
John Bradley, ML 1984:339

Roughly half of a flat-bottomed heating tray with a pointed rim. The interior is largely devoid of glaze except for a raised area in the centre, which suggests it was used for working an annular object or as a crucible stand. JB

BIBLIOGRAPHY Bradley forthcoming, fig. 5

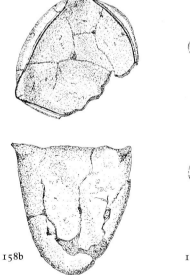

158b

158c

160

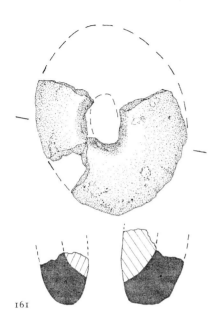

161

161 Tuyère

Moynagh Lough, Co. Meath. Found in round house 1
Baked clay; mouth 1.5 × 2.4 cm, nozzle D. 2.7 cm
Irish, 8th century
John Bradley, ML 1984:344

Baked clay nozzle with an elliptical mouth for a small bellows or blowpipe. A small portion of the clay lining survives encased in a shell of mottled red vitreous glaze. Blowpipes, like bellows, were used to increase the heat of a flame, but no actual blowpipe has yet been identified on a metalworking site. They were probably of some non heat-conducting organic material such as bone. JB/SY

BIBLIOGRAPHY Bradley forthcoming, fig. 4

162 Ingot

Moynagh Lough, Co. Meath. Found in round house 1
Copper-alloy; 3.2 × 0.95 × 0.35 cm, WT 7 g
Irish, 8th century
John Bradley, ML 1984:350

Small copper-alloy ingot of subrectangular shape. An almost identical example in silver is known from Feltrim Hill, Co. Dublin (Hartnett and Eogan 1964, 32). JB

BIBLIOGRAPHY Bradley forthcoming, fig. 4

163 Ingot mould

Moynagh Lough, Co. Meath. From occupation debris outside palisade
Sandstone; 8.3 × 7.4 × 2.75 cm
Irish, 7th–8th century
John Bradley, ML 1984:1665

Multiple stone mould used to cast four bar ingots of varying lengths and thicknesses arranged parallel to one another across the stone.

An ingot has been recovered (no. 162) which is about half the length of the smallest bar in this mould. JB

BIBLIOGRAPHY Bradley forthcoming, fig. 4

164 Brooch mould

Moynagh Lough, Co. Meath. From metalworking area 2
Baked clay; max DIAM. 6.3 cm, brooch DIAM. 4 cm, terminal L. 0.85 cm
Irish, 7th–8th century
John Bradley, ML 1984:1209

Lower piece of a penannular brooch mould of grey clay internally with pink slip on the exterior, and nicks which probably functioned as keying devices or which may have been made to allow for expansion without distortion during firing. The brooch terminals were faceted and decorated with a lozenge panel enclosing a circular motif.

This is an example of a type G brooch (Fowler 1963; Dickinson 1982) and it may be compared to the lozenge-terminalled brooch mould from Dooey, Co. Donegal (no. 180; Ó Ríordáin and Rynne 1961, 62). Many moulds for type G penannular brooches were excavated at Dunadd, Argyll, in a seventh-century context (see discussion of no. 181). JB/SY

BIBLIOGRAPHY Bradley 1984, fig. 2, no. 915; Bradley forthcoming, fig. 7

165 Two-piece mould

Moynagh Lough, Co. Meath. From metalworking area 2
Baked clay; L. 4.4 cm, w. 3.65 cm, combined lid and base TH. 1.8 cm
Irish, 7th–8th century
John Bradley, ML 1984:1211

Two-piece pear-shaped mould for a decorated mount. The lower piece is complete, the top broken. The mouth, or ingate, is funnel-shaped. The design consists of two opposed trumpet motifs terminating in a spiral of one turn. At the top these are joined by a bar which contained one rivet hole, presumably in order to attach the mount to the desired surface. The impression is not evenly executed and is deeper on one side than the other. JB

BIBLIOGRAPHY Bradley 1984, 89, fig. 2, no. 917; Bradley forthcoming, fig. 7

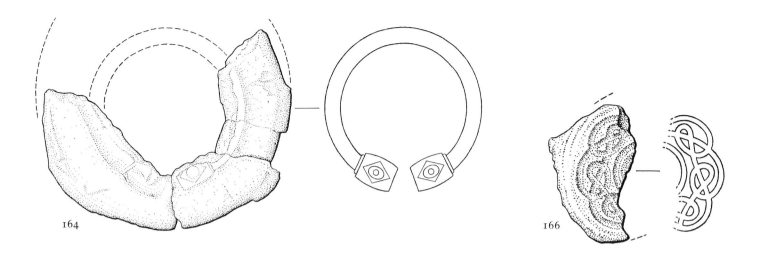

164

166

166 Stud mould

Moynagh Lough, Co. Meath. From metalworking area 2
Baked clay; max L. 1.9 cm, estimated DIAM. 1.5 cm
Irish, 7th–8th century
John Bradley, ML 1984:1212

About half a mould for a circular stud setting decorated around the
perimeter with two-strand ribbon interlace forming a type of
running scroll. The same simple design runs in reverse around a
stud mount from Nendrum, Co. Down (O'Meadhra 1987, 73, fig.
50b). This mould bears a similarity to a stud on the front of the
Lough Erne shrine (no. 130b), and many mounts of this form are
known from Viking-Age deposits in Scandinavia (Wamers 1985,
nos 62, 95, 136). A recently discovered Irish example was part of
a set of saddle fittings. JB/SY

BIBLIOGRAPHY Bradley forthcoming, fig. 8

167a–e Double and multiple moulds

Moynagh Lough, Co. Meath
Baked clay; (a) 4.6 × 3.5 × 1.1 cm; (b) 3.5 × 2.35 × 1.1 cm;
 (c) 2.6 × 2.6 × 1 cm; (d) 4.5 × 3 × 1 cm; (e) 4.8 × 2.3 × 1.2 cm
Irish, 7th–8th century
John Bradley, (a) ML 1984:1214; (b) ML 1984:1215; (c) ML 1984:1216; (d)
 ML 1984:1217; (e) ML 1984:1220

Part of a group of moulds producing near-identical, symmetrical,
bar-shaped mounts. The interlace design consists of two triquetras
linked by a lozenge with loops top and bottom and set within
opposed beaked terminals. On *a* the impression for the ingate (metal

channel) can be seen immediately above the larger impression.
Some nineteen moulds for similar mounts were recovered from
metalworking area 2. At least four of these, including *a*, *b* and *e*,
were multiple moulds for the simultaneous production of matching
fittings. Significant variations in detail and size as between *a* and *c*
show that more than one model was used to impress the clay.

Copper-alloy mounts of similar type were produced in multiple
batches for Irish harness-mount sets such as those recovered from
Viking graves at Gausel (Wamers 1985, no. 90) and Soma (no.
114) in Norway. Their ornamental motifs include much low-relief
interlace, similar to the simpler range of Moynagh Lough mould
patterns, and all are distantly derived from chip-carved ornament.
The small outcurved terminals on these moulds are harder to paral-
lel, an incurving fish-tail form being more usual. JB/SY

BIBLIOGRAPHY Bradley forthcoming, fig. 8

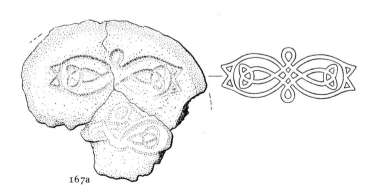

167a

168 Anthropomorphic mould

Moynagh Lough, Co. Meath. From metalworking area 2
Baked clay; face L. 1.6 cm, face W. 1.1 cm, mould TH. 1.2 cm
Irish, 7th–8th century
John Bradley, ML 1985:3180

Fragment of a clay mould for a small subtriangular face with bulbous eyes, arched eyebrows, a pointed nose and slit mouth. The hair is parted in the centre and frames the face as it falls, terminating in a loop.

The design is similar to that of the heads joining the terminals on the Co. Cavan, or 'Queen's' brooch, no. 73. Although the Cavan brooch heads are integral parts of a larger casting, the mount found at Markyate (no. 116) has two projecting heads, though with deep attachment lugs behind. It cannot be assumed, however, that this mould was used for copper-alloy. A pair of individual small green glass heads are mounted on the chain attachment of the 'Tara' brooch (Henry 1965a, pl. 38), and there is evidence for glass-working on site at Moynagh Lough (see no. 208). JB/SY

BIBLIOGRAPHY Bourke, Fanning and Whitfield 1988, 94; Bradley forthcoming, fig. 9

169 Lidded crucible

Garryduff ringfort no. 1, Co. Cork. From period II
Baked clay; H. (inc. lid) 7.0 cm, w. 4.0 cm
Irish, 7th–8th century
Cork Public Museum L.739 (374)

Complete crucible of fine clay, now grey in colour, with rounded base rising to a triangular mouth. A separate lid of clay was luted to the rim, one corner being left open. At the centre of the lid is a pulled lug to enable the crucible to be gripped with tongs. There are only slight traces of vitrification on the outer base, and the interior is clean.

Irish crucibles take a variety of forms – bag-shaped, flat-based and triangular – and were sometimes provided with handles or lids. Together with moulds used in casting they attest a familiarity with ceramics at a time when most of the country lacked native domestic pottery. In size and shape lidded crucibles like this resemble the more common open pyramidal type (see nos 158, 173). Although not common at any one site, the type is widely distributed, occurring at Dinas Powys in Wales (Alcock 1963, fig. 30) and at Dunadd in Scotland (Hewat Craw 1929–30, fig. 8, 5). O'Kelly suggested that they may have been used in glassmaking, but none have been found with traces of glass waste. The Dinas Powys crucibles of this type were used for copper-alloy working and traces of gold were found in one (Alcock 1987, 124–5). The lid helped to exclude impurities, retain heat and reduce oxidation in the molten metal. RÓF/CB

BIBLIOGRAPHY O'Kelly 1962–4, 95–6, and fig. 21, 374

169

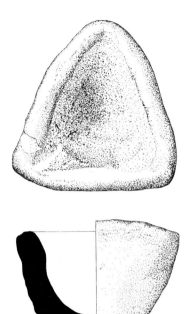

170

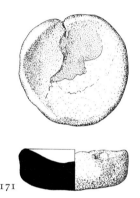

171

170 Crucible

Lagore Crannog, Co. Meath
Baked clay; H. 4.3 cm, sides L. 6.3 cm
Irish, 7th–9th century
NMI E14:486

Crucible of fine-grained baked clay. It has a rounded base, the sides rising to a triangular mouth. The external colour of the base is buff-grey, while the top edge is brown. The interior and lip are highly vitrified with a thick green glaze.

This is an example of the triangular-mouthed crucible so common on early medieval sites in Ireland (for example, at Moynagh Lough, no. 158) and Scotland (Birsay, Orkney, Curle 1982, no. 393). They were the commonest type found at the excavations at Garranes (Ó Ríordáin 1941–2, 134–9) and Armagh (Gaskell-Brown and Harper 1984, 145–9). Almost all are vitrified on the outside and this example is atypical in being glazed internally, indicating that its contents were heated from above using a blowpipe. There is quite a considerable range in size, some examples being only 2.0 cm deep. Size, however, does appear to have some bearing on the metal smelted. Although all the crucibles of this type analysed earlier this century from a variety of Irish sites proved to have been used for smelting copper or copper-alloy (Moss 1924–7), very small examples from Dunadd and Clogher (no. 220) were used for gold and silver.

Triangular-mouthed crucibles were found at all levels in excavations at Lagore. This example was associated with period 1b which also produced E-ware imported pottery.　　　　RÓF

BIBLIOGRAPHY Hencken 1950–1, 235, and fig. 117, 1312

171 Heating tray or stand

Lagore Crannog, Co. Meath
Baked clay; W. 4.1 cm; H. 1.5 cm
Irish, 7th–9th century
NMI E14:439

Triangular in shape with rounded corners, this object is made from a flattened ball of clay. Part of the interior is covered with a red vitreous material. The slightly rounded base is dark grey in colour, while the upper surface and part of the side are buff-grey. Analysis of the red glaze showed it to be fused silica with a trace of iron, and no copper or sulphur was detected (Hencken 1950–1, 237).

These objects have been variously described as containers, crucibles or heating trays. Hencken suggested that they were used as stands on which crucibles were set. They were undoubtedly used in metalworking to judge from their association with crucibles and other metalworking debris on excavated sites. All are vitrified on their interior indicating that they were heated directly from above. O'Kelly (1962–4, 97) suggested that they were crucibles in their own right and that some have added clay linings indicating that they were used more than once. The type is widespread in early medieval contexts in Ireland (at Garranes and Garryduff) and in Scotland at Birsay (Curle 1982, 41) and Kildonan (Fairhurst 1938–9, fig. 10, 5). They are also common on Scandinavian sites of the early medieval period and analyses of examples from Fyrkat have shown traces of silver, lead and copper (Graham-Campbell 1980, no. 425).

Flat-bottom vessels were found only in the earliest levels at Lagore (periods 1a and b), dated by stratified finds to the seventh to ninth centuries.　　　　RÓF

BIBLIOGRAPHY Hencken 1950–1, 235, 237, and fig. 117, 32

Clogher, Co. Tyrone (nos 172–4; see also nos 188, 193, 220–1)

A complex of earthworks, excavated in the 1970s, was the habitation of the kings of a powerful tribe, the Uí Crimthainn, from the sixth to the early ninth centuries. Extensive industrial activity was uncovered, including iron, bronze, glass and gold-working, which agrees with the evidence of contemporary texts on kingship.

172

173

172 Romano-British bracelet

Clogher, Co. Tyrone
Copper-alloy, ?tinned; L. 8.6 cm, W. 0.4 cm. TH. 0.16 cm
Romano-British, late 4th century
UM CL 2309

Narrow strip of bronze decorated on one face with a series of deeply carved transverse and alternating oblique grooves. One end tapers, the other is missing. This is probably to be identified either as a fragment of a late fourth-century Romano-British bracelet of the kind found in large quantities at temple sites in southern Britain (for instance Lydney, Gloucestershire) or as an Irish derivative of such a bracelet.

It was found amongst the scrap-bronze associated with a brooch factory (nos 173, 188, 193) of the late sixth century. The conclusion is that the bracelet was a personal heirloom of one of the Clogher families for up to two centuries until being condemned to the melting-pot to produce a new brooch. The fact that the brooches being produced here had developed from a type coming from the same Romano-British background as the bracelet is not without interest and significance in the study of the origins of early Christian Irish culture. RW

173 Crucible

Clogher, Co. Tyrone
Baked clay; H. 4.1 cm
Irish, late 6th century
UM CL 3739

Triangular crucible of symmetrical form (height and side width about equal). The sides straighten as they rise from an almost pointed rounded bottom until at the mouth they form a perfect subtriangle. The lip and exterior are glazed, green and red, and a fragment of bronze can be seen adhering to the interior.

The heavy vitrification on the outside of these objects is due to the heat-induced migration of silicates from within the ceramic fabric, not, as is often thought, a spillage of the contents (which were relatively pure metal). The devitrification of the fabric caused the disintegration of a crucible after only a few melts, and it is not surprising that complete crucibles are uncommon. Many of those from Clogher still contain some bronze, though others were undoubtedly used for glass or gold melting (see no. 220).

The object was found in the area of a bronze ornament workshop. The majority of crucibles and crucible fragments came from bronze-working areas and all were of the simple triangular form, large enough for up to 200 g of bronze (25 cc capacity). This was more than enough for contemporary ornaments, such as the penannular brooches that were being made here. RW

BIBLIOGRAPHY Warner 1979; Warner 1988

174

175

174 Crucible stand

Clogher, Co. Tyrone
Baked clay; H. 3.5 cm, DIAM. 1.8 cm
Irish, 7th century
UM CL 3781

Shallow flat-bottomed crucible-like object showing vitrification on the rim and extending in concave fashion some way over the interior, leaving a space below. The exterior is unvitrified.

These objects were believed by M. J. O'Kelly to have been for metal-melting (1962–4, 97), but with the heat applied to the interior by a blowpipe rather than to the exterior from the fire as in the case of the triangular crucibles. The alternative explanation, that this was a stand for triangular crucibles when out of the fire, seems to be better for this object. RW

175 Crucible and stand

Nendrum monastic site, Mahee Island, Co. Down. From metalworking area
Baked clay, stone; crucible H. 4.9 cm, side L. 6.7 cm, stand H. 4.0 cm
Irish, 8th–10th century
UM A1925.53 & 54

Triangular crucible of grey clay suitable for working in bronze, precious metals or glass. A mixed grey and red glaze on the exterior results from exposure to heat (see no. 173). The crucible was placed in the fire on a shaped stone stand, now vitrified, in order to ensure stability. It contains traces of bronze. CB

BIBLIOGRAPHY Lawlor 1925, 141–2, pl. xi.98, 99

Brough of Birsay, Birsay, Orkney (nos 176–9, 183)
Excavations on this tidal island show it was continuously settled
from the eighth century onwards, from the Pictish to the early
Viking period (Curle 1982). Industrial debris includes much
evidence for extensive and varied fine metalware manufacture.

RMS

176

176a–c Crucibles

Brough of Birsay, Birsay, Orkney
NMS HB 394, 410, 398

(a) Found during 1975 excavations, from area III, house site L
Baked clay; L. 3.9 cm, W. 3.7 cm, H. 3.3 cm
Pictish or Norse, 8th–10th century

Crucible with heavy upright sides and broad, somewhat flattened
base. The opening is roughly triangular with a thick lip and a slight
spout.

(b) Found during 1936–9 excavations, from Pictish horizon
in area II
Baked clay; L. 3.7 cm, W. 4.1 cm, H. 2.2 cm
Pictish, late 8th century

Incomplete crucible of shallow open form, straight-sided and with
a slightly concave base, possibly used as a hot-working tray.

(c) Found during 1936–9 excavations, from Pictish horizon
in area II
Baked clay; L. 2.1 cm, W. 4.0 cm, H. 4.2 cm
Pictish; late 8th century

Crucible with a lug handle set low to extend the flat base. The sides
narrow to a small circular mouth. The base is lightly vitrified. RMS

BIBLIOGRAPHY Curle 1982, 40–2, 114

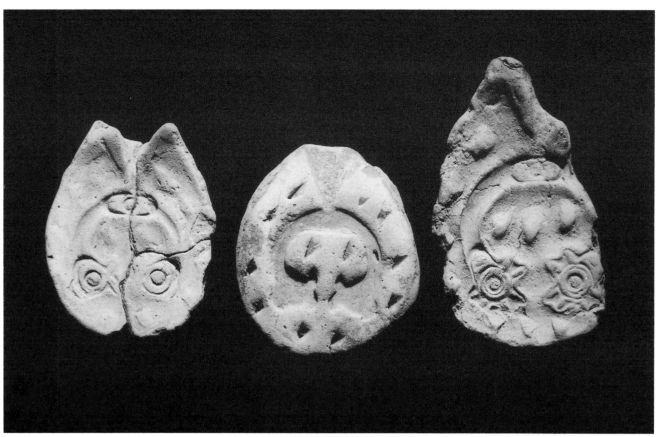

177 left and centre, 178 right

177 Brooch mould

Brough of Birsay, Birsay, Orkney. Found during 1936–9 excavations, from
 Pictish horizon in area II
Baked clay; (HB 294) L. 5.2 cm, W. 4.5 cm; (HB 295) L. 5.5 cm, W. 4.8 cm
Pictish, late 8th century
NMS HB 294 and 295

Both parts of a two-piece mould for the casting of a penannular
brooch. The front valve (HB 294) carries the pattern of the brooch's
cast decoration and positive keying. The back valve (HB 295) carries
a plain pattern with negative keying. The brooch cast in this mould
had zoomorphic terminals, the majority of which are taken up with
a recess for decorative eye studs. There are slight cusps at the
junction between the terminals and hoop, and an oval cartouche
with a circular setting at the top of the hoop.

 The cusps, terminals and oval cartouche are typical of Pictish
brooches of this period. RMS

BIBLIOGRAPHY Curle 1982, 26–9, 111

178 Brooch mould-valve

Brough of Birsay, Birsay, Orkney. Found during 1936–9 excavations, from
 Pictish horizon in area II
Baked clay; L. 7.1 cm, W. 4.2 cm
Pictish, late 8th century
NMS HB 298

Front valve of two-piece mould for penannular brooch, slightly
damaged. The brooch cast in this mould would have had zoomorphic
trilobate terminals. At the centre of each terminal is a recess for a
large circular setting. Recesses for cusp insets are placed between
each terminal and the hoop. There is a cartouche at the top of the
hoop with a central recess for a further setting. A number of positive
keying marks occur on the face of the mould. RMS

BIBLIOGRAPHY Curle 1982, 26–9, 111

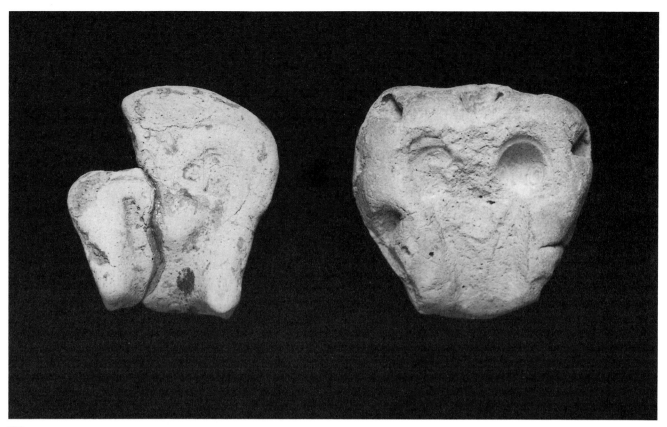

179

179a, b Mould for bird heads

Brough of Birsay, Birsay, Orkney. Found during 1936–9 excavations, from
 Pictish horizon in area II
Baked clay; (HB 311) L. 3.8 cm, W. 4.0 cm; (HB 312) L. 4.1 cm, W. 4 cm
Pictish, late 8th century
NMS HB 311 and 312

Both parts of a two-piece mould for the casting of ornamental bird
heads. The front valve (HB 311) is very worn and incomplete. It
carries the pattern of a bird head in profile, identical with that on
the back valve. The back valve (HB 312) is complete and shows two
bird heads, one in profile, the other impressed 'head down' into the
clay. Both heads would have had flat bases. Such cast heads may
have been used as ornamental mountings on brooch terminals (see
the Rogart and Perth brooches, nos 111, 109). RMS

BIBLIOGRAPHY Curle 1982, 29–31, 112

180 Brooch mould-valve

Dooey, Co. Donegal. Found in excavations at a settlement site
Baked clay; mould L. 5.7 cm, W. 5.0 cm, av. TH. 0.7 cm, matrix W. 3.8 cm
Irish, 7th–8th century
NMI E33:621

180

Complete valve of a two-piece clay mould for casting a penannular
brooch. It is provided with a v-shaped pouring gate, a central boss
and several raised triangular keying devices around the edge. The
fine-grained micaceous clay is oxidised, orange in colour externally
and dark grey internally. It was used to cast a brooch with lozenge-
shaped, faceted terminals with a raised collar at either end of the
terminal.

 The closest parallels for this mould include the ring of a brooch

from Dowalton Lough and a series of moulds from Dunadd (Dickinson 1982, figs 6, 7). This mould represents a brooch type current in western Scotland and the north of Ireland from the seventh to the eighth centuries. RÓF

BIBLIOGRAPHY Ó Ríordáin and Rynne 1961, 61, and fig. 7; Fowler 1963, n. 4, 141; Dickinson 1982, 45

181 Brooch mould

Dunadd Fort, Argyll
Baked clay; 3.7 × 3.3 × 0.7 cm
Irish style, 7th century
Scottish Historic Buildings and Monuments Directorate, DA 653

Almost complete lower valve of two-piece mould showing the front face of a small, highly decorated bird-headed brooch which is described as it would appear when cast. The terminals have opposed incurving raptor beaks with raised margins. The eyes (DIAM. 6 mm), fill the entire head and also have raised margins and sunken interiors, possibly for decorative settings. The hoop also has raised margins. Within the sunken field is a complex raised interlace decoration (cf Romilly Allen and Anderson 1903, no. 653). The hoop top has a square-ended hoop panel in relief. The sides of the hoop, the eyes and the beaks slope steeply outwards and have vertical milled decoration, but this does not extend to the hoop panel. The external hoop diameter is 2.8 cm. The mould has negative keying consisting of two dowel holes and slash marks on the outer margin. The brooch as cast would be c. 2 mm thick.

The fortified site at Dunadd is known from brief annal references in AD 683 and 736 to have been a place of importance in the kingdom of Scottish Dál Riada and may have been the inauguration site of the Dál Riadic kings.

Excavations in 1904–5 and 1929 recovered a major, but unstratified, early medieval finds assemblage including an important collection of fine metalworking debris for which an eighth- to ninth-century date has been postulated (Wilson 1973, 87–8). The bird-headed mould comes from new excavations in 1980–1 which revealed deep undisturbed metalworking deposits. Seven radiocarbon dates, two Anglo-Saxon metalwork fragments and imported continental pottery all indicate a seventh-century date for this deposit. The deposit also contained moulds for several other bird-headed brooches, for many Fowler type G penannular brooches and for several panelled penannular or annular brooches of similar size to the Hunterston brooch (no. 69).

The only surviving bird-headed brooch of this type is from Clogh, Co. Antrim (no. 182), which has been variously dated to the seventh or ninth century (Henry 1965b, 58–63; Graham-Campbell 1973–4, 55). The Dunadd bird heads can be closely paralleled by a small group of seventh-century Anglo-Saxon ring brooches from Northumbria (Hirst 1985, fig. 41; Speake 1980, fig. 11). The interlace on the mould shows that very fine detail could be cast from clay moulds. Identical interlace is found on two large decorated pseudo-penannular brooches from Mull and Snåsa.

The presence of Anglo-Saxon objects together with Northumbrian-influenced brooch moulds in a seventh-century deposit in Dál Riada provides important new evidence for the introduction of Anglo-Saxon motifs into the Celtic metalworking repertoire. EC

BIBLIOGRAPHY Lane 1984

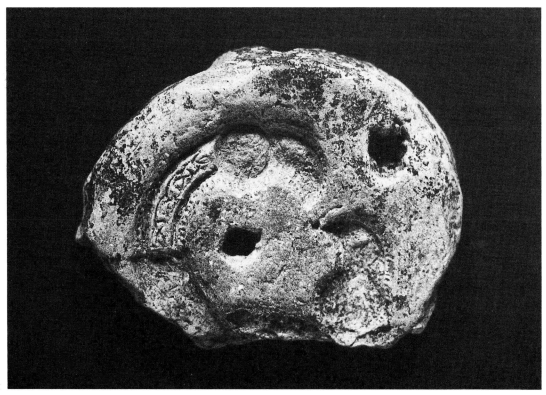

181

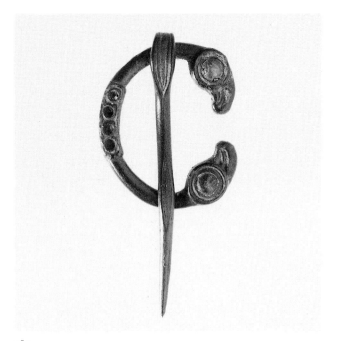

182

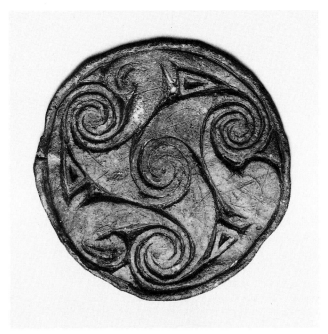

183

182 Penannular brooch

Clogh, Co. Antrim, Ireland
Copper-alloy, amber; hoop DIAM. 3 cm, pin L. 5.1 cm
Irish style, 7th–8th century
BM, MLA 1898, 6-18, 8, Greenwell Collection

Plain hoop of variable cross-section, oval to subrectangular, with a slightly broader panel at the top framing four round collared recesses with inner rings and dots. The terminals are large bird heads dominated by cabochon amber eyes with an outer circle. The recesses on the hoop panel were probably settings for more amber or glass. Amber in the birds' eyes is now partly opaque, and it is not certain whether reflective foil backings were used. The thick beaks curve slightly and have an inner line in a recessed panel. The brooch back is plain. The pin has a simple hook wrapped around the hoop and broadens into a lentoid panel at the head and another halfway down the shank. The top panel has an inner frame of cast lines; the bottom is apparently textured in some way but the surface is now worn. The pin is markedly dished where it crosses the hoop.

The ornament on this brooch appears so Germanic that it has been firmly dated to the seventh century (Henry 1965b, 58–63; Hencken 1950–1, 64), but more recent commentators argue equally firmly for the ninth century (Graham-Campbell 1973-4, 55). What is now certain, on the evidence of moulds excavated from Dunadd, Argyll, is that brooches of this type were manufactured in the Irish-ruled kingdom of Scottish Dál Riada (see no. 181). The excavator now argues for a seventh-century date for these moulds on the evidence of radiocarbon dates and associated finds. Another bird-headed brooch of rather different form is known from Lagore. The only annular brooch of top quality which has bird heads of this type is the one found at Hunterston in western Scotland (no. 69). It is noted above (no. 15) that early zoomorphic brooches often have

a short pin which is markedly dished like the pin on this brooch, reinforcing an early date for the piece. SY

BIBLIOGRAPHY Smith 1923, 133–4; Rynne 1965, 103; Hencken 1950–1, 64, fig. 10; Fowler 1963, 119–20; Henry 1965b, 58–63, fig. 2a; Graham-Campbell 1973-4, 55; Stevenson 1974, 35, n. 57; Lane 1984, 53–4

183 Decorated disc

Brough of Birsay, Birsay, Orkney. Found during the 1936-9 excavations, from lower Norse horizon
Lead; DIAM. 5.0 cm, TH. 0.5 cm, WT 52.4 g
Pictish, 6th–8th century
NMS HB 509

Lead disc decorated on one side with three interlocking incised and carved trumpet spirals. Scratches and surface irregularities may in part be the result of later abrasions. The reverse of the disc is also marked with two rectangular grooves and a number of linear scratches. The design has been simply executed and it may be incomplete and either a model for moulding or a motif piece. RMS

BIBLIOGRAPHY Curle 1982, 48–9, 117

184 Die

Louth, Lincolnshire
Copper-alloy; H. 2.8 cm, W. 2 cm
Insular; ?Northumbrian, 7th–8th century
Private collection, C. Marshall, K 246

Solid D-shaped casting with a concave recess on the straight edge and small subcircular projection on the curved edge, the whole with a beaded border. The central field holds a sharply cut, near-symmetrical pattern of spirals and trumpet ornament.

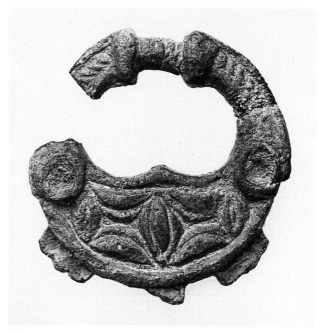

185

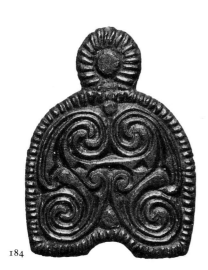

184

This piece was clearly designed as a unit in a larger ornamental scheme, and a dummy rivet head placed just below the projecting terminal suggests that it is a die for making foil mounts, probably in silver or gilt bronze. The Moylough belt-shrine (no. 47) is particularly rich in similar foils; that in the centre of the false buckle plate has an integral beaded border, while the spiral pattern in the triangular field of the same buckle plate is closer to the ornament on the Louth piece. Both circular and rectangular die-impressed silver panels with curvilinear ornament are found also on the underneath of the Derrynaflan paten (no. 125a). Panel 2 (Ryan 1983, pl. 65) has a dotted border, while on panels 4 and 5 (Ryan 1983, pls 66, 67) the borders are tightly beaded. Further die-impressed foils with beaded inner frames surround the rectangular glass studs on the paten stand (no. 125b, Ryan 1983, pl. 72).

Impressed foils are a widespread feature of Germanic metalwork and became particularly popular in seventh-century Anglo-Saxon England. Foils with Celtic curvilinear ornament also occur on the mount found in a seventh-century Anglo-Saxon grave at Swallowcliffe Down (no. 41), in association with others with typical Anglo-Saxon animal ornament. The Louth die probably post-dates these foils and should perhaps be considered as an example of Insular art, when cultural exchange and contact amongst late seventh-century Scottish, Northumbrian and Irish monasteries led to the production of exquisite decoration fluent in both Celtic and other European motifs. This die was found in association with a wide range of Anglo-Saxon and Viking-style metalwork on a deserted medieval village site near Louth. SY

EXHIBITION *The Lost Kingdom. The search for Anglo-Saxon Lindsey*, Scunthorpe Museum and Art Gallery, 1987–8

185 Model of brooch-pin

Dooey, Co. Donegal. Surface find *c.* 1958 in sandhills
Lead-alloy; DIAM. 2.4 cm
Irish, 8th–9th century
NMI 1963:18

Lead-alloy ring of brooch-pin, the hoop broken after discovery. The back is plain and flat, while the front is decorated with ornament in low relief. In the centre of the hoop is a constriction with raised buffers at either side. The hoop is rectangular in cross-section and decorated with a rope-moulding. There are two settings at the junction of the hoop with the fused terminals which are decorated with a symmetrical arrangement of crescents and pointed ovals. The outer edge of the terminals bears three lobed projections.

This is a model or die from which small brooch-pins such as no. 186 from Lagore were cast. Another copper-alloy example with marginal lobes from Fenagh crannog, Co. Galway, is in the Royal Ontario Museum (Pryor 1976, 32, 83), and there is another example, provenanced as Raphoe, Co. Donegal (some forty kilometres east of Dooey), in the National Museum. The parallels suggest that the type was very popular in Ireland and that the central lobe on the fused terminals was pierced to take a thread to secure the ring to the pin. In addition to the lead-alloy die, the Dooey site has produced several mould fragments for the production of brooch-pins (O'Meadhra 1987, fig. 20b). This object represents an intermediate stage in the production of a finished object. Dies such as these would have been cast from a mould bearing the impression of a wax model. A blank for producing such a model occurs on the face of a wooden object from Lagore (O'Meadhra 1979, pl. 49, 120B). It has a kidney-shaped opening and a projection on the outer curve of the ring, and in shape and size resembles the brooch-pins. RÓF

BIBLIOGRAPHY NMI 1966, 17, and fig. 5

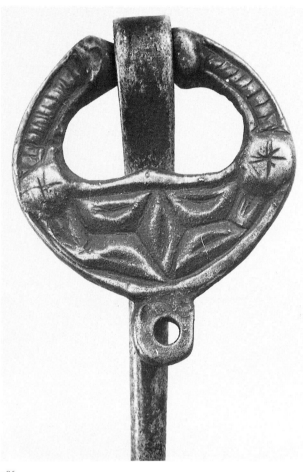

186

186 Brooch-pin

Lagore Crannog, Co. Meath. Found in 19th century
Copper-alloy; pin L. 10.0 cm, head w. 2.1 cm, head L. 2.5 cm
Irish, 9th century
NMI WK. L. 3

The pin is circular in cross-section, hammered flat at one end and bent into a loop. It swivels on a connecting bar confined between buffers in the centre of the hoop. The ring is circular with a kidney-shaped opening. The back is flat and plain, the front decorated with cast ornament in low relief. The hoop is rectangular in cross-section, decorated with a simple rope-moulding. There are low bosses at the junction of hoop and terminals which were engraved with star shapes after casting. The conjoined terminals are decorated with a central lentoid cell, flanked by pairs of lunate cells. A large loop is attached to the base of the ring.

In size and arrangement of decoration the ring of this brooch-pin is very close to the model from Dooey (no. 185). The form of the terminal decoration indicates that it is a negative impression of the Dooey type. It lacks the stud settings and marginal lobes of the latter. It otherwise gives a good idea of what a ring cast from the Dooey impression would have looked like. In addition to prov-enanced examples from Co. Galway and Co. Donegal (see no. 185) there are two other unprovenanced brooch-pins of similar size and decoration in the National Museum of Ireland indicating that this was a popular type. RÓF

BIBLIOGRAPHY Hencken 1950–1, 77, and fig. 18B

187 Model of ring for brooch-pin

Moylarg Crannog, Co. Antrim. Found in 1893 in excavations
Lead-alloy; DIAM. 1.3 cm
Irish, 9th century
NMI 1905:188

Complete ring of brooch-pin made of cast lead-alloy. The plain hoop is D-shaped in cross-section, and the terminals are fused and expand to form a pair of opposing pelta shapes. At the junction of hoop and terminal are two raised circular flat bosses. These are made of a lighter-coloured metal and are insertions which penetrate the thickness of the piece.

This miniature ring was probably used as a model which was pressed into a clay mould in which the finished product would have been cast. No ring brooches of this form are known, nor is it a miniature copy of any of the more elaborate silver brooch types. The plain ring with D-shaped cross-section is a feature of Irish brooches normally dated to the ninth century such as the Roscrea brooch (no. 79) or the bossed penannular brooches (no. 89). A mould for a ring of comparable size was found at Lagore (Hencken 1950–1, fig. 60, 1517). The small size of the ring and movable pin is more comparable with the brooches of the ninth century and later, rather than with the brooch-pins with fixed heads which tend to be more elaborate. Brooch-pins of the type represented by the Moylarg die are hard to find. The closest are perhaps the annular brooches with small heads illustrated by Henry (1936, fig. 7, i, and pl. XXVII, 8) who considers the curvilinear ornament on the terminals to be early, but the decoration and plain hoops of these pins equally could be as late as the ninth century. RÓF

BIBLIOGRAPHY Buick 1894, 319, 323

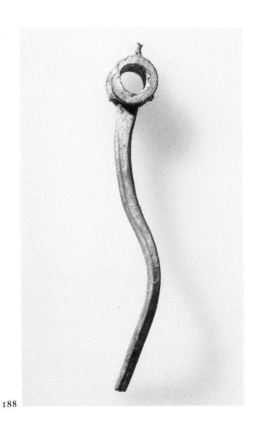

188

189

188 Brooch pin model

Clogher, Co. Tyrone
Lead; L. 9 cm, head w. 1 cm
Irish, late 6th century
UM CI 2213

Lead pin with faceted shank and hollow barrel-shaped pinhead bearing three symmetrically placed peaks and heavy rims.

It is a model for the 'peaked' form of pin widely found on Irish developed zoomorphic penannular brooches, particularly on the sub-class known to have been made at Clogher (see no. 172). Indeed, it was found in the Clogher brooch workshop in close proximity to a brooch terminal (no. 193). For a discussion of the site see no. 172. It is safe to conclude from the nature of the model that an investment – rather than piece – mould would have been required, and that the mould was made by the 'lost-lead' rather than 'lost-wax' method. The pinhead is closed; the final casting would have been slit to allow it to be prised open to receive the brooch ring. RW

BIBLIOGRAPHY Kilbride-Jones 1980b, no. 150

189 Die or model

Lough Ravel Crannog, Derryhollagh, Co. Antrim
Lead-alloy, copper-alloy; DIAM. 2.5 cm, H. 0.5 cm
Irish, 8th–9th century
NMI S.A 1927:932, Day Collection

This object consists of a disc with a central circular perforation. The flat back and outer edge consist of a hollow casing of copper-alloy enclosing a lead-alloy filling with decorated surface. The decoration consists of a continuous frieze of interlocking c-scrolls, beaded in imitation of filigree contained within a beaded border which follows the inner and outer edges of the slightly concave copper-alloy casing.

Although the decorated surface of the lead-alloy core is damaged, the surviving portion is fresh and suggests that, if used as a die, this piece was impressed into a soft surface such as clay or wax to produce mounts such as the medallions found on house-shaped shrines, the central area being reserved for a stud of glass or amber.

The crannog of Lough Ravel produced a number of finds in the last century (Wood-Martin 1886, 163–4), including two important ninth-century brooches (Graham-Campbell 1973–4). Evidence of metalworking is indicated by a crucible fragment from the site, now in the National Museum of Ireland. RÓF

BIBLIOGRAPHY Sotheby 1913, 57, lot 388; Mahr 1932, pl. 19, 5; Raftery (ed.) 1941, 110

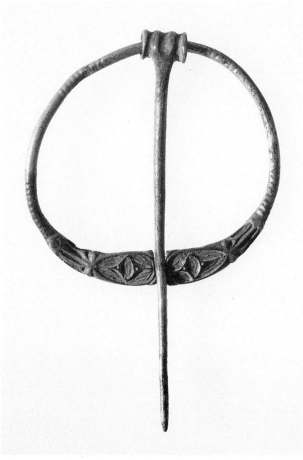

190a

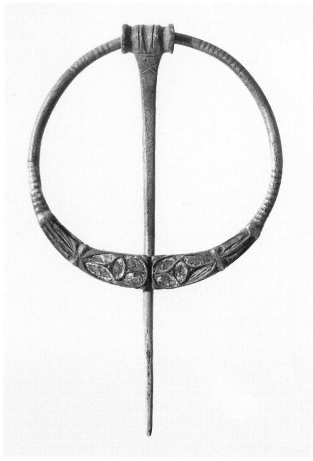

190b

190a, b Pair of penannular brooches

(a) River Bann at the Creagh, Co. Derry; (b) river Bann near Coleraine, Co. Derry

Copper-alloy, enamel; (a) hoop w. 7.25 cm, pin L. 10.9 cm;
(b) hoop w. 7 cm, pin L. 11.3 cm

Irish, 6th century

UM (a) AL8.1932; (b) A500.1976

Two virtually identical examples of a variant of the Irish developed zoomorphic penannular brooch. A thin circular penannular ring of circular section, bearing discontinuous sections of fine ribbing on its upper side, terminates in a pair of flat subtriangular plates. Each plate has the single large lobe ('snout'), with two smaller flanking lobes ('eyes') between the plate and the ring, and the pair of small lobes ('ears') at the extremity of the plate that give the whole class the description 'zoomorphic'. Each plate is decorated with a pair of reserved dotted triangles, surrounded by keying for red enamel of which only faint traces remain. Each snout is grooved longitudinally, again for enamel. The pin of each differs only in detail,

both being of grooved barrel form and having an incised x on their backs. On the neck of one is an incised x between transverse grooves.

These brooches belong to the first distinctly Irish class which goes by the rather clumsy name of the 'developed zoomorphic penannular brooch'. The zoomorphism is more evident on the British-Irish precursor than on this developed form.

The interest of these two brooches lies in the fact that they were both dredged from the river Bann and are virtually identical, the only differences being in the head of the pin. That they were made in the same workshop by the same craftsman at the same time cannot seriously be doubted. One brooch (no. 190a) was found at the southern end of the lower Bann where it leaves Lough Neagh, the site of an important ford. The other came from the northern end of the river near Coleraine, close to the find-spot of a hanging-bowl mount (no. 37). RW

BIBLIOGRAPHY (no. 190a) Lawlor 1932, 209, fig. I, pl. vi. 7; Kilbride-Jones 1980b, no. 57

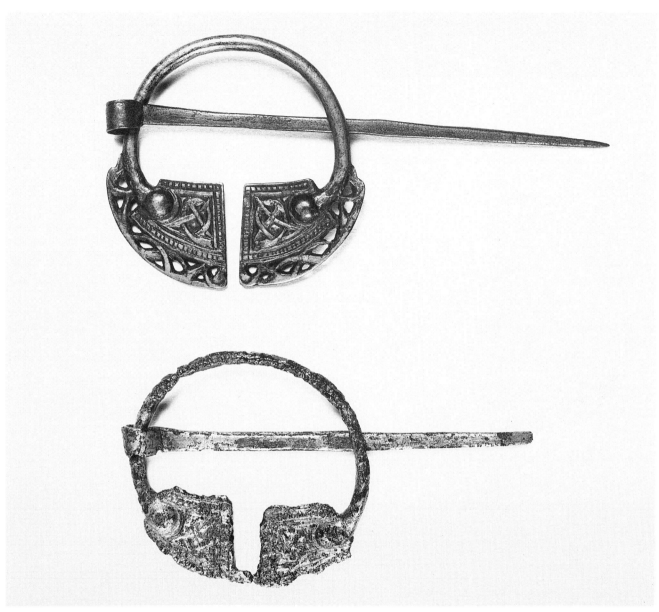

191 *top*, 192 *bottom*

191 Penannular brooch

Crannog in Carrafin Lough, Rivory, Co. Cavan
Copper-alloy; pin L. 12.2 cm, ring DIAM. 5.6 cm
Irish, 9th century
NMI 1938:30

Penannular brooch, complete. The pin is rectangular in cross-section and tapers to a fine point with a slight swelling midway along its length. It is flattened at one end and bent over to form an open loop, the sides of which are hammered up to a slight flange. The ring is cast with a hoop of oval cross-section ending in a knob on each terminal plate. The latter are flat and of curved trapezoidal shape and have an openwork border consisting of a pair of animals arranged back-to-back shown in profile. The centre of each terminal plate is filled with a single interlaced animal viewed in profile surrounded by a billeted border. The backs of the terminal plates are plain save for the terminal knobs of the hoop which also bear a ridge or spur at the junction with the hoop.

This brooch can be seen as a simpler version of more elaborate brooches such as those from Ardagh (no. 81) and Roscrea (no. 79), with marginal animals around the terminals and circular hoops continued on to the terminal plate. Here the plain boss replaces the amber studs of the former. These features would place this brooch firmly in the ninth-century tradition of Irish brooch manufacture. Two early ringed pins and a socketed iron axehead were also found on this site, together with material of late medieval date.

This brooch has almost exactly the same dimensions as that from the river Bann at Portna, and both appear to have been cast from a similar model (see discussion under no. 192). There is also a third brooch formerly in the Day Collection which bears identical decoration to the Rivory brooch (Day 1887–8). It was found 'in a crannog near the town of Cavan' (Day 1887–8, 115) which would place its find-spot in the immediate vicinity of the Rivory brooch. The diameter of the hoop is some 0.8 cm greater, and there are only slight differences in the decoration which could be accounted for in finishing off decorative features after casting. The Day brooch also shows casting flaws in the openwork animals on the terminals, not

found on the Rivory brooch. We have thus tentative evidence for the manufacture of brooches on a large scale using a finished brooch ring as a model, as was suggested for Viking-Age oval brooches (Jansson 1981). All three brooches have simple hooked pins which could be easily removed to enable the rings to be used as models for subsequent brooches. The variations in the decoration on the backs of all three suggest that only the front of the ring was impressed in the mould.

<div align="right">RÓF</div>

192 Annular brooch

Found in the river Bann at Portna, Co. Antrim
Copper-alloy, tinned; pin L. 10.0 cm, ring DIAM. 5.8 cm
Irish, 9th century
NMI W.357. Presented in 1852 by the Board of Works

Cast, tinned copper-alloy brooch, heavily corroded. The pin is oval in cross-section. The ring has a hoop of circular cross-section ending in a knob on each terminal plate. The latter, of curved trapezoidal shape, are joined by a rectangular strap at the outer edge. They may have originally been joined at the inner edge also. They have a billeted border, each containing a single contorted animal which is shown in profile.

Allowing for differences in condition, this brooch is almost identical in size with no. 191. Examination of the outer curve of the terminals shows that the brooch could have had a band of openwork animals as found on the Rivory brooch. However, this band did not extend on to the hoop, which indicates that the model for both was not the same. It does, however, show that these humbler brooches (unlike the brooch-pins – see nos 185–6) were not all made from wax models or lead-alloy dies; rather an existing ring of a brooch was used to create the next. The fact that this brooch is annular while the Rivory brooch is penannular illustrates how the annular brooch fashion still remained popular after the reintroduction of true penannular brooches to Ireland in the ninth century.

The decoration of the terminals shows that they lie typologically between the brooches of the eighth century and those of the ninth to tenth centuries. The single animal designed to be viewed from above has an ancestry going back to the 'Tara' and Hunterston brooches (no. 69), while the plain bosses, the billeted border and plain hoop are features which were soon to become the norm in the bossed penannular series (nos 82 and 89).

It has been noted that bossed penannular brooches are found only in the northern half of Ireland (Ó Floinn 1987, 179), and the fact that these transitional brooches also come from the same part of the country suggests that it is perhaps here that the origins of the former are to be found. The motif piece from Dunadd (no. 155) would suggest that the neighbouring part of south-western Scotland was also involved.

<div align="right">RÓF</div>

BIBLIOGRAPHY Mulvany 1852, lxiv, no. 4; Wilde 1861, 586

193 Brooch terminal waster

Clogher, Co. Tyrone. Found in a bronze ornament workshop (see no. 172)
Copper-alloy; L. 2.6 cm, w. 1.6 cm
Irish, late 6th century
UM CI 2048

Terminal of a zoomorphic penannular brooch, broken from its ring just behind the snout. The snout is a flat-topped peak and the terminal plate is a circular platform to which the circular 'ears' are attached. A casting flash is clear around the edge of the terminal and a piece of clay mould adheres.

This distinctive form of developed zoomorphic penannular brooch lacks the 'eyes' otherwise characteristic of the class (the lobes usually found between the snout and the plate). On finished examples the snout and plate-platform normally bear *millefiori* floating in enamel, or some other decoration. The absence of decoration or of recesses for decoration raises the possibility that ornament could be applied to zoomorphic brooches after casting. That this was a faulty casting about to be reassigned to the crucible seems clear.

The provenanced examples of the two sub-classes of developed zoomorphic penannular brooches that were found at Clogher have a distribution strongly suggestive of the hypothesis that Clogher might have been the place of manufacture of both sub-classes. This hypothesis was in fact proven by recovery during excavation of the debris related to the place of manufacture of one of these sub-classes. The brooch-factory debris, including a large number of fragments of triangular crucibles and tiny, undiagnostic pieces of moulds (indicative of the mould destruction necessitated by investment casting), was stratified with imported pottery, firmly placing it in the latter half of the sixth century, a useful dating horizon for the study of Insular metalwork.

<div align="right">RW</div>

BIBLIOGRAPHY Kilbride-Jones 1980b, no. 131, map, fig. 17

193

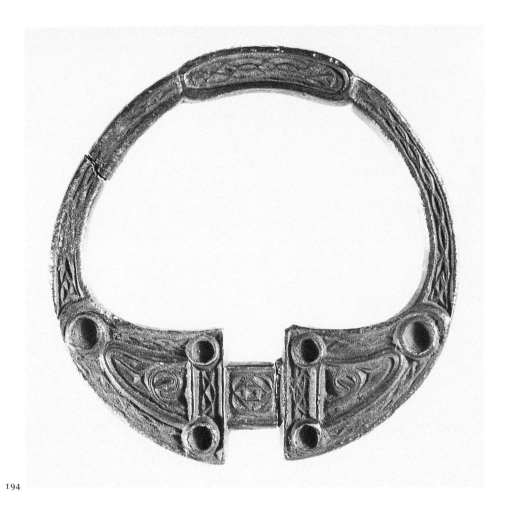

194

194 Annular brooch ring

Co. Louth
Copper-alloy, tinned; W. 7.8 cm, H. 7.6 cm
Irish, 8th century
NMI W.369, Underwood Collection

Cast ring of an annular brooch in two pieces. The back is flat and plain and is tinned. The hoop is trapezoidal in cross-section ending in curved triangular terminals which are linked by a single bar. The centre of the hoop broadens into a panel with curved ends. There are three settings on each terminal, one at the junction with the hoop and two at the broad end. All are empty. The front of the brooch is filled with sunken panels of imitation chip-carved ornament. The hoop and terminal margins are decorated with two-strand interlace, while the central panel on the hoop contains two interlocking knots of two-strand interlace. The connecting bar is decorated with an interlaced quatrefoil. At the centre of each terminal is a single contorted animal, shown in profile, which fills the space, the body of the animal being double-contoured.

Previously thought to be unprovenanced, the county provenance is given in newspaper accounts of the 1830s. This brooch ring belongs to a small group of related brooches, recently discussed by Lewis (1982), of which that from Pierowall in the Orkneys (no. 195) is perhaps the closest. These are ultimately simplified versions of the great filigreed brooches of the eighth century such as the 'Tara' and Hunterston examples. The Pierowall brooch-pin is clearly secondary and in the Pictish brooch tradition. Parallels would suggest that this brooch would probably have had a trapezoidal or rectangular pinhead with decoration reflecting that of the terminals, and its morphological features would suggest that the group is likely to have been of Irish manufacture. RÓF

BIBLIOGRAPHY *Saunder's Newsletter*, 1834; *Dublin Penny Journal*, IV (1835–6), 45; Wilde 1861, 586; Lewis 1982, 152

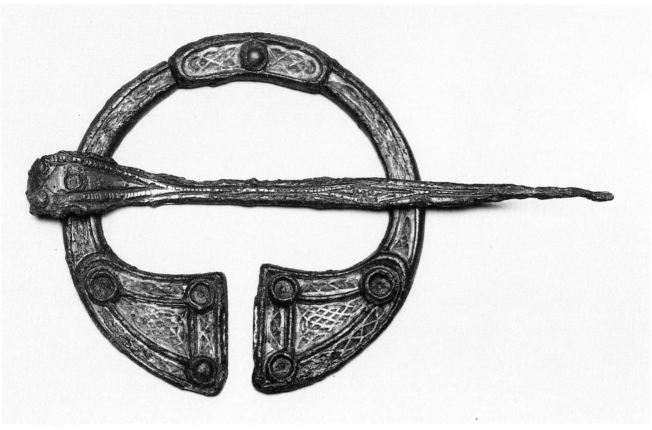

195

195 Penannular brooch

Pierowall, Westray, Orkney. Found in mid-19th century in Norse grave
 mound with oval brooch, iron shield boss, axe and spearhead
Copper-alloy, tinned, glass; hoop DIAM. 7.6 cm, pin L. 12.3 cm
Irish style, 8th century
NMS IL198

A penannular brooch of gilt-bronze, ornamented with gilt interlace
and glass studs. There is a central stud of blue glass in the cartouche
at the top of the hoop, and settings for studs in each of the corners
of the triangular terminals. Only one of the latter remains, which
is also of blue glass. The cartouche and fields along the arms of the
hoop are filled with cast chip-carved-style interlace decoration as
are the central triangular fields and margins of the terminals. The
pin found with this brooch is tinned and is not believed to have
been original.

The brooch is most close in design to the annular brooch from
Co. Louth (no. 194) and made in Irish rather than Pictish tradition
(Lewis 1982). RMS

BIBLIOGRAPHY Anderson 1881, 28–9; Grieg 1940, 93–4; Thorsteinsson
1968, 150–73; Wilson 1973, 89, 91, pl. XLVC; Lewis 1982, 153

Inlays and foils
(*nos 196–216*)

196 Enamel block

Between Tara and Kilmessan, Co. Meath
Enamel; L. 16.6 cm, W. 14.5 cm, H. 11.1 cm, WT 2.264 kg
Irish, early medieval
NMI 1887:149a

Large, irregular block of red enamel, in two pieces, the surface flaked. Only part of the original outer surface remains. The block was originally much larger: when found it weighed *c.* 4.5 kg, the surface being described as 'encrusted and decomposed'. A sample was analysed and was found to contain 43.28 per cent silica, 32.85 per cent lead oxide, 9.82 per cent sodium oxide, potassium, calcium and other oxides making up the remainder (Ball and Stokes 1893, 280–1). The enamel was tested by the Dublin jeweller Edmund Johnson, who found that it was very hard and could not be fused easily. It would seem, therefore, that the block was not intended as a source of molten enamel, but that chips removed from it could be cut to shape rather like gem cutting. This technique does not appear in Irish enamelling before the late seventh century at the earliest; enamel used on earlier metalwork such as the zoomorphic pen-annular brooches (nos 16–19) and handpins (nos 1–6) was applied in a molten state. The red enamel used on the studs on the Derrynaflan paten (no. 125a) was not fused but consisted of small chips set in a field of molten glass.

There is some difficulty in establishing the true provenance of this piece. One account states that the block was found in the ditch of an earthwork known as Rath Caelchu on the Hill of Tara, while another states that it was found in a railway cutting at Kilmessan, three kilometres to the south-east. Both accounts agree that it was discovered *c.* 1857. RÓF

BIBLIOGRAPHY Ball and Stokes 1893; Coffey 1909, 72; Armstrong 1911

197 Enamel block

Moynagh Lough, Co. Meath
Enamel; 2.5 × 2.3 × 1.4 cm
Irish, 7th–8th century
John Bradley, ML1987:416

Lump of yellow enamel excavated from levels contemporary with metalworking areas 1 and 2 (see introduction to no. 157).

Analysis of early Christian period yellow enamel has established that it is similar in composition to yellow glass beads from Anglo-Saxon sites and also to contemporary red enamel, in that both colours contain substantial amounts of lead. The colourant, on the basis of these analyses, is likely to be yellow tin oxide or 'tin yellow' (Hughes 1987, 11), whereas Iron Age yellow enamels are coloured with lead antimonate (Hughes 1987, ref. to Henderson and Warren

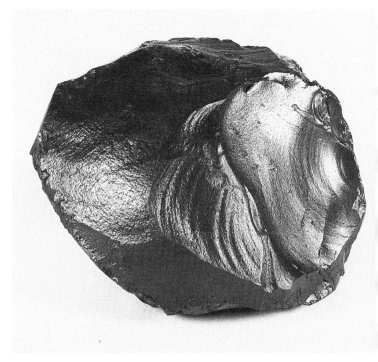

196

1981). A common imported source may be shared with the yellow glass beads. Yellow champlevé enamel was added to the fine metal-worker's repertoire probably early in the seventh century and appears on a buckle from Lough Gara (no. 46) as well as on some British hanging-bowl mounts (Leeds 1933, pl. III). Unlike the red enamel in use at the time, yellow (and white) would fuse with a tin-bronze surface, thus fixing the inlay more securely (Hughes and Bimson forthcoming). In Ireland yellow was used for ribbon inlay or to fill T- or L-shaped cells and not usually like red as a background colour (Henry 1956; Henry 1965a, 96). There are rare examples of the use of yellow enamel on iron objects such as a plate from Rathmullan, Co. Down (Bourke 1985). It remained in favour for about two centuries (see nos 49 and 52), and came back into fashion in the late eleventh and early twelfth centuries (Bourke 1985, 136). JB/SY

198 Crucibles with enamel

Garranes ringfort, Co. Cork
Enamel, baked clay; L. largest fragment 2.0 cm
Irish, 6th–7th century
Cork Public Museum, CPM L765(430), University College, Cork

Two fragments of clay crucibles, with droplets of red enamel attached, which were found with crucibles, *millefiori* and other glassworking debris on the site. RÓF

BIBLIOGRAPHY Ó Ríordáin 1941–2, 121

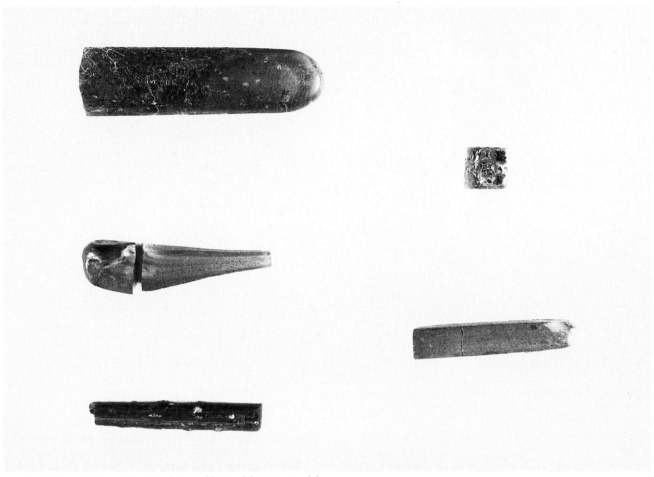

199 *top right*, 200 *bottom right*, 201a, b *top and bottom left*, 202 *centre left*

199 *Millefiori* plaque

Garranes ringfort, Co. Cork
Glass and enamel; L. 2 mm, W. 5 mm
Irish, 6th–7th century
Cork Public Museum, L739(267), University College, Cork loan

Square plaque of *millefiori* glass, the edges filed back as if to be held in a setting. Made from nine fused square rods, the pattern is cruciform, the four corners being of blue glass, the central cross red with complex star-shaped insets of blue and white glass. Although considered by the excavator as the end piece of a rod, its regular shape and bevelled edges would suggest rather that it was intended for use as a decorative setting. RÓF

BIBLIOGRAPHY Ó Ríordáin 1941–2, 118 and fig. 15, 267

200 *Millefiori* glass rod

Garranes ringfort, Co. Cork
Glass and enamel; L. 1.8 cm, TH. 3.4 mm
Irish, 6th–7th century
Cork Public Museum, L739(268), University College, Cork loan

Portion of the end of a rod of *millefiori* glass. One end is rounded, the cut end is flat and polished. The design is cruciform, the arms

of the cross being of yellow glass and in the centre a star pattern of blue and white surrounded by a red border. The spaces between the cross arms are occupied by rods of blue glass and the whole is encased in red glass. RÓF

BIBLIOGRAPHY Ó Ríordáin 1941–2, 118–19, and fig. 15, 268

201a,b Two glass rods

Lagore Crannog, Co. Meath. Excavated in unstratified contexts
Glass; (a) L. 2.7 cm, max. W. 0.8 cm; (b) L. 1.9 cm, max. W. 0.3 cm
Irish, 7th–9th century
NMI (a) E14:1555; (b) E14:1463

Two rods of blue glass, both incomplete.

(a) Pointed oval in cross-section with a rounded end. Hencken suggested it might have been used as part of a complex *millefiori* pattern. Pointed oval settings of glass and amber do occur, however, on brooches and brooch-pins.

(b) Portion of a glass rod, circular in cross-section with a rough surface, incorporating air bubbles. RÓF

BIBLIOGRAPHY Hencken 1950–1, 132, and fig. 64, 1434 and 686

202 *Millefiori* rod

Lagore Crannog, Co. Meath. Excavated in an unstratified context
Glass; L. 2.0 cm, max. dims 0.50 × 0.45 cm
Irish, 7th–8th century
NMI E14:1484

Portion of the end of a rod of *millefiori* glass broken in two pieces, tapering to a point, the tip missing. The pattern consists of a chequer design of blue and white glass, much distorted.

A discarded piece, the tapering end illustrates how the molten glass was gripped with small pincers or tweezers and stretched. Glass of this pattern was widely used (see nos 19, 47). RÓF

BIBLIOGRAPHY Hencken 1950–1, 132, and fig. 64, 277

203 Buckle

Derry, Co. Down. Excavated in a disturbed context at early ecclesiastical site
Copper-alloy, enamel, *millefiori* glass; leading edge L. 2.41 cm
Irish, 7th–8th century
HMBB, Belfast 81/416

A rectangular buckle, lacking its pin, with sides of asymmetrical section and with a round-sectioned bar. The inner edge of the longest side is notched for the tip of the pin, and the short sides have flared and mitred ends. As well as the pin, the bar secured either the end of a strap or a metal plate to which a strap was fastened. The sides of the buckle form a continuous channel originally filled with red enamel; some of this is lost and what remains is largely decolourised to off-white. Four platelets of *millefiori* set in the enamel can be described as follows: two identical designs of a four-petalled white flower set in each of the quadrants of a square of blue glass – the quadrants representing four identical composite rods fused to create the total pattern; a round 'sunburst' of nine white rays with

a central light-green dot set in a blue ground – a pattern apparently made by wrapping a composite rod in a skin of blue glass; a nine-unit chequer in which four white squares are combined with five squares which are themselves chequer patterns of white and blue – an off-cut from a composite rod made up of plain and composite rods.

Buckles are relatively uncommon in the Insular tradition and can have either D-shaped or rectangular loops. Enamel is used on this example as on the loop of the elaborate buckle from Lough Gara (no. 46). Of the *millefiori* patterns, the first is duplicated on the Moylough belt-shrine (no. 47), and the second is similar to 'sunburst' patterns on the large hanging-bowl from Sutton Hoo (Bimson 1983). The third pattern, a chequer incorporating subordinate chequers, is duplicated on an iron tag from Co. Down (Bourke 1985) and on an appliqué cross from Co. Antrim. These objects, like the buckle, have a north-eastern Irish provenance. However, the Moylough belt-shrine has a blue and white pattern which is similar except that the positions of the two colours in the subordinate chequers are reversed. CB

BIBLIOGRAPHY Waterman 1967, 55, 63–4, fig. 4.3

204 *Millefiori* rod

Scotch Street excavations, Armagh, Co. Armagh
Glass; L. 1.1 cm
Irish, 6th–9th century
HMBB, Belfast: Armagh 1979, 39–41 Scotch Street, F.192

The *millefiori* rod was found in a disturbed context during excavation of an extensive early and high medieval ecclesiastical site; small excavations at various parts of the site have produced evidence for a wide variety of craft activities, including bronzeworking, comb manufacture, and amber-lignite and glassworking. The *millefiori* rod was probably imported into Ireland rather than actually manufactured there; with other glass and metalworking material, its use testifies to the production of objects with enamel and *millefiori* inlays on this important ecclesiastical site. Similar rods are known from the Northumbrian monastic sites of Jarrow and Whitby. LW

BIBLIOGRAPHY Hamlin and Lynn (eds) 1988, 57–61

204

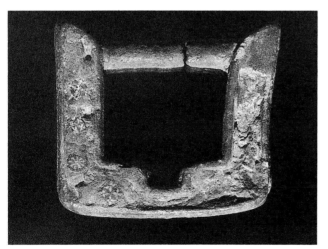

203

205a

205b

205c

205d

205a–d Four glass rods

Scotch Street excavations, Armagh, Co. Armagh
Glass; (a) blue and grey-white L. 2.7 cm; (b) blue and grey-white L. 0.93 cm;
(c) blue and yellow L. 1.5 cm; (d) yellow and greenish yellow L. 0.9 cm
Irish, 6th–9th century
HMBB, Belfast: Armagh (a) 50–6 Scotch Street 1984, Tr.2, sf 59; (b) 48
 Scotch Street 1979, F.19; (c,d) 50–6 Scotch Street 1984, Tr.3, F.168

Like nos 204 and 208, these twisted particolour glass rods derive
from the ecclesiastical workshop site at Armagh. Like the *millefiori*
rods, these ultimately reflect continental traditions and may also be
imports. The rods were probably used in the manufacture of beads.

LW

BIBLIOGRAPHY Hamlin and Lynn (eds) 1988, 57–61; Lynn 1988

206

206 Plate

Scotch Street excavations, Armagh, Co. Armagh
Iron; L. 10.6 cm
Irish, 6th–9th century
HMBB, Belfast. Armagh: 39–41 Scotch Street 79/317

The plate has a projecting strip at each end. It was found in a pit
containing glassworking debris and may have been used in this
connection for heating or rolling glass rods. LW

207 Pan or ladle

River Suck at Correen, Co. Roscommon
Iron; L. 17.4 cm; bowl DIAM. 8.5 cm
Irish, 6th–9th century
NMI Wk. 22

Pan forged from two pieces of iron. The bowl is circular with a
slightly convex base, the sides splayed outwards at the lip. The
handle is rectangular in section, flaring outwards at either end. It
is split into two branches at the outer extremity and each arm is
twisted into an incurving spiral. Along each edge there is a slight
flange. The handle is bent slightly upwards along its long axis.

Similar pans are known as stray finds from some of the Strokes-
town, Co. Roscommon, crannogs and excavated examples have
been found at Lagore, Garryduff, Dooey and Ballinderry 2. All are
of similar size, the only variation being in the treatment of the
terminal of the handle. Their function was regarded as uncertain
but it may be suggested, on the basis of parallels with continental
finds (Roth 1986, 111), that they were used as trays in which
glass was melted. This is strengthened by the fact that evidence of
glassworking was found at all four excavated sites either in the form
of glass rods or fragments of glass vessels which may have been
used as raw materials. RÓF

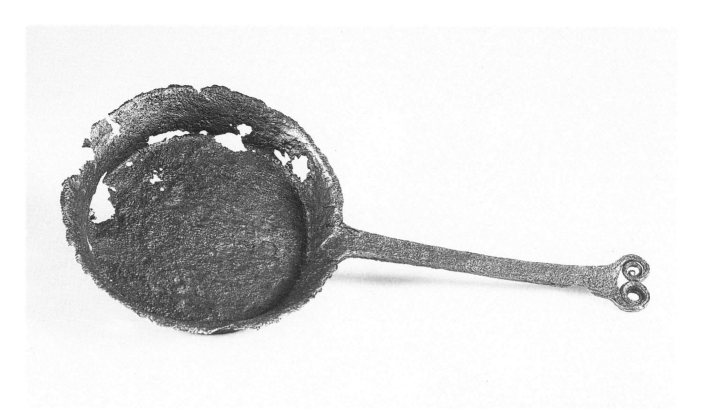

207

208 Glass rod

Moynagh Lough, Co. Meath. From occupation area east of round house 1
(see introduction to no. 157)
Glass; 0.8 × 0.8 cm
Irish, 7th–8th century
John Bradley, ML 1984:832

Glass rod of rounded cross-section, the metal clear, with a tinge of
blue-green colour. Similar rods are known from Garranes (Ó Ríor-
dáin 1941–2, 121, fig. 14, 269, 347b).

Glass had a variety of decorative uses: for beads, as inlays in the
form of flat and cabochon settings, or as complete bangles. There is
no evidence that glass was manufactured in Ireland, rather it was
imported for reworking. JB

209 Mould and stud

Lagore Crannog, Co. Meath
Baked clay, glass; mould DIAM. 2.6 cm, H. 0.8 cm, glass stud DIAM. 2.12 cm,
TH. 0.4 cm
Irish, 8th century
NMI E14:1572a,b

Flat-based, circular clay mould with a raised geometric pattern. It
was found with a stud of light green glass still in position. The
surface of the stud is flat and bears the sunken pattern found on the
mould. This consists of a cross, dividing the surface into quadrants,
and a square shape smaller than the diameter of the stud. At the
intersection of cross and square is a series of step patterns. The
stud is untrimmed, with excess glass visible along the edges as an
irregular flange.

This is a mould for casting glass studs with recessed geometric
patterns to take inlays of silver or enamel. This mould indicates
that, in at least some cases, the stud may have been cast first and

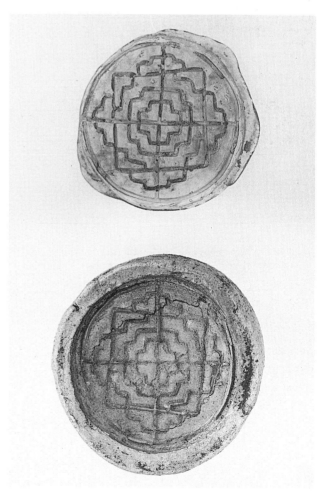

209

the inlay or grille applied later. Glass studs without inset grilles are known, however (Hencken 1950–1, fig. 63a and c). O'Kelly suggested the reverse for the manufacture of the studs on the Moylough belt (1965, 175–6). The Lagore stud is unusual in that its surface is flat and not domed, like those on the major pieces of Irish eighth-century metalwork such as the Ardagh chalice and Derrynaflan paten. The inlaid glass stud from Whitby (no. 48) also has a flat surface which, like the flat glass studs on the underside of the foot of the Ardagh chalice, would be suitable for mounting on the foot of a vessel. There is another unfinished glass stud from Garryduff, Co. Cork (O'Kelly 1962–4, pl. ix), which is also flat, in this case contained within a raised border and the design in relief, such as those on the Derrynaflan paten (no. 125a). Moulds comparable with this one are those from Iona (Graham-Campbell 1981). These were stamped with the same die indicating that studs of the same design were being mass-produced. Other moulds for casting studs of glass were also found at Lagore (Hencken 1950–1, fig. 62), all, as here, from the second phase of occupation, broadly datable to the eighth to ninth centuries. RÓF

BIBLIOGRAPHY Hencken 1950–1, 129–30, and fig. 62, 1302a, b; Henry 1965a, 93, and pl. 36; Laing 1975, 257, and fig. 75A; O'Meadhra 1987, 140–1

210 Inlaid stud

Deer Park Farms, Co. Antrim
Glass, gold wire; DIAM. 1.4 cm
Irish, first half of 8th century
HMBB, Belfast: DPF2401

The stud is inlaid with gold wire in a geometric pattern imitating cloisonné. It was excavated in a raised enclosure, at Deer Park Farms, in a context dated to the first half of the eighth century. The site itself consists of a remarkable series of enclosed early Christian settlements, probably representing continuous occupation from the sixth to the tenth centuries, with evidence of high-status occupation in the eighth and ninth centuries. LW

BIBLIOGRAPHY Hamlin and Lynn (eds) 1988, 44–7; Lynn 1989, 194

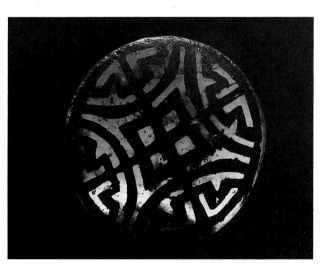

210

211 front 211 back

211 Annular brooch

Co. Westmeath
Copper-alloy, gilt, enamels, glass; max. dim. 6 cm
Irish, 8th–9th century
BM, MLA 1921,12–6,44, White King Collection

Left half of an annular brooch, broken off before the apex of the hoop and beyond the terminal bridge. Cast ornament and settings decorate both sides, and only the front is gilded. The hoop has largely effaced billeting and two median lines; a broad terminal is edged by a border of running scrolls in low relief around an empty central lozenge and small interlace panels. There is a small rectangular setting, now empty, on the terminal bridge. The hoop and terminal junction are marked by a raised opaque (?blue) glass stud with recessed step-pattern. The back of the hoop has damaged T cells inlaid with yellow enamel. A central panel on the terminal has a profile animal with decorative scrolls running from its extremities. There is yellow enamel on the body and elsewhere, while the main ground is red. A rivet projects near the terminal bridge.

Although damaged, with half missing, this brooch has several unusual features. The first puzzle is the extensive use of bright polychrome enamel on the back. The T cells of the hoop recall those on the Moylough belt-shrine (no. 47), presumably an early model for small secular pieces such as the brooch-pin head from Cahercommaun (Hencken 1938, 34) and the Westmeath brooch. There is no doubt, by analogy with the grand Irish brooches of the eighth and ninth centuries, that this is the 'back' of the piece, yet it has the most technically accomplished ornament in the lively beast with interlace springing from tongue, ear and legs. Stylistically this beast seems to resemble some of the animals on the late eighth-century Leningrad gospel book (Alexander 1978, no. 39, pls 189, 192) where a number of the beasts are liberated from biting their own limbs, and are free-standing, their extremities running off into background ribbons.

It may be that on this brooch the enamel work was not relegated

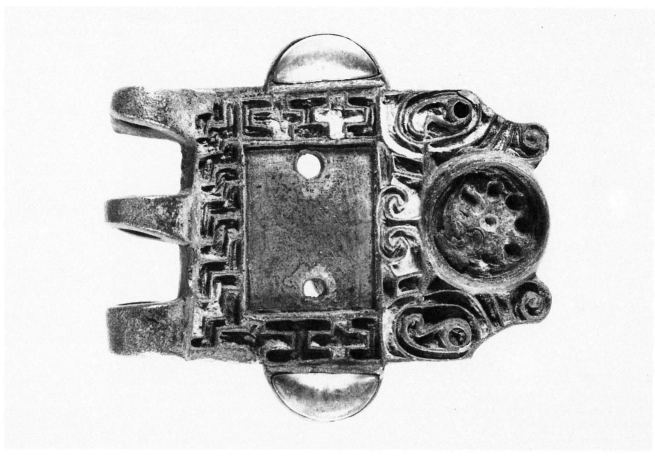

212

to obscurity on the back, that it could, indeed, have been used reversibly; it is not such a luxurious production as the earlier 'Tara' brooch where the whole piece, front and back, would be valued as a complete jewel. The front of the Westmeath fragment shows that it is one of several derived from the seventh-century type F brooches with lozenge terminals. Here, unusually, scrolls and trumpets are cast in rounded relief and used as principal decoration on the front. It is noted elsewhere how 'traditional' curvilinear ornament is usually confined to the back of brooches of the eighth and ninth centuries. SY

BIBLIOGRAPHY Henry 1936, 236–7, pl. XXXIV, 1; Hencken 1938, 35–7

212 Hinged shrine mount

Ireland
Copper-alloy, enamel, pigment, glass; L. 5.2 cm, W. 4.4 cm, tabs L. 1.8 cm
Irish, 8th century
NMI 1920:45, Chapman Collection, ex Killua Castle Collection

Mount of copper-alloy cast in a single piece consisting of a decorated plate with a pair of rectangular perforated shanks projecting from the back. The rectangular plate has three pierced lugs on one of the long sides and a plain back. The front contains a number of raised settings and champlevé enamel fields arranged around a central rectangular recess, now empty, which would have held a setting secured by a pair of rivets. This is surrounded on three sides by interlocking step and cross panels, alternately filled with red and yellow enamel of which traces remain. The side opposite the pierced lugs takes the form of a pair of enamelled animal heads seen in profile with rounded snouts ending in spirals and comma-shaped eyes. Between the heads are an empty circular setting and a pelta device. Each of the short sides has D-shaped settings with cast studs of translucent green glass. The convex surface of the studs bears a step-pattern apparently painted on with a yellow pigment.

This mount exemplifies a variety of techniques deployed to give a polychrome effect, including champlevé enamel and painted glass studs. It is the fixed lower half of a carrying hinge from a house-shaped shrine, the length of the shanks suggesting it was attached to a shrine with a wooden core, while the dimensions of the mount indicate a shrine of considerable size. The enamelled fields and animal heads are reminiscent of those on the buckle and counterplate of the Moylough belt-shrine (no. 47). They also occur on the drop of the Prosperous crozier and on an unlocalised mount in the Petrie Collection (Ball and Stokes 1893, pl. XIX, 1). The painted fret pattern on the glass studs is so far unique, presumably imitating the inset grilles on many of the great Irish metalwork pieces of the eighth century. RÓF

BIBLIOGRAPHY Henry 1936, pl. XXXVI, 3; Mahr 1932, pl. 50, 5; Raftery (ed.) 1941, 113

213 Amber stud

Ballinderry Crannog 2, Co. Offaly
Amber; DIAM. 0.85 cm, TH. 0.60 cm
Irish, 8th–9th century
NMI E6:667

Roughly finished disc-shaped piece of amber. It is possible that this may represent an unfinished stud such as the stud from Lagore (no. 215). There is amberworking debris from tenth-century and later levels at Dublin and perhaps from the eighth or ninth century at Armagh (no. 216), but no clear evidence for amberworking from rural sites in Ireland. RÓF

BIBLIOGRAPHY Hencken 1941–2, 51, and fig. 21, 75

214 Amber ring fragment

Ballinderry Crannog 2, Co. Offaly
Amber; W 0.6 cm
Irish, 8th–9th century
NMI E6:666

Portion of a ring of polished amber, D-shaped in cross-section, with an original diameter of 3 cm, perhaps used as a finger ring or as a pendant. A similar example was found at Lagore (Hencken 1950–1, fig. 74, 660). RÓF

BIBLIOGRAPHY Hencken 1941–2, 51, and fig. 21, 477

215 Amber stud

Lagore Crannog, Co. Meath
Amber; DIAM. 0.8 cm, H. 0.46 cm
Irish, 8th–9th century
NMI E14:1456

Finished stud of amber, circular with domed and polished head. The lower edge is chipped along its entire length, presumably to help key the stud to its backing.

Found unstratified in the course of excavation, this stud was probably lost from a decorated object such as a brooch (as nos 78 and 91) or mounting. It is unlikely to represent evidence of amberworking at the site as amber waste and unfinished objects of amber are absent. RÓF

BIBLIOGRAPHY Hencken 1950–1, 151, and fig. 74, 776

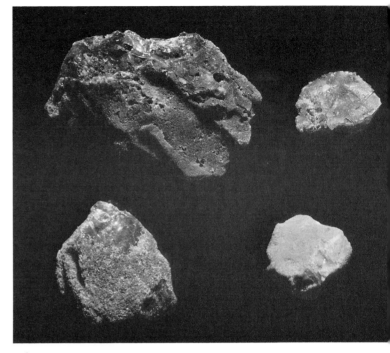

216

216 Fragments of amber

46–8 Scotch Street, Armagh. Excavated in workshop area (see nos 204–6)
Amber; max L. 1.8 cm
Irish, 8th–9th century
HMBB, Belfast: Armagh, 46–8 Scotch Street

The largest of many fragments of amber associated with decorative glass on a workshop site. Both materials were used for cold inlays on a variety of types of decorated metalwork as well as for bead-working. Armagh, through its claim to hold the body of St Patrick, was a major ecclesiastical centre in Ireland, publicising its pre-eminence through early biographies of the saint. The amber is therefore debris from a workshop under church patronage. The material must have been imported from the Baltic region and appears first in historic times on late seventh-century metalwork to become the principal coloured inlay in ninth-century work. SY

BIBLIOGRAPHY Lynn 1988

Goldworking (*nos 217–22*)

217 Gold mount (*col. illus. p. 168*)

Garryduff ringfort no. 1, Co. Cork
Gold; max. L. 1.4 cm, foil TH. 0.21 mm
Irish, 7th–8th century
Cork Public Museum L.739

Small gold bird designed to be attached to a larger piece and formed from two pieces of gold foil. An outer one is trimmed to the shape of the bird and beaten up repoussé fashion to form the body, the rim remaining flat. The reverse is hollow and on to it has been soldered a strip of gold which runs around the circumference. This is cut in a number of places to form tabs which were used to attach the bird. The concave body carries simple beaded wire filigree scrollwork within a border composed of a pair of twisted beaded wires flanked by single beaded wires. The feet and lower tail projection are edged with a beaded wire.

The filigree is very worn in places but is sufficiently well preserved to show that it belongs to the mainstream of Irish filigree production and dates probably to the later seventh or eighth century. The twisted wire border and simple scrolls match minor panels of important objects. The tabs on the reverse suggest that it was fitted into slots on a metal backing. We can only speculate about the sort of object it came from, but it is worth noting that birds in relief are a feature of Anglo-Saxon ring brooches and some Celtic annulars and penannulars. The mount was found in the south-east corner of house I and deposited either before or during the primary occupation of the site. MR

BIBLIOGRAPHY de Paor and de Paor 1958, 121, and pl. 17; O'Kelly 1962–4, 27–30, 119–20, fig. 1 and pl. VIII; Henry 1965a, 74, 95 and fig. 6,b; Whitfield 1987, 75

218 Gold filigree panel (*col. illus. p. 168*)

Moynagh Lough, Co. Meath. From occupation debris outside palisade
Gold; L. 0.86 cm, W. 0.65 cm, TH. 0.02 cm
Irish, 8th–9th century
John Bradley, ML 1984:1819

Incomplete filigree panel, consisting of beaten sheet gold ornamented with soldered gold wires. Three undamaged edges are bordered by two-ply twisted round wire, but the others are uneven and were broken off. A small gold tag overlaps this wire border near the tiny v of beaded wire: its purpose may have been to hold the wire in place during soldering. There is a second clip, now detached from the backplate. The decoration is composed of diagonally beaded gold wire (N. Whitfield, personal communication): the principal motif consists of three c-scrolls, their ends touching, set back to back inside a circle of beaded wire, now incomplete. One of these c-scrolls survives only at the spiral ends – the missing part is apparent as a depression in the sheet gold backing. From the centre of each c-scroll a straight piece of beaded wire originally radiated out to the circular frame. A tiny v of this same type of wire fills an angle between the frame and circle. Two spirals and a straight length of beaded wire, all incomplete, run off the damaged side of the piece.

When complete the little piece appears to have had the curved, subrectangular shape characteristic of a penannular brooch terminal, in this case perhaps one of a pair of tiny settings from a brooch-pin with a closed ring (compare, for example, no. 70). A border panel on the Dunbeath fragment (no. 44) has c-scrolls back to back (Stevenson 1974, pl. XX, c). Technically this small piece shows some very interesting features. In Celtic metalwork the use of clips from the backplate to attach the twisted wire border has been observed only on the Derrynaflan paten (no. 125a) and on this object, although it is found on continental filigree (N. Whitfield, personal communication). Obliquely beaded wire is also unusual in an Irish context but has been identified on Lombardic and Merovingian filigree work (Whitfield 1987, 78). However, the original shape of the plate and the ornament of back-to-back scrolls on the Moynagh Lough piece suggest that it is of Irish origin. The scroll ornament finds other small-scale filigree parallels on a boss from the 'Tara' brooch and the pinhead of the Co. Cavan brooch (no. 73), and also in the glass studs in the base of the Ardagh chalice (Bradley 1982, 118; Whitfield 1987, 75, pl. I,a). Despite its small size the Moynagh Lough fragment and separate piece of gold wire (no. 219) are of considerable interest, although not necessarily of local manufacture. Dating is on stylistic grounds. JB/SY

BIBLIOGRAPHY Bradley 1982, 117–18, fig 43 (a); Whitfield 1987, 75

219 Gold wire

Moynagh Lough, Co. Meath. From occupation area east of round house 1
 (see introduction to no. 157)
Gold; L. 2 cm
Irish, 7th–8th century
John Bradley, ML 1984:847

Bent piece of twisted gold wire similar to that on the border of the filigree fragment (no. 218) but of slightly different colour. It provides evidence for the presence and possible manufacture of top-quality jewellery at Moynagh Lough. JB

BIBLIOGRAPHY Bradley forthcoming

220 Gold-working crucible

Clogher, Co. Tyrone (see introduction to no. 172)
Baked clay; H. 1.8 cm, side L. 2.0 cm
Irish, 6th–8th century
UM CL3384

A very small triangular crucible, smaller than any others from Clogher, containing a tiny bead of gold. As would be expected with relatively low-temperature gold-melting, it lacks the external surface glazing of the bronzeworking crucibles. The crucible, with only 0.5 cc capacity, could have held up to 8 g of gold.

The precise chronological position of the Clogher goldworking

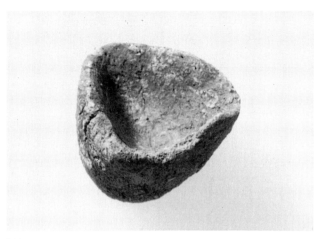

220

within the sixth- to eighth-century bracket is not yet ascertained. It is to be supposed that it would be later, rather than earlier, there being no archaeological evidence for the use of gold in medieval Ireland before the late seventh century. RW

221 Gold-rubbing stone

Clogher, Co. Tyrone
Sandstone; 8.5 × 3.1 × 1.4 cm
Irish, 6th–8th century
UM CL77

Flat piece of sandstone, the edges of which have been chipped to a convenient shape for holding. A section of one edge is polished to a smooth rounded profile, still carrying a bright lustre. Into this highly polished section gold has been impacted.

This must be interpreted as a rubber, perhaps for use with gold leaf on leather or wood, and stands with the crucible (no. 220) as evidence for goldworking at this royal site (see introduction to no. 172). RW

221 221 side

222 Filigree panel

Lagore Crannog, Co. Meath. Found in a construction phase
Gold; L. 4.91 cm, w. 1.18 cm
Irish, ?7th century
NMI E14:216

Approximately oval decorative panel which has often been described; the filigree wires are soldered to a flat strip of gold which in turn is fixed to the upper edge of two parallel ribbons of gold standing proud of a backing foil. The backing plate has had the pattern traced within repoussé. The pattern is an interlace motif with, in the centre, an oval cloison with a further inner oval. The wires consist of an inner single twisted wire flanked by two plain ones. The border is a single twisted wire on the turned-up edge of the backing plate.

The panel was found in three fragments in a construction layer of Lagore Crannog. It was made to be fitted into a decorative frame on a larger, composite object. The decorative filigree technique was devised to lend depth to the design. In eighth-century work this effect was achieved by stamped cutaway foil carrying the gold wires on a backplate, the hollow-platform technique. It has often been asserted that the wires are flanked by the ribbons of gold and the filigree is thus Anglo-Saxon in type; this is clearly not so. It appears to be an experimental piece. MR

BIBLIOGRAPHY Hencken 1950–1, 86–7; Henry 1965a, 74, 95; Whitfield 1987

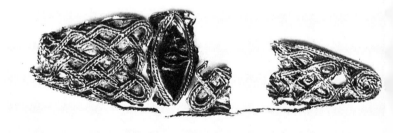

222

Tools (*nos 223–31*)

223 Awl

Garranes ringfort, Co. Cork. Found in excavation in black deposit, site D
Iron; L. 24.8 cm, max. DIAM. 0.8 cm
Irish, 6th–7th century
Cork Public Museum, University College, Cork loan, L765(106)

Long awl-like implement, the shank circular in cross-section ending
in a blunt point. The tapering tang is of square section. RÓF

BIBLIOGRAPHY Ó Ríordáin 1941–2, 104, and fig. 8, 106

224 Awl

Garranes ringfort, Co. Cork. Found in excavation
Iron; L. 10.6 cm, head DIAM. 1.1 cm
Irish, 6th–7th century
Cork Public Museum, University College, Cork loan, CPM L765 (88)

Iron awl with disc-shaped head. There is a collar at the lower end
of the tang which is circular in cross-section. The awl point is
narrower, the tip missing.

This was found with the previous example and a number of
others in an area of the site which produced evidence of metal and
glassworking. A third awl from the site was found with a portion
of an antler handle. RÓF

BIBLIOGRAPHY Ó Ríordáin 1941–2, 104, and fig. 9, 88

225 Tongs

Moynagh Lough, Co. Meath. From occupation debris outside the palisade
 (see introduction to no. 157)
Iron; L. 23 cm
Irish, 7th–8th century
John Bradley, ML1984:1771

Iron tongs, almost complete. The inner surfaces, now corroded
together, may be ribbed like modern pliers to improve the grip.
Marks from a ribbed tool were observed on two crucibles (no. 158a
and c) from Moynagh Lough. Tongs were an essential metalworking
tool, used both for holding hot metal – especially iron, which could
be neither cold-worked nor cast – and for lifting crucibles used in
enamel or bronzeworking. Although presumably once common,
such iron tools rarely survive in the archaeological record.

A similar pair of tongs was found at the later monastic workshop
of Nendrum, in Strangford Lough, Co. Down (no. 226, Lawlor
1925). Because of the high temperatures involved in metalworking
these tongs would have been held in hands protected against the
heat or possibly been fitted with wooden or leather grips. JB

BIBLIOGRAPHY Bradley forthcoming, fig 4

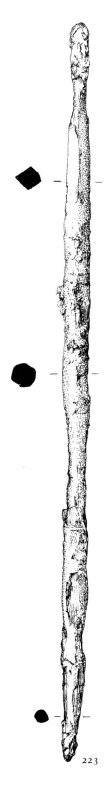

223

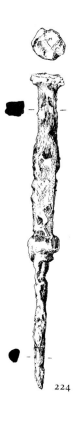

224

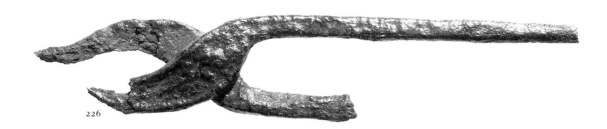

226

226 Tongs

Nendrum monastic site, Mahee Island, Co. Down. From metalworking area
Iron: L. 14.7 cm
Irish, 8th–10th century
UM A1925.35

These tongs, now damaged, are of simple two-part construction and of a form standardised in the pre-Roman Iron Age.

Excavations at Nendrum also yielded iron ore, slag and crucibles (for example, no. 175). There is other evidence for monastic metal-working; at Iona metal and glassworking are attested archae-ologically, and the existence there of a smithy is implied by Adamnán in his seventh-century Life of Columba. CB

BIBLIOGRAPHY Lawlor 1925, 143, pl. xiii.65

227 Shears

Garryduff ringfort, no. 1, Co. Cork
Iron; L. 11.0 cm, bow w. 2.0 cm
Irish, 7th–8th century
Cork Public Museum, L739(376)

Iron shears, corroded, with fused, overlapping blades. The spring bow is u-shaped in outline and rectangular in cross-section. The stems are circular in outline ending in triangular blades with curved backs. RÓF

BIBLIOGRAPHY O'Kelly 1962–4, 44, and fig. 5, no. 376

228 Shears

Garryduff ringfort, no. 1, Co. Cork
Iron; L. 13.7 cm, bow w. 2.5 cm
Irish, 7th–8th century
Cork Public Museum, L739(478)

Iron shears, badly corroded, the blades fused. The spring bow is oval in outline, rectangular in cross-section with raised side flanges on the outer curve. The stems are of circular cross-section, expanding into triangular blades with curved backs, the tip of one blade missing.

Small shears such as this and no. 227 could have had a number of uses and may have been employed in metalworking to cut thin sheets of metal. At the ringfort site of Garranes, Co. Cork, a small pair of iron shears was associated with a metalworking area (Ó Ríordáin 1941–2, fig. 7, no. 188). The simple bow of no. 227 is regarded as the earlier form, the circular or oval bowed type being later. However, an example of the latter type is known from an Iron Age context at Carbury, Co. Kildare. RÓF

BIBLIOGRAPHY O'Kelly 1962–4, 44, and fig. 5, no. 478

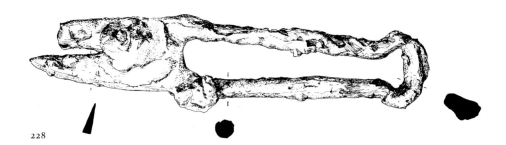

228

229 Anvil

Garryduff ringfort, no. 1, Co. Cork
Iron; L. 10.6 cm, working surface 3.2 × 3.2 cm
Irish, 7th–8th century
Cork Public Museum L739(601)

Beaked anvil made from a single block of iron, of square section. The working surface is slightly convex, and the body of the anvil tapers towards the base from which a tapering spike of rectangular section projects. In the centre of one of the sides there is a conical projection – its tip missing.

This is the only securely dated anvil of the early medieval period from Ireland. It is fitted with a spike for securing it to a wooden block or workbench. Its small size would suggest that it was used in fine metalworking. The convex working surface would have been used for smoothing and expanding the metal, while the beak enabled it to be worked into a curve. RÓF

BIBLIOGRAPHY O'Kelly 1962–4, 56–7, and fig. 10, 601

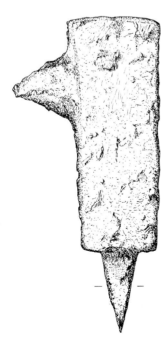

229

230 Hammer-head

Viking cemetery at Islandbridge, Dublin
Iron; head L. 4.7 cm, H. 2.7 cm
Irish, 9th century
NMI Wk.54; R.2370, acquired in 1866

Small iron hammer-head, much of the original surface missing. Rectangular in cross-section, the lower face is flat, the upper curved. The hammering end was originally flat and broadens to a thin edge at the back. The shaft hole contains a pointed iron nail to secure the head to the haft.

One of three hammer-heads from the cemetery, its small size would suggest it was used for fine metalworking. RÓF

BIBLIOGRAPHY Wilde 1866, 13, 17; Coffey and Armstrong 1910, 118; Bøe 1940, 47

231 Stake

Moynagh Lough, Co. Meath. From metalworking area 1 (see introduction to no. 157)
Iron; L. 11 cm, TH. 1.2 cm
Irish, 7th–8th century
John Bradley, ML 1984:1139

Cylindrically shaped tool with a slight taper and faceted sides, a unique survival. This would have been set in a wooden stake block and used to raise small vessels by hammering sheet metal against it (Untracht 1975, 245–51; Painter 1977, 142, fig. 4b; Sherlock 1977). PC

BIBLIOGRAPHY Bradley forthcoming, fig. 4

Glossary

annular	In the form of a ring.
brambled	Scored in a grid pattern to leave upstanding knobs like the surface of a blackberry.
brooch-pin	Pin with a small separate pendant head resembling an annular or penannular brooch but on which the pin is usually fixed in a central recess.
cabochon	Gem or glass with a smooth convex surface.
cartouche	Ornamental panel.
chalice	Cup reserved for the blessing and/or distribution of Eucharist wine in the Christian Communion service.
champlevé	Describing enamel applied to recesses cut or cast in a metal base; *see also* cloisonné.
chape	Fitting protecting the blade tip at the end of a scabbard.
chip-carving	Cutting away the background to a pattern with oblique cuts to leave facets, originally a wood-working technique imitated in metalwork to give added brilliance.
ciborium	Vessel for the reservation of the Eucharist.
cloisonné	Describing enamel set in small metal cells individually mounted on a separate backplate.
crannog	From Irish 'crann', a tree, an artificial island built of wood dating from the Later Bronze Age to the seventeenth century in Ireland. Also found in prehistoric Scotland and with one early medieval example identified in Wales.
crozier	Staff of office carried by senior churchmen, originally of wood but often with a highly decorated casing or fittings of metal, usually with a curved handle or 'crook'.
drop	Terminal section of a crozier crook, often a hollow box-like extension.
E-ware	Wheel-made pottery of several forms imported to Ireland and western Britain in the late sixth and seventh centuries and important in dating early medieval sites. Probably made in Atlantic France.

ferrule	The reinforced tip of a staff, usually a metal fitting.
filigree	Fine wires of gold or silver, often beaded and twisted, and usually soldered on to a metal backing.
granulation	Small decorative beads of gold or silver soldered on to a metal base.
hexafoil	Antique geometric design of six oval petals springing from a central point, usually compass-drawn.
high cross	Large free-standing stone cross with a ring linking the arms of the cross head, richly decorated with scriptural and other religious scenes. Characteristic of Irish monastic sites from the eighth century onwards.
Insular	Belonging stylistically to the early medieval common cultural area of Britain and Ireland.
investment moulding	Metal casting process in which a model of the object to be produced is made in wax (or lead) and coated or 'invested' with clay. The model is removed by heating and replaced by metal. Also known as *cire-perdu*, or lost-wax casting.
Irish style	Made in the Irish decorative tradition and used here primarily to describe artefacts made locally in Scottish Dál Riada.
knop	Decorative metal fitting on the shaft of a crozier.
lappet	Elongated crest or streamer springing from the brow.
lentoid	Of pointed oval shape formed by intersecting arcs.
lost-wax	*See* investment moulding.
millefiori	Decorative glass formed from bundles of rods of contrasting colours, these bundles being themselves often built up into more complex patterns and then sliced across.
niello	A black compound of metallic sulphide, usually silver or copper, inlaid for decorative contrast.
ogham	A system of writing, designed to be incised, which uses groups of short, straight lines on or across

a continuous line, often the edge of a stone slab. It was invented in Ireland in the fourth or fifth century and was based on the sound values of a simplified Roman alphabet.

omphalos	A concave, circular recess.
parcel-gilt	Gilding restricted to certain areas of a surface; partially gilded.
paten	Dish used by a priest to hold the bread or wafer blessed in a Communion service.
pelta	Decorative motif of great age formed from three arcs, resembling a simple mushroom shape.
penannular	Of circular form but with a gap in the ring.
repoussé	Of ornament worked in metal from the back.
reticella	Decorative twisted glass rods usually of two contrasting colours. Used in bead making.
runic	In a script of straight-line characters originally designed to be inscribed, used in the early medieval period by the Germanic peoples, particularly in Scandinavia.
skeuomorph	Representation of an object in another material.
stitching	In metalworking describes small hooks of metal cut from the walls of a recess to hold a decorative plate in position.
treasure trove	Gold or silver deemed to have been deliberately hidden and legally the property of the Crown or State.
triquetra	A simple knot with three points formed from three intersecting arcs.
triskele	A figure where three curves radiate at equal intervals in one direction from a central point.
trumpet scroll	A curl which opens out into a broad curve ending in an oval motif like a trumpet mouth. Often found in confronted pairs.
tuyère	Clay collar which protects the mouth of a furnace bellows.
zoomorphic	In the form of an animal or part of an animal.

Bibliography

ABBREVIATIONS

Ant. J. The Antiquaries Journal
Arch. J. The Archaeological Journal
BAR, BS British Archaeological
 Reports, British Series
JRSAI Journal of the Royal
 Society of Antiquaries of
 Ireland
Med. Arch. Medieval Archaeology
Proc. Soc. Ant. Proceedings of the Society
 of Antiquaries of London
PRIA Proceedings of the Royal
 Irish Academy
PSAS Proceedings of the Society
 of Antiquaries of Scotland
UJA Ulster Journal of
 Archaeology

AKERMAN, J. Y. 1855. *Remains of Pagan Saxondom*, London

ALCOCK, L. 1963. *Dinas Powys, an Iron Age, Dark Age and Medieval Settlement in Glamorgan*, Cardiff

ALCOCK, L. 1987. *Economy, Society and Warfare among the Britons and Saxons*, Cardiff

ALEXANDER, J. J. G. 1978. *Insular Manuscripts, 6th to the 9th century, A Survey of Manuscripts Illuminated in the British Isles*, vol. I, London

AMBROSIANI, K. 1981. *Viking Age Combs, Comb Making and Comb Makers*, Stockholm Studies in Archaeology, 2, Stockholm

ANDERSON, J. 1879–80a. 'Notice of a silver penannular brooch ... found at Achavrole, Dunbeath, Caithness, in 1860; and of two silver brooches ... said to have been found in the neighbourhood of Perth', *PSAS* XIV, 445–52

ANDERSON, J. 1879–80b. 'Notice of an ancient Celtic reliquary exhibited to the society by Sir Archibald Grant, Bart., of Monymusk', *PSAS* XIV, 431–5

ANDERSON, J. 1881. *Scotland in Early Christian Times*, 2 vols, Edinburgh

ANDERSON, J. 1883–4. 'Notice of the gold ornaments found at Lower Largo, and the silver ornaments, &c, found at Norrie's Law near Largo ...', *PSAS* XVIII, 233–47

ANDERSON, J. 1909–10. 'The Architecturally Shaped Shrines and other Reliquaries of the Early Celtic Church in Scotland and Ireland', *PSAS* XLIV, 259–81

ANDERSON, A., and ANDERSON, O. (eds) 1961. *Adomnán's life of Columba*, Edinburgh

ANDREW, W. J., and SMITH, R. A. 1931. 'The Winchester Anglo-Saxon Bowl', *Ant. J.* XI, 1–13

ANDRIEU, M. 1948. *Les Ordines Romani du Haut Moyen Age, II Les Textes*, Louvain

ANON. 1858–9. 'Proceedings and papers', *JRSAI* 5, 239–52

ANON. 1873. 'Proceedings at meetings of the Royal Archaeological Institute', *Arch. J.* 30, 181–93

ANON. 1928. 'The Roscommon Brooch', *JRSAI* 58, 166

ANON. 1929. 'The Pettigo Brooch', *JRSAI* 59, 176

ARBMAN, H. 1940–3. *Birka I: Die Gräber*, Stockholm

ARMSTRONG, E. C. R. 1911. 'Note on the block of enamel from Tara', *JRSAI* 41, 61–2.

ARMSTRONG, E. C. R. 1914. *Catalogue of Finger Rings in the Collection of the Royal Irish Academy*, Dublin

ARMSTRONG, E. C. R. 1915. 'Catalogue of the silver and ecclesiastical antiquities in the collection of the Royal Irish Academy by the late Sir William Wilde, M.D., M.R.I.A.', *PRIA* 32c, 287–312

ARMSTRONG, E. C. R. 1921. 'An imperfect Irish shrine recently purchased by the Royal Irish Academy', *Ant. J.* I, 48–51

ARMSTRONG, E. C. R. 1921–2. 'Irish bronze pins of the Christian period', *Archaeologia* 72, 71–86

ARMSTRONG, E. C. R. 1922. 'Some Irish antiquities of unknown use', *Ant. J.* 2, 6–12

ARMSTRONG, E. C. R. 1923. 'The La Tène Period in Ireland', *JRSAI* 53, 1–33

ARWIDSSON, G. 1942. *Die Gräberfunde von Valsgärde I: Valsgärde 6*, Uppsala and Stockholm

ARWIDSSON, G., and BERG, G, 1983. *The Mästermyr Find*, Stockholm

ATKINSON, D. 1916. *The Romano-British Site on Lowbury Hill in Berkshire*, University College Reading Studies in History and Archaeology, Reading

BAKKA, E. 1963. 'Some English decorated metal objects found in Norwegian Viking graves', *Årbok for Universitetet i Bergen*, Humanistik Serie no. I, 4–66

BAKKA, E. 1965. 'Some Decorated Anglo-Saxon and Irish metalwork found in Norwegian Viking Graves', in A. Small (ed.), *The Fourth Viking Congress, York, August 1961*, Edinburgh, 32–40

BAKKA, E. 1984. 'Der Holzeimer aus Bj.507', in G. Arwidsson (ed.), *Birka II: 1: Systematische Analysen der Gräberfunde*, Stockholm, 233–5

BAILEY, P. R. 1974. 'The Anglo-Saxon Metalwork from Hexham', in D. P. Kirby (ed.), *Saint Wilfrid at Hexham*, Newcastle upon Tyne, 141–67

BALDWIN BROWN, G. 1915. *Saxon Art and Industry in the Pagan Period, The Arts in Early England*, vols III, IV, London

BALL, V., and STOKES, M. 1893. 'On a block of red enamel said to have been found on Tara Hill, with observations on the use of red enamel in Ireland', *Transactions of the Royal Irish Academy* 30, 277–94

BATESON, J. D. 1973. 'Roman material in Ireland', *PRIA* 73c, 21–97

BAYLEY, J. 1988. 'Non-ferrous metalworking: continuity and change' in E. Slater and J. O. Tate (eds), *Science and Archaeology. Glasgow 1987*, BAR, BS 196, Oxford, 193–208

BELFAST 1852. *Descriptive Catalogue of the Collection of Antiquities and other Objects Illustrative of Irish History exhibited in the Museum, Belfast*, Belfast

BIELER, L. 1979. *The Patrician Texts in the Book of Armagh*, Dublin

BIMSON, M. 1983. 'Aspects of the technology of glass and of copper alloys. A. Coloured glass and millefiore in the Sutton Hoo grave deposit' in R. L. S. Bruce-Mitford, *The Sutton Hoo Ship-Burial*, vol. 3, ed. A. Care Evans, London, 924–44

BLINDHEIM, M. 1984. 'A house-shaped Irish-Scots reliquary in Bologna, and its place among the other reliquaries', *Acta Archaeologia* 55, 1–53

BøE, J. 1924–5. 'An ornamented Celtic Bronze Object found in a Norwegian grave', *Bergen Museums Årbok 1924–5, Historisk-Antikvarisk Rekke* 4, 1–34

BøE, J. 1940. *Viking Antiquities in Great Britain and Ireland*, ed. H. Shetelig, *Part III Norse Antiquities in Ireland*, Oslo

BOON, G. 1975. 'Two Celtic pins from Margam Beach, West Glamorgan', *Ant. J.* 55, 400–4

BOURKE, C. 1980. 'Early Irish Hand Bells', *JRSAI* 110, 52–66

BOURKE, C. 1985. 'An enamelled iron object from Rathmullan County Down', *UJA* 48, 134–7

BOURKE, C. 1987. 'Irish Croziers of the Eighth and Ninth Centuries' in M. Ryan (ed.), *Ireland and Insular Art A.D. 500–1200*, Dublin, 166–73

BOURKE, C., FANNING, T., and WHITFIELD, N. 1988. 'An insular brooch-fragment from Norway', *Ant. J.* LXVIII, pt I, 90–8

BRADLEY, J. 1982. 'A separate-bladed shovel from Moynagh Lough, Co. Meath', *JRSAI* 112, 117–22

BRADLEY, J. 1982–3. 'Excavations at Moynagh Lough, Co. Meath 1980–1: Interim Report', *Riocht na Midhe* 7, no. 2, 12–32

BRADLEY, J. 1984. 'Excavations at Moynagh Lough, Co. Meath 1982–3: Interim Report', *Riocht na Midhe* 7, no. 3, 86–93

BRADLEY, J. 1985–6. 'Excavations at Moynagh Lough 1984. Summary report', *Riocht na Midhe* 7, no. 4, 79–92

BRADLEY, J. forthcoming. 'The crannog as industrial centre: Moynagh Lough, Co. Meath' in V. Buckley (ed.), *Irish Crannogs*, BAR, BS, Oxford

BRENAN, M. J. 1988. 'Hanging-bowls and their contexts. An archaeological survey of their socio-economic significance from the fifth to the seventh centuries A.D.' Unpublished doctoral thesis, Dept of History, University College London

BRILL, R. H. 1967. 'Lead isotopes in ancient glass', *Annales du 4' Congrès des Journées Internationales du Verre*, Liège, 255–60

BRUCE-MITFORD, R. L. S. 1960. 'Decoration and Miniatures' in T. Kendrick *et al.*, *Evangeliorum Quattuor Codex Lindisfarnensis*, vol. II, Olten, 109–258

BRUCE-MITFORD, R. L. S. 1964. 'A Hiberno-Saxon Bronze Mounting from Markyate, Hertfordshire', *Antiquity* XXXVIII, 219–20

BRUCE-MITFORD, R. L. S. 1974. *Aspects of Anglo-Saxon Archaeology*, London

BRUCE-MITFORD, R. L. S. 1978. *The Sutton Hoo Ship-Burial*, vol II, London

BRUCE-MITFORD, R. L. S. 1983. *The Sutton Hoo Ship-Burial*, vol. III, ed. A. Care Evans, London

BRUCE-MITFORD, R. L. S. 1986. 'The Sutton Hoo Ship-Burial: some foreign connections', *Settimane di studio del centro italiano di studi sull'alto medioevo* 32, Spoleto, 143–218

BRUCE-MITFORD, R. L. S. 1987. 'Ireland and the hanging-bowls – a review' in M. Ryan (ed.), *Ireland and Insular Art A.D. 500–1200*, Dublin, 30–9

BUICK, G. R. 1893. 'The Crannog of Moylarg', *JRSAI* 23, 27–43

BUICK, G. R. 1894. 'The Crannog of Moylarg. Second Paper', *JRSAI* 24, 315–31

BURLEY, E. 1955–6. 'A Survey and Catalogue of the Metalwork from Traprain Law', *PSAS* 89, 118–226

BYRNE, F. J. 1973. *Irish Kings and High Kings*, London

CAMPBELL, A. (ed.) 1967. *Aethelwulf De Abbatibus*, Oxford

CAMPBELL, E. 1987. 'A cross-marked quern from Dunadd and other evidence for relations between Dunadd and Iona', *PSAS* 117, 105–17

CAMPBELL, J. (ed.) 1982. *The Anglo-Saxons*, Oxford

CARRUTHERS, J. 1856–7. 'Notices of coins found in Ireland', *JRSAI* 4, 49–51

CATALOGUE 1892. *Catalogue of the National Museum of Antiquities of Scotland*, new edn, Edinburgh

CHRISTISON, D., and ANDERSON, J. 1904–5. 'Excavations of forts on the Poltalloch Estate, Argyll', *PSAS* XXXIX, 259–322

CLARK, J. G. 1879–80. 'Notice of a . . . massive silver chain found at Whitecleugh, Lanarkshire', *PSAS* XIV, 222–4

CLOSE-BROOKS, J. 1986. 'Excavations at Clatchard Craig, Fife', *PSAS* 116, 117–84

CLOSE-BROOKS, J. and STEVENSON, R. B. K. 1982. *Dark Age Sculpture. A selection from the collections of the National Museum of Antiquities of Scotland*, HMSO, Edinburgh

COFFEY, G. 1909. *Guide to the Celtic Antiquities of the Christian Period preserved in the National Museum*, Dublin

COFFEY, G. 1910. *Guide to the Celtic Antiquities of the Christian Period preserved in the National Museum*, 2nd edn, Dublin

COFFEY, G., and ARMSTRONG, E. C. R. 1910. 'Scandinavian objects found at Island-bridge and Kilmainham', *PRIA* 28c, 107–22

COLGRAVE, B., and MYNORS, R. A. B. 1969. *Bede's Ecclesiastical History of the English People*, Oxford

CONE, P. (ed.) 1972. *Treasures of Early Irish Art 1500 B.C.–1500 A.D.*, Metropolitan Museum of Art, New York

CONNOLLY, S., and PICARD, J. M. 1987. 'Cogitosus's Life of St Bridget', *JRSAI* 117, 5–27

COWAN, J. D. 1931. 'The Capheaton bowl', *Archaeologia Aeliana*, 4th ser., VIII, 328–38

CRAMP, R. 1986. 'Northumbria and Ireland' in P. Szarmach and V. D. Oggins (eds), *Sources of Anglo-Saxon Culture*, Kalamazoo, 185–201

CRAWFORD, H. S. 1923. 'A descriptive list of Irish shrines and reliquaries', *JRSAI* 53, 74–93 and 151–76

CUNLIFFE, B. (ed.) 1988. *The Temple of Sulis Minerva at Bath*, vol. 2, Oxford University Committee for Archaeology monograph no. 16, Oxford

CUNNINGTON, W. 1860. 'An account of the Ancient British and Anglo-Saxon barrows on Roundway Hill in the parish of Bishops Cannings', *Wiltshire Archaeological Magazine* 6, 159–67

CUNNINGTON, W., and GODDARD, E. H. 1934. *Catalogue of Antiquities in the Museum of the Wiltshire Archaeological and Natural History Society at Devizes*, Devizes

CURLE, A. O. 1923. *The Treasure of Traprain*, Glasgow

CURLE, C. L. 1982. *Pictish and Norse finds from the Brough of Birsay 1934–74*, Society of Antiquaries of Scotland Monograph 1

DAY, R. 1887–8. 'On a Bronze Brooch', *JRSAI* 18, 115–17

DE PAOR, L. 1961. 'Irish belt-buckles and strap-mounts' in G. Bersu (ed.), *Bericht über den V. Internationalen Kongress für Vor- und Frühgeschichte, Hamburg 1958*, Berlin, 649–53

DE PAOR, L. 1962. 'Antiquities of the Viking Period from Inchbofin, Co. Westmeath', *JRSAI* 92, 187–91

DE PAOR, M., and DE PAOR L. 1958. *Early Christian Ireland*, London

DICKINSON, T. M. 1982. 'Fowler's Type G Penannular Brooches Reconsidered', *Med. Arch.* 26, 41–68

DONATIONS 1870. 'Donations to the Museum', *PSAS* VIII, 302–12

DONATIONS 1889. 'Donations to the Museum, by Mrs Young, two bronze mounts', *PSAS* 23, 122–3

DONATIONS 1905–6. 'Donations to the Museum, two Celtic brooches of silver, found in the neighbourhood of Perth', *PSAS* XL, 347–50

DORNIER, A. 1977. 'The Anglo-Saxon monastery at Breedon-on-the-Hill, Leicestershire' in A. Dornier (ed.), *Mercian Studies*, Leicester, 115–68

DOWKER, G. 1887. 'A Saxon Cemetery at Wickhambreux', *Archaeologia Cantiana* XVII, 6–9

DUDLEY, H. E. 1949. *Early Days in North West Lincolnshire*, Scunthorpe

DUIGNAN, M. V. 1951. 'The Moylough (Co. Sligo) and other Irish Belt-Reliquaries', *Journal of the Galway Archaeological and Historical Society* 24, 83–94

DUNCAN, H. B. 1982. 'Aspects of the early historic period in south west Scotland: a comparison of the material cultures of

DUNCAN, H. B. 1982—*contd.*
Scottish Dál Riada and the British kingdoms of Strathclyde and Rheged', Unpublished M.Litt. thesis, Glasgow University

DUNS, J. 1879. 'Notice of a bronze penannular brooch from the Island of Mull', *PSAS* XIII, 67–72

EELES, F. C. 1933–4. 'The Monymusk Reliquary or Brecbennoch of St Columba', *PSAS* LXVIII, 433–8

EHRENBERG, M. 1981. 'The anvils of Bronze Age Europe', *Ant. J.* 61, 14–28

EVISON, V. I. 1968. 'Quoit brooch style buckles', *Ant. J.* XLVIII, 231–46

FAIRHURST, H. 1938–9. 'The Galleried Dun at Kildonan Bay, Kintyre', *PSAS* 73, 185–228

FOSTER, J. 1980. *The Iron Age Moulds from Gussage All Saints*, British Museum Occasional Paper 12, London

FOWLER, E. 1960. 'The origins and development of the penannular brooch in Europe', *Proceedings of the Prehistoric Society* 26, 149–77

FOWLER, E. 1963. 'Celtic metalwork of the fifth and sixth centuries A.D.: a reappraisal', *Arch. J.* 120, 98–160

FOWLER, E. 1968. 'Hanging bowls' in J. M. Coles and D. D. A. Simpson (eds), *Studies in Ancient Europe. Essays presented to Stuart Piggott*, Leicester, 287–310

FRIELL, J. G. P., and WATSON, W. G. (eds) 1984. *Pictish Studies*, BAR, BS 125, Oxford

GASKELL-BROWN, C., and HARPER, A. E. T. 1984. 'Excavations on Cathedral Hill, Armagh, 1968', *UJA* 47, 109–61

GILMORE, G. R., and METCALF, D. M. 1980. 'The alloy of the Northumbrian coinage of the mid-ninth century' in D. M. Metcalf and W. A. Oddy (eds), *Metallurgy in Numismatics* 1, 83–98

GOUGAUD, L. 1920. 'The earliest Irish representations of the crucifixion', *JRSAI* 50, 128–39

GRAHAM-CAMPBELL, J. 1972. 'Two groups of ninth-century Irish brooches', *JRSAI* 102, 113–28

GRAHAM-CAMPBELL, J. 1973–4. 'The Lough Ravel, Co. Antrim, Brooch and Others of Ninth Century Date', *UJA* 36–7, 52–7

GRAHAM-CAMPBELL, J. 1975. 'Bossed Penannular Brooches: a Review of Recent Research', *Med. Arch.* 19, 33–47

GRAHAM-CAMPBELL, J. 1976. 'The Viking-Age Silver Hoards of Ireland' in B. Almqvist and D. Green (eds), *Proceedings of the Seventh Viking Congress, Dublin*, Dublin, 39–74

GRAHAM-CAMPBELL, J. 1980. *Viking Artefacts. A Select Catalogue*, London

GRAHAM-CAMPBELL, J. 1981. 'The bell and the mould' in R. Reece (ed.), *Excavations in Iona 1964–1974*, University of London, Institute of Archaeology, Occasional Publication no. 5, London, 23–5

GRAHAM-CAMPBELL, J. 1985. 'A lost Pictish treasure (and two Viking-age gold armrings) from the Broch of Burgar, Orkney', *PSAS* 115, 241–61

GRIEG, S. 1928. *Kongsgaarden. Osebergfundet 2*, Oslo

GRIEG, S. 1940, *Viking Antiquities in Great Britain and Ireland*, ed. H. Shetelig, *Part II Viking Antiquities in Scotland*, Oslo

HALL, R. A. 1974. 'A Viking Grave in the Phoenix Park, Co. Dublin', *JRSAI* 104, 39–51

HALL, R. 1984. *Excavations at York. The Viking Dig*, London

HAMLIN, A., and LYNN, C. (eds) 1988. *Pieces of the Past*, HMSO, Belfast

HARBISON, P. 1978. 'The Antrim Cross in the Hunt Museum', *North Munster Antiquarian Journal* 20, 17–40

HARBISON, P. 1981. 'The date of the Moylough Belt-shrine' in D. Ó. Corráin (ed.), *Irish Antiquity*, Cork, 231–9

HARBISON, P. 1984. 'The bronze crucifixion plaque said to be from St John's (Rinnagan), near Athlone', *Journal of Irish Archaeology* II, 1–17

HARBISON, P. 1985–6. 'The Derrynaflan ladle: some parallels illustrated', *Journal of Irish Archaeology* III, 55–8

HARTNETT, P. J., and EOGAN, G. 1964. 'Feltrim Hill, Co. Dublin: a Neolithic and Early Christian site', *JRSAI* 94, 1–37

HASELOFF, G. 1979. 'Die Iren' in H. Roth (ed.), *Kunst der Völkerwanderungszeit, Propyläen Kunstgeschichte Supplementband*, vol. IV, Frankfurt am Main, 223–43

HASELOFF, G. 1987. 'Insular and animal styles with special reference to Irish art in the early medieval period' in M. Ryan (ed.), *Ireland and Insular Art AD 500–1200*, Dublin, 44–55

HAWKES, S. C. 1958. 'The Anglo-Saxon Cemetery at Finglesham, Kent', *Med. Arch.* 2, Appendix II, 63–70

HEIGHWAY, C. 1987. *Anglo-Saxon Gloucestershire*, Gloucester

HENCKEN, H. O'N. 1936. 'Ballinderry Crannog No. 1', *PRIA* 43c, 103–92

HENCKEN, H. O'N. 1938. *Cahercommaun: A Stone Fort in County Clare*, Royal Society of Antiquaries of Ireland, Extra Volume, Dublin

HENCKEN, H. O'N. 1941–2. 'Ballinderry Crannog No. 2', *PRIA* 47c, 1–76

HENCKEN, H. O'N. 1950–1. 'Lagore Crannog: an Irish royal residence of the 7th to 10th centuries A.D.', *PRIA* 53c, 1–237

HENDERSON, I. 1967. *The Picts*, London

HENDERSON, I. 1971. 'The meaning of the Pictish symbol stones' in P. Meldrum (ed.), *The Dark Ages in the Highlands*, 53–68

HENDERSON, I. 1979. 'The silver chain from Whitecleugh, Shieldholm, Crawford John,

Lanarkshire', *Transactions of the Dumfries & Galloway Natural History and Archaeological Society* 54, 20–8

HENIG, M. 1978. *A Corpus of Roman Engraved Gemstones from British Sites*, BAR, BS 8, Oxford

HENRY, F. 1936. 'Hanging-bowls', *JRSAI* LXVI, 209–46

HENRY, F. 1938. 'Deux objets de bronze irlandais au Musée des Antiquités Nationales', *Préhistoire* VI, 65–91

HENRY, F. 1947. *Irish Art in the Early Christian Period*, 2nd edn, London

HENRY, F. 1948. 'A bronze escutcheon found in the River Bann', *JRSAI* 78, 182–4

HENRY, F. 1952. 'A wooden hut on Iniskea North, Co. Mayo', *JRSAI* 82, 163–78

HENRY, F. 1954. *Early Christian Irish Art*, Dublin

HENRY, F. 1956. 'Irish enamels of the Dark Ages and their relation to the cloisonné techniques' in D. B. Harden (ed.), *Dark Age Britain*, 71–88

HENRY, F. 1965a. *Irish Art during the Early Christian Period to 800 A.D.*, London

HENRY, F. 1965b. 'On some early Christian objects in the Ulster Museum', *JRSAI* 95, 51–63

HENRY, F. 1967. *Irish art during the Viking invasions (800–1020 A.D.)*, London

HENRY, F. 1974. *The Book of Kells*, London

HEWAT CRAW, J. 1929–30. 'Excavations at Dunadd and at other sites on the Poltalloch Estates, Argyll', *PSAS* 64, 111–46

HIRST, S. M. 1985. *An Anglo-Saxon Inhumation Cemetery at Sewerby, East Yorkshire*, York University Archaeological Publications 4, York

HOLMQVIST, W. 1955. 'An Irish crozier-head found near Stockholm', *Ant. J.* 35, 46–51

HÜBENER, W. 1972. 'Gleicharmige Bügelfibeln der Merowingerzeit im Westeuropa', *Madrider Mitteilungen* 13, 211–69

HUGHES, M. J. 1972. 'A technical study of opaque red glass in the Iron Age in Britain', *Proceedings of the Prehistoric Society* 38, 99–107

HUGHES, M. J. 1984. 'Enamels: materials, deterioration and analysis' in L. Bacon and B. Knight (eds), *From Pinheads to Hanging Bowls*, UK Institute of Conservation Occasional Paper no. 2 (publ. 1987), 10–12

HUGHES, M. J., and BIMSON, M. forthcoming. 'Red and Yellow Dark Age Enamels: Composition and Technical Studies'

HUNT, J. 1956. 'On two D-shaped objects in the St Germain Museum', *PRIA* 57c, 153–7

IVENS, R. 1984. 'Movilla Abbey, Newtonards, County Down: excavations 1981', *UJA* 47, 71–108

JACKSON, K. H. 1969. *The Gododdin. The Oldest Scottish Poem*, Edinburgh

JACKSON, J. S. 1980. 'Bronze Age copper in

Ireland' in P. T. Craddock (ed.), *Scientific Studies in Early Metallurgy* 1, British Museum Occasional Paper 20, London, 9–30

JAMES, M. R. 1928. *The Bestiary*, Oxford

JANSSEN, W. 1981. 'Die Sattelbeschläge aus Grab 446 des Fränkischen Gräberfeldes von Wesel-Bislich, Kreis Wesel', *Archaeologisches Korrespondenzblatt* 11, 149–69

JANSSON, I. 1981. 'Economic aspects of fine metalworking in Viking Age Scandinavia' in D. M. Wilson and M. L. Caygill (eds), *Economic Aspects of the Viking Age*, British Museum Occasional Paper 30, London, 1–20

JESSUP, R. 1950. *Anglo-Saxon Jewellery*, London

JOHANSEN, O. S. 1973. 'Bossed Penannular Brooches. A systemization and study of their cultural affinities', *Acta Archaeologica* 44, 63–124

JOHNS, C. M. 1974. 'A Roman silver pin from Oldcroft, Gloucestershire', *Ant. J.* LIV, 295

KALAND, S. 1973. 'Westnessutgravninge på Rousay, Orknøyene', *Viking* 37, 77–102

KENDRICK, T. D. 1932. 'British hanging-bowls', *Antiquity* VI, 161–84

KENDRICK, T. D. et al. 1960. *Evangeliorum Quattuor Codex Lindisfarnensis*, 2 vols, Olten

KILBRIDE-JONES, H. E. 1935. 'The evolution of penannular brooches with zoomorphic terminals in Great Britain and Ireland', *PRIA* 43c, 379–455

KILBRIDE-JONES, H. E. 1936–7. 'A bronze hanging-bowl from Castle Tioram, Moidart and a suggested absolute chronology for British hanging-bowls', *PSAS* LXXI, 206–47

KILBRIDE-JONES, H. E. 1937. 'The evolution of penannular brooches with zoomorphic terminals in Great Britain and Ireland', *PRIA* XLIII, no. 13

KILBRIDE-JONES, H. 1980a. *Celtic Craftsmanship in Bronze*, London

KILBRIDE-JONES, H. 1980b. *Zoomorphic Penannular Brooches*, Reports of the Research Committee of the Society of Antiquaries of London no. XXIX, London

KÜHN, H. 1941–2. 'Die Danielschnallen der Völkerwanderungszeit', *Jahrbuch für prähistorische und ethnographische Kunst* 15–16, 140–69

LAING, L. 1973. 'The Mote of Mark', *Current Archaeology* 39, 121–5

LAING, L. 1975. *The Archaeology of Late Celtic Britain and Ireland c. 400 A.D.–1200 A.D.*, London

LAING, L. 1987. *Late Celtic Art*, Shire Archaeology, Aylesbury

LAING, L., and LAING, J. 1984. 'The date and origin of the Pictish Symbols', *PSAS* 114, 261–76

LANE, A. M. 1980. *The Excavations at Dunadd, Mid-Argyll, 1980. An Interim Report*, Dept of Archaeology, University College Cardiff

LANE, A. M. 1981. *Excavations at Dunadd, Mid-Argyll, 1981. An Interim Report*, Dept of Archaeology, University College Cardiff

LANE, A. M. 1984. 'Some Pictish problems at Dunadd' in J. G. P. Friell and W. G. Watson (eds), *Pictish Studies*, BAR, BS 125, Oxford, 43–62

LANE, A. forthcoming. *Excavations at Dunadd*

LA NIECE, S. C. 1983. 'Niello', *Ant. J.* 63, 279–97

LAWLOR, H. C. 1925. *The Monastery of St Mochaoi of Nendrum*, Belfast Natural History and Philosophical Society, Belfast

LAWLOR, H. C. 1932. 'Objects of archaeological interest in the Lough Neagh and River Bann drainage scheme', *JRSAI* 63, 208–11

LEEDS, E. T. 1913. *The Archaeology of the Anglo-Saxon Settlements*, Oxford

LEEDS, E. T. 1933. *Celtic Ornament in the British Isles down to A.D. 700*, Oxford

LEEDS, E. T. and RILEY, M. 1942. 'Two Early Saxon Cemeteries at Cassington, Oxon', *Oxoniensia* 7, 61–70

LEIGH, P., COWELL, M. R., and TURGOOSE, S. 1984. 'The composition of some sixth-century Kentish silver brooches', *Journal of the Historical Metallurgy Society* 18, no. 11, 35–41

LEWIS, J. M. 1982. 'Recent finds of penannular brooches from Wales', *Med. Arch.* XXVI, 151–4

LIESTØL, A. 1953. 'The Hanging Bowl, a Liturgical and Domestic Vessel', *Acta Archaeologica* 24, 163–70

LONGLEY, D. 1975. *Hanging-Bowls, Penannular Brooches and the Anglo-Saxon Connection*, BAR, BS 22, Oxford

LUCAS, A. T. 1973. *Treasures of Ireland: Irish Pagan and Christian Art*, Dublin

LUCAS, A. T. 1986a. 'The social role of relics and reliquaries in ancient Ireland', *JRSAI* 116, 5–37

LUCAS, A. T. 1986b. 'In the Middle of Two Living Things?' in E. Rynne (ed.), *Figures from the Past. Studies on the Figurative Art of Christian Ireland*, Dublin, 92–7

LYNN, C. 1988. 'Excavations at 46–48 Scotch Street, Armagh, 1979–80', *UJA* 51

LYNN, C. 1989. 'Deer Park Farms', *Current Archaeology* 113, 193–8

MACADAM, R. (anon.) 1856. 'Bronze pin', *UJA*, 1st ser., 4, 269

MACALISTER, R. A. S., and PRAEGER, R. LL. 1931. 'The excavation of an ancient structure in the townland of Togherstown, Co. Westmeath', *PRIA* 39c, 54–83

MAC DERMOTT, M. 1950. 'Terminal mounting of a Drinking-horn from Lismore, Co. Waterford', *JRSAI* LXXX, 262

MAC DERMOTT, M. 1955. 'The Kells Crozier', *Archaeologia* 96, 59–113

MAC GREGOR, M. 1976. *Early Celtic Art in North Britain*, 2 vols, Leicester

MC KENNA, J. E. 1931. *Devenish. Its History, Antiquities and Traditions*, 2nd edn, Dublin and Enniskillen

MAC NIOCAILL, G. 1972. *Ireland before the Vikings*, Dublin

MAHR, A. 1932. *Christian Art in Ancient Ireland*, vol. I, Dublin

MAHR, A. 1941. 'The Early Christian Epoch' in J. Raftery (ed.), *Christian Art in Ancient Ireland*, vol. II, 29–76

MANCINELLI, F. 1973–4. 'Reliquie e Reliquiari ad Abbadia S. Salvatore', *Pontifica Accademia Romana di Archeologia Rendiconti* 46, 251–71

MARSTRANDER, S. 1963. 'Et nytt vikingetidsfunn fra Romsdal med vesteuropeiske importsaker', *Viking* XXVI, 123–59

MARTIN, M. 1976. 'Römische und Frühmittelalterliche Zahnstocher', *Germania* 54, 456–60

MEANEY, A. L. 1981. *Anglo-Saxon Amulets and Curing Stones*, BAR, BS 96, Oxford

MEANEY, A. L., and HAWKES, S. C. 1970. *Two Anglo-Saxon Cemeteries at Winnall, Winchester, Hampshire*, Society for Medieval Archaeology Monograph 4, London

MEEKS, N. 1986. 'Tin-rich surfaces on bronze', *Archaeometry* 28(2), 133–62

MEREWETHER, J. 1849. 'Diary of the Examination of barrows and other earthworks in the neighbourhood of Silbury Hill and Avebury', *Proceedings of the Archaeological Institute* 1, 82–112

MITCHELL, G. F. 1977. Catalogue entries in P. Cone (ed.), *Treasures of Early Irish Art 1500 B.C.–1500 A.D.*, Metropolitan Museum of Art, New York

MOISL, H. 1983. 'The Bernician Royal Dynasty and the Irish in the seventh century', *Peritia* 2, 103–26

MOSS, R. J. 1924–7. 'A chemical examination of the crucibles in the collection of the Irish Antiquities of the Royal Irish Academy', *PRIA* 37c, 175–93

MÜLLER-WILLE, M. 1977. 'Der frühmittelalterliche Schmied im Spiegel skandinavischer Grabfunde', *Frühmittelalterliche Studien* 11, 127–201

MULVANY, W. T. 1852. 'Collection of Antiquities presented to the Royal Irish Academy', *PRIA* 5, Appendix V, xxxi–lxvi

MURPHY, D. 1891–3. 'On a shrine lately found in Lough Erne, now belonging to Thomas Plunkett, Esq., T. C., Enniskillen', *PRIA* 18, 290–4

MURPHY, D. 1892. 'On the ornamentation of the Lough Erne shrine', *JRSAI* 22, 349–55

NMI 1960. 'National Museum of Ireland: Archaeological Acquisitions in the year 1958', *JRSAI* 90, 1–40

NMI 1961. 'National Museum of Ireland, Archaeological Acquisitions in the year 1961', *JRSAI* 91, 44–107

NMI 1962. 'National Museum of Ireland: Archaeological Acquisitions in the year 1960', *JRSAI* 92, 139–73

NMI 1966. 'National Museum of Ireland: Archaeological Acquisitions in the year 1963', *JRSAI* 96, 7–27

NMI 1971. 'National Museum of Ireland: Archaeological Acquisitions in the Year 1968', *JRSAI* 101, 184–244

Ó CORRÁIN, D. 1972. *Ireland before the Normans*, Dublin

ODDY, W. A. 1977. 'The production of gold wire in antiquity', *Gold Bulletin* 10, no. 3, 79–87

ODDY, W. A. 1980. 'Gilding and tinning in Anglo-Saxon England' in W. A. Oddy (ed.), *Aspects of Early Metallurgy*, British Museum Occasional Paper 17, London, 129–34

ODDY, W. A. 1983a. 'Bronze alloys in Dark Age Europe' in R. L. S. Bruce-Mitford, *The Sutton Hoo Ship-Burial*, vol. III, ed. A. Care Evans, London, 945–62

ODDY, W. A. 1983b. 'Gold wire on the Thetford jewellery and the technology of wire production in Roman times' in C. Johns and T. Potter, *The Thetford Treasure*, London, 62–4

Ó FLOINN, R. 1983a. 'The bronze strainer-ladle' in M. Ryan (ed.), *The Derrynaflan Hoard I, a Preliminary Account*, Dublin, 31–4

Ó FLOINN, R. 1983b. 'Bronze basin' in M. Ryan (ed.), *The Derrynaflan Hoard I, a Preliminary Account*, Dublin, 35

Ó FLOINN, R. 1987. 'Schools of metalworking in eleventh- and twelfth-century Ireland' in M. Ryan (ed.), *Ireland and Insular Art A.D. 500–1200*, Dublin, 179–87

Ó FLOINN, R. Forthcoming. 'The "Tipperary Brooch" reprovenanced', *Jour. Tipperary Arch. and Hist. Soc. 2*

O'KEEFFE, J. G. 1904. 'The Rule of Patrick', *Eriu* 1, 216–24

O'KELLY, M. J. 1962–4. 'Two ring-forts at Garryduff, Co. Cork', *PRIA* 63c, 17–125

O'KELLY, M. J. 1965. 'The belt-shrine from Moylough, Sligo', *JRSAI* 95, 149–88

OLSEN, M. 1954. 'Runic inscriptions in Great Britain, Ireland and the Isle of Man' in H. Shetelig (ed.), *Viking Antiquities in Great Britain and Ireland, Part VI. Civilisation of the Viking Settlers in relation to their old and new Countries*, Oslo, 151–234

O'MEADHRA, U. 1979. *Early Christian, Viking and Romanesque Art: Motif-Pieces from Ireland. An illustrated and descriptive catalogue*, Theses and Papers in North-European Archaeology 7, Stockholm

O'MEADHRA, U. 1986. 'Preliminary observations on the manufacture of relief back-plates in Hiberno-Saxon filigree work', *Laborativ arkeologi: Rapport fran Stockholms Universitets Arkeologiska Forsknings-laboratorium*, no. 1, 81–94

O'MEADHRA, U. 1987. *Early Christian, Viking and Romanesque Art: Motif-Pieces from Ireland, 2. A discussion*, Theses and Papers in North-European Archaeology 17, Stockholm

O'MEADHRA, U. 1988. 'Skibe i Ranveigs skrin', *Skalk* 5, 3–5

O'MEARA, J. J. (ed.) 1982. *Gerald of Wales. The History and Topography of Ireland*, London

ORGAN, R. 1973. 'Examination of the Ardagh Chalice – a case history' in W. J. Young (ed.), *Application of Science in Examination of Works of Art*, Boston, 237–71

Ó RÍORDÁIN, A. B., and RYNNE, E. 1961. 'A settlement in the sandhills at Dooey, Co. Donegal', *JRSAI* 91, 58–64

Ó RÍORDÁIN, S. P. 1934–5. 'Recent Acquisitions from County Donegal in the National Museum', *PRIA* 42c, 145–91

Ó RÍORDÁIN, S. P. 1941–2. 'The excavation of a large earthen ringfort at Garranes, Co. Cork', *PRIA* 47c, 77–150

Ó RÍORDÁIN, S. P. 1945–8. 'Roman Material in Ireland', *PRIA* 51c, 35–82

Ó RÍORDÁIN, S. P. 1949. 'Lough Gur excavations: Carraig Aille and the "Spectacles" ', *PRIA* 52c, 39–111

PAINTER, K. S. 1977a. 'Gold and silver in the Roman world', in W. A. Oddy (ed.), *Aspects of Early Metallurgy*, Historical Metallurgy Society and British Museum Research Laboratory Symposium, London, 135–58

PAINTER, K. S. 1977b. *The Water Newton Early Christian Silver*, London

PEERS, C, and RADFORD, C. A. R. 1943. 'The Saxon monastery of Whitby', *Archaeologia*, 89, 27–88

PETERSEN, J. 1940. *Viking Antiquities in Great Britain and Ireland*, ed. H. Shetelig, *Part V British Antiquities of the Viking Period, found in Norway*, Oslo

PRYOR, F. 1976. 'A Descriptive Catalogue of some Ancient Irish Metalwork in the Collections of the Royal Ontario Museum, Toronto', *JRSAI* 106, 73–91

RAFTERY, B. 1983. *A Catalogue of Irish Iron Age Antiquities*, 2 vols, Maburg

RAFTERY, B. 1984. *La Tène in Ireland. Problems of Origin and Chronology*, Maburg

RAFTERY, J. 1940. 'New early iron age finds from Kerry', *Journal of the Cork Archaeological and Historical Society* 45, 55–6

RAFTERY, J. (ed.) 1941. *Christian Art in Ancient Ireland*, vol. II, Dublin

RAFTERY, J. 1941. 'Recent Acquisitions from Co. Clare in the National Museum', *North Munster Antiquarian Journal* 2, 170–1

RAFTERY, J. 1956. 'A Wooden Bucket from County Louth', *County Louth Archaeological Journal* 13, 395–8

RAFTERY, J. 1980. *Artists and Craftsmen: Irish Art Treasures*, Dublin

RALSTON, I., and INGLIS, J. 1984. *Foul Hordes. The Picts in the North East and their Background*, Anthropological Museum, University of Aberdeen

RHODES, J. F. 1974. 'The Oldcroft (1971–2) Hoard of bronze coins and silver objects', *Numismatic Chronicle*, 7th ser., XIV, 65

RITCHIE, J. N. G., 1981. 'Excavations at Machrins, Colonsay', *PSAS* 111, 263–81

ROBINSON, P. H. 1977–8. 'The Merovingian Tremisses from "near Devizes". A probable context', *Wiltshire Archaeological Magazine* 72/3, 191–5

ROMILLY ALLEN, J. 1898. 'Metal bowls of the Late Celtic and Anglo-Saxon Periods', *Archaeologia* LVI, 39–56

ROMILLY ALLEN, J., and ANDERSON, J. 1903. *The Early Christian Monuments of Scotland*, 2 vols, Edinburgh

ROTH, H. 1986. *Kunst und Handwerk im Frühen Mittelalter*, Stuttgart

RYAN, M. 1982. 'The Roscrea Brooch', *Eile* 1, 5–23

RYAN, M. 1983. *The Derrynaflan Hoard I, a Preliminary Account*, Dublin

RYAN, M. (ed.) 1983. *Treasures of Ireland, Irish Art 3000 B.C.–1500 A.D.*, Dublin

RYAN, M. 1984a. 'Early Irish Chalices', *Irish Arts Review* 1, no. 1, 21–5

RYAN, M. 1984b. 'The Derrynaflan and other early Irish Eucharistic Chalices: some speculation' in M. Richter and P. Ni Catháin (eds), *Ireland and Europe – The Early Church*, Stuttgart

RYAN, M. 1985. *Early Irish Communion Vessels: Church Treasures of the Golden Age*, Dublin

RYAN, M. 1986. 'A gilt-bronze object in the M.R.A.H.', *Musea* 56, 57–60

RYAN, M. 1987a. 'The Donore Hoard: early medieval metalwork from Moynalty, near Kells, Ireland', *Antiquity* 61, 57–63

RYAN, M. 1987b. 'Some aspects of sequence and style in the metalwork of eighth- and ninth-century Ireland' in M. Ryan (ed.), *Ireland and Insular Art A.D. 500–1200*, Dublin, 66–74

RYAN, M. 1987c. 'A suggested origin for the figure representations on the Derrynaflan Paten' in E. Rynne (ed.), *Figures from the Past. Studies on Figurative Art in Christian Ireland*, Dublin, 62–72

RYAN, M. (ed.) 1987. *Ireland and Insular Art A.D. 500–1200*, Dublin

RYAN, M. 1989. 'Fine metalworking and early Irish monasteries' in J. Bradley (ed.), *Settlement and Society in Medieval Ireland*, Kilkenny, 33–48

RYAN, M., and CAHILL, M. 1981. *Gold aus Irland*, Munich

RYAN, M., and CAHILL, M. 1988. *Irish Gold: 4000 Years of Personal Ornaments*, Melbourne

RYAN, M., AND KELLY, E. P. 1987. 'New finds at the National Museum of Ireland', *Ireland of the Welcomes* 36, 22–5

RYAN, M., and Ó FLOINN, R. 1983. 'The Paten and Stand' in M. Ryan, *The Derrynaflan Hoard I, a Preliminary Account*, Dublin, 17–30

RYGH, O. 1885. *Norske Oldsager*, Christiania

RYNNE, E. 1964. 'The coiled bronze armlet from Ballymahon, Co. Meath', *JRSAI* 94, 67–72

RYNNE, E. 1965. 'A bronze ring brooch from Luce Sands, Wigtownshire, its affinities and significance', *Transactions of the Dumfries and Galloway Natural History and Antiquarian Society*, vol. xliii, 99–113

SAVORY, H. N., 1956. 'Some Sub-Romano-British Brooches from South Wales', in D. B. Harden (ed.), *Dark Age Britain*, 40–58

SCHARFF, R. F. 1906. 'The exploration of the Caves of County Clare', *Transactions of the Royal Irish Academy* 33b, 1–76

SCHWIND, F. 1984. 'Zu karolingerzeitlichen Klöstern als Wirtschafts-Organismen und stalten handwerklicher Tätigkeit' in L. Fenske, W. Rosner and T. Zotz (eds), *Institutionen, Kultur und Gesellschaft im Mittelalter. Festschrift für Josef Flekenstein*, Sigmaringen, 101–23

SCOTT, B. G. 1981. 'Gold working techniques in early Irish writings', *Zeitschrift für celtische Philologie* 38, 243–54

SELKIRK, A., 1986. 'St Albans', *Current Archaeology* 101, 178–83

SHERLOCK, D. 1977. 'Silver and Silversmithing' in D. Strong and D. Brown (eds), *Roman Crafts*, London, 11–24

SHETELIG, H. 1920. *Vestfoldskolen, Oseberg-fundet*, 3, Copenhagen

SHETELIG, H. 1927. 'Stamnes-Ringen. Et irsk importstykke fra vikingetiden', *Bergen Museums Årbok 1927, Historisk-Antikvarisk Rekke* 3, 1–10

SHETELIG, H. 1933. *Vikingeminner i Vest-Europe*, Institutet for Sammenlingende Kulturforskning, serie A: Forelesninger XVI, Oslo

SMALL, A., and COTTAM, M. B. 1972. *Craig Phadrig*, University of Dundee Dept of Geography Occasional Papers no. 1

SMALL, A., THOMAS, C., and WILSON, D.M. 1973. *St Ninian's Isle and its Treasure*, 2 vols, Oxford

SMITH, J. A. 1872–4. 'Notice of a silver chain or girdle, the property of Tomas Simson, of Blainslie, Esq., Berwickshire; another in the possession of the University of Aberdeen, and of other ancient Scottish silver chains', *PSAS* 10, 321–47

SMITH, R. A. 1903–5. 'Late Keltic Pins of the Hand Type', *Proc. Soc. Ant.* 2nd ser., XX, 344–54

Smith, R. A.1906–7. 'Note on thistle and other brooches', *Proc. Soc. Ant.* 2nd ser., XXI, 63–71

SMITH, R. A. 1907–9. 'Bronze hanging bowls and enamelled mounts', *Proc. Soc. Ant.* 2nd ser., XXII, 66–86

SMITH, R. A. 1914. 'Irish Brooches of Five Centuries', *Archaeologia* LXV, 223–50

SMITH, R. A. 1915–16. 'Notes on a bronze-gilt boss from Steeple Bumpstead church, Essex', *Proc. Soc. Ant.* 2nd ser., XXVIII, 87–94

SMITH, R. A. 1917–18. 'Irish serpentine latchets', *Proc. Soc. Ant.* 2nd ser., XXX, 120–31

SMITH, R. A. 1923. *British Museum Guide to Anglo-Saxon and Foreign Teutonic Antiquities*, London

SOTHEBY 1913. *Catalogue of the important Collection . . . formed by . . . Robert Day Esq.*, London

SPEAKE, G. 1980. *Anglo-Saxon Animal Art and its Germanic Background*, Oxford

SPEAKE, G. 1989. *A Saxon bed-burial on Swallowcliffe Down*, English Heritage Archaeological Report no. 10, London

STANLEY, W. O. 1876. 'Notices of Sepulchral Deposits with Cinerary Urns found at Porth Dafarch, in Holyhead Island, in 1848 . . .', *Arch. J.* XXXIII, 132–43

STENBERGER, M. 1966–7. 'A Ringfort at Raheennamadra, Co. Limerick', *PRIA* 65, 37–54

STEVENSON, R. B. K. 1963–4. 'The Gaulcross hoard of Pictish silver', *PSAS* XCVII, 206–11

STEVENSON, R. B. K. 1966. 'Metalwork and some other objects in Scotland and their cultural affinities' in A. L. F. Rivet (ed.), *The Iron Age in Northern Britain*, Edinburgh

STEVENSON, R. B. K. 1968. 'The Brooch from Westness, Orkney' in B. Niclasen (ed.), *The Fifth Viking Congress, Torshavn 1965*, 25–31

STEVENSON, R. B. K. 1972. 'Note on a mould from Craig Phadrig' in A. Small and M. B. Cottam, *Craig Phadrig*, University of Dundee Dept of Geography Occasional Papers no. 1, 49–51

STEVENSON, R. B. K. 1974. 'The Hunterston brooch and its significance', *Med. Arch.* 18, 16–42

STEVENSON, R. B. K. 1976. 'The earlier metalwork of Pictland' in J. Megaw (ed.), *To Illustrate the Monuments*, London, 246–51

STEVENSON, R. B. K. 1983. 'Further notes on the Hunterston and "Tara" brooches, Monymusk reliquary and Blackness bracelet', *PSAS* 113, 469–77

STEVENSON, R. B. K. 1985. 'The Pictish brooch from Aldclune, Blair Atholl, Perthshire', *PSAS* 115, 233–9

STEVENSON, R. B. K. 1987. 'Brooches and pins: some seventh- to ninth-century problems' in M. Ryan (ed.), *Ireland and Insular Art A.D. 500–1200*, Dublin, 90–5

STEVENSON, R. B. K. 1988. 'The Westness Brooch and other hinged pins', *PSAS* 118

STEVENSON, R. B. K., and EMERY, J. 1963–4. 'The Gaulcross hoard of Pictish silver', *PSAS* 97, 206–11

STOKES, M. 1894. *Early Christian Art in Ireland*, Part I, London

STOKES, M. 1932. *Early Christian Art in Ireland*, Dublin

STUART, J. 1867. *The Sculptured Stones of Scotland*, II

SWANSTON, W. 1903. 'Ancient Irish Bronze Ornament', *UJA* 9, 191

SWARZENSKI, H. 1954. 'An Early Anglo-Irish Portable Shrine', *Bulletin of the Museum of Fine Arts Boston* III, 50–62

SWARZENSKI, H., and NETZER, N. 1986. *Enamels and Glass, Catalogue of Medieval Objects, Museum of Fine Arts*, Boston

THOMAS, C. 1984. 'The Pictish Class I Symbol Stones' in J. G. P. Friell and W. G. Watson (eds), *Pictish Studies* BAR, BS 125, Oxford, 169–85

THORSTEINSSON, A. 1968. 'The Viking burial place at Pierowall, Westray, Orkney' in B. Niclasen (ed.), *Proceedings of the 5th Viking Congress, Torshavn 1965*, 150–73

TOYNBEE, J. C. M., and PAINTER, K. S. 1986. 'Silver Picture Plates of Late Antiquity', *Archaeologia* 108, 15–65

TRISCOTT, J. 1980. 'Aldclune, defended enclosures', *Discovery and Excavation in Scotland 1980*, ed. E. Proudfoot, Council for British Archaeology, Scotland, 82–3

UNTRACHT, O. 1975. *Metal Techniques for Craftsmen*, New York

UNTRACHT, O. 1982. *Jewellery. Concepts and Technology*, London

WAINWRIGHT, F. T. (ed.) 1955. *The Problem of the Picts*, Edinburgh

WAKEMAN, W. F. 1874–5. 'Two ancient pins', *JRSAI* 13, 155–9

WAMERS, E. 1985. *Insularer Metallschmuck in Wikingerzeitlichen Gräbern Nordeuropas*, Offa-Bücher 56, Neumunster

WAMERS, E. 1987. 'Egg-and-dart derivatives in insular art' in M. Ryan (ed.), *Ireland and Insular Art A.D. 500–1200*, Dublin, 96–104

WARNER, R. B. 1973–4. 'The re-provenancing of two important penannular brooches of the Viking period', *UJA* 36–7, 58–70

WARNER, R. B. 1979. 'The Clogher Yellow Layer', *Medieval Ceramics* 3, 37–40

WARNER, R. B. 1983. 'Ireland, Ulster and Scotland in the earlier Iron Age' in A. O'Connor and D. V. Clarke (eds), *From the Stone Age to the 'Forty-Five*, Edinburgh, 160–87

WARNER, R. B. 1985/6. 'The date of the start of Lagore', *Journal of Irish Archaeology* III, 75–7

WARNER, R. B. 1987. 'Ireland and the origins of escutcheon art' in M. Ryan (ed.), *Ireland and Insular Art A.D. 500–1200*, Dublin, 19–22

WARNER, R. B. 1988. 'The archaeology of early historic Irish kingship' in S. Driscoll and M. Nieke (eds), *Power and Politics in Early Medieval Britain and Ireland*, Edinburgh, 47–68

WATERMAN, D. M. 1967. 'The early Christian Churches and Cemetery at Derry, Co. Down', *UJA* 30, 53–69

WAUGH, H. 1966. 'The Hoard of Roman Silver from Great Horwood, Buckinghamshire', *Ant. J.* 46, 60–71

WEITZMANN, K. 1977. *Late Antique and Early Christian Book Illumination*, London

WERNER, J. 1978. 'Jonas in Helgo', *Bonner Jahrbücher* 178, 519–30

WHEELER, R. E. M. 1925. *Prehistoric and Roman Wales*, Oxford

WHITFIELD, N. 1985. 'Beaded wire in the early Middle Ages', preprint from the *3rd International Symposium on the History of Jewellery Materials and Techniques 4–6 Nov. 1985*, London

WHITFIELD, N. 1987. 'Motifs and techniques of Celtic filigree. Are they original?' in M. Ryan (ed.), *Ireland and Insular Art A.D. 500–1200*, Dublin, 75–84

WILDE, W. 1836–40. 'The animal remains and antiquities recently found at Dunshaughlin in the county of Meath', *PRIA* 1, 420–6

WILDE, W. 1849. *The Beauties of the Boyne and its tributary the Blackwater*, 1st edn, Dublin

WILDE, W. 1850. *The Beauties of the Boyne and its tributary the Blackwater*, 2nd edn, Dublin

WILDE, W. 1861. *A Descriptive Catalogue of the Antiquities of Animal Materials and Bronze in the Museum of the Royal Irish Academy*, Dublin

WILDE, W. 1866. 'On the Scandinavian Antiquities lately discovered at Islandbridge, near Dublin', *PRIA* 10, 13–22

WILSON, D. 1863. *Prehistoric Annals of Scotland*, vol. II, London and Cambridge

WILSON, D. M. 1961. 'An Anglo-Saxon Bookbinding at Fulda (Codex Bonifatianus I)', *Ant. J.* 41, 199–217

WILSON, D. M. 1970. *Reflections on the St Ninian's Isle Treasure*, Jarrow lecture for 1969, Jarrow

WILSON, D. M. 1973. 'The Treasure' in A. Small, C. Thomas and D. M. Wilson, *St Ninian's Isle and its Treasure*, Oxford, 45–148

WILSON, D. M. 1984. *Anglo-Saxon Art from the seventh century to the Norman Conquest*, London

WOOD-MARTIN, W. G. 1886. *The Lake Dwellings of Ireland*, Dublin

WOOD-MARTIN, W. G. 1903–4. 'Bronze serpentine latchets and other Cumbrous Dress Fasteners', *UJA*, 3rd ser., IX, 160–6

YATES, M. 1983. 'Preliminary Excavations at Movilla Abbey, County Down, 1980', *UJA* 46, 53–66

Acknowledgements

My thanks to all lenders and contributors for their help and patience. In addition I would like to thank Ewan Campbell and Alan Lane, University of Wales College of Cardiff, the Apostolic Pro-Nuncio His Excellency Archbishop L. Barbarito, Michelle Brown of the British Library, James Graham-Campbell, University College London, Conor Newman and Niamh Whitfield for many kinds of assistance and support. Colleagues in Dublin and Edinburgh, Raghnall Ó Floinn, Dr Michael Ryan and Michael Spearman have between them taken on the lion's share of the work and the catalogue has benefited also from the editorial acumen of Raghnall Ó Floinn. In the British Museum thanks are owed to Dr Paul Craddock, Dr Michael Hughes and Susan La Niece of the Scientific Research Department, Ruth Goldstraw, Hazel Newey, Dick Ryan of the Conservation Department, and to Deborah Wakeling, editor at British Museum Publications. In my own department I have had generous help from Barry Agar, Cathy Haith, Jim Farrant, Ray Higgs and the Museum Assistants, Pamela Goss, Evadne Jackson, Tracy Kemp, Judy Rudoe, Lesley Spooner, Valerie Springett and Timothy Wilson. My greatest debt is to Leslie Webster for her encouragement, expert knowledge and hard labour.

S. M. YOUNGS

EXHIBITION DESIGN TEAMS
Dublin: Patrick Gannon
Edinburgh: James Simpson
London: Peter Jackman, Judith Simmons, Julia Walton, Andrea Easey

PHOTOGRAPHIC ACKNOWLEDGEMENTS
Photographs and drawings have been supplied by the lenders or lending institutions with the following exceptions:
Crown copyright, by permission of Her Majesty's Stationery Office, fig. 2; Commissioners of Public Works in Ireland, fig. 3; Trinity College Library, Dublin, col. illus. p. 36; British Library, col. illus. p. 76; David Lee Photography Ltd, Barton-on-Humber, no. 34; Dr Ann Dornier, no. 50; Archivio Restauri, Opificio delle Pietre Dure, Florence, no. 128; National Museum of Ireland, nos 199, 200, 228–9

PHOTOGRAPHERS
Brendan Doyle, Valerie Dowling, National Museum of Ireland; Ian Larner, Royal Museums of Scotland; Dudley Hubbard, Peter Stringer, British Museum